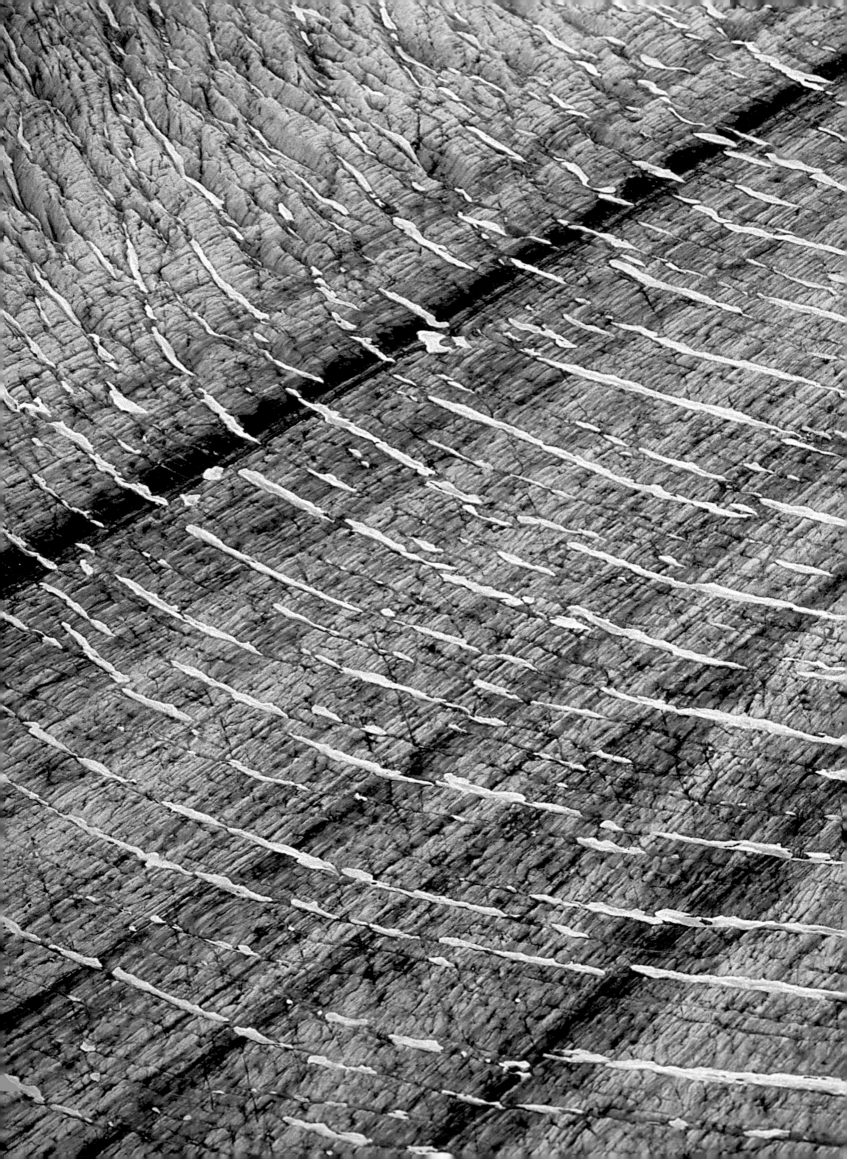

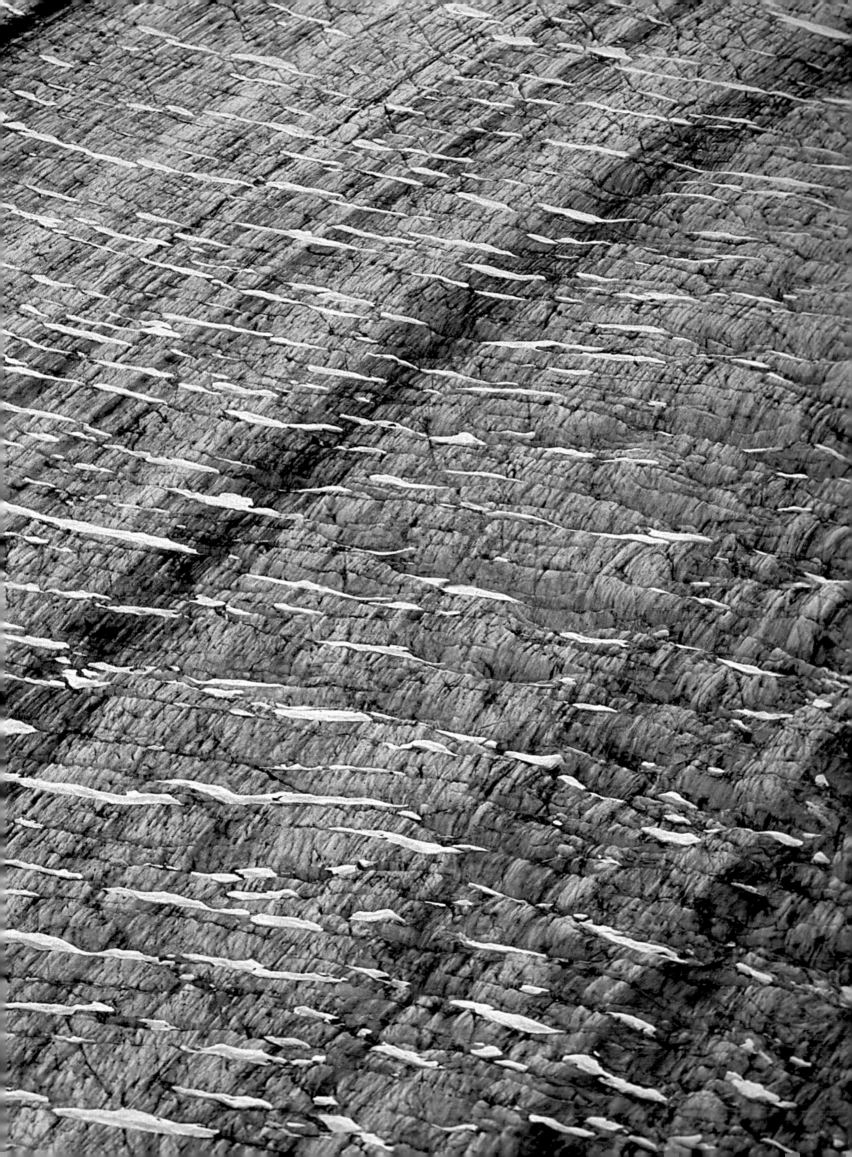

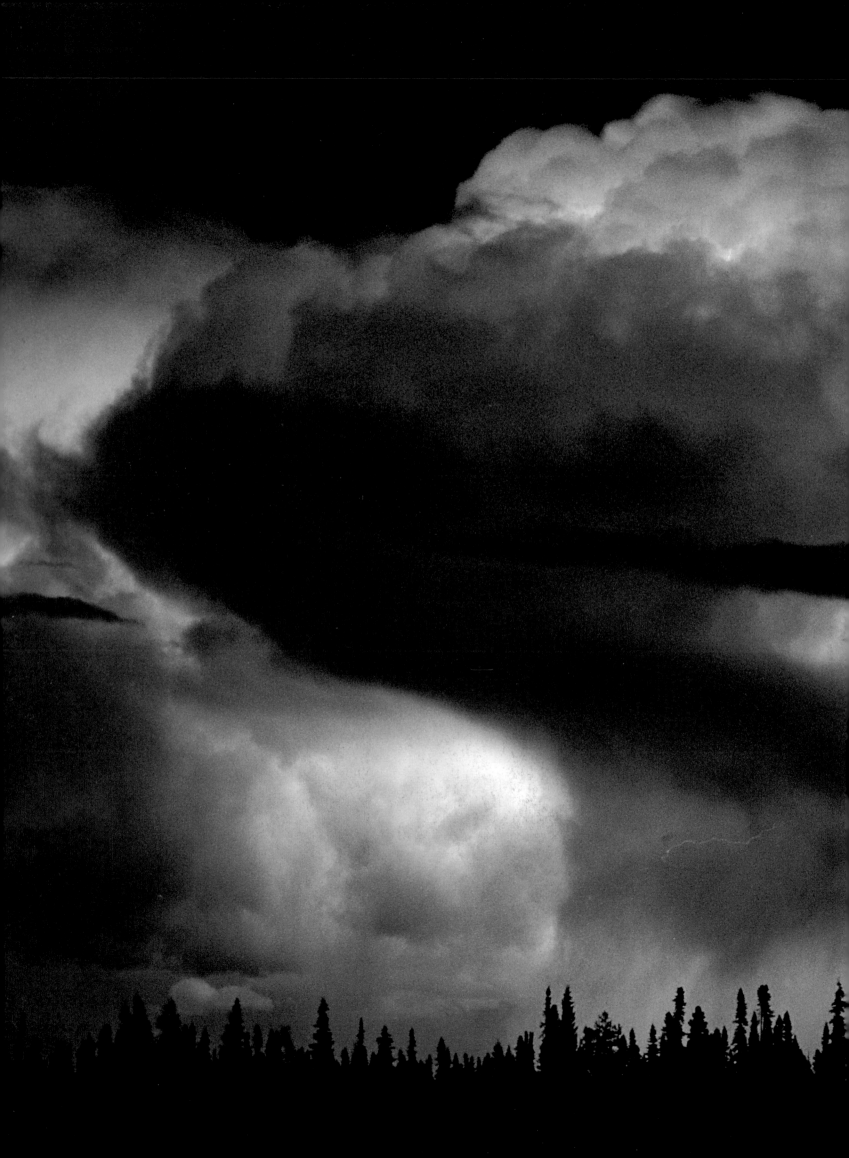

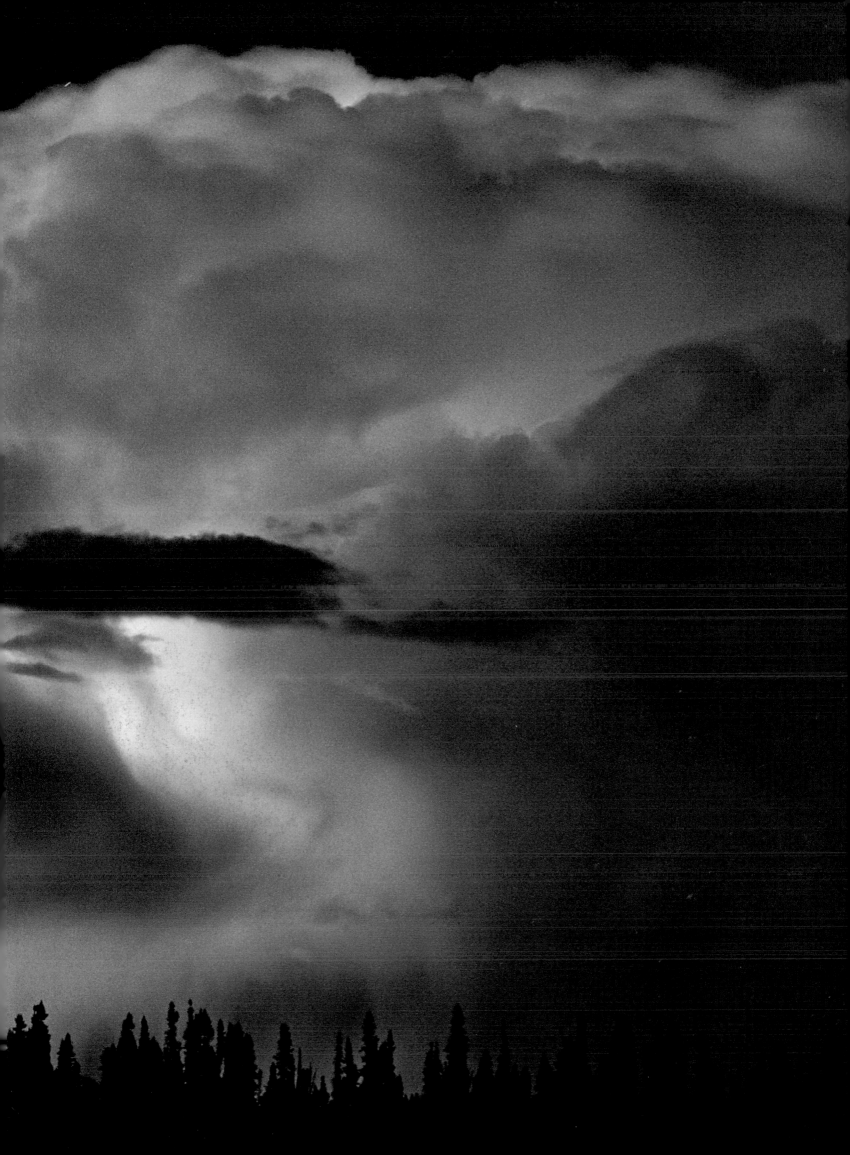

LEAVE NO TR

THE VANISH

AMERICAN W

ACE:
ING NORTH
ILDERNESS

AERIAL PHOTOGRAPHY BY **JIM WARK**
ESSAYS BY **RODERICK F. NASH**

UNIVERSE

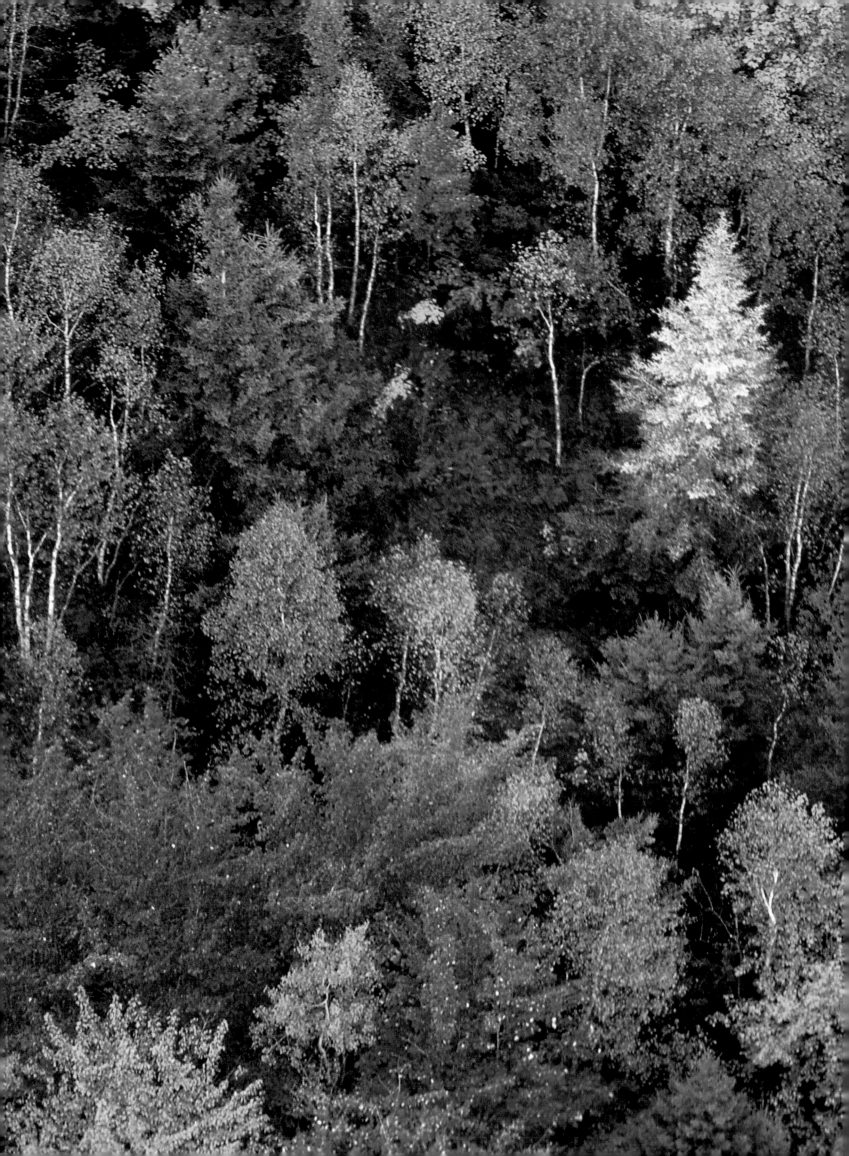

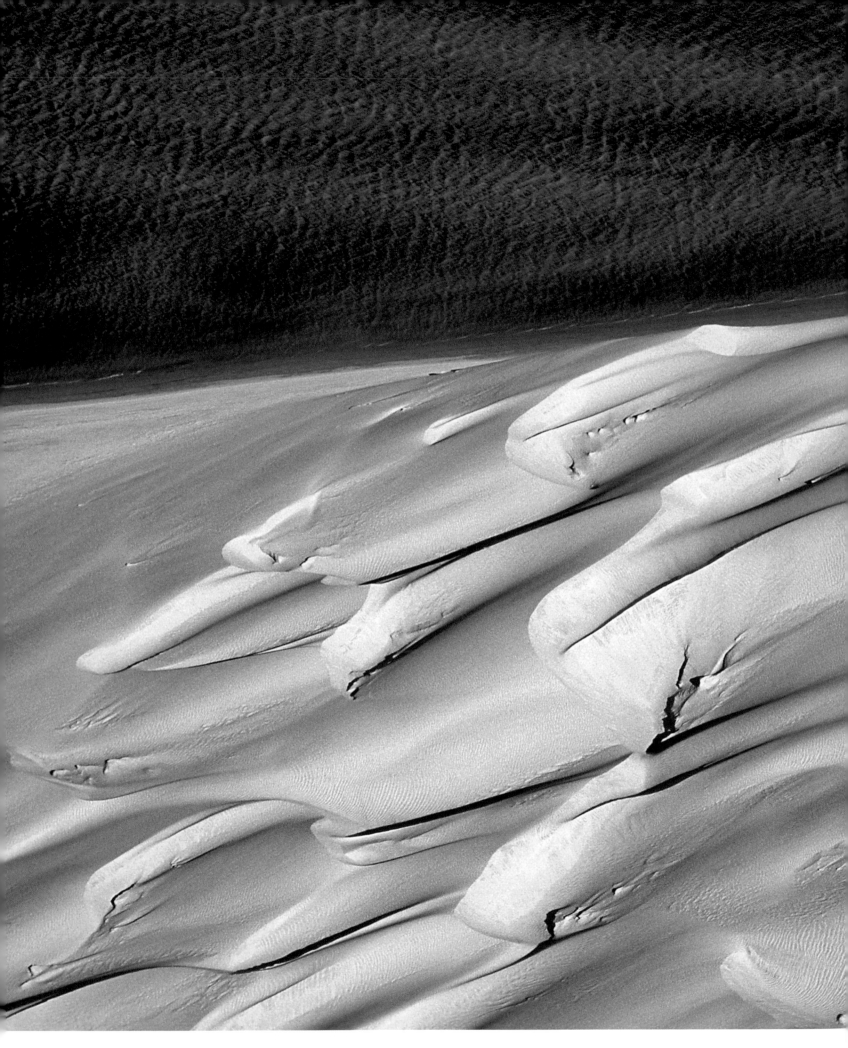

(OPENERS) CHISANA GLACIER, Wrangell-Saint Elias Wilderness, Wrangell-Saint Elias National Park, Alaska. Numerous small crevasses transect the glacial striations (July 1991).

PRAIRIE THUNDERSTORMS, Red Deer, Alberta. These storms flickered most of the night around an Alberta airstrip campsite. After each episode of lightning, the clouds would glow a bright, slowly diminishing, orange for perhaps ten minutes—a phenomenon for which I have not found an explanation (July 1991).

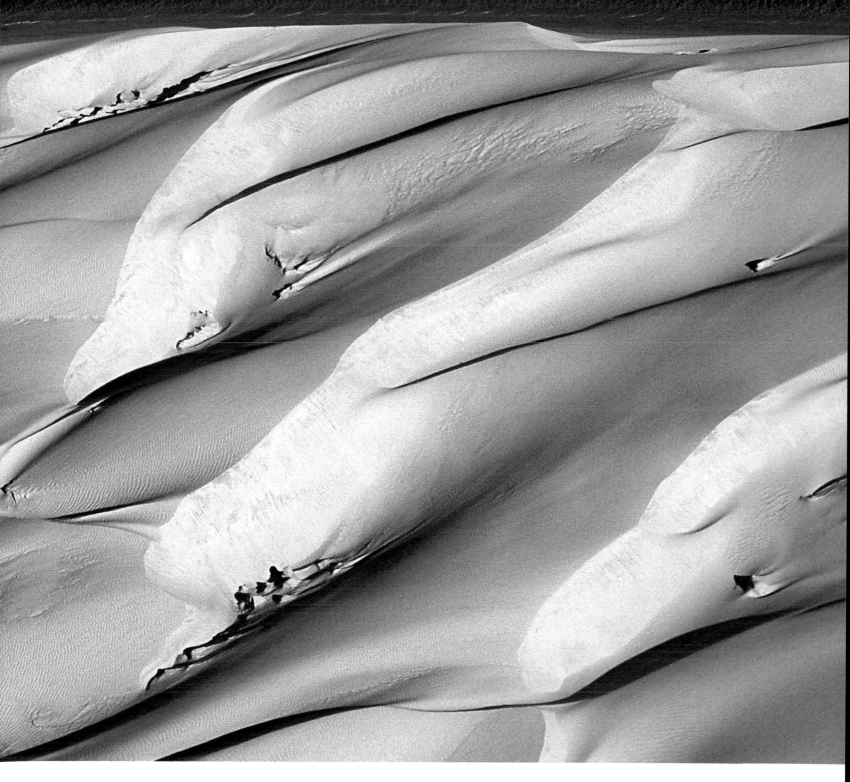

ALBINO OR "GHOST TREE," near Lubec, Washington County, Maine. Albinos of spruce and balsam have been found. Even though albino plants do not live long, their occurrence is useful to those who study forest genetics.

SCAMMONS LAGOON DUNES, Pacific Coast, Baja California Sur, Mexico. Some of the dune patterns bear a resemblance to the whales for which the Scammons Lagoon is famous (January 1996).

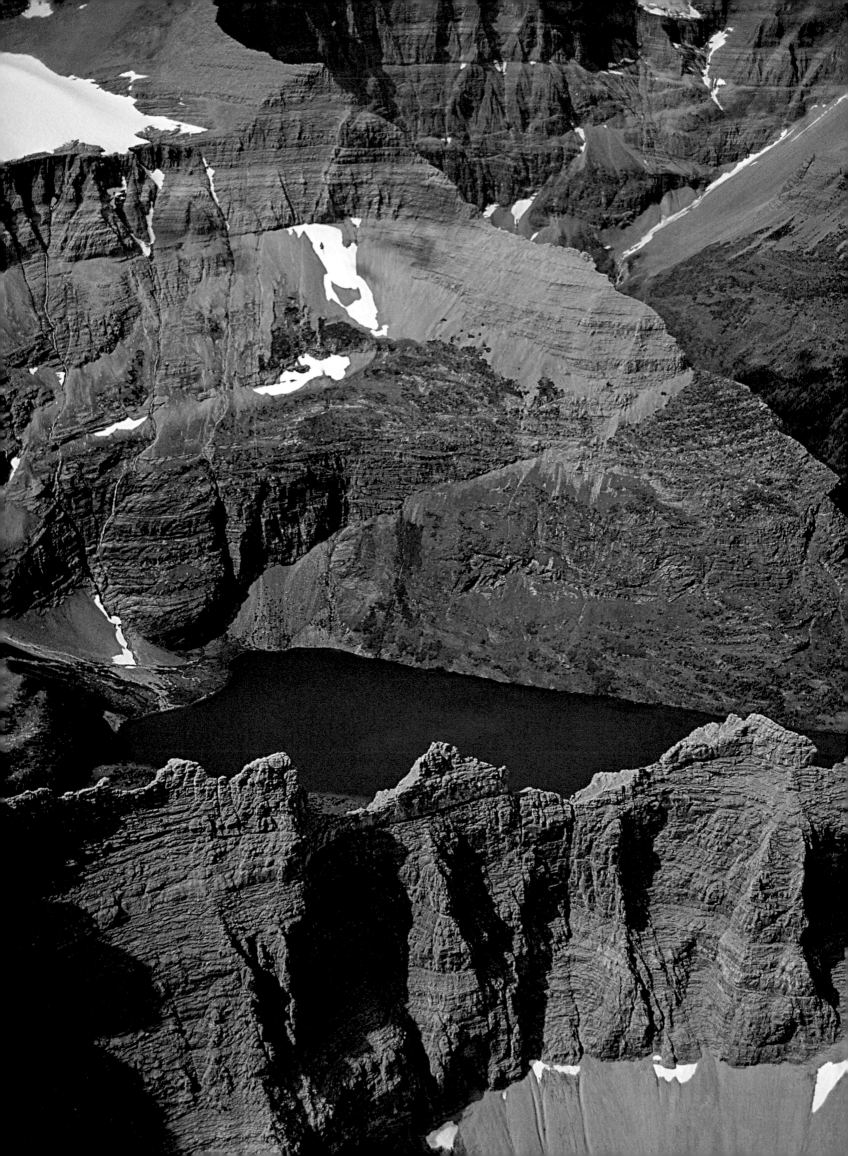

AS YOU TURN THE PAGES of the beautiful book in your hands you will be looking down at terrain some of us would call "wilderness." But what does that really mean? Well, we do pass legislation and draw lines on maps that create "wilderness areas." But there's a lot more to the definitional story. The problem is that unlike "canyon" or "mountain" the word does not describe a specific geographical feature. Rather, it refers to a perceived quality or attribute of a place. The "ness" part of the word is significant. Think of "vastness" or "loneliness." We are talking about feelings here and, inevitably, subjectivity.

Consider the word "will"; it is an ancient and important concept in the English language that has to do with the essence of being. Someone, even some thing, that is not controlled or forced is said to be "willful" and to have its "own free will." That's what witnesses are ensuring when someone signs a "Last Will." Regarding nature, after the beginning of herding and agriculture it made sense to talk about conquering or taming the land and "breaking" animals like horses. What was broken, obviously, was their wills.

The adjective "wild" came into early use to describe something that had its own will. "Wilderness," then, literally means self-willed land. There are a lot of implications in this definition for how we should understand, value, and, particularly, manage wilderness. The first axiom might be that less is more. Can we be guardians, not gardeners, when it comes to self-willed land?

FOREWORD

Remembering that wilderness is more of a perception than a place, it makes sense to say that civilization created it. For the nomadic hunters and gatherers (which we've been for most of our existence as a species) "wilderness" was meaningless. Everything natural was simply habitat and people understood themselves to be members, not masters, of the life community. With the advent of herding, agriculture, and settlement, lines began to be drawn on the land and in our minds. Distinctions between controlled (domesticated) and uncontrolled (wild) animals and plants acquired significance. So did controlled space as defined by fences and town walls. For the first time humans saw themselves as distinct from and, they reasoned, better than the rest of nature.

Until very recently the largest part of human cleverness and energy went into keeping the wild at bay or, even better, exploiting it for economic gain. Nowhere did this subjugation proceed with more fervor than in North America, where the full pastoral biases of the Judeo-Christian tradition met a vast new wilderness. To be sure, humans lived there, but in the mind of the European pioneers they were wild men ("savages") who should also be tamed.

Over time, of course, civilization prevailed in North America and the frontier vanished. Uncontrolled land now exists as scattered remnants of the once wild carpet. In the forty-eight states the amount of pavement is approximately equal to the amount of protected wilderness. Self-willed land is now an endangered geographical species and the people of the present century will have the final say about its continued existence. That is one compelling reason why the celebration of wild places in this book is so important. It testifies to a momentous intellectual revolution that transformed the perception that wilderness is a liability into the recognition that it is an asset to be valued and protected.

RODERICK F. NASH

GLACIER NATIONAL PARK, Glacier County, Montana. This scene is typical of the rugged park beauty set in motion by thrust fault movements of 170 million years ago. The glaciers in the park are now few and small (August 1990).

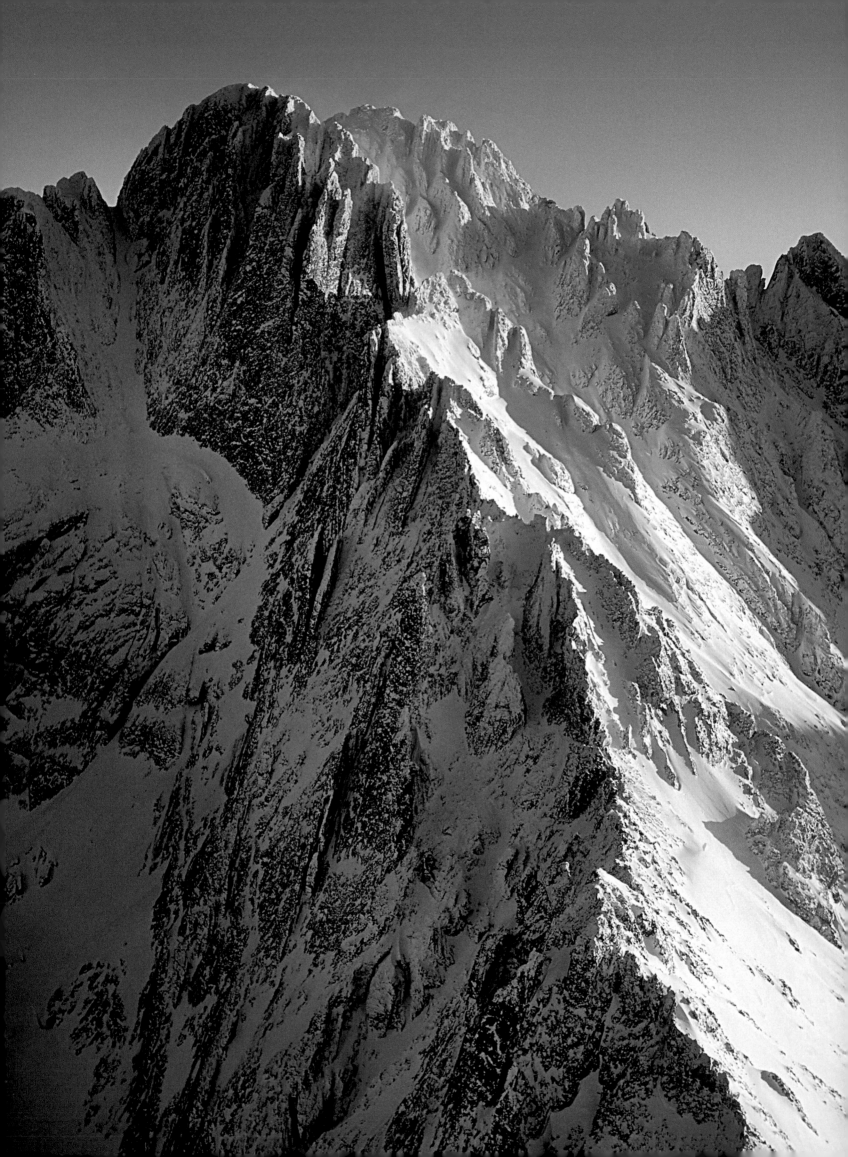

THE CONCEPT OF STATE WILDERNESS preservation began in the United States in 1832 when Congress and President Andrew Jackson set aside 2,600 acres as a reserve in Hot Springs, Arkansas. In 1864, under President Abraham Lincoln, more land was designated in California's Yosemite Valley and Great Sequoia areas. The world's first national park designation, Yellowstone, was established by Congress in 1872. Australia became home to the world's second national park, the Royal National Park, in 1879 and Canada's first national park, now called Banff, was founded in 1885. By 2006 there were 6,555 national parks worldwide.

The Wilderness Act of 1964, signed into law by President Lyndon Johnson, set aside some 9 million acres. It succinctly defined wilderness: "A wilderness, in contrast with those areas where man and his own works dominate the landscape, is hereby recognized as an area where the earth and community of life are untrammeled by man, where man himself is a visitor who does not remain."

By 2009 more than 109 million acres were set aside in the United States as designated wilderness, with many new areas, including 9 million acres of a proposed Red Rocks Wilderness in Utah, waiting in the wings.

Over the years I have photographed almost every type of wilderness area, from the hot, parched deserts of the American Southwest to the cool mountain meadows of the Rockies; from the dismal, dark swamps of the South to the raging clear rivers of Canada's Northwest Territories. I've seen everything from Alaska's soaring eagles to Costa Rica's jungle-swooping scarlet macaws; from polar bears on the shore of Hudson Bay to dall sheep grazing Alaska's peaks. To some, wilderness speaks of freedom, purity, and solitude; to others it suggests restriction and elite privilege. To me it is not just a place, but a concept and a state of mind. In geologic time it is an ever-changing landscape. In the present it seems a place unchanged by man. Spiritually, it is a representation of God's, or Nature's earth, as it was created and for which it was intended. Practically, it is a place to refresh the soul, mind, and spirit. With this thought in mind, it's interesting to read these two scriptural verses, identical in thought, from the Bible and the Koran: "For in six days the Lord made heaven and earth, and on the seventh day he rested, and was refreshed" (Exodus 31:1); "We created the heavens and the earth and all between them in six days, nor did any sense of weariness touch us" (Koran 50:38).

THE VANISHING WILDERNESS

To gain this renewal of mind and spirit, wilderness must really be experienced in person, on the ground. However, the concept may be best expressed in art, be it literature, illustration, or photography. But why aerial photography, which in a sense removes us from the concept? The aerial view does not substitute for, or even equate to, the view from the ground, but it does provide an element of content and context that is complementary and sometimes essential to grasping the sense of "place." It can also provide a uniquely artistic view, unattainable on foot or horseback, for times when we may not see "the forest, for the trees." From an airplane we can circle a mountain peak in minutes, capturing a full array of light, shadow, elevation, and perspective that would take days to traverse on the ground. Although we miss the close-up aspect of the wilderness experience, we are afforded vistas that can be seen in no other way—all without leaving a trace.

SNOW DUSTED CRESTONE NEEDLE, San Isabel National Forest, Sangre de Cristo Wilderness Area, Custer County, Colorado. This is one of a handful of 14,000-foot peaks of the Sangre de Cristo Range of southern Colorado. Rising 14,197-feet, it was first climbed in July 1916 by Allen Ellingwood and Eleanore Davis. It is considered one of the fifty classic climbs of North America (January 1994).

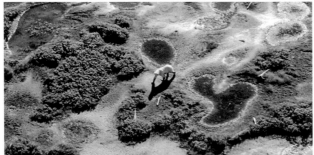

Polar bear in Manitoba

Black flies, Hudson Bay, Manitoba

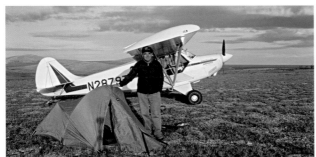
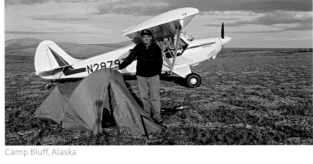

Camp Bluff, Alaska

Hawk in Alaska

Scarlet macaws in Costa Rica

Poor weather in Alaska

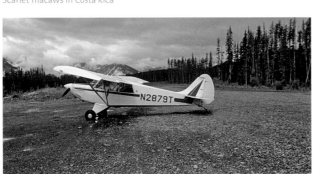

Mudstuck airplane in British Columbia

Lone wolf visit, Alaska

There are, indeed, places where the aerial view does not do justice to the landscape—places like Zion National Park, the Grand Canyon, and Wheeler Geologic Monument in Colorado. By contrast, places like Bryce Canyon National Park and the Carrizo Plain Natural Area, California, benefit from the aerial view.

In this book, Rod Nash's essays, plus my captions and notes, provide the text, but it is the photos that truly tell the story. Included are photos from twenty-seven states, nine Canadian provinces, and three Central American countries. The images selected are not necessarily from places formally designated as wilderness. A few photos show the impact of civilization on areas adjacent to or surrounded by wilderness. Some areas are federal or state parks, preserves, and monuments without a wilderness designation, but all of the photos have a wilderness connection.

The work was done over a period of twenty years, from 1990 to 2010. During this time there were forced landings due to weather and engine failure; times when I got "hopelessly" stuck in the mud or confined to a small tent for days at a time in snow and rain; a camp visit by a shy lone wolf; my campsite marauded by a hungry black bear; my tent attacked by an arctic hawk defending its territory; and more than one night spent sitting in a cold, cramped cockpit waiting out the wind and rain. In my experience, the mosquitoes of Alaska are overrated and the flesh-eating black flies of northern Canada are fearsomely underrated. But the black flies did force me to abandon a camp on the shore of Hudson Bay that I was later informed, would surely have been visited by even more fearsome polar bears. Rather than trials and tribulations, these experiences are now all cherished and priceless memories—better than any thoughts of campfires and sunsets. My hope is that these photos and the words of Rod Nash will challenge and encourage you to seek out your own wilderness experiences and memories, and that you will help to preserve these areas for future generations.

JIM WARK
Pueblo, Colorado

DESERTS,
DUNES,
BUTTES,
AND
HOODOOS

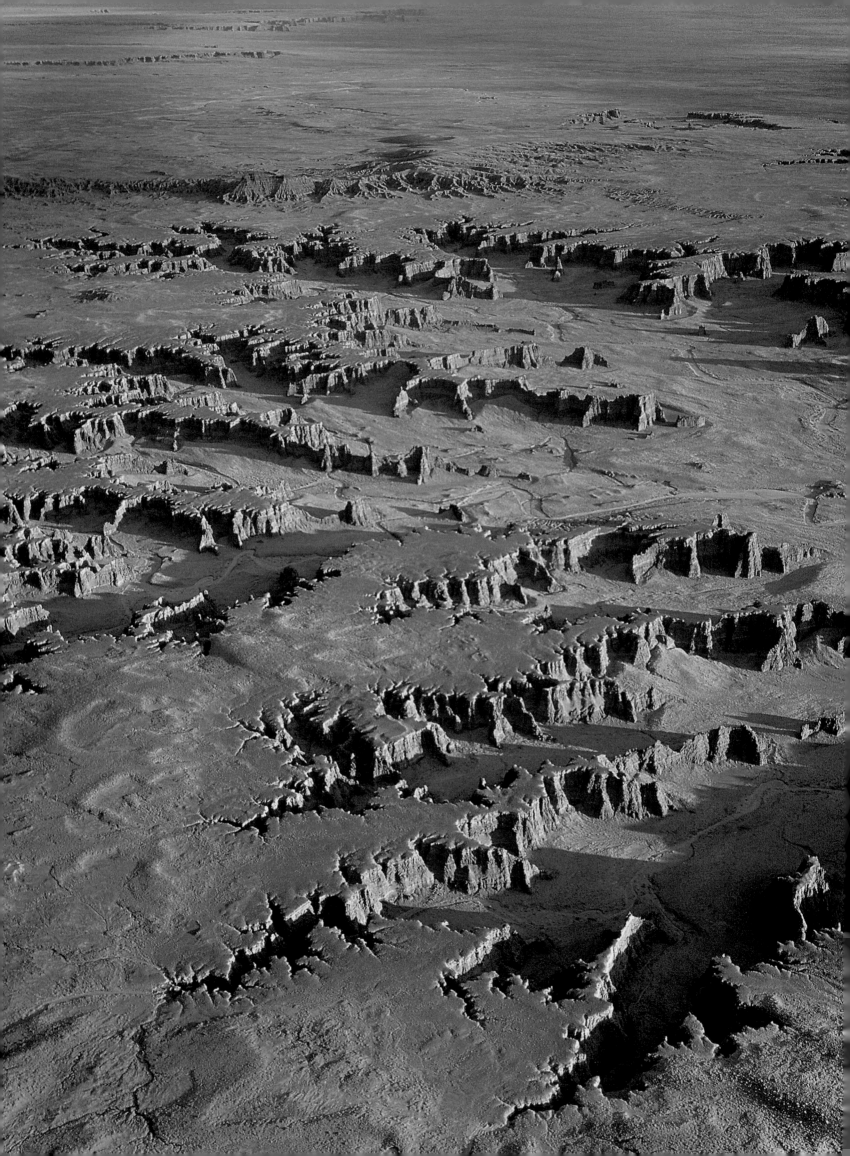

THE APPRECIATION OF SELF-WILLED LAND was slow to make headway against the biases of a pastoral civilization that succeeded by controlling nature. Writers used adjectives like "howling" to describe wilderness, and there is still considerable fear and loathing in wolf country. Historians are not surprised. The Bible is strongly anti-wilderness. Paradise was lost when God drove Adam and Eve out of the idyllic Garden of Eden. Their punishment was to wander in a wilderness, and it was not a recreational experience! Indeed conventional American attitude regarded westward expansion as God-sanctioned and an opportunity to reclaim Eden in the American West.

We are just now beginning to conquer our fear and hatred of the wild. Bottom line: we had to become civilized enough (Theodore Roosevelt would have said "over-civilized") to appreciate wild places. One rung on that intellectual ladder was a reversal of the traditional Christian spiritual polarities of good and evil. Maybe it was the cities that were unhallowed and wilderness an unspoiled cathedral in which to marvel at God and his handiwork. Certainly Ralph Waldo Emerson and Henry David Thoreau found their "transcendent" moments of religion in natural places like Walden Pond, where Thoreau famously retreated in 1845. By this time painters like Thomas Cole, Frederick Church, and Thomas Moran were painting wild mountains. The Middle Ages regarded such places as ugly deformities on Earth's surface—sort of terrestrial pimples and warts! Romanticism, with its disdain for cities, underlay a new aesthetic that found glory rather than gloom in alpine scenery. When, in the 1970s, Edward Abbey called wilderness paradise, the circle fully closed.

DESERTS, DUNES, BUTTES, AND HOODOOS

The nationalism of nature figured importantly in the beginnings of American wilderness appreciation in the nineteenth century. The logic was simple: America could not compete with the castles, cathedrals, and ancient history of the Old World. In terms of wild and amazing natural features, however, America held the trump cards. First Niagara Falls and the Adirondack Mountains and later the Grand Canyon and Yosemite became celebrated as the American equivalents of the Acropolis and Buckingham Palace. By the 1850s Thoreau could celebrate the physical and intellectual vigor of the wild as a necessary counterpoint to an effete and stale civilization. He called for people and landscapes that were "half-cultivated" and even wrote that "in Wildness is the preservation of the World."

Of course ideas change slowly and incompletely, but as the American frontier drew to a close in 1890 substantial philosophical groundwork had been laid for a higher valuation of the once-howling back of beyond.

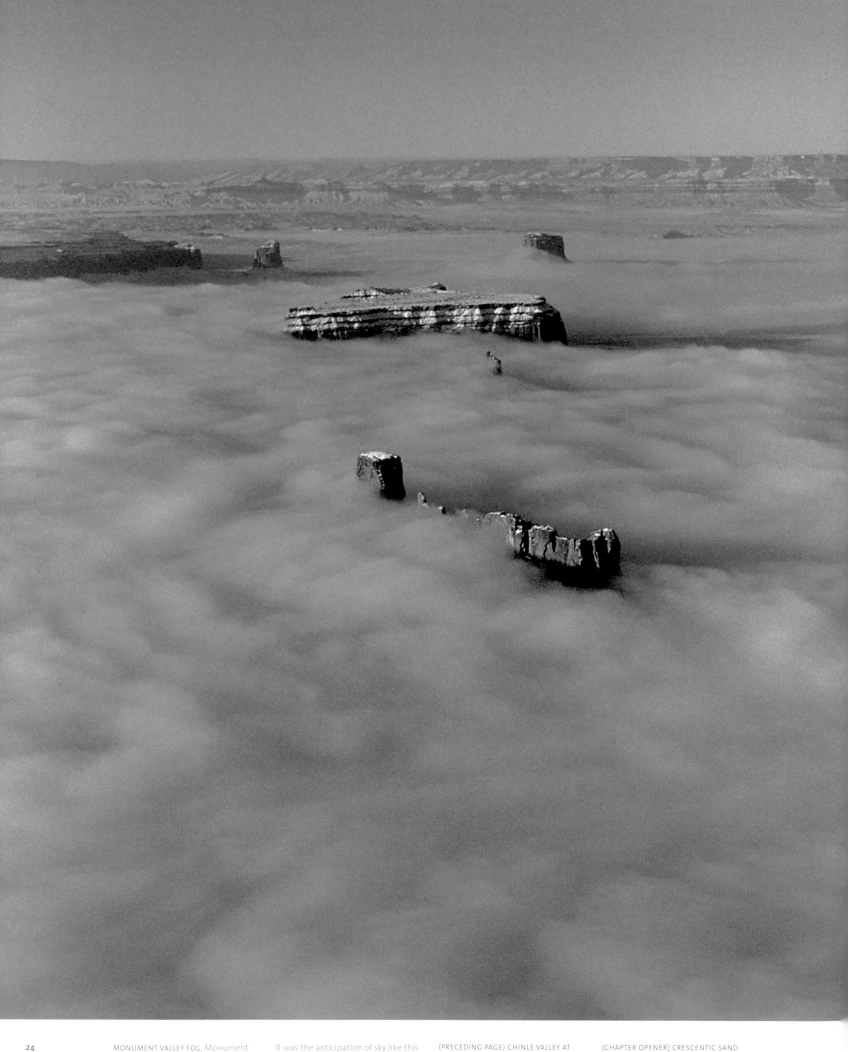

MONUMENT VALLEY FOG, Monument Valley Navajo Tribal Park, San Juan County, Utah. This view looks southwest to The Castle (left), Natani-Tso "Big Leader" (center), and Brigham's Tomb (right).

It was the anticipation of sky like this that brought me here on the early morning of January 20, 1990.

(PRECEDING PAGE) CHINLE VALLEY AT SUNSET, Navajo Indian Reservation, Apache County, Arizona (January 1998).

(CHAPTER OPENER) CRESCENTIC SAND DUNE, Great Sand Dunes National Park, Saguache County, Colorado (September 1990).

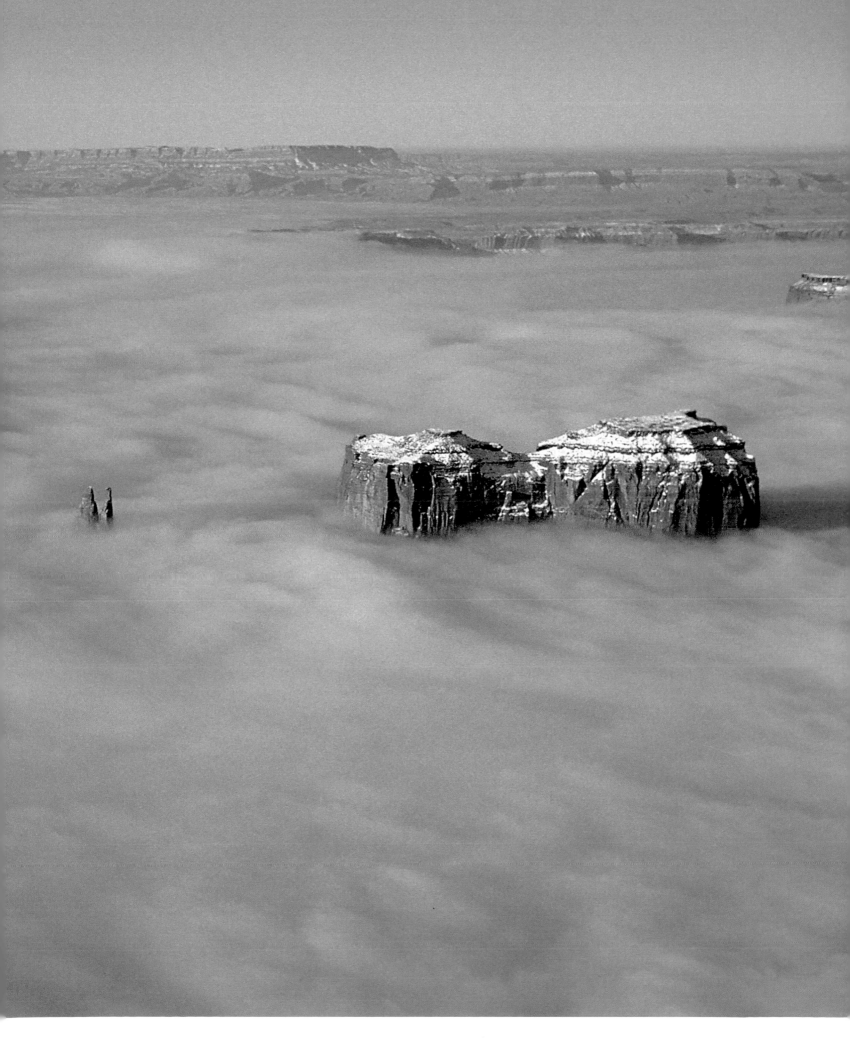

THE BEAR AND THE RABBIT, Monument Valley Navajo Tribal Park, San Juan County, Utah. With some imagination, the standing bear can be seen at the center of the photo and the sitting rabbit on the right. The rock formations of the valley are principally composed of sandstone with some layers of shale (January 1990).

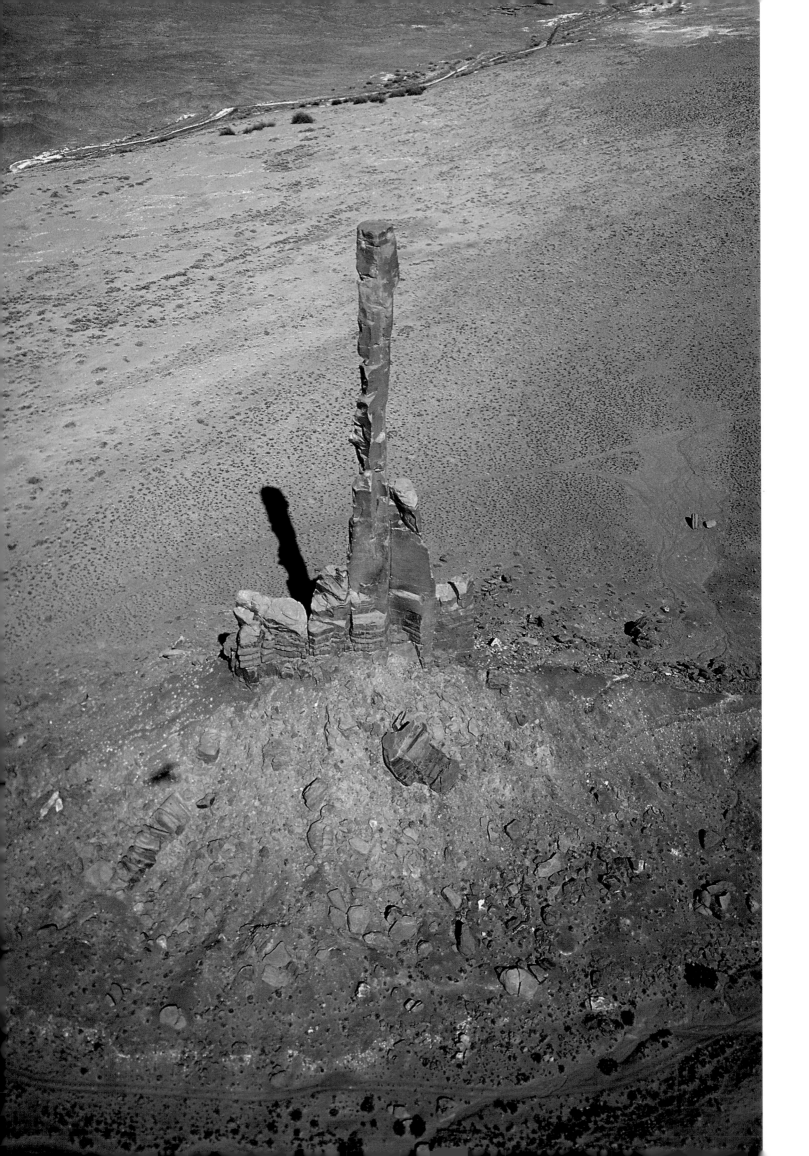

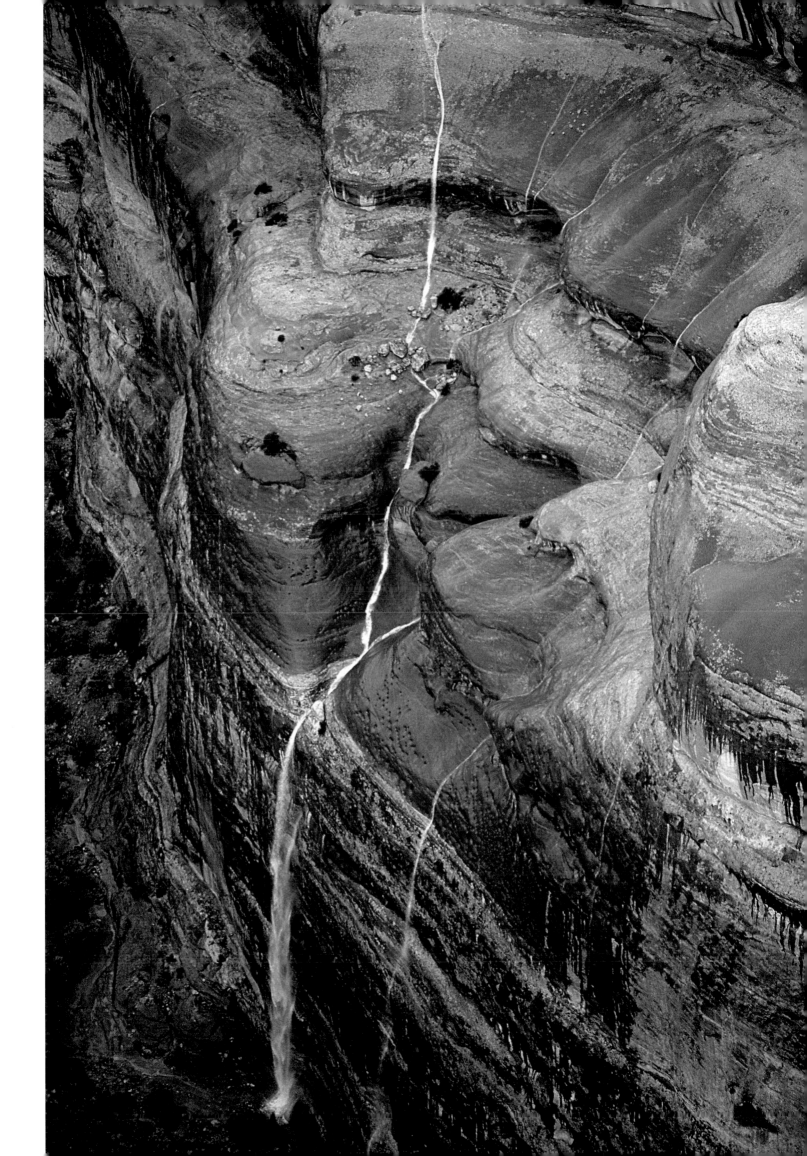

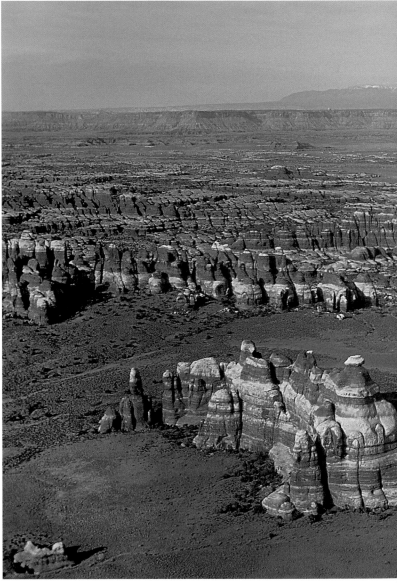

THE NEEDLES, Canyonlands National Park, San Juan County, Utah. Typical hoodoos of the Needles District (September 2004).

CHESLER PARK, Canyonlands National Park, San Juan County, Utah. For a brief time during the spring, Canyonlands wears a mantle of green as seen in this photo of the Needles District (May 1992).

CHOCOLATE DROPS, Canyonlands National Park, San Juan County, Utah. This formation stands 200 feet tall in a transition zone between the Needles District and the Maze District of the park (bombsight view) (March 1994).

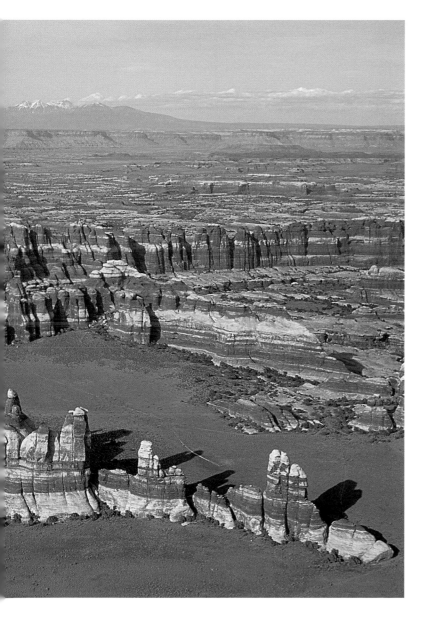

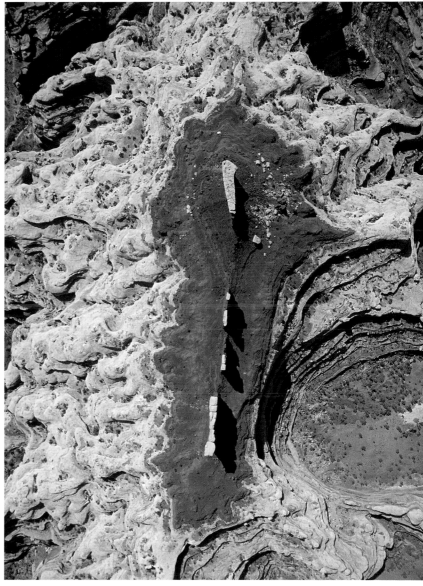

(PRECEDING PAGE, LEFT) TOTEM POLE, Monument Valley Navajo Tribal Park, San Juan County, Utah. A sacred part of the Yei bi chai formation (February 1994).

(PRECEDING PAGE, RIGHT) EPHEMERAL WATERFALL, Canyonlands National Park, San Juan County, Utah. A pouroff from a brief passing desert rainstorm—in ten minutes it will be gone (October 1991).

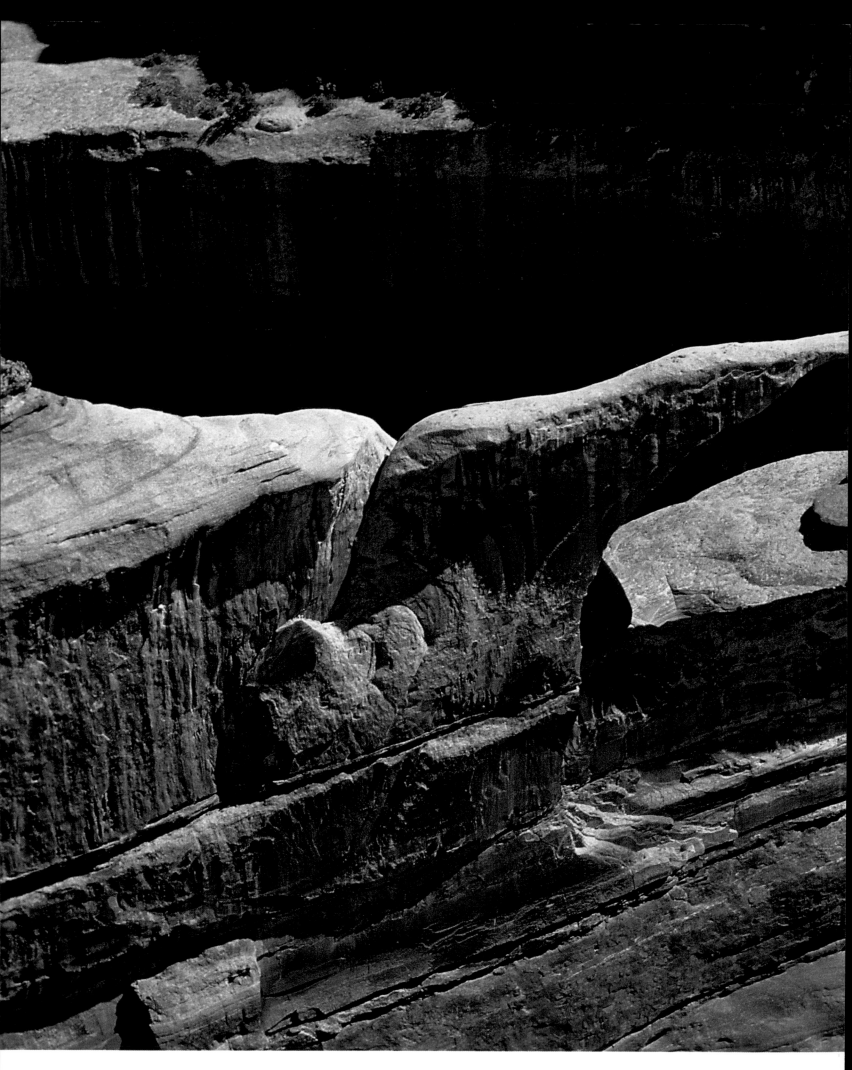

KIRK ARCH, Canyonlands National Park, San Juan County, Utah. One of many similar arches located in the Needles District (April 1990).

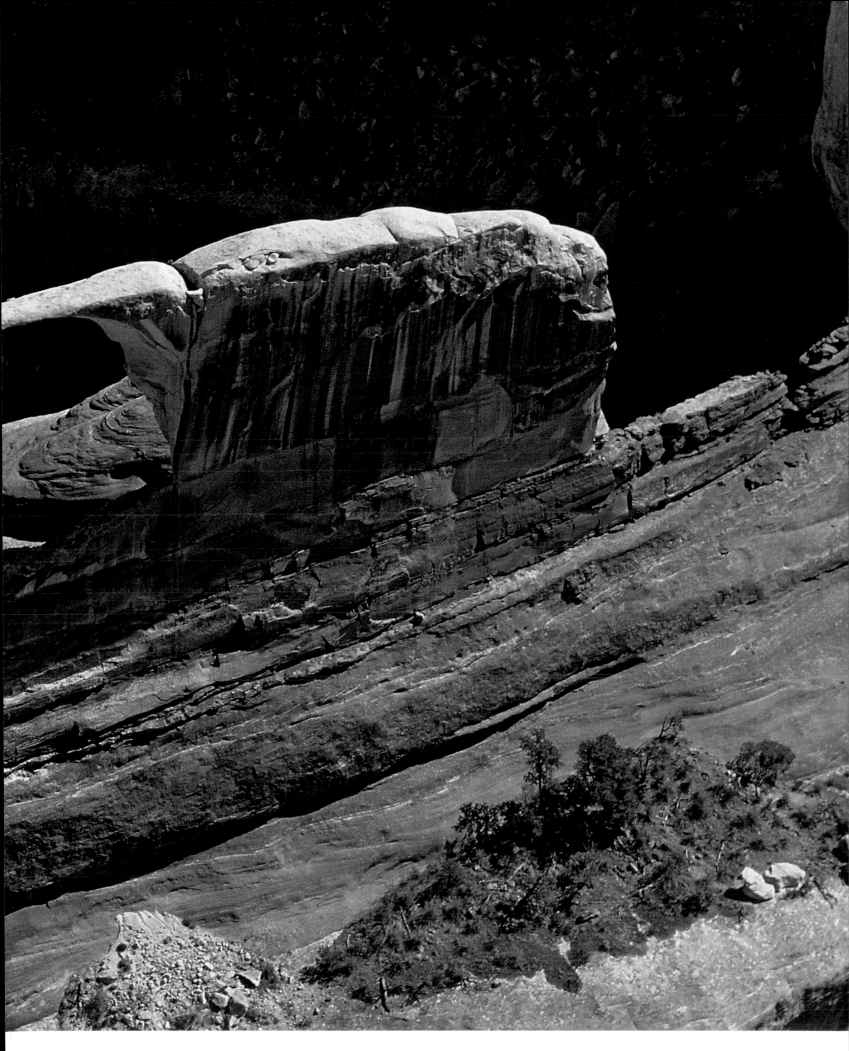

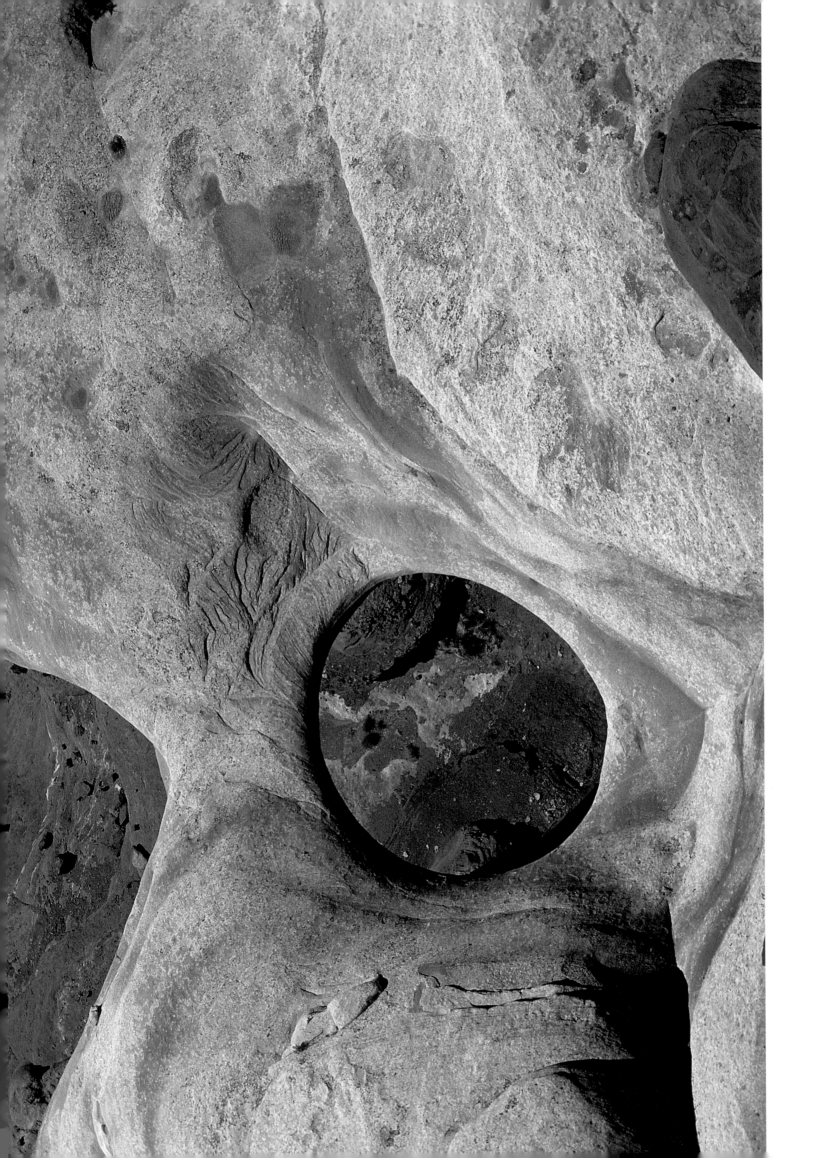

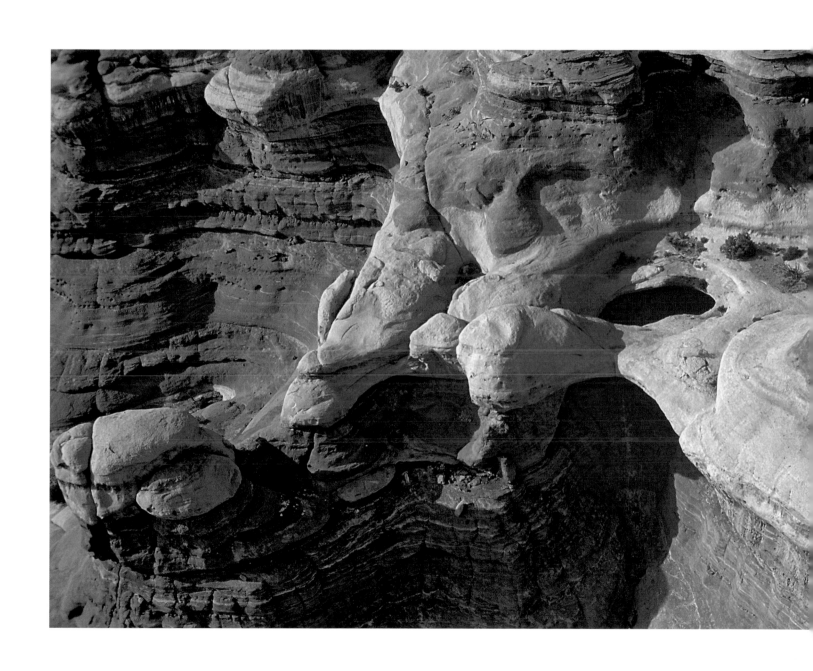

PAUL BUNYAN'S POTTY, Canyonlands National Park, San Juan County, Utah Opposite: The "seat" is about 75 feet across and several hundred feet above the ground. Located in Horse Canyon, Needles District. This is a bombsight view. Above: An oblique view of an unnamed potty (March 1992).

ORANGE CLIFFS, Wayne County, Utah. Glen Canyon National Recreation Area—this is why photographers get up early (May 1990).

(FOLLOWING PAGES) WILDCAT MESA, Waterpocket Fold at Oak Creek, Capitol Reef National Park, Garfield County, Utah (April 2007.)

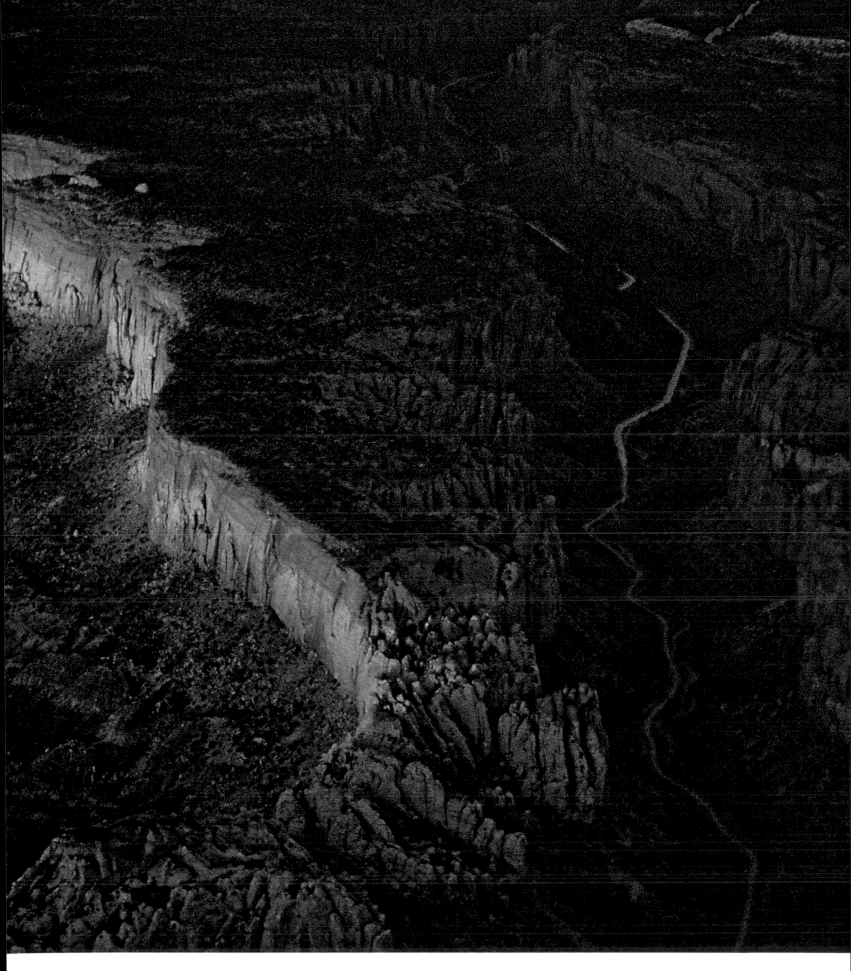

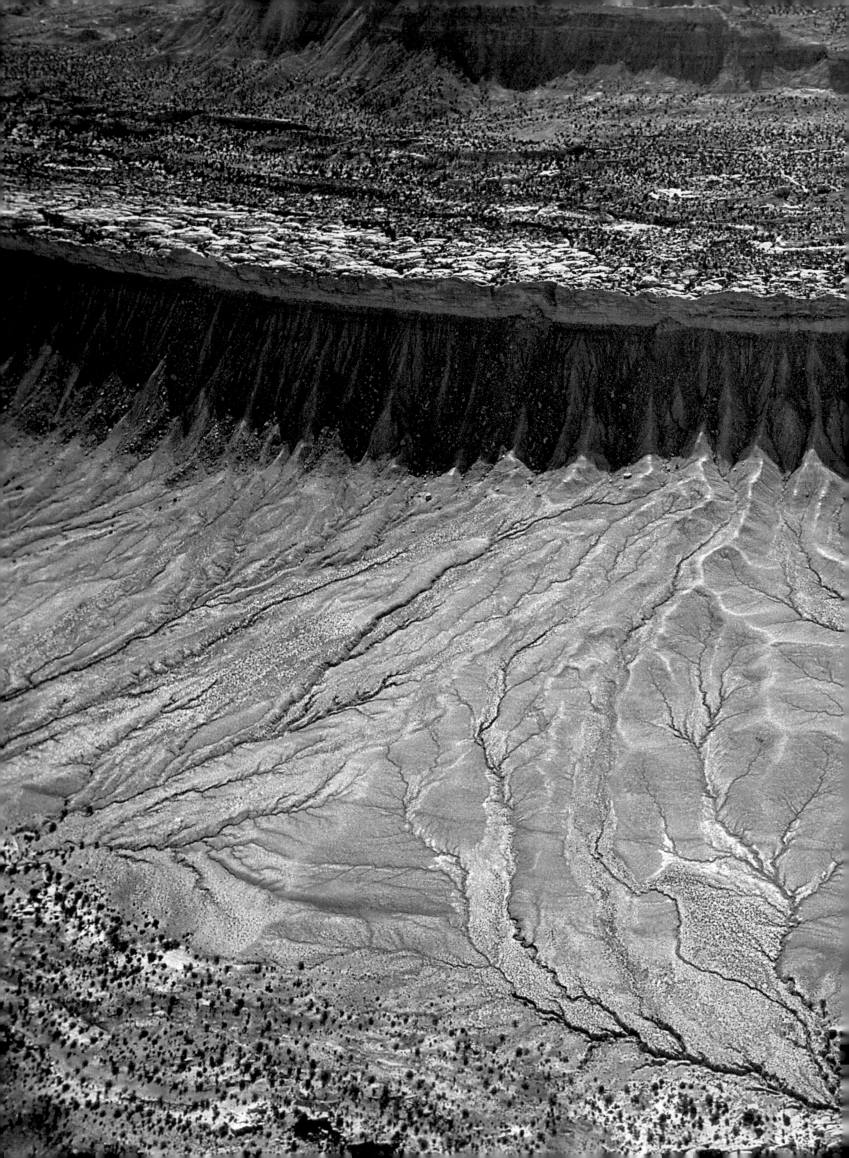

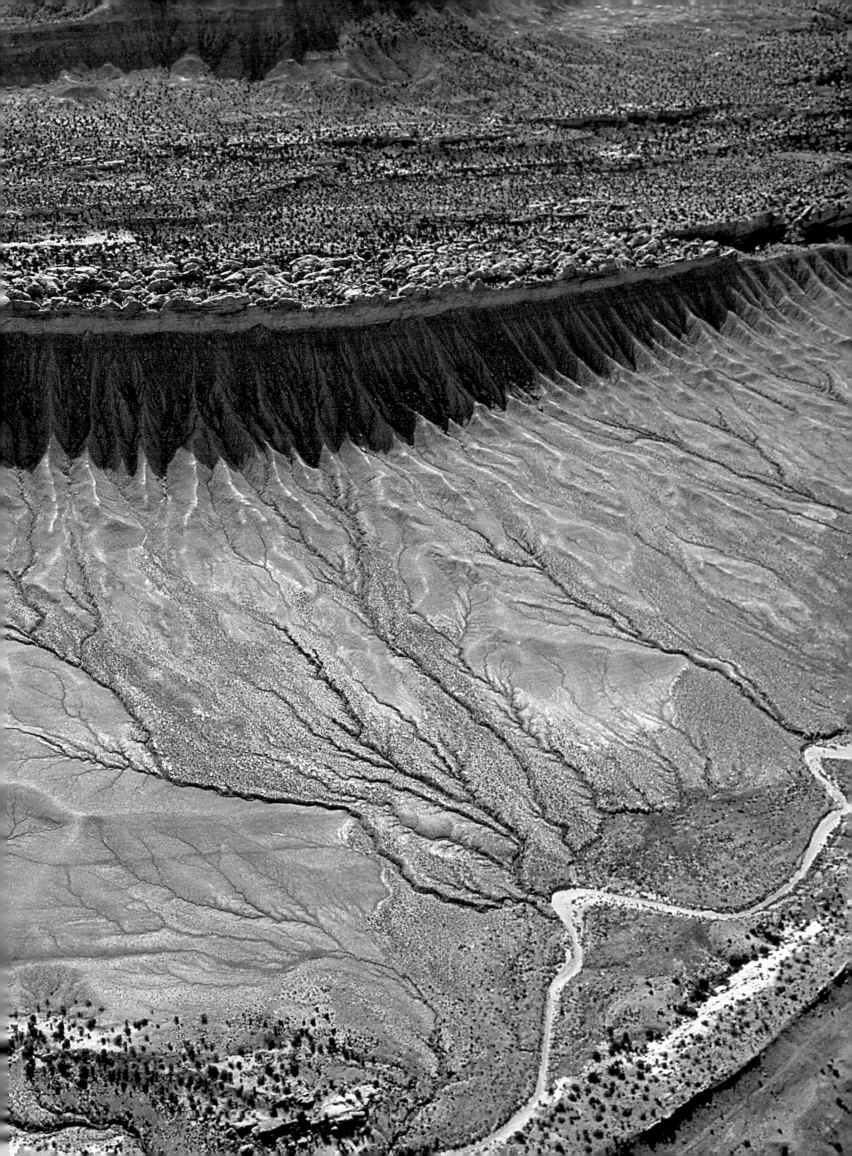

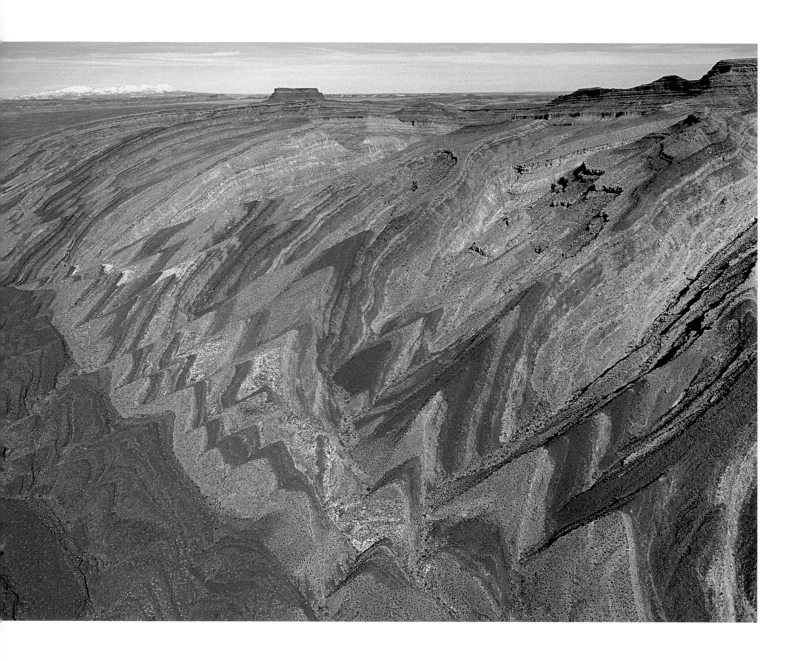

MONUMENT UPLIFT, San Juan County, near Bluff, Utah. Above: Looking Northwest, the Monument Uplift slopes upward to the right of the photo (February 1994). Opposite: Looking north, the Monument Uplift slopes upward to the left with Comb Ridge appearing on the top right and Abajo Mountains in the distance (April 2002).

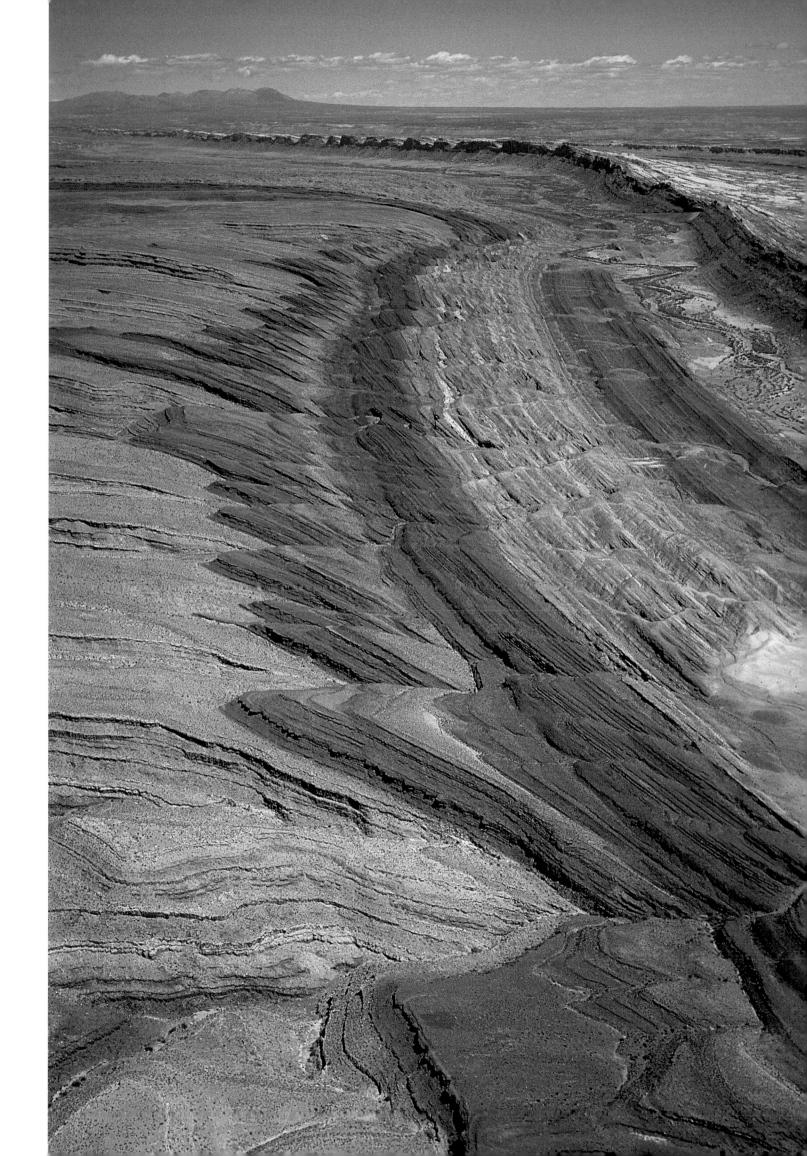

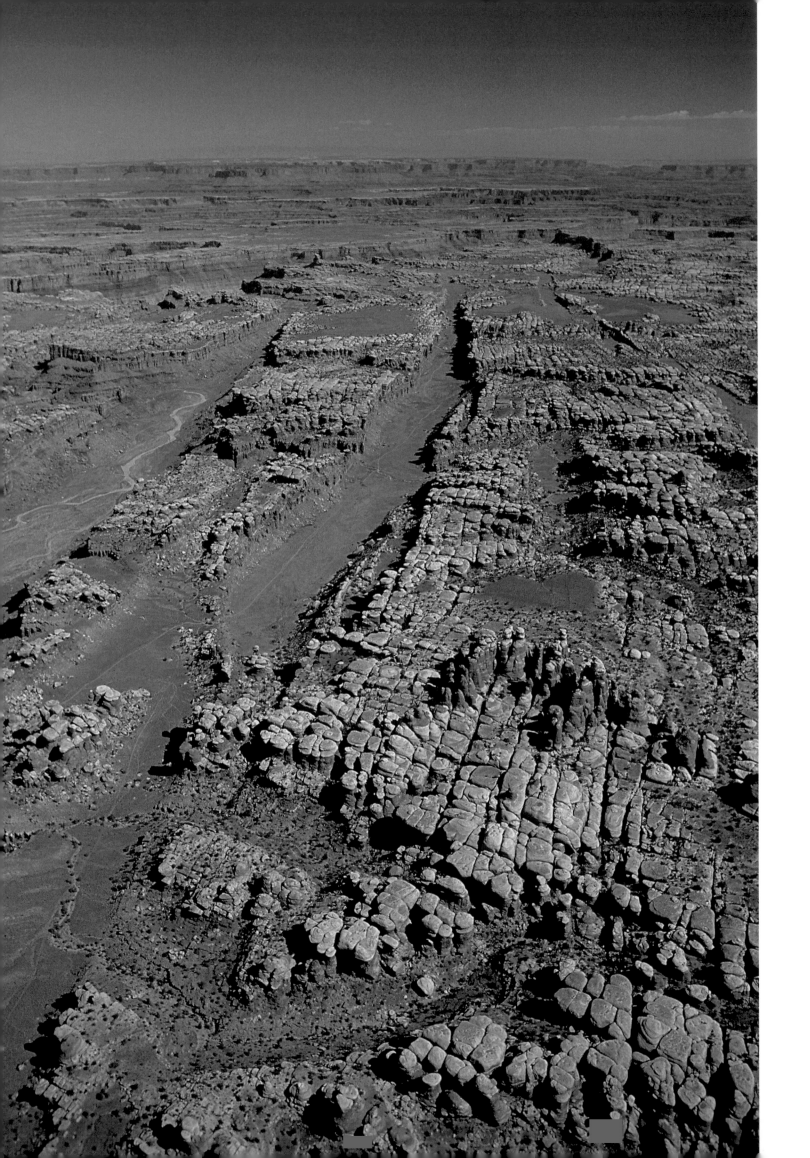

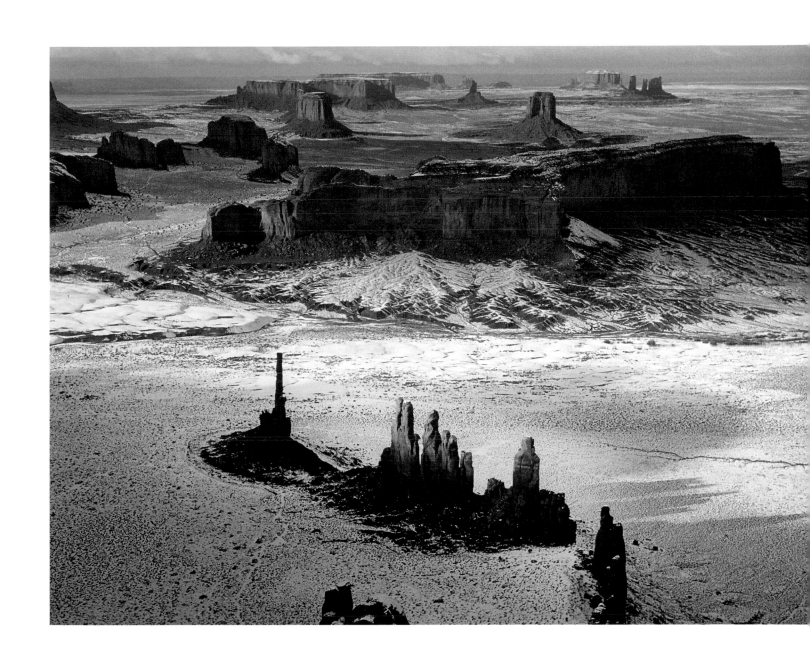

FAULT GRABENS, Canyonlands National Park, San Juan County, Utah. The grabens, or corridors, are formed by a geologic collapse when underlying salt beds are dissolved and/or squeezed out. The collapsing in this area of the Needles District is estimated to have begun 55,000 years ago and continues imperceptibly today (September 2004).

YEI BI CHAI FORMATION, Monument Valley Navajo Tribal Park, Navajo County, Arizona. This photo looks north into Utah (January 1990).

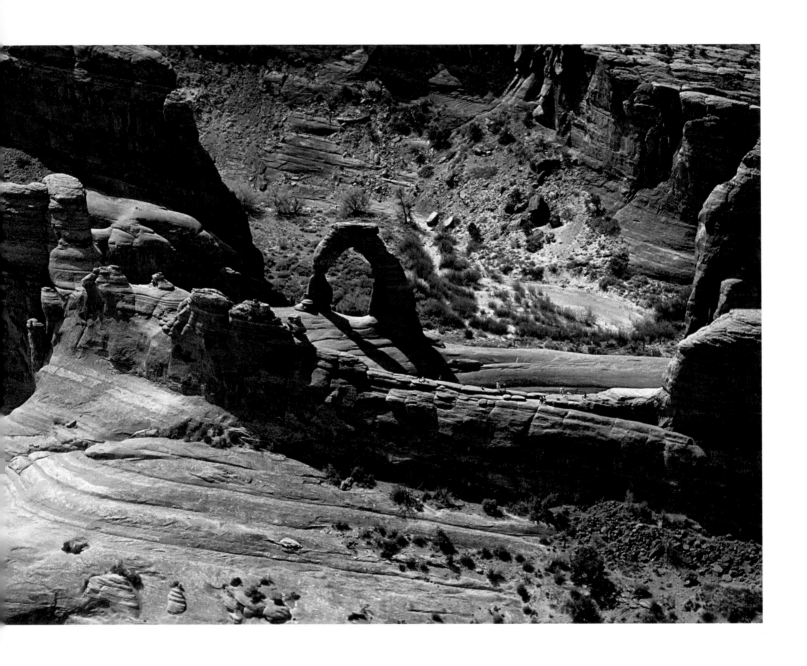

DELICATE ARCH, Grand County, Utah.
The most famous arch of Arches
National Park (April 1990).

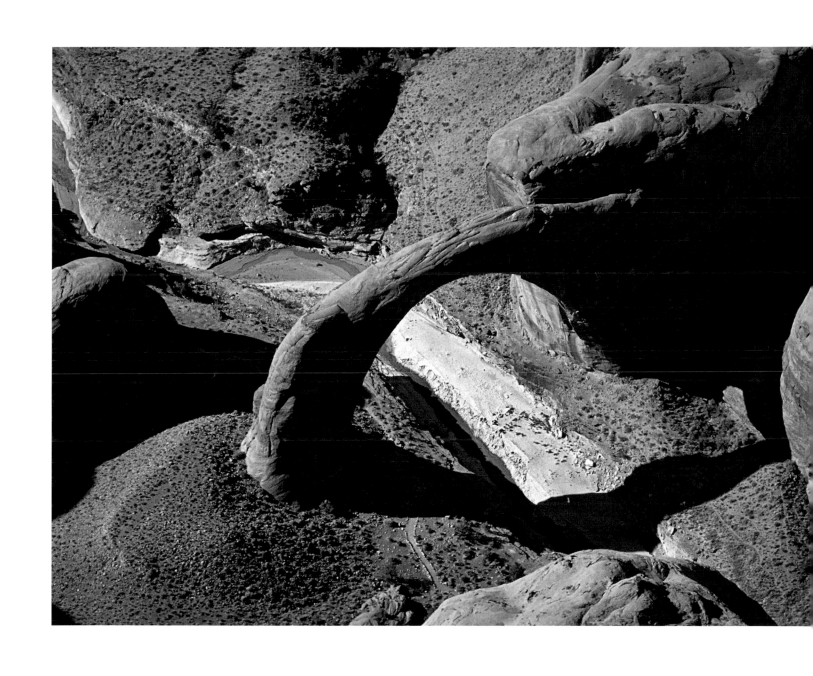

RAINBOW BRIDGE, Rainbow Bridge National Monument, Glen Canyon National Recreation Area, Navajo Indian Reservation, San Juan County, Utah. Notwithstanding its monument status, this sacred Native American site must be visited respectfully. The arch was formed from a "fin" similar to the one seen on the left of the arch. At their height, the waters of Lake Powell can reach the area. The bridge spans 175 feet wide and is 290 feet high (May 1990).

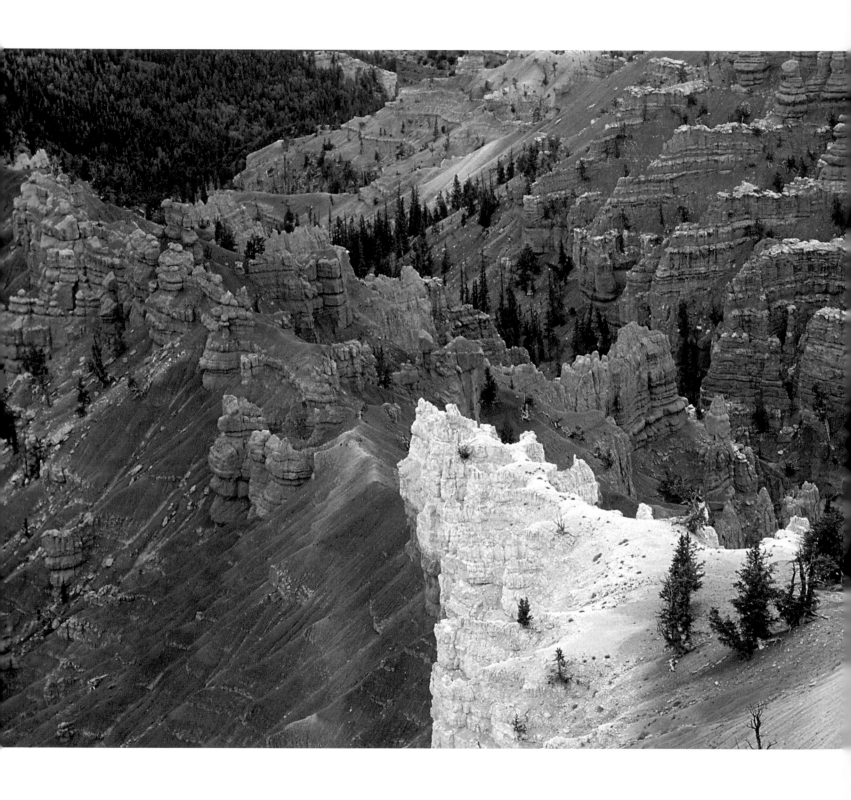

CEDAR BREAKS HOODOOS, Cedar Breaks National Monument, Iron County, Utah. These hoodoos are from the same geologic formations as those in Bryce Canyon (January 1999).

HOODOOS, Bryce Canyon National Park, Garfield County, Utah. Bryce Canyon is the hoodoo capital of the world. The hoodoos were thought to be formed 40 to 65 million years ago (January 1995).

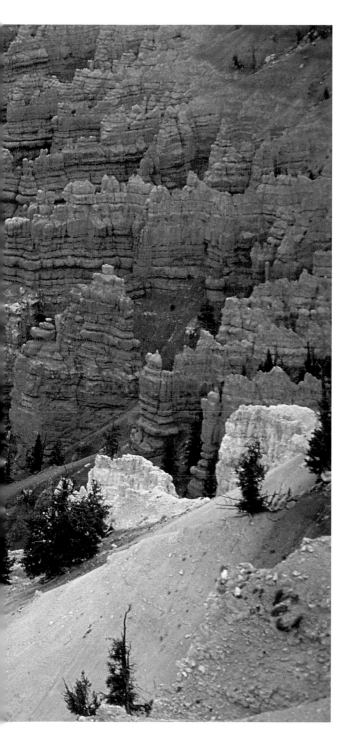

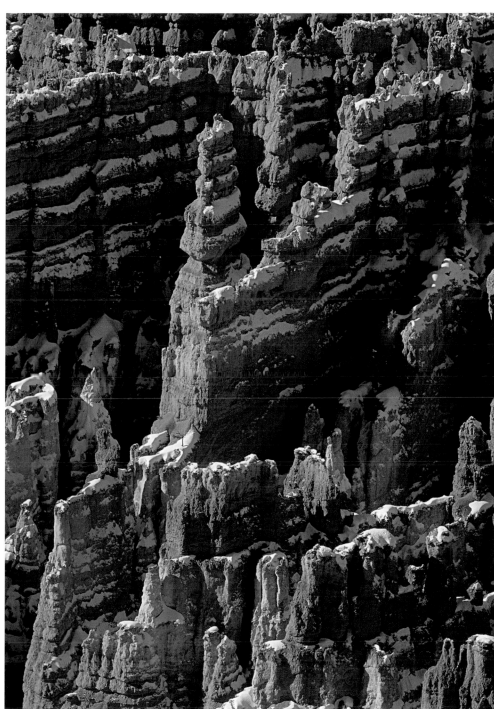

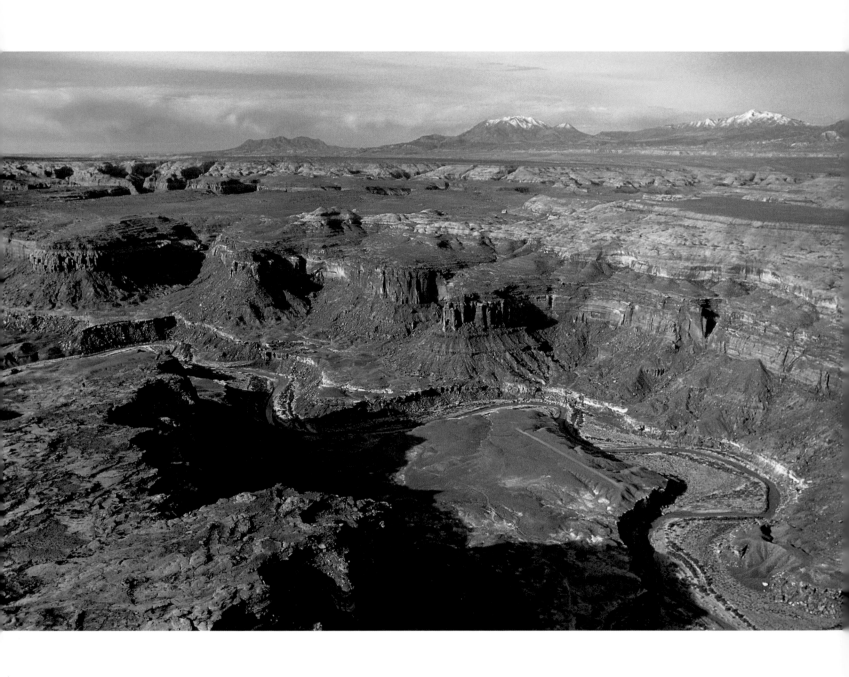

DIRTY DEVIL STRIP, Wayne County, Utah. The airstrip shown here, fifteen miles north of Lake Powell, is a thin diagonal line at lower right center of the photograph. Originally used for uranium prospecting in the 1950s, this remote place is accessible otherwise only by horseback or a very long hike. The entire area is within the proposed Red Rocks Wilderness Area. View is southwest to the Henry Mountains (April 2007).

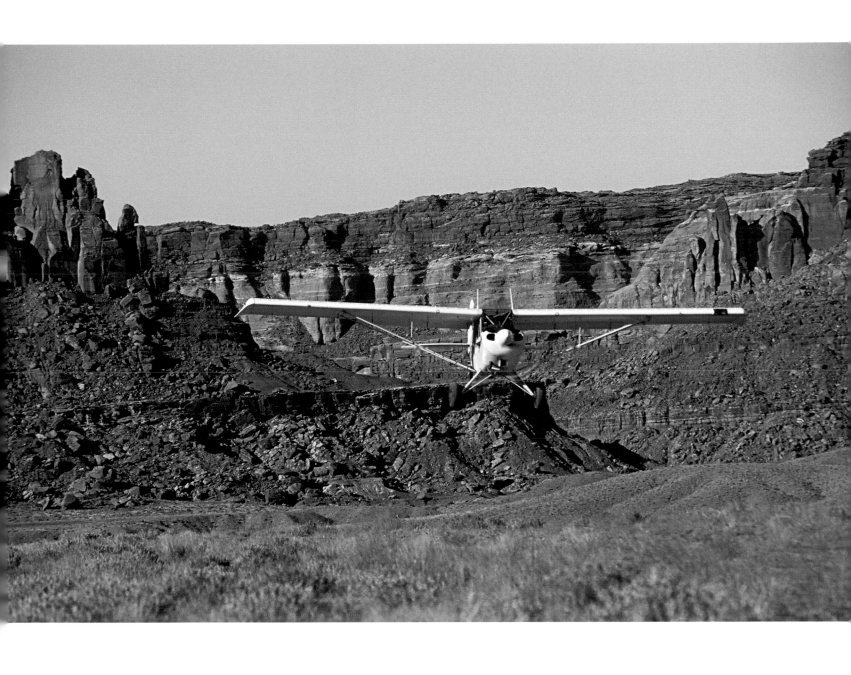

LANDING AT THE DIRTY DEVIL. The edge of the grass is a precipice at the near end of the strip. This is currently not a protected area, so it's been my personal joy and photo-operating camp since I discovered it on May 1, 1990. I do not think it had been visited by air since the 1950s and was rough and overgrown. It is a place of stunning silence, amazing echoes, huge fallen trees of petrified wood, few bugs, a few lizards, a rare herd of mountain sheep, gentle breezes, star-filled nights, and a few broken old airplane parts (October 2001).

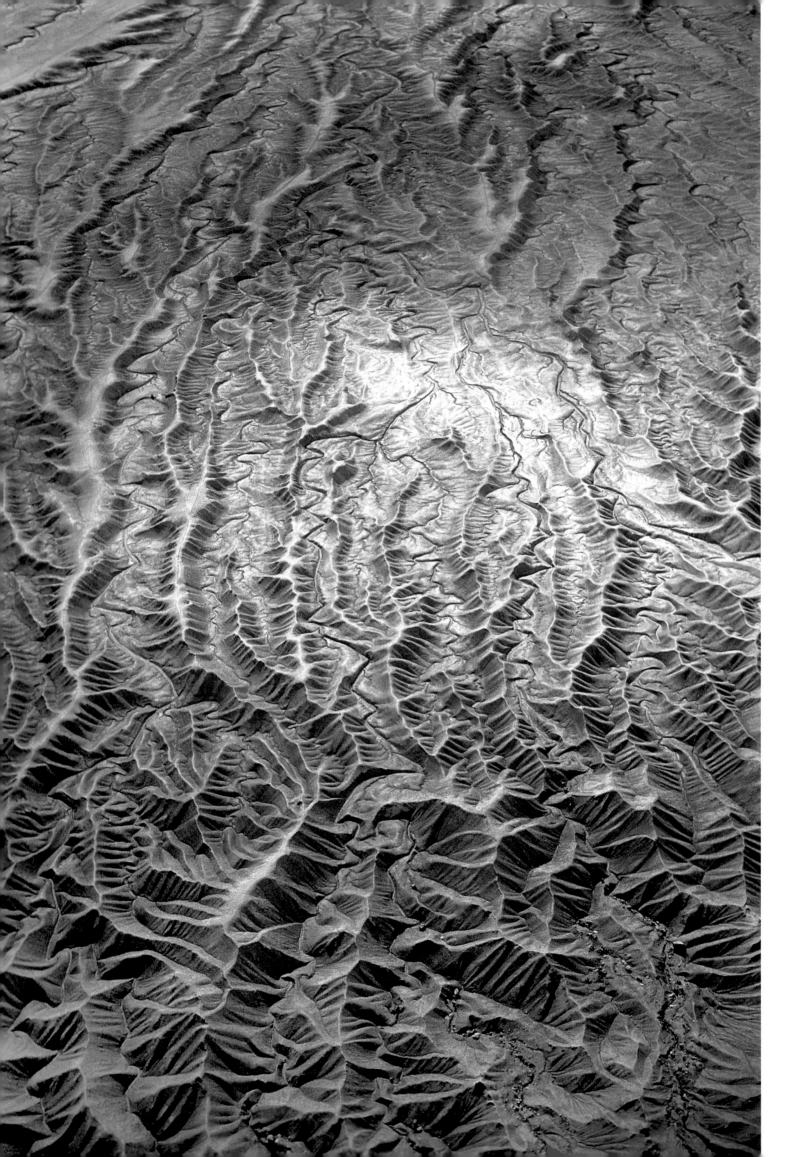

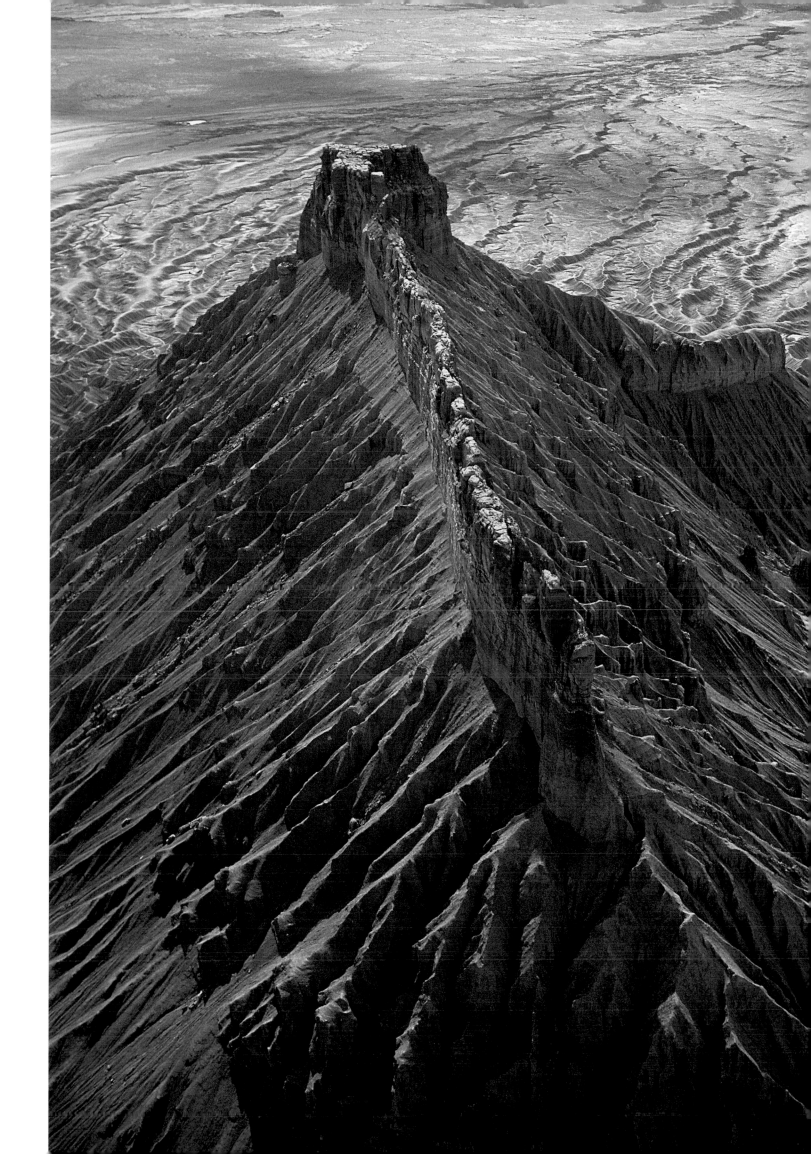

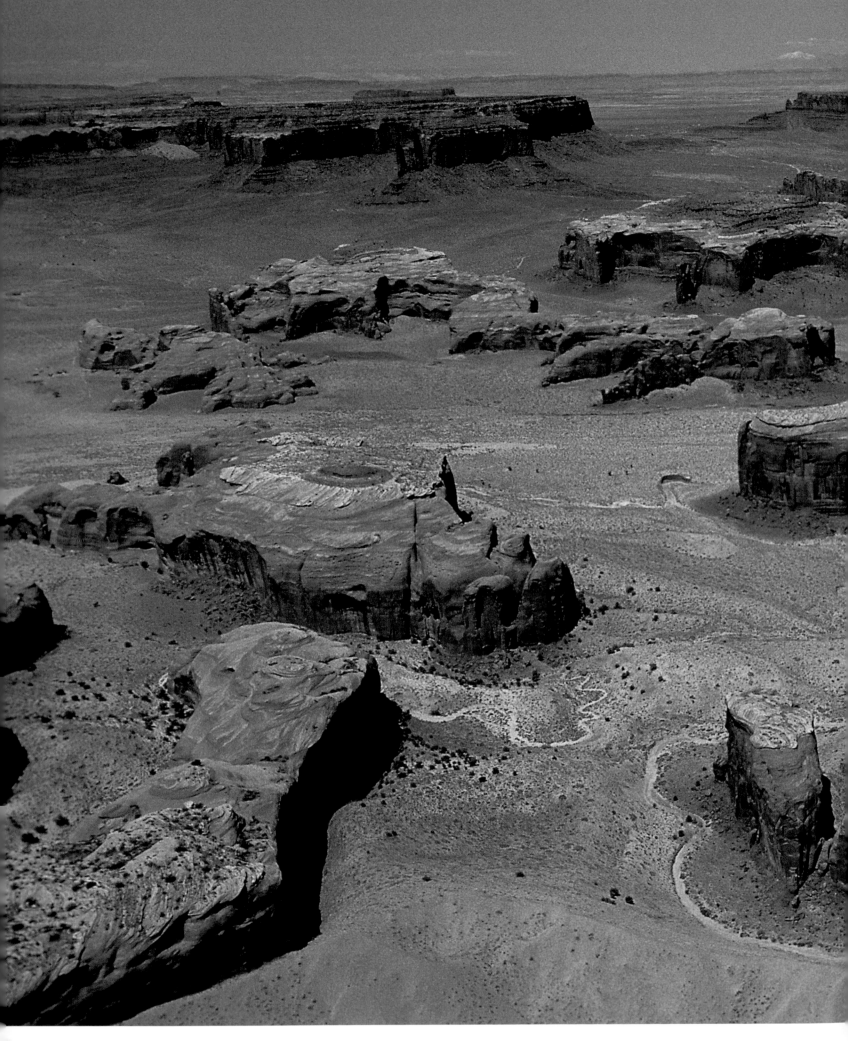

MONUMENT VALLEY PANORAMA, Monument Valley Navajo Tribal Park, Navajo County, Arizona. This view looks north from Yei Bi Chai Mesa into Utah.

Brigham's Tomb and Castle Butte are the last things you can see in the distance (top right) (April 2007).

(PRECEDING PAGE, LEFT) DESERT EROSION, Wayne County, Utah (March 1999).

(PRECEDING PAGE, RIGHT) FACTORY BUTTE, Wayne County, Utah. This is one of southern Utah's most famous landmarks and climbing destinations (March 1991).

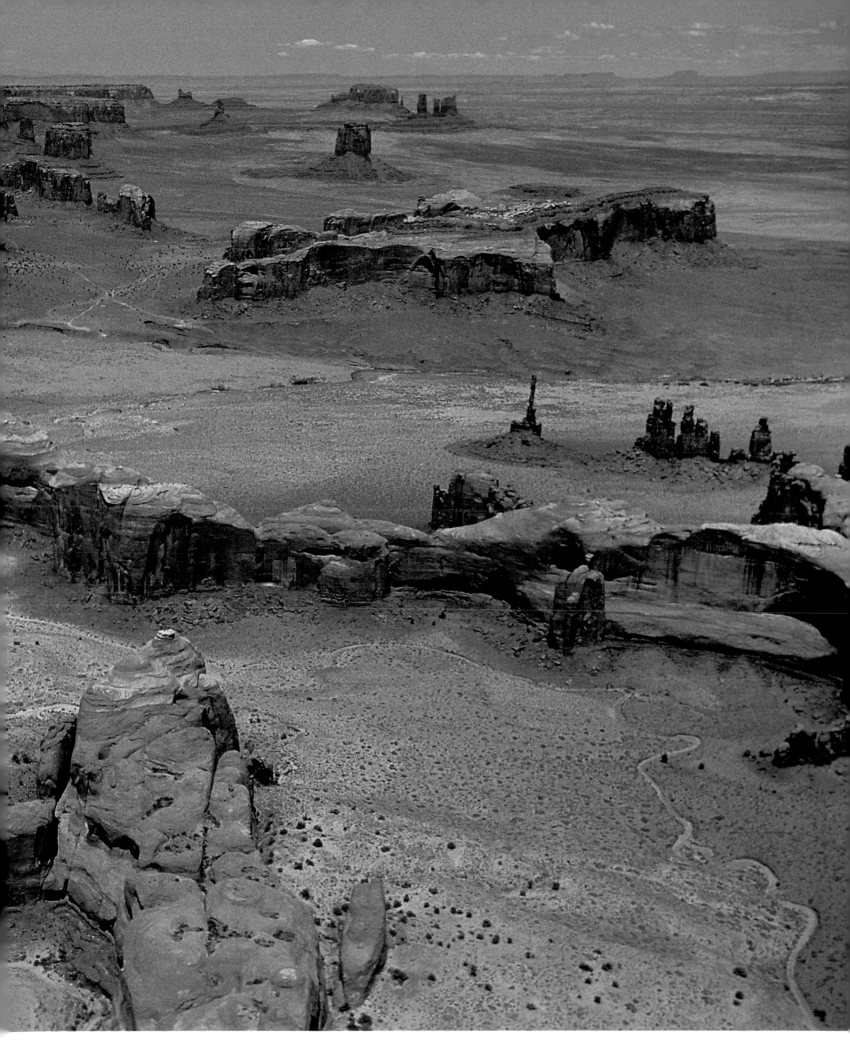

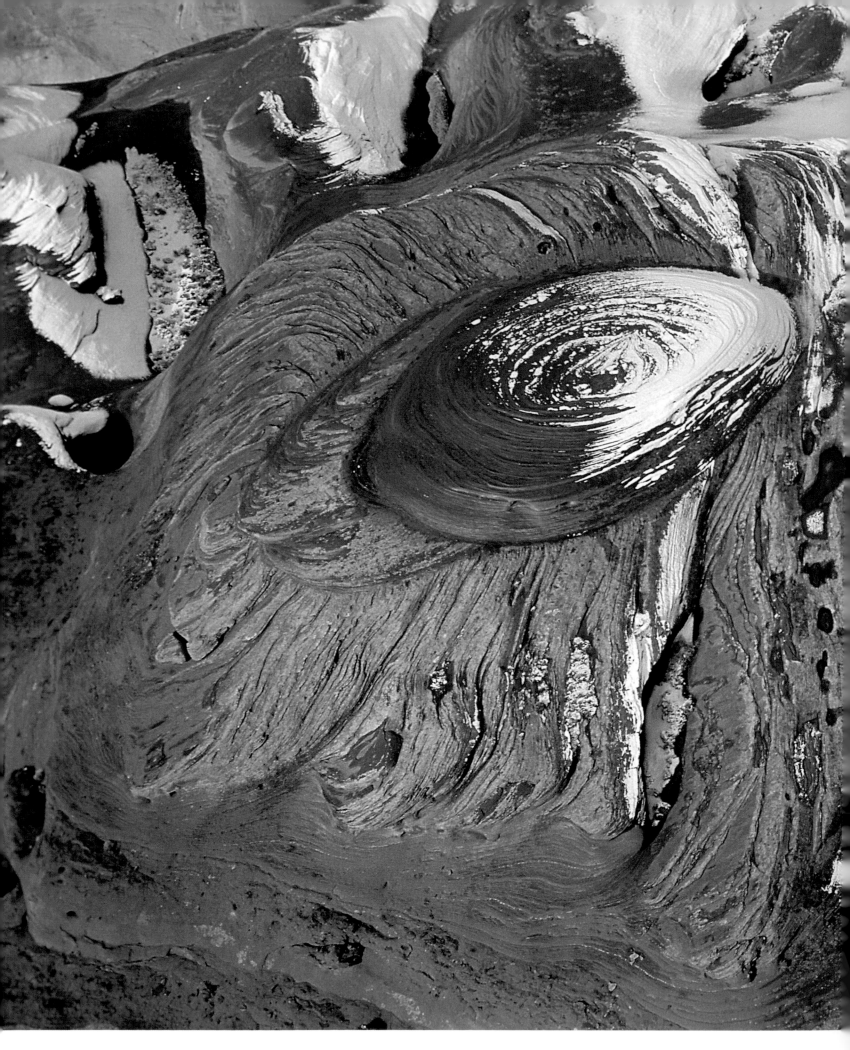

PETRIFIED DUNES, Navajo County, Arizona. These unusual dunes probably resulted from differential weathering of an aeolian (wind deposition) cross-bedded sandstone formation.

The more erosion-resistant layers were preserved while the less-resistant layers have been weathered away (January 1995).

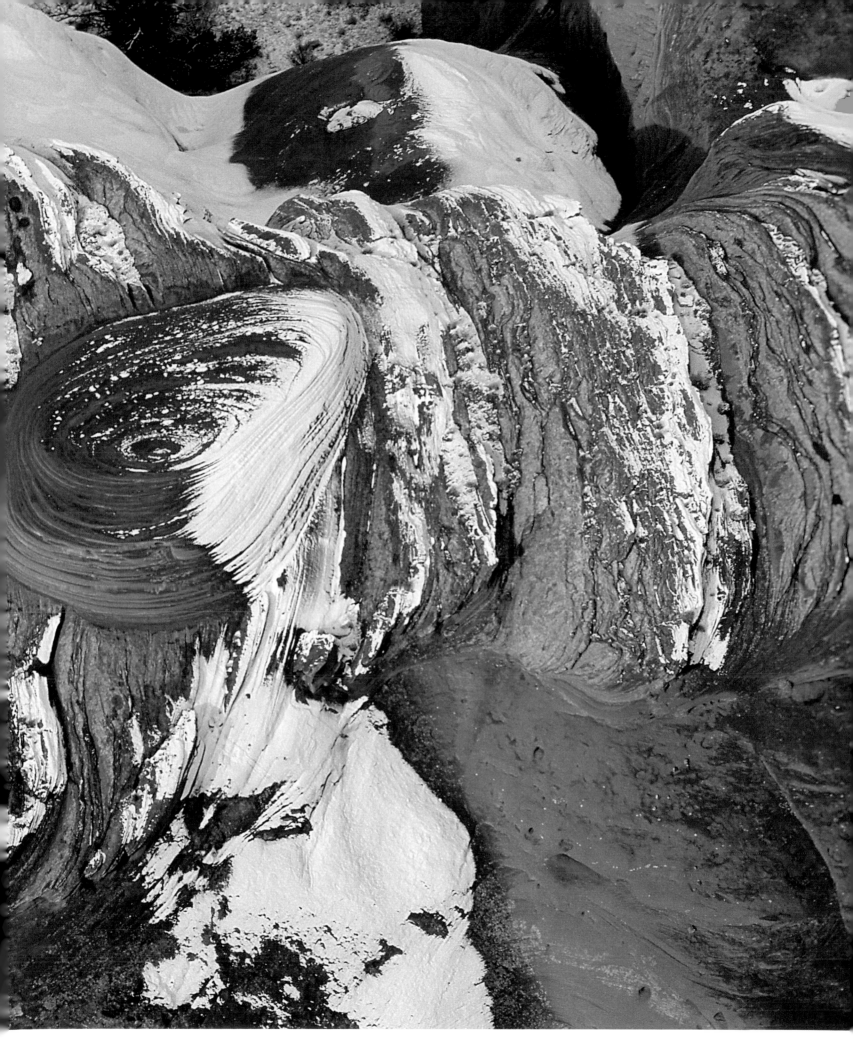

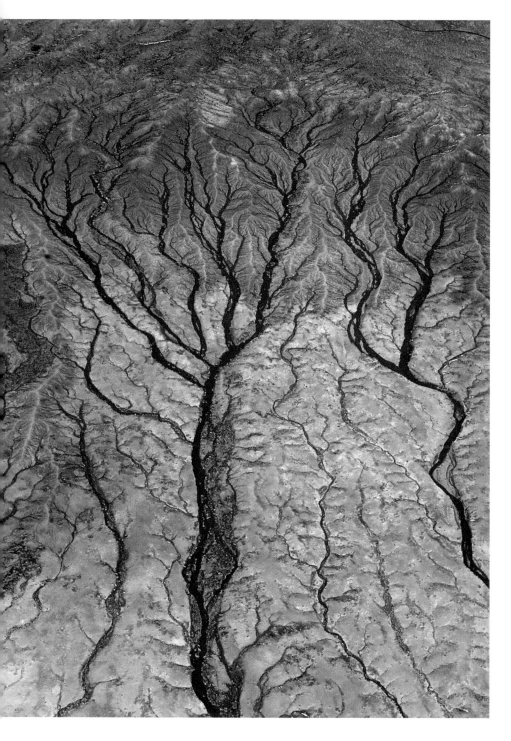
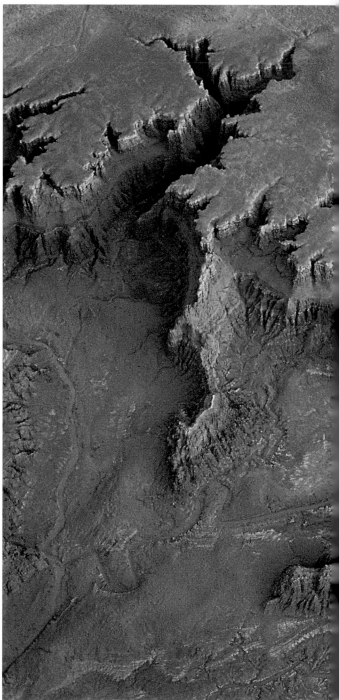

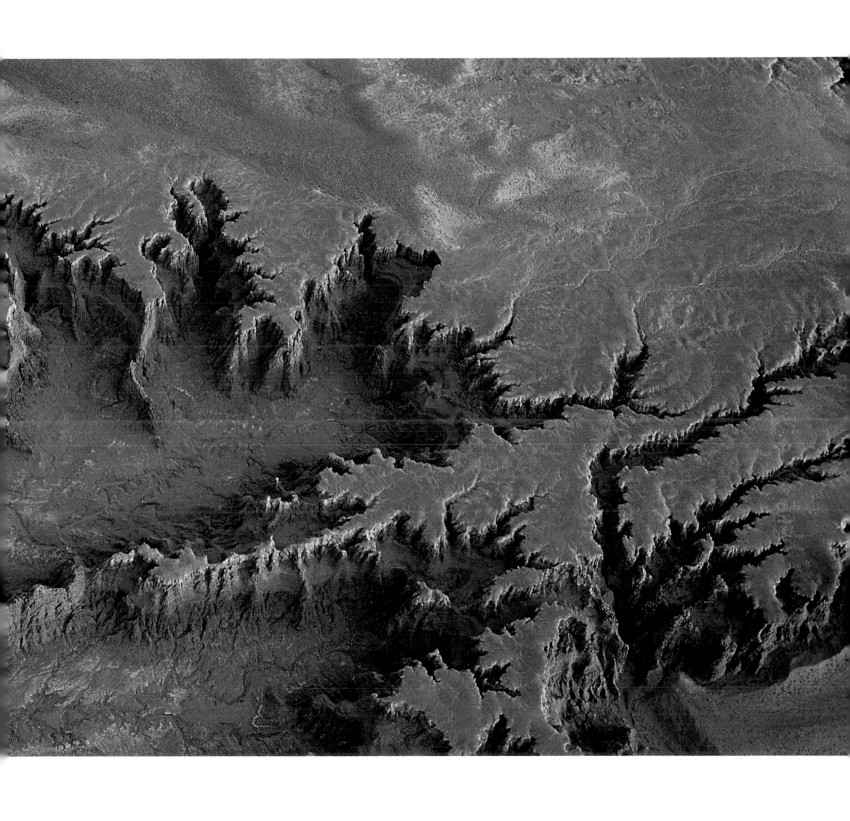

PAINTED DESERT, Apache County, Arizona. Opposite: Drainage patterns in the Painted Desert section of the Petrified Forest National Park (November 2000). Above: Navajo Indian Reservation (January 1998).

(FOLLOWING PAGE, LEFT) LAVA MEETS DESERT, Blaine County, Idaho. Snake River Plain, Great Rift region (September 1995).

(FOLLOWING PAGE, RIGHT) LAVA FLOW CRATER, Yuma County, Arizona. Part of the Pinacate Lava Flow, Cabeza Prieta Wildlife Refuge, on the Arizona–Mexico Border 50 miles southeast of Yuma, AZ.

The crater is about 800 feet wide and 100 feet high and is one of a number of small craters in this lava field of the Sonoran Desert (March 1997).

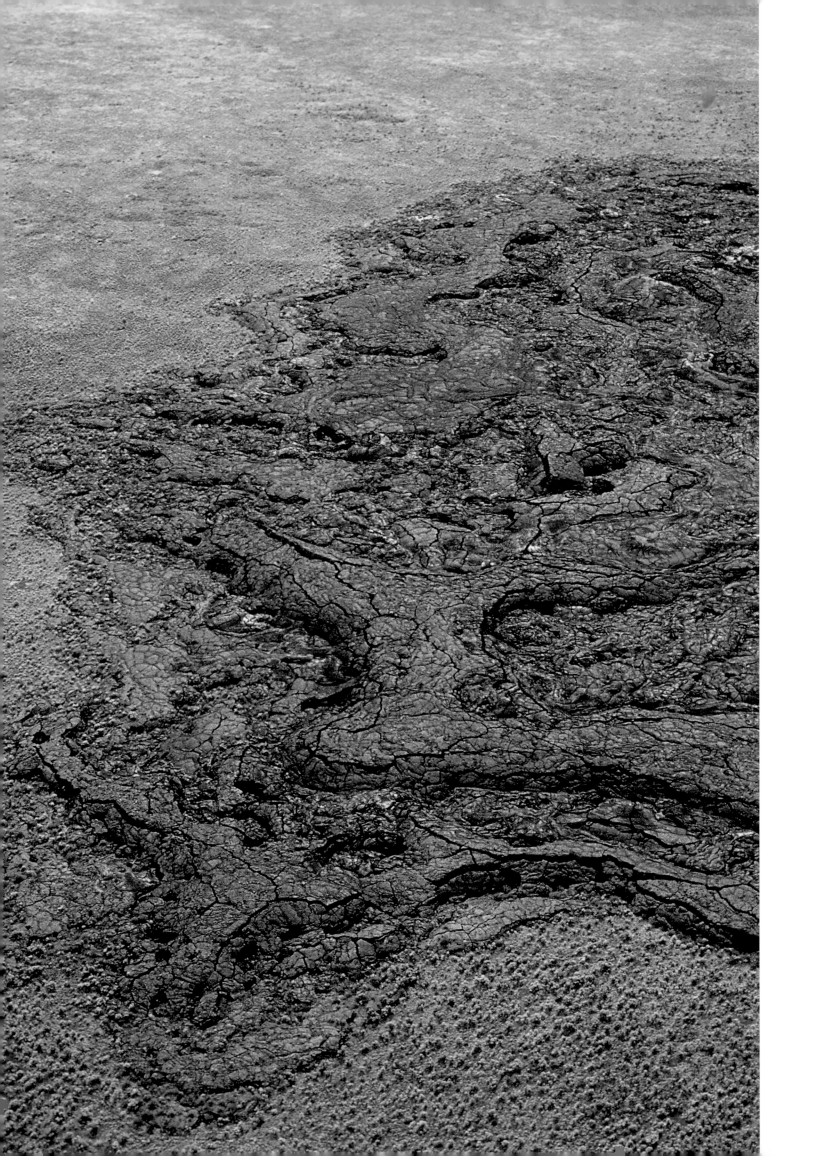

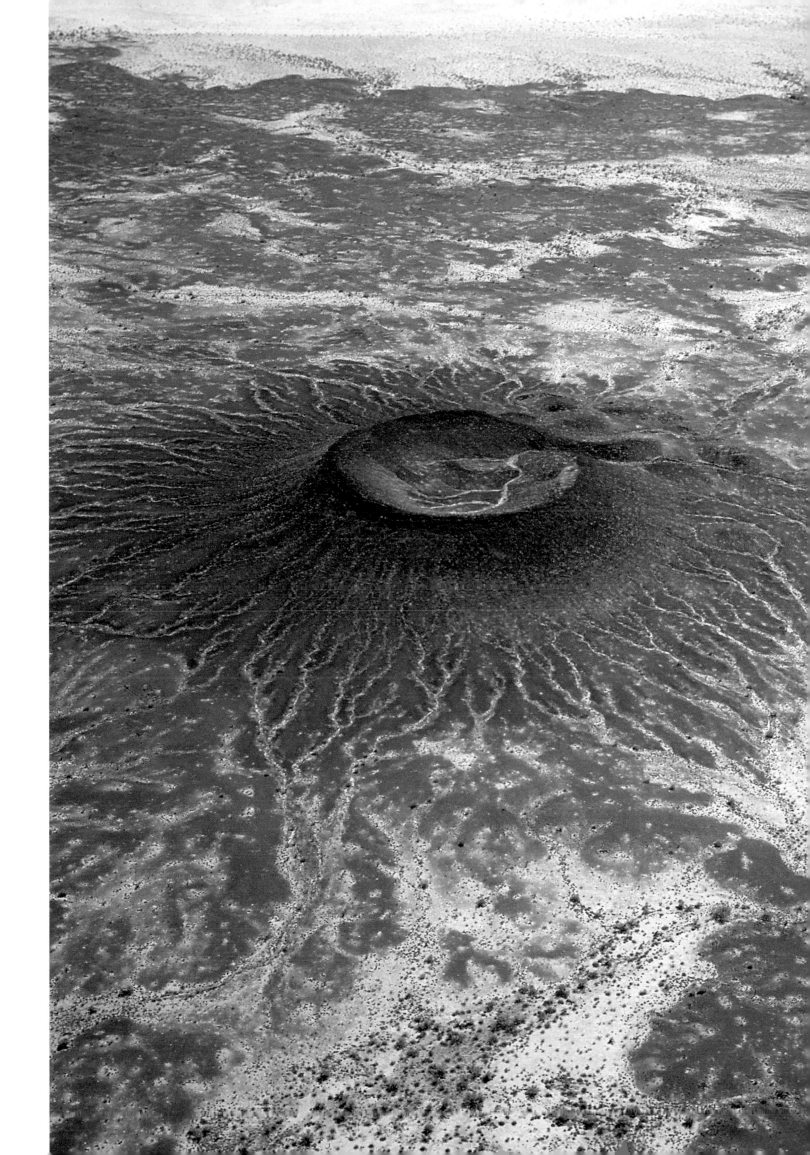

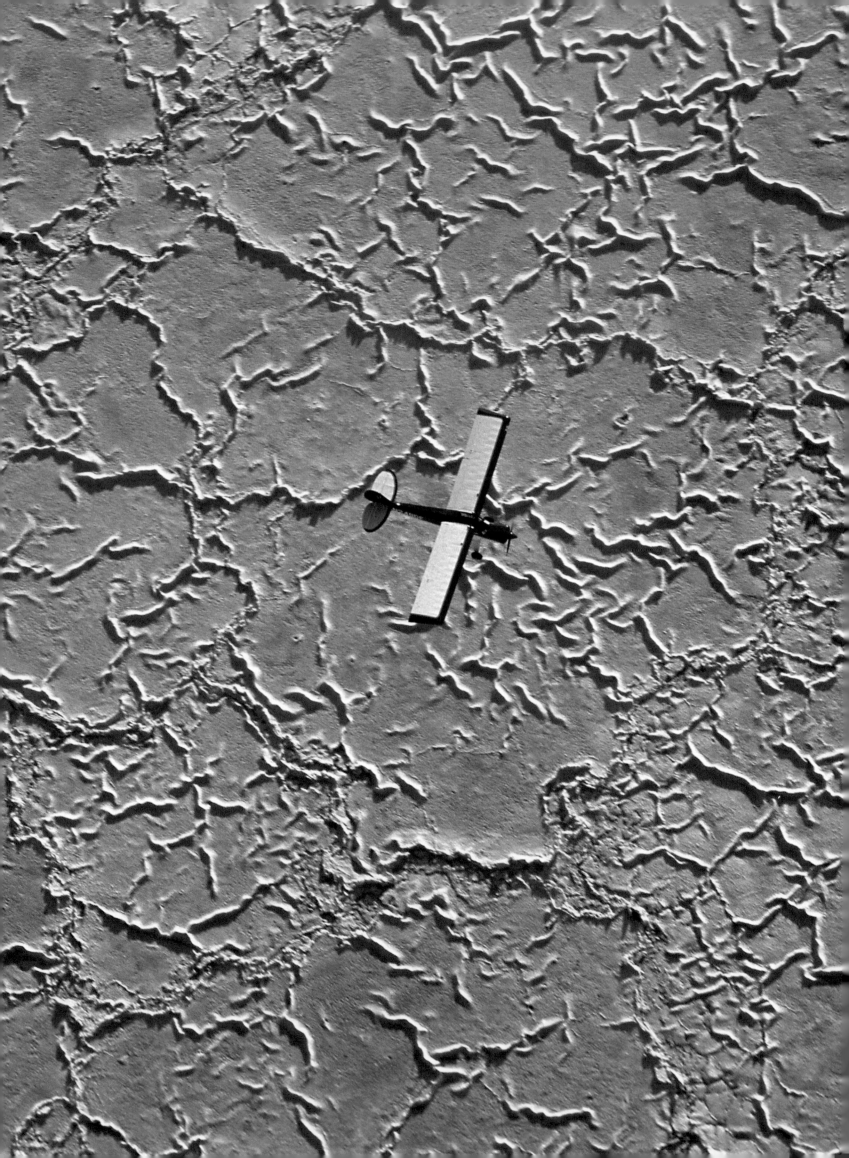

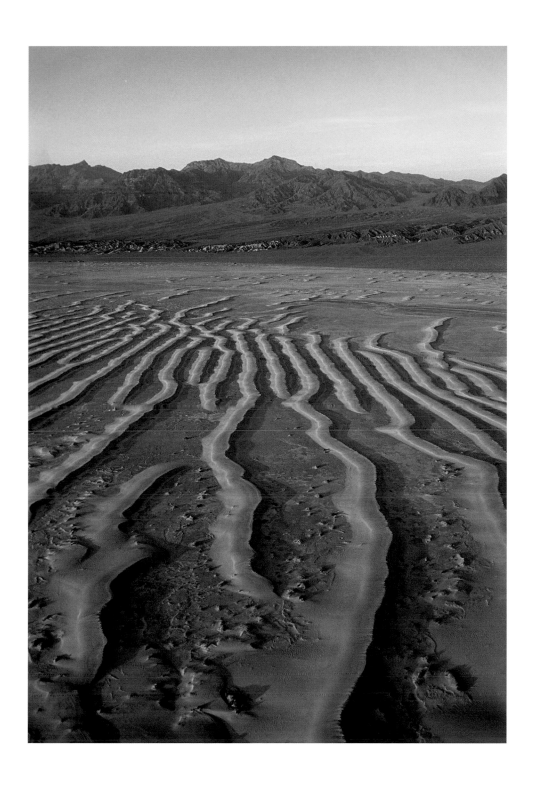

AIRPLANE OVER SODA LAKE, Carrizo Plain Natural Area, San Luis Obispo County, California (November 2000).

SEIF DUNES, Inyo County, California. These seif sand dunes in the north end of Death Valley National Park are a form of transverse, or linear dunes, that exhibit some sinuosity.

The dunes form crosswise to the prevailing winds and can be temporal and shifting (April 1992).

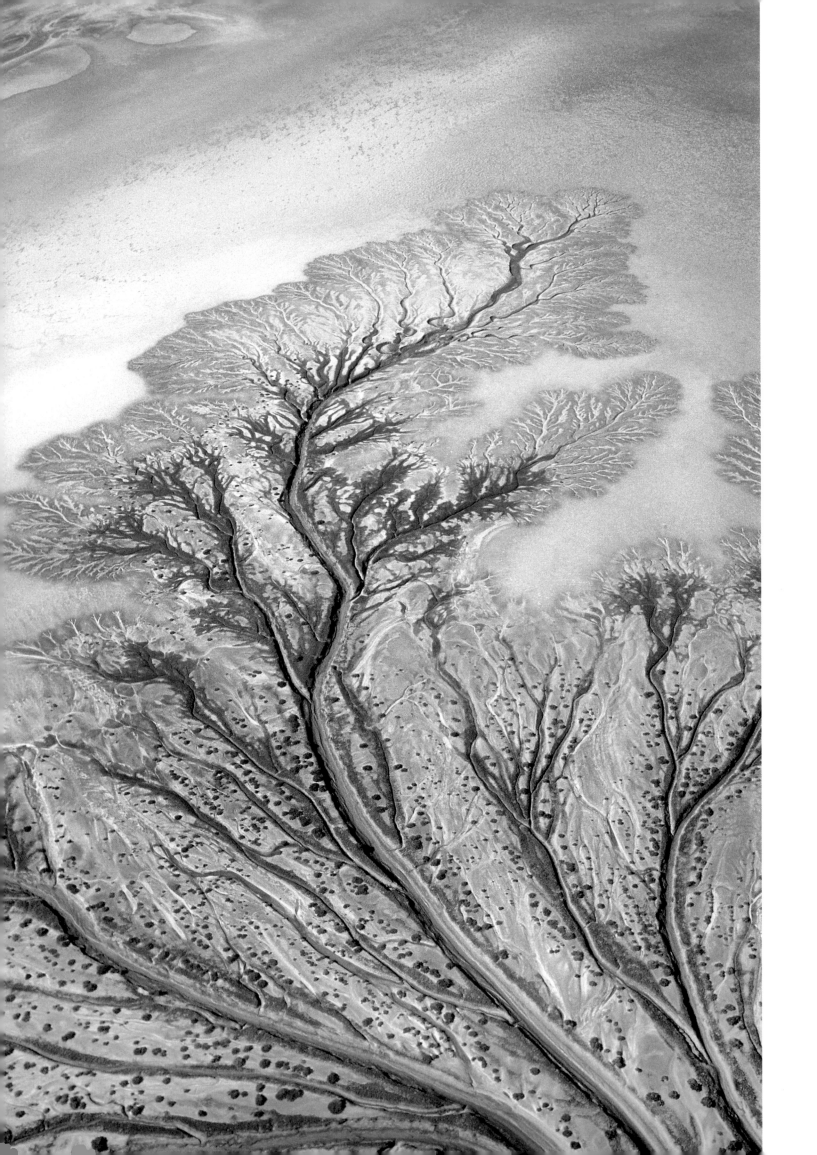

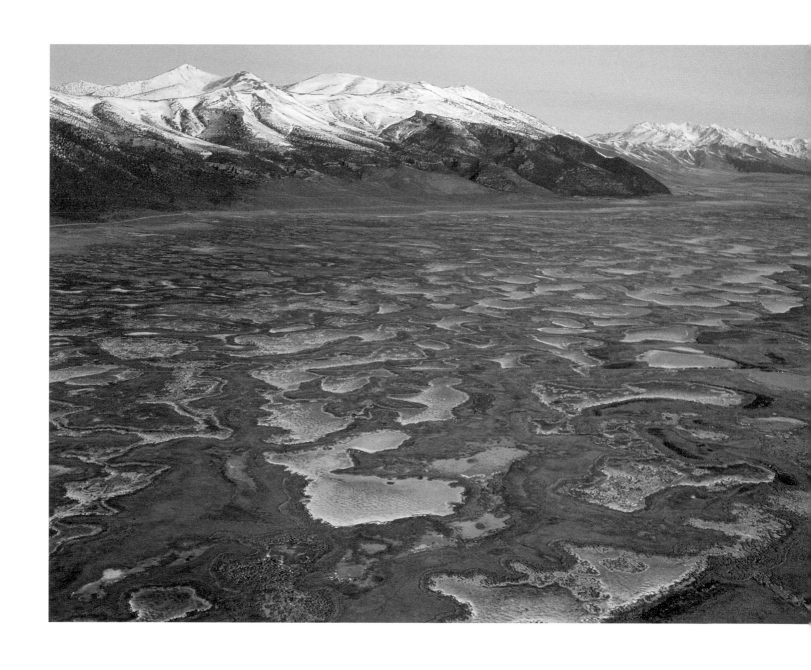

DENDRITIC DRAINAGE PATTERN,
Sonora, Mexico. Colorado River Delta
where it flows into the Sea of Cortez
(January 1996).

RUBY VALLEY NATIONAL WILDLIFE REFUGE,
Ruby Valley National Wildlife Area,
White Pine County, Nevada. This
6,000-foot-high basin area is home to
hundreds of small pothole lakes.

The Ruby Mountains are in the
distance (February 1990).

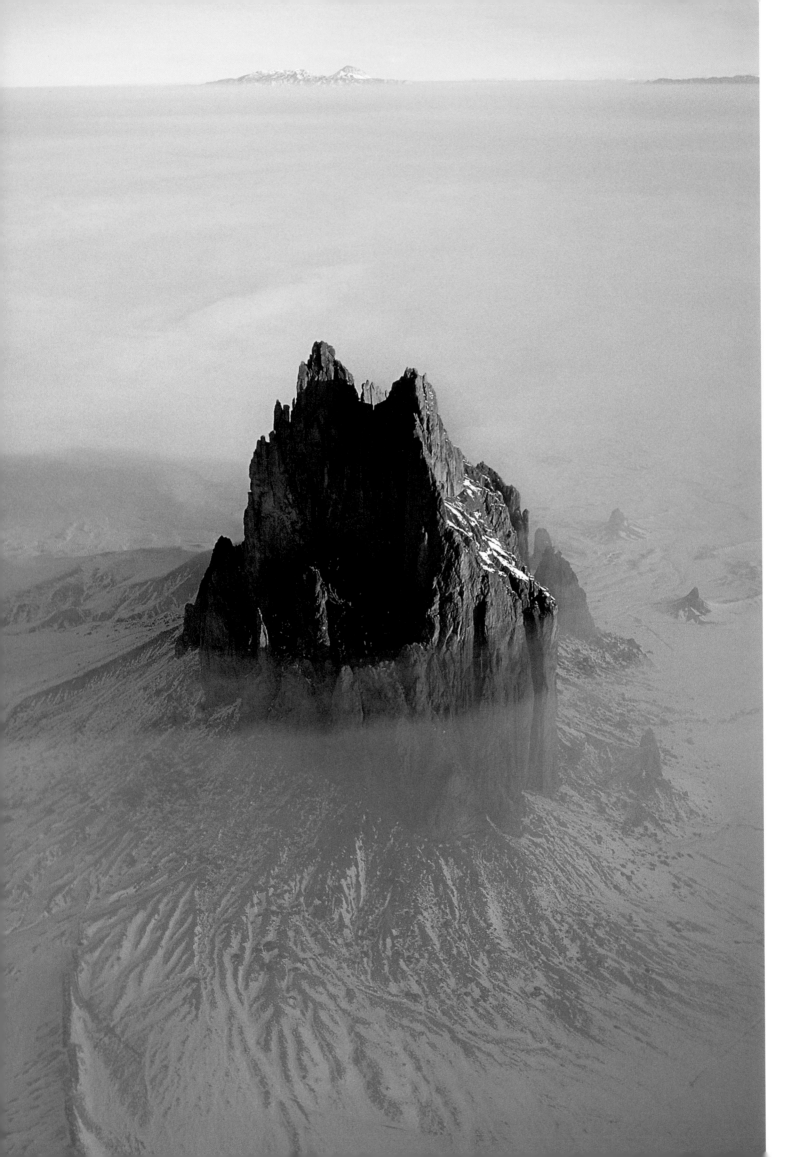

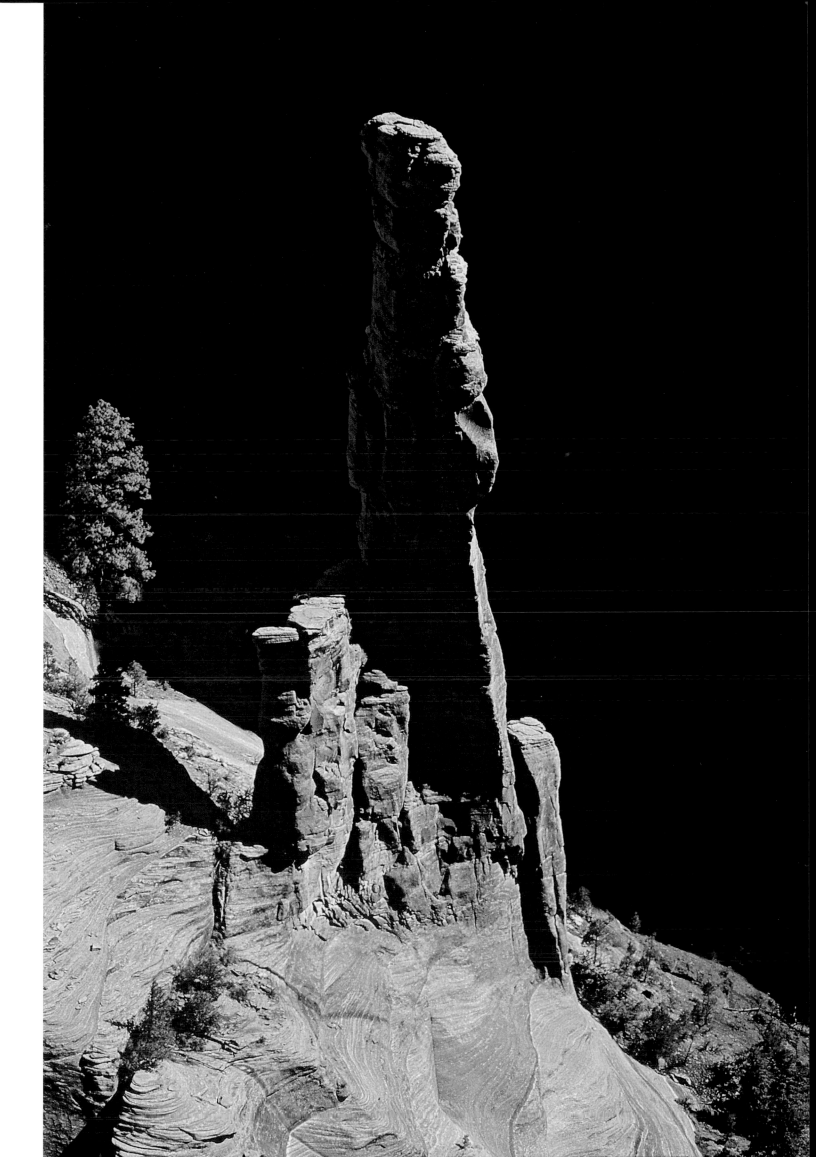

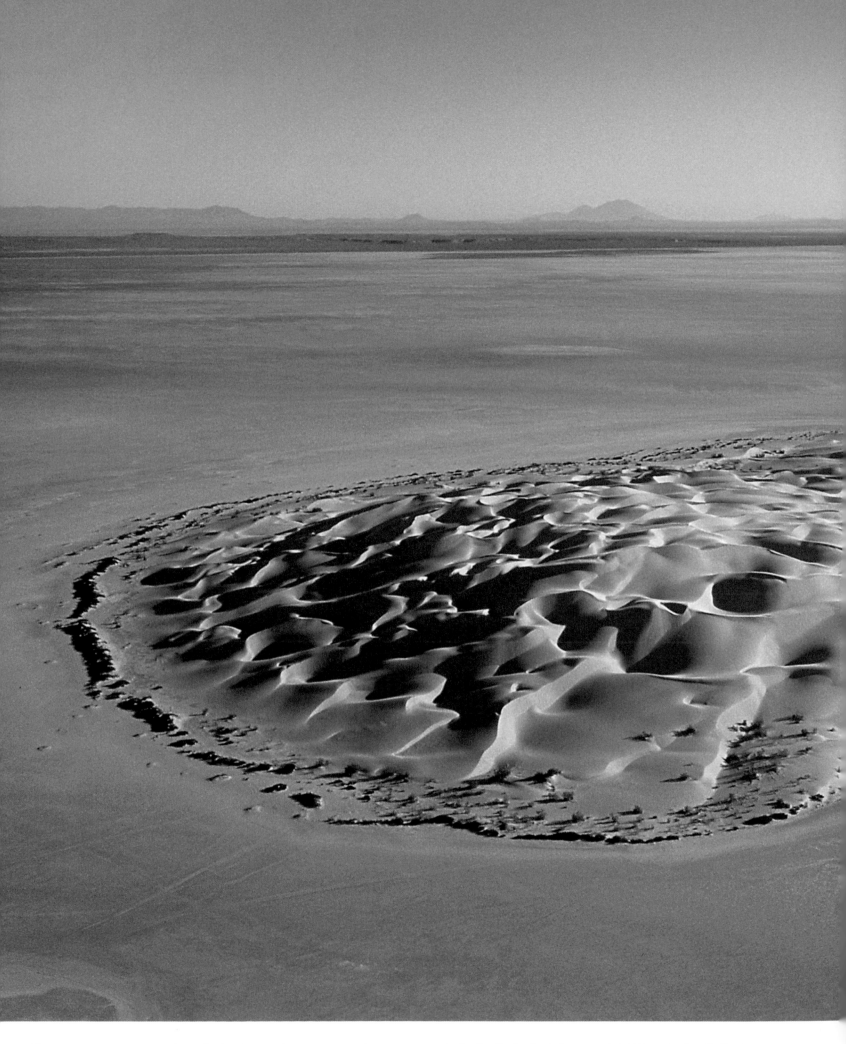

SHORE DUNES, Laguna San Ignacio, El Vizcaino Biosphere Reserve, Pacific coast, Baja California Sur, Mexico (January 1996).

(PRECEDING PAGE, LEFT) SHIPROCK, San Juan County, New Mexico. Legend has it that this rock resembles a sailing ship. Here, the rock forms a bow wave in a thin, drifting ground fog. The Navajo name, Tsé Bit'a'í, means "rock with with wings" and refers to the legend of the great bird that brought the people from the north to their present lands. Many prominent igneous dikes radiate from the core. Climbing of the 1,800-foot-high rock is forbidden and enforced by Navajo law. Sleeping Ute Mountain, CO, is in the distance (January 1997).

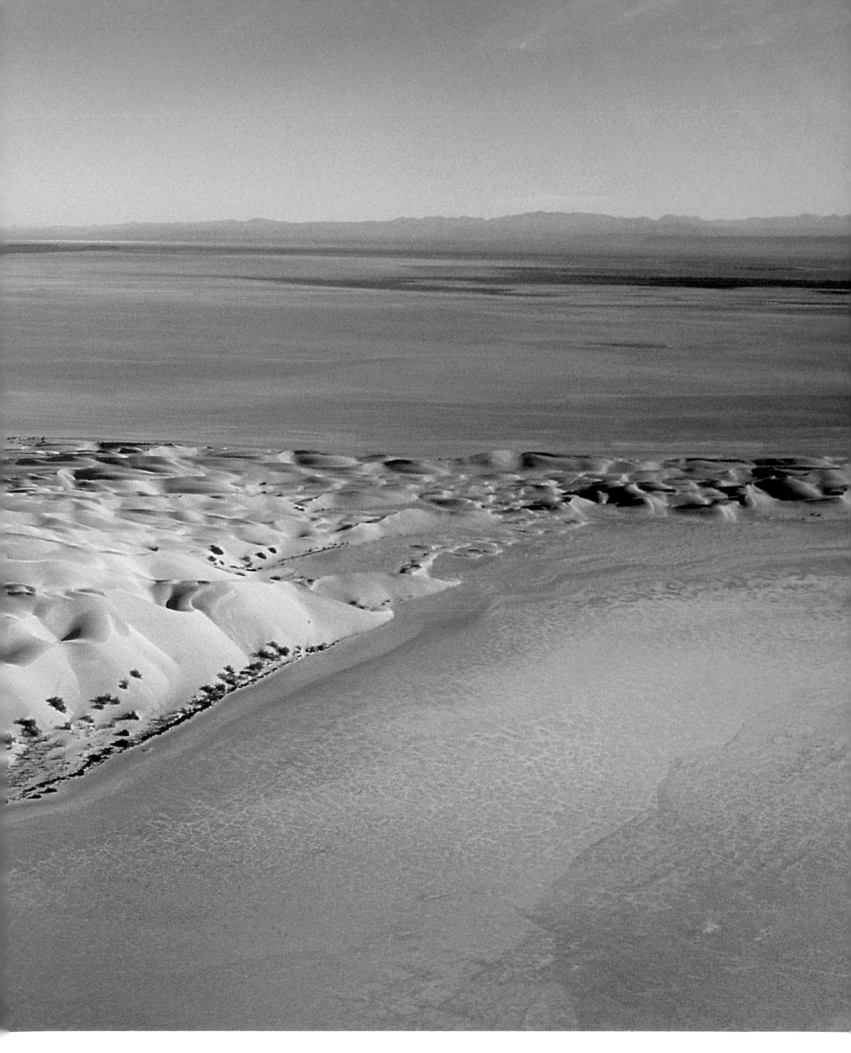

(PRECEDING PAGE, RIGHT) EDGE OF EARTH, Canyon de Chelly National Monument, Apache County, Arizona. This lone rock spire stands somewhere on the north rim of the canyon. Though administered by the Park Service, Canyon de Chelly (pronounced "de-shay") remains part of the Navajo Nation (October 1991).

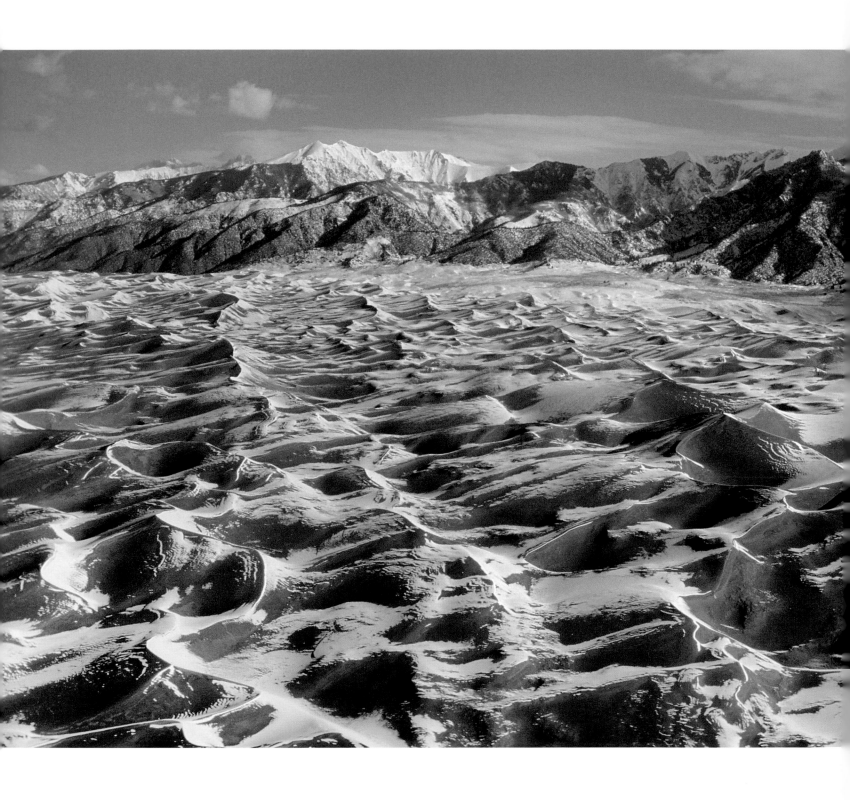

GREAT SAND DUNES NATIONAL PARK,
Saguache County, Colorado.
Above: This view looks south to the
Blanca Peak massif, elevation 14,345
feet (April 1990).

Opposite: At times the dunes get
snowfalls that exceed two feet. This
view looks north to the Sangre de
Cristo Range (April 2007).

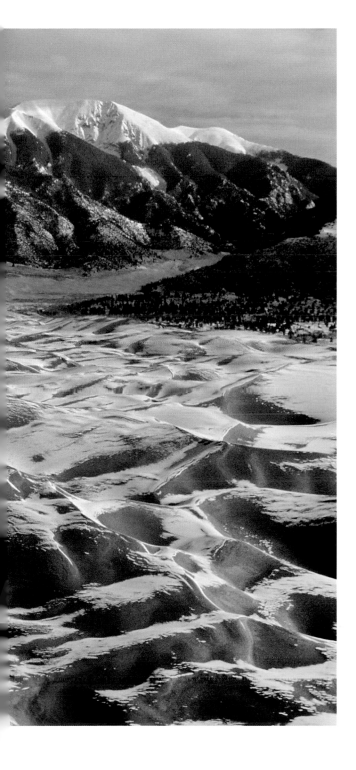

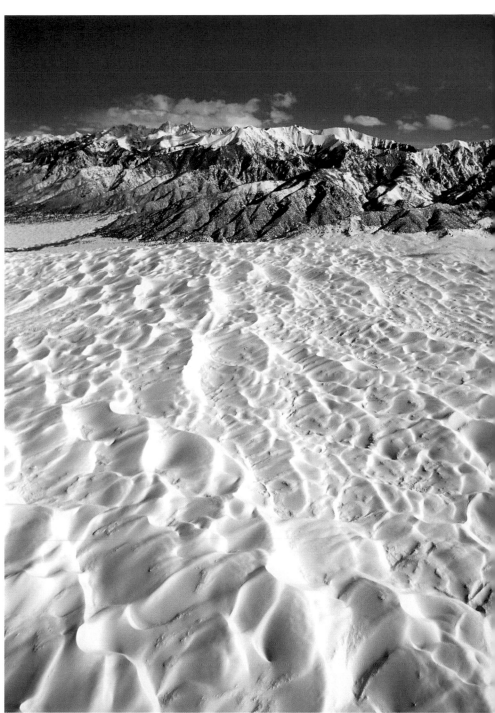

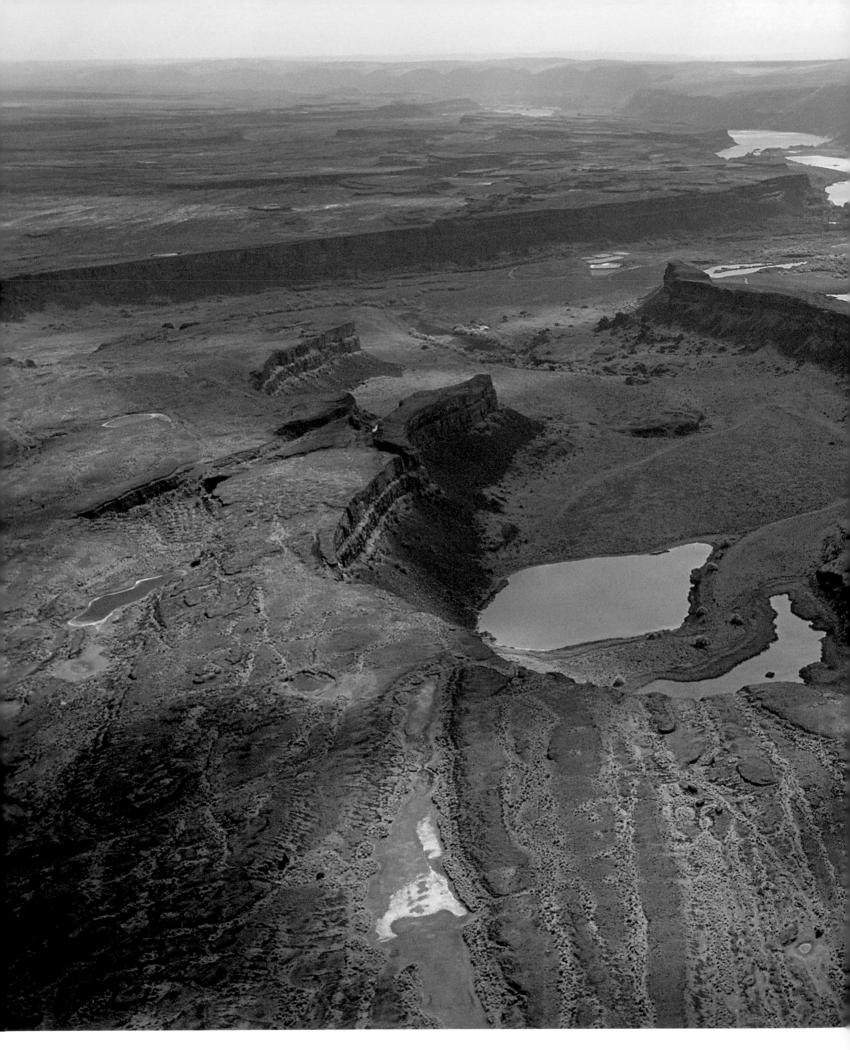

DRY FALLS, Grant County, Washington. Located in what is known as the "Channeled Scablands," this was once a falls bigger than Niagara, probably formed from an ice dam break at Glacial Lake Missoula about 15,000 years ago. This view of the Lower Grand Coulee looks south to Sun Lakes State Park. The Scablands end at the Columbia River and cover an immense desert-like area of eastern Washington (May 2007).

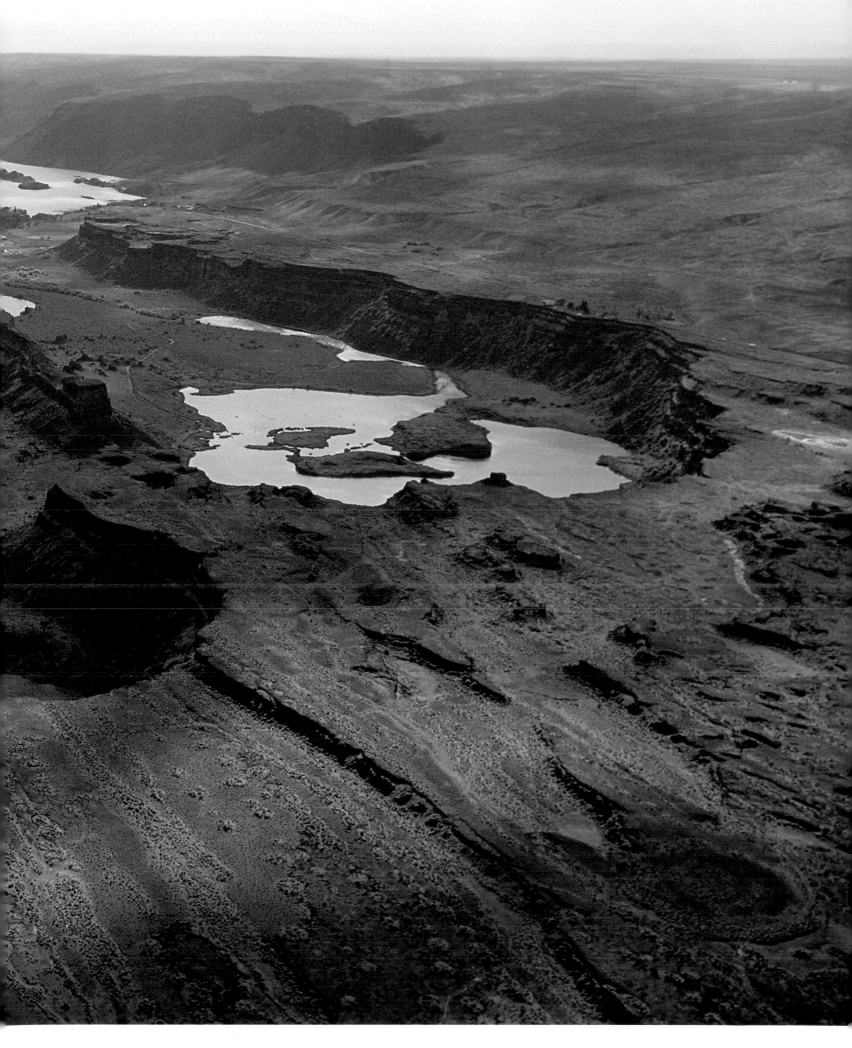

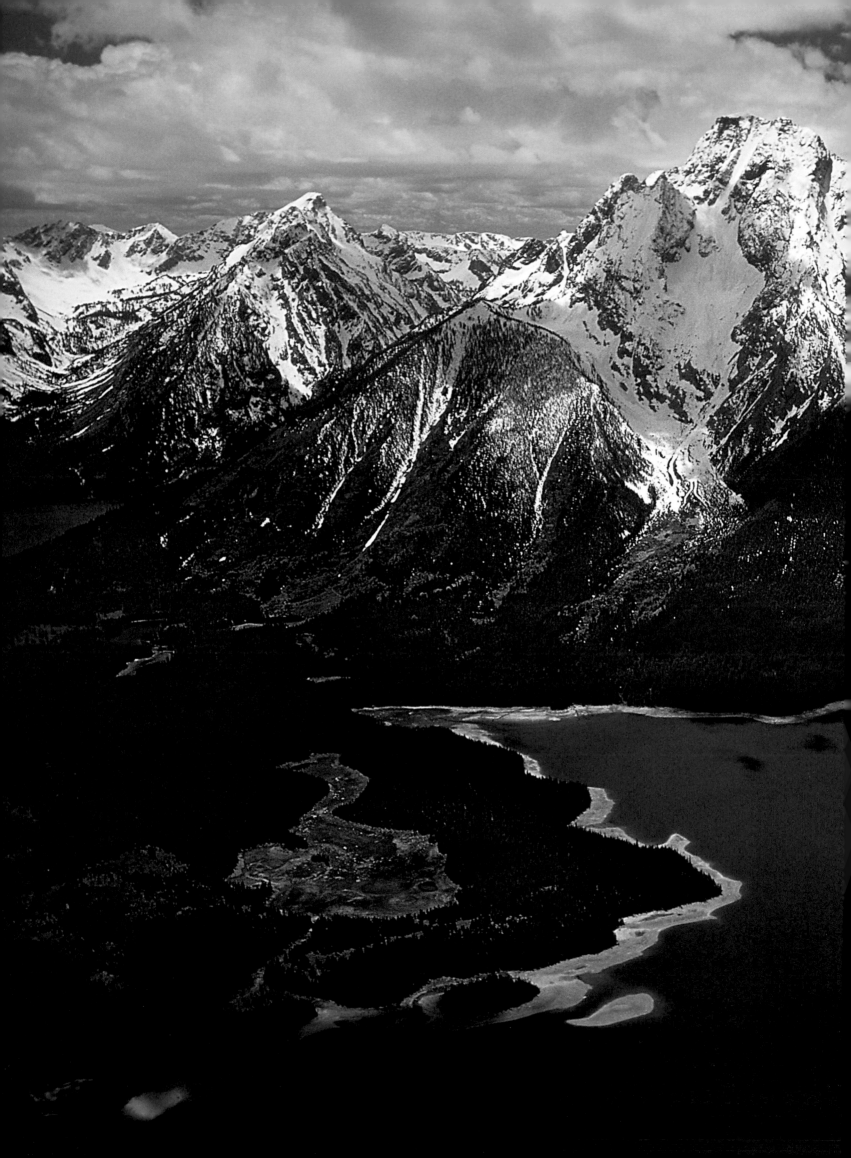

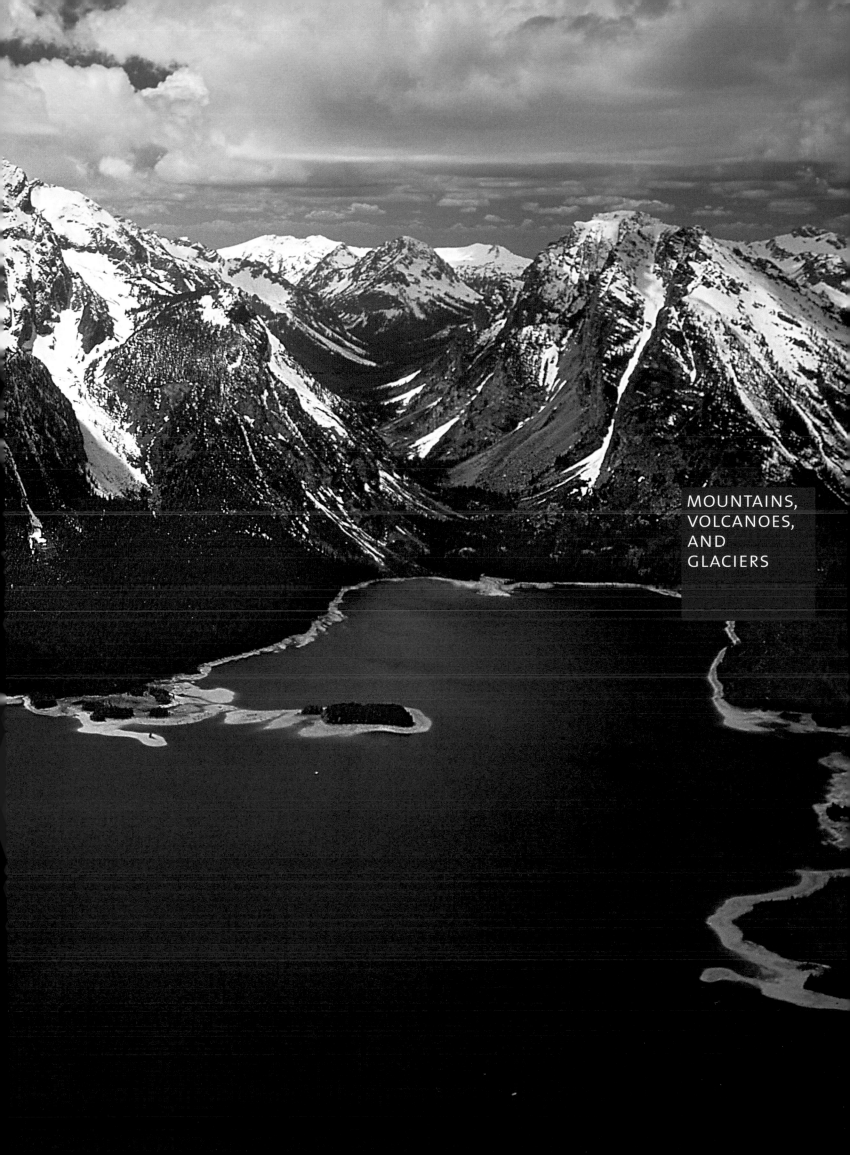

MOUNTAINS,
VOLCANOES,
AND
GLACIERS

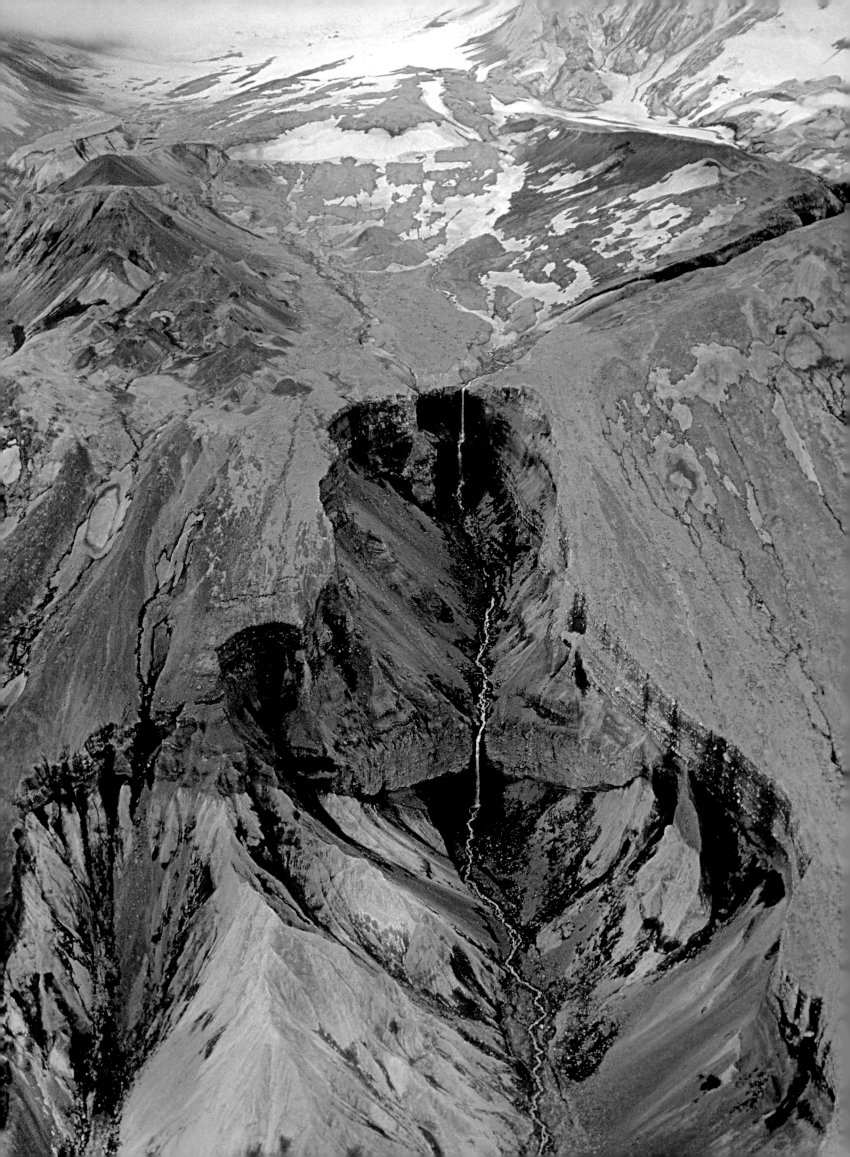

THE NINETEENTH CENTURY was a time of major transformation in American civilization's relationship to wilderness. At the outset, much of the continent was still wild and civilization was struggling for existence. By 1900 the reverse was true and a movement for wilderness preservation had begun. Wild country contemplated from city streets and comfortable homes seemed quite different than it had from pioneer clearings. No more battles with wild places and wild peoples. Instead of an enemy to be conquered, wilderness had become a place to vacation and recreate, to "get away from it all." The scarcity theory of value had finally swung in favor of wilderness.

The ending of the frontier in 1890 shocked a nation finally flirting with middle age. "Frontier" has an interesting significance in the United States. In Europe it meant the boundary between nations, but in the New World—where civilization expanded from east to west—the frontier was the boundary between controlled and self-willed land. The United States Census kept track of this westward-shifting line, using a criteria of less than two inhabitants per square mile to define wilderness. It was drawn in western Pennsylvania, then in Daniel Boone's Kentucky, and later in Indiana and Nebraska. As the nineteenth century came to a close, California was a state (1850) and the Golden Spike had been hammered into the transcontinental railroad (1869). Manifest destiny fulfilled; pioneering game over! The Census of 1890 simply announced that there was no more frontier.

The statement shocked Americans. They now realized that many of the environmental realities that had shaped their culture and character were vanishing. Primary among them was the disappearance of the wilderness. The historian Frederick Jackson Turner underscored one problem when he argued in his 1893 paper that the frontier experience and its abundant opportunities had built respect for the individual and democratic institutions. Without wilderness, and the outlet it provided from controlling institutions, what would become of freedom? The Puritans in Massachusetts Bay and the Mormons in Utah had understood this association. Turner, and Theodore Roosevelt—who admired his work and also dreaded too intense a civilization—felt that wild country was just as much a historical document as a library book. Further destruction of wilderness was comparable to tearing out important pages. How would new Americans understand the values and ideals of their nation? Doesn't the present owe the future a chance to know the past? Understanding was not going to come from shopping malls, suburbs, and freeways.

Such concerns associated with the ending of the frontier gave rise to nostaligia, worry, and even anger. It can be traced in changing attitudes toward American Indians in the novels of Helen Hunt Jackson and those of Jack London, who wrote memorably about "the call of the wild" in 1906. Six years later, Edgar Rice Burroughs published the most popular American literary work of all time concerning a man who heard that call and became a superhero. His name was Tarzan. John Muir, who founded the Sierra Club in 1892, called on his contemporaries to leave the cities to seek tranquility and spirituality in wild mountains. Muir had been instrumental in the creation of Yosemite National Park in 1890, the year the frontier ended, and the coincidence of those events was not lost on his contemporaries. Maybe it was time to keep the New World new by protecting the environment that had made it so different in the first place.

MOUNTAINS,
VOLCANOES,
AND
GLACIERS

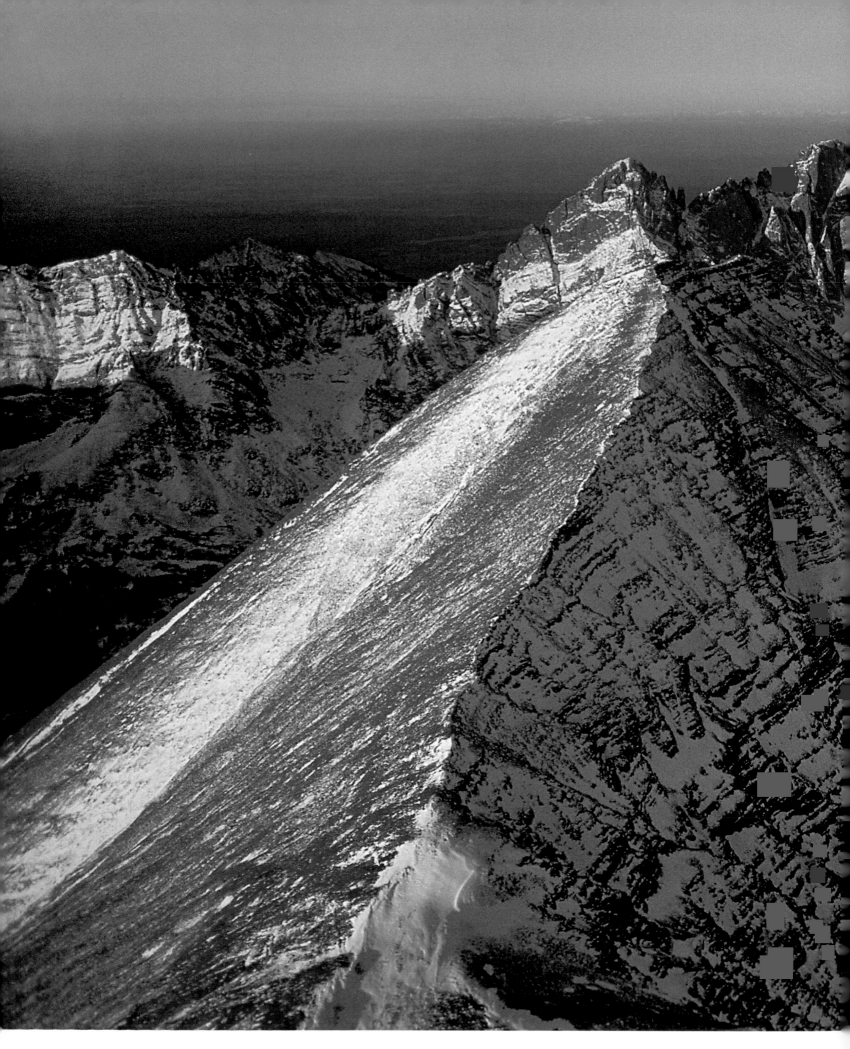

DAWN BREAKS ON HUMBOLDT PEAK, Custer County, Colorado. Humboldt, an easy climb at 14,064 feet, is inside the Sangre de Cristo Wilderness Area of the San Isabel National Forest.

Crestone Peak and Crestone Needle can be seen in the distance of this westward-looking view (October 2000).

(PRECEDING PAGE) MOUNT ST. HELENS, Mount St. Helens National Volcanic Park, Skamania County, Washington. Erosion of volcanic ash on the north slope of Mount St. Helens (May 1994). It would look much different today.

(CHAPTER OPENER) MOUNT MORAN AND JACKSON LAKE, Teton Range, Grand Teton National Park, Teton County, Wyoming. View looks west from Moran Bay (June 2004).

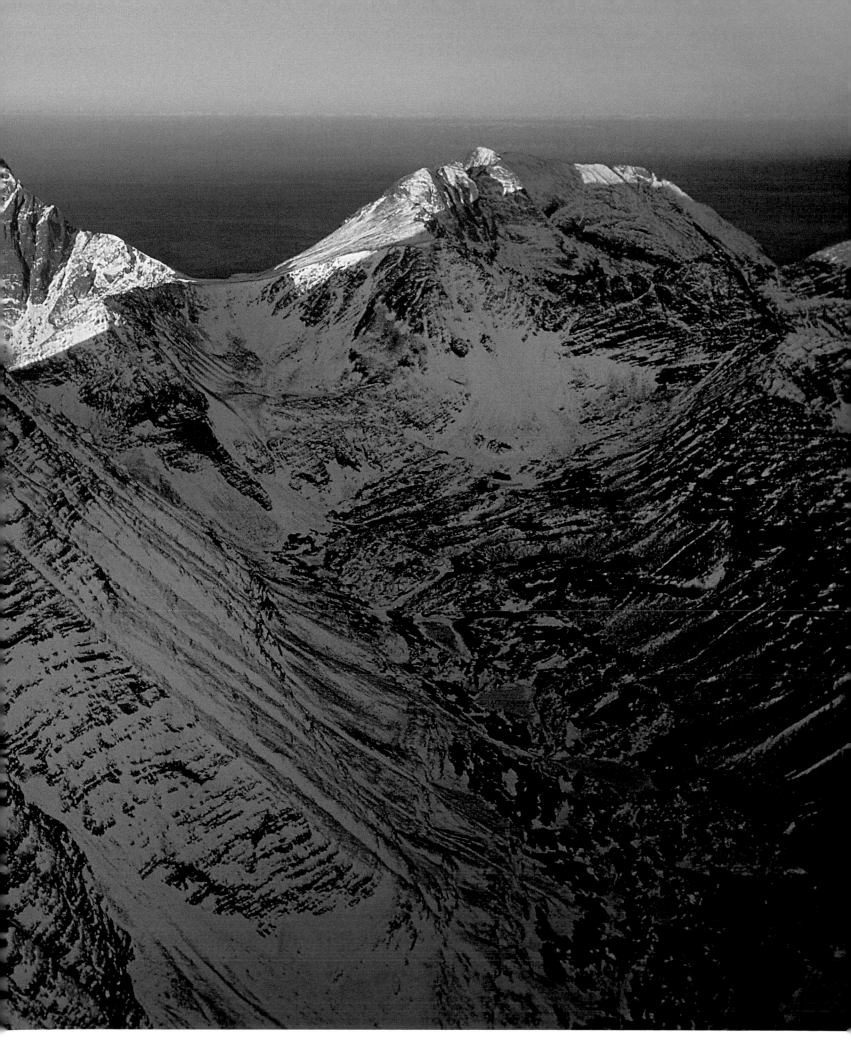

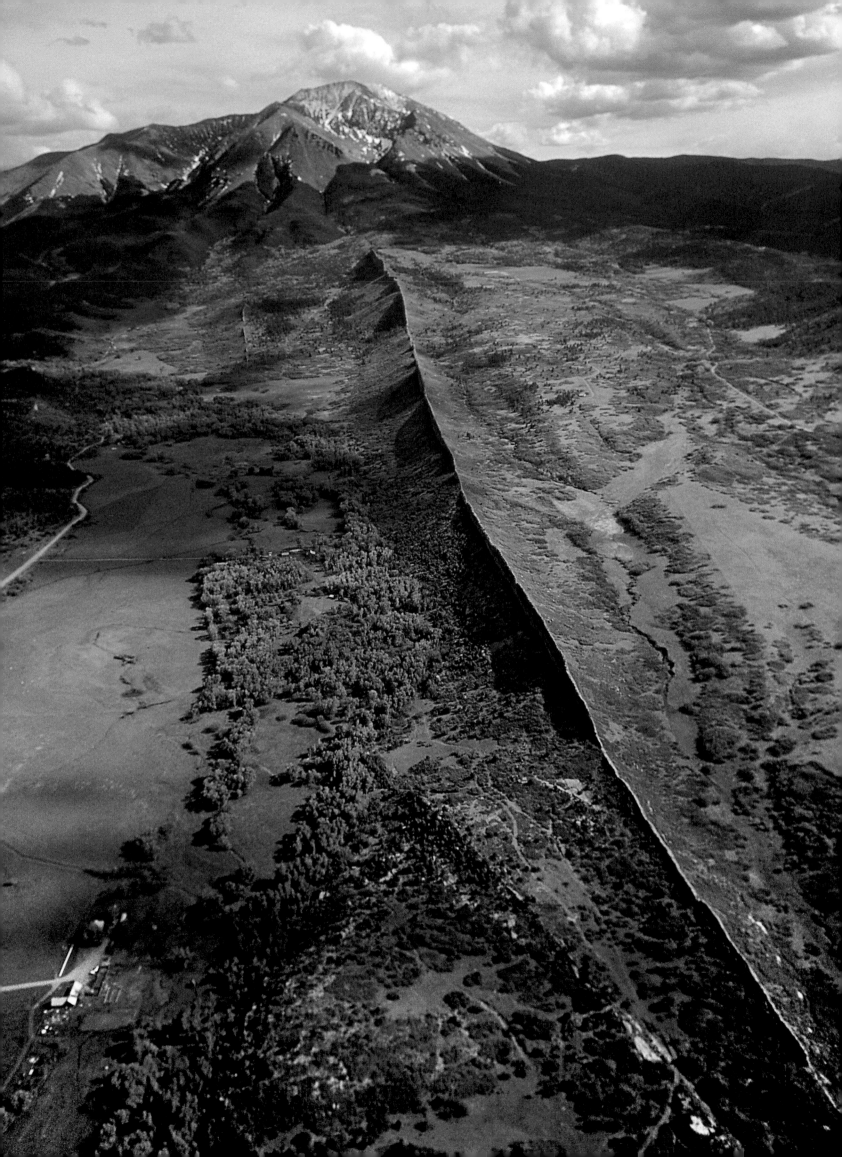

ELK MOUNTAIN, WYOMING (MAY 1991). Aerial photography of the mountains, glaciers, and wilderness areas of North America is not without risks. In May 1991, the Husky and I were returning to Colorado from mountain photography in Montana. An advancing cold front was creating storms and low ceilings over the mountains of southern Wyoming. We attempted to follow

I-80 near Rawlins, but approaching the Continental Divide the clouds met the ground. We retreated to the west and found clear air, where a climb to 14,000 feet put us over both clouds and mountains.

The clouds below were like a table top, the air was smooth, and the sky above covered us like a dark blue bowl. When the engine quit, the blood drained to my socks and I took what I imagined might be my last look at blue sky. Soon we were in the clouds and making a "mayday" radio call. Basic navigation suggested we were near 11,500-foot Elk Mountain. Flying by instruments alone, I took up a heading I thought best to avoid the mountain.

Much attention was required in trying to fix the problem—studying the chart and answering radio calls—so much attention that the airplane seemed to have a mind of its own as to the direction we should be heading. This was a source of both frustration and anger during the fifteen-minute descent and I was frequently slamming the ship back to the "correct" heading.

Pilots who fly in such weather know that when ceilings are very low, the view suddenly darkens as the ground approaches. In aviation terms, the weather was at "ILS minimums." Then, expecting a windshield full of rocks, I abruptly saw a perfectly lined up, perfectly straight, deserted, paved county road. I had either died and gone to heaven (honestly, my first thought), or had won life's lottery. Every turn the Husky had made on its own had put us in a million-to-one place! Not the slightest maneuver was required to position for landing. Go, figure. We landed safely.

Soon, a police car showed up "looking for a downed plane." We moved the Husky off the road and the officer took me to a spooky, deserted lodge where an English lady gave me the best room and cut and burned the finest slice of beefsteak on the planet. Oh, the engine trouble was real, but easily fixed in ten minutes. The next morning the officer picked me up and held the road clear so we could depart. It was neither the first, nor the last time, that the Husky would save the day on its own wits.

WEST SPANISH PEAK, Spanish Peaks Wilderness Area, San Isabel National Forest, Huerfano County, Colorado. This view looks south to 13,623-foot West Spanish Peak, part of the "Twin Peaks," known to Native Americans as the "Wahatoya" or "Breast of Nature." The peaks are volcanic stocks and the rib, or wall, seen coming forward in the photo is one of many spectacular volcanic dikes which radiate out from these peaks (May 1991).

(INSETS) My airplane on the highway; the fishing lodge.

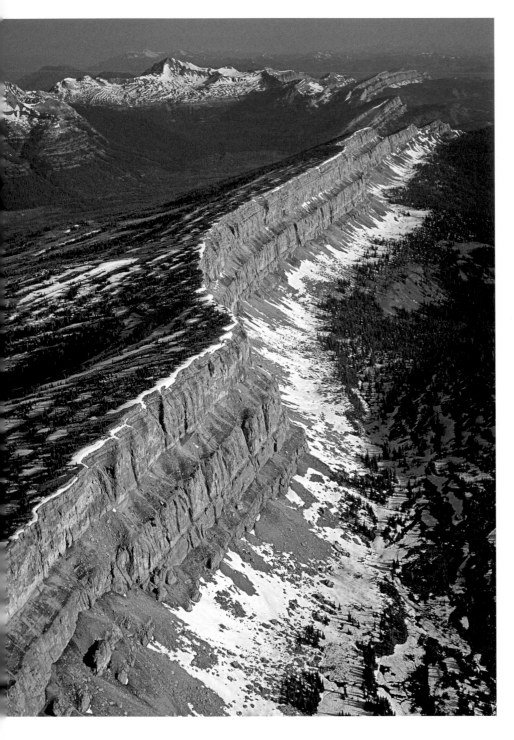

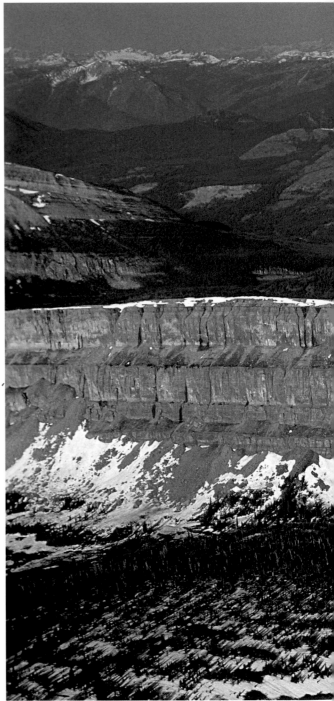

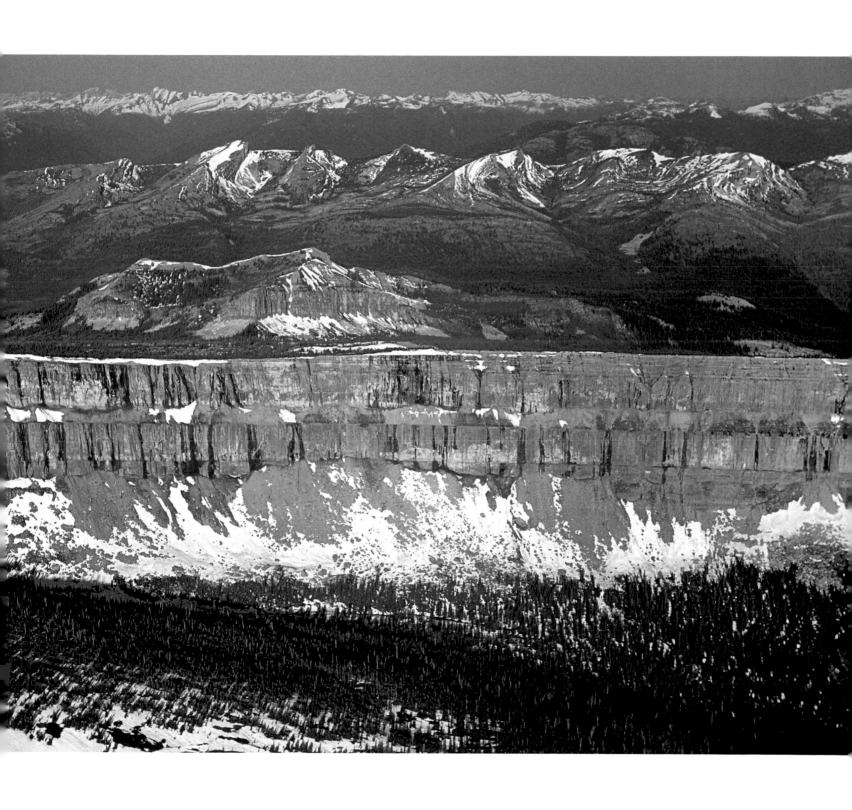

CHINESE WALL, Lewis and Clark County, Montana. About 170 millon years ago, the Lewis Overthrust Fault created a 1,000-foot-high, 20-mile-long escarpment that separates the Rocky Mountains from the eastern plains.

Opposite: To the left of the wall is the Bob Marshall Wilderness Area of the Flathead National Forest (June 2003).

Above: Also known as the "Rocky Mountain Front," this photo looks across the Chinese Wall to the Mission Range in the distance (July 2002).

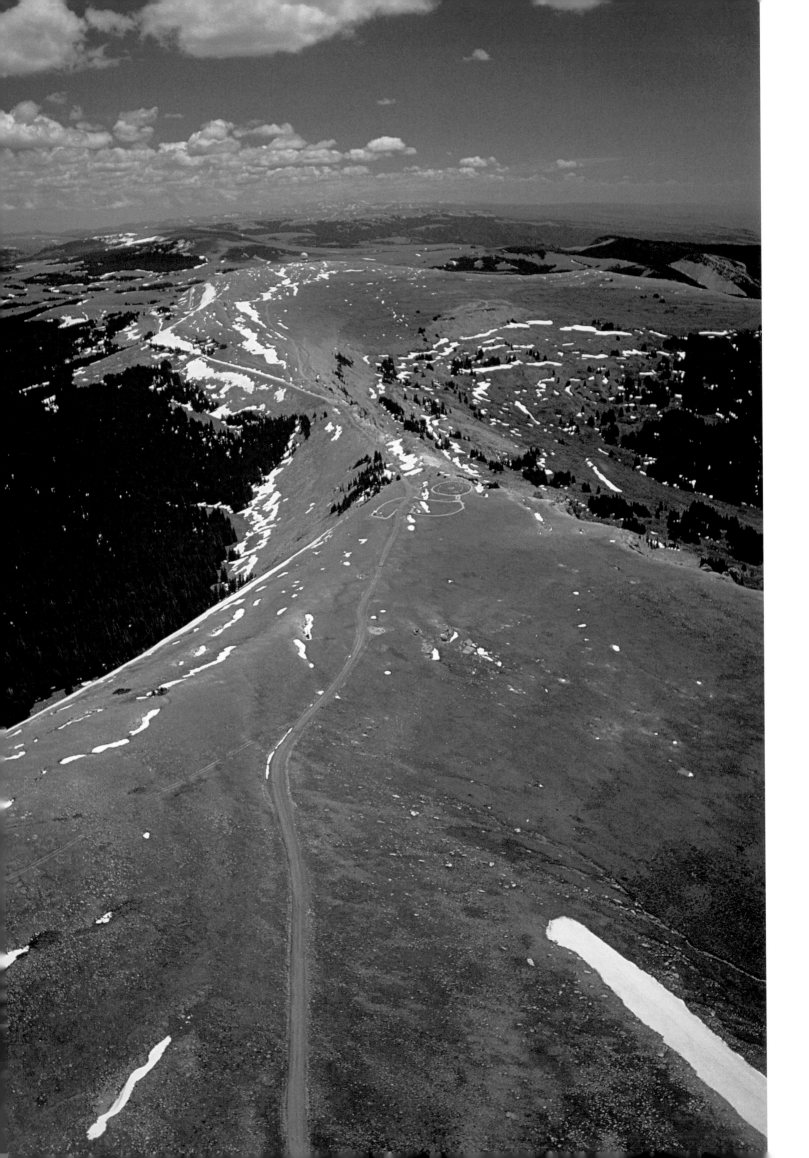

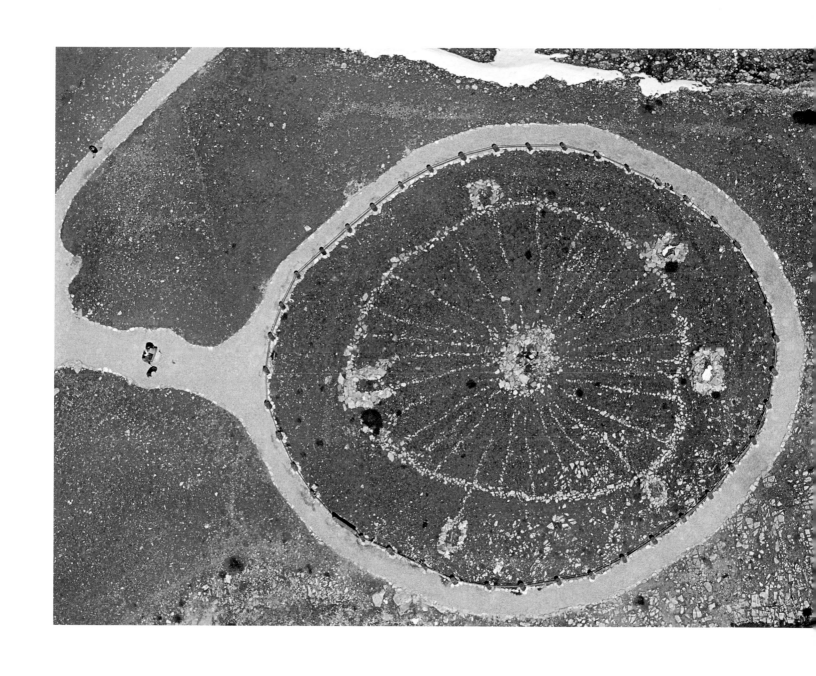

MEDICINE WHEEL MOUNTAIN, Bighorn County, Wyoming. The Medicine Wheel is located just before the narrowest portion of this 9,500-foot elevation ridge (June 2002).

The wheel itself is a Native American ceremonial or astronomical site, which was constructed between 300–800 years ago (bombsight view) (June 2002).

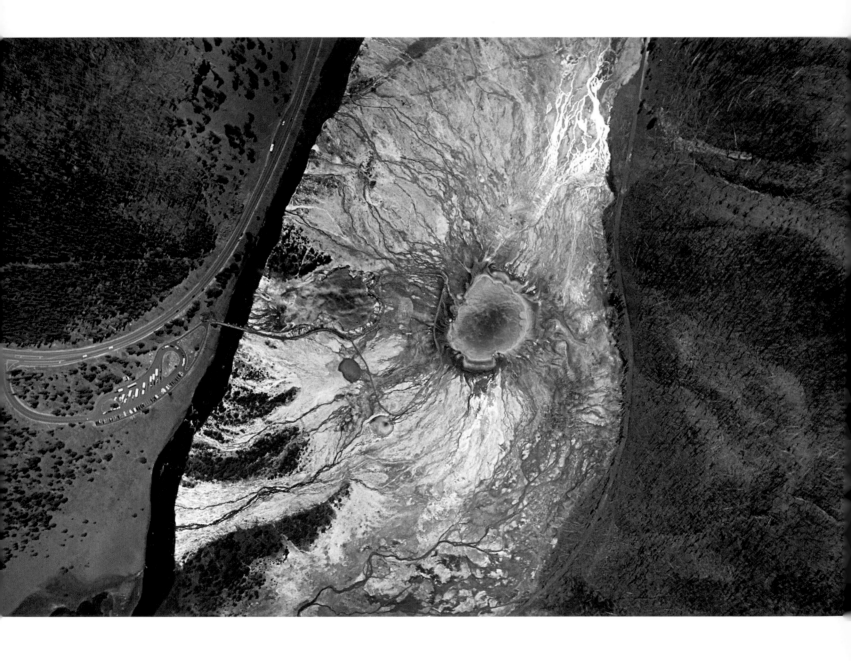

GRAND PRISMATIC SPRING AND EXCELSIOR GEYSER CRATER, Yellowstone National Park, Teton County, Wyoming. Excelsior Geyser and the Firehole River are to the left of Grand Prismatic in this bombsight view (July 1997).

THE AMAZING GRAND PRISMATIC SPRING, Yellowstone National Park, Teton County, Wyoming. This geothermal pool is 300 feet wide and located in Midway Geyser Basin (bombsight view).

The center blue portion of the pool is about 160 degrees Fahrenheit and contains no life. The varying colors are caused by different forms of bacteria that thrive at lower temperatures.

The spring was first recorded by Europeans in 1839 as a "boiling lake" (April 2004).

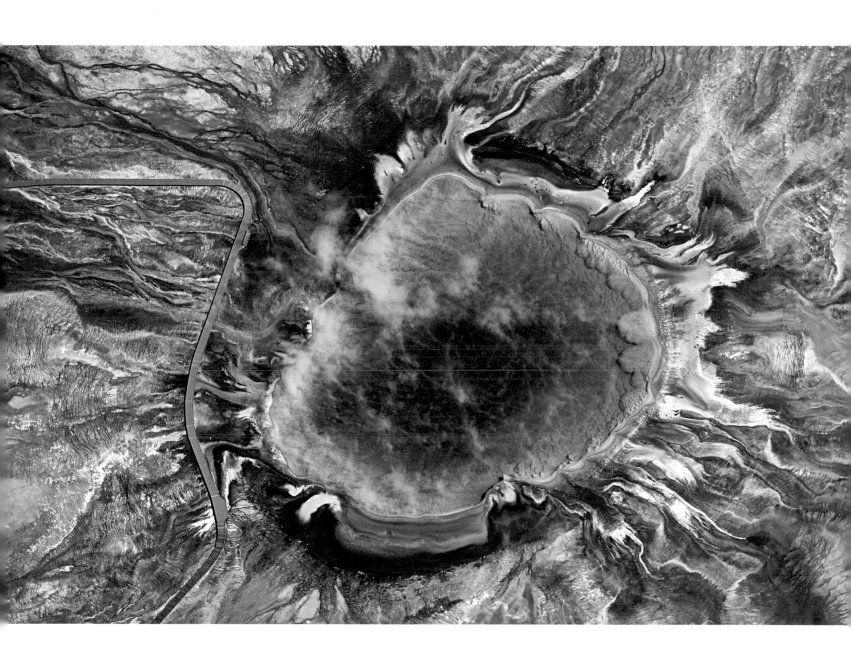

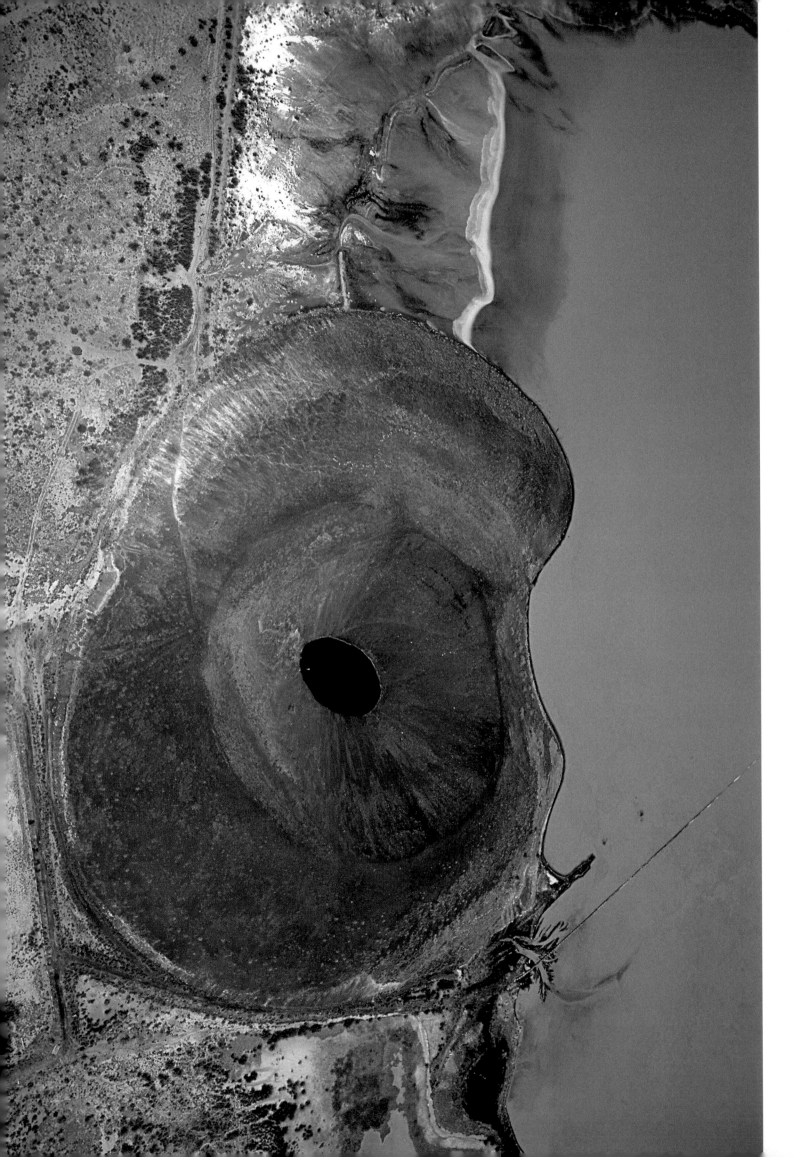

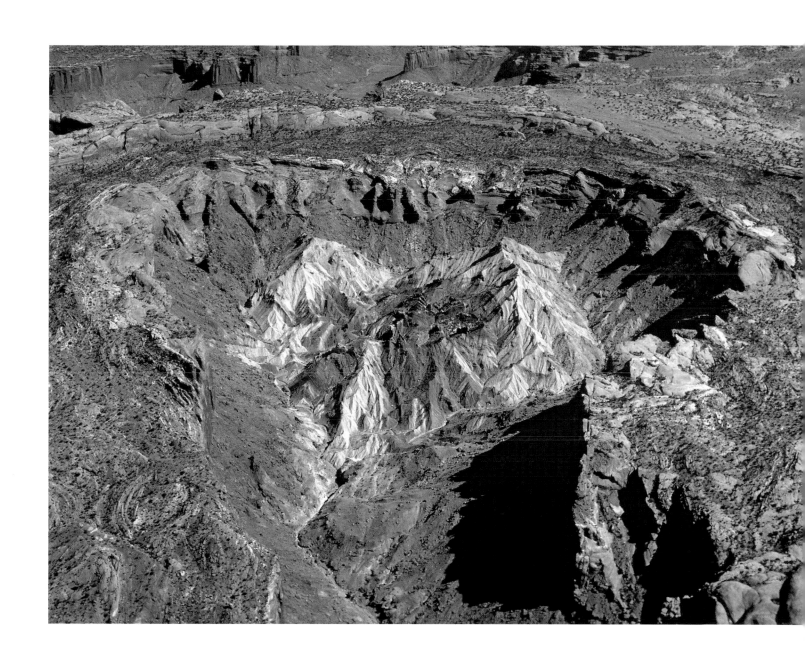

ZUNI SALT LAKE, Catron County, New Mexico. This shallow crater, or maar, is a sacred Native American site and home to Ma'l Oyattsik'i, Salt Woman. Salt from this location is used in sacred ceremonies and this place is said to be one of the "eleven most endangered historic sites" in the United States. This bombsight view shows a small volcanic cone on the shore of the maar lake (April 2005).

UPHEAVAL DOME, Canyonlands National Park, San Juan County, Utah. Measuring 2.5 miles in diameter, this meteorite impact crater is estimated to be about 170 million years old (March 1990).

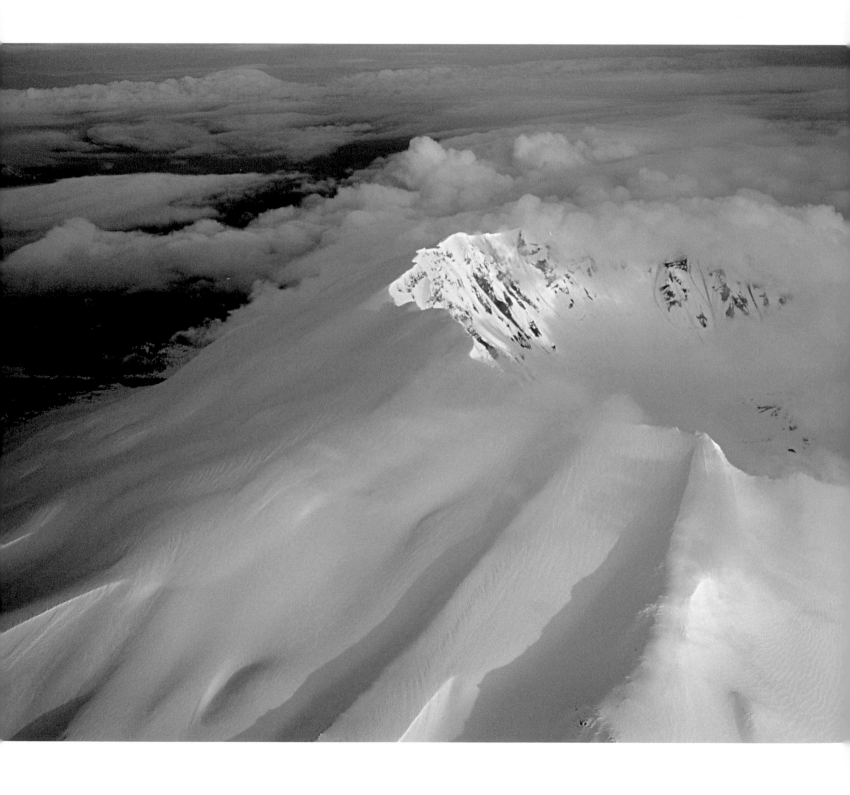

SNOW-CAPPED MOUNT ST. HELENS AT DAWN, Mount St. Helens National Volcanic Park, Skamania County, Washington. The eruption on May 18, 1980, lowered the summit from 9,677 feet to 8,365 feet (May 2003).

MOUNT ST. HELENS WATERFALL, Mount St. Helens National Volcanic Park, Skamania County, Washington. Accented by early morning light, a small stream and waterfall cut through the ash slopes of the north face of the volcano. The combination of flowing water and easily eroded ash created a very primeval, colorful, and rapidly changing landscape (May 1994).

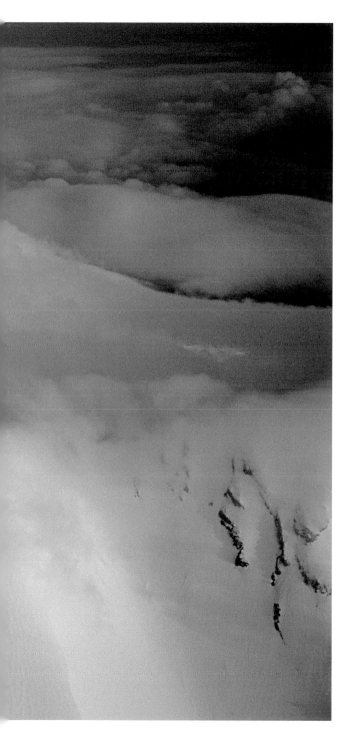

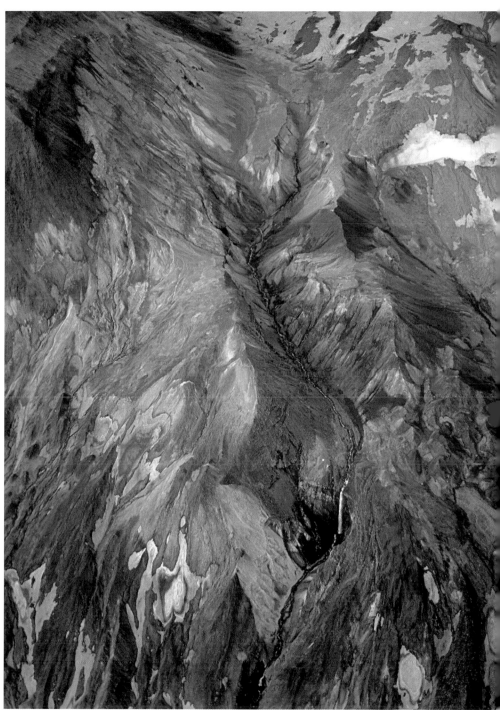

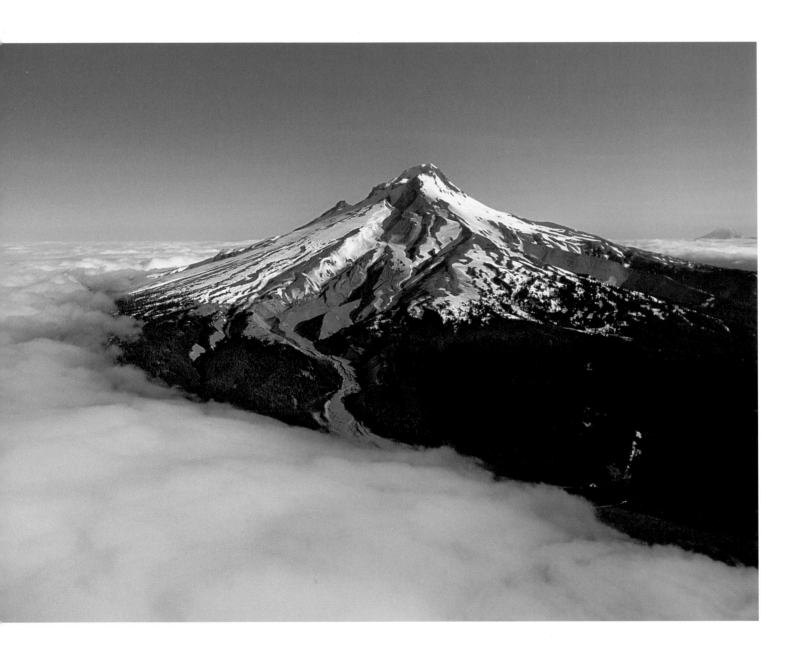

MOUNT HOOD, Mount Hood Wilderness, Mount Hood National Forest, Hood River County, Oregon. A stratovolcano located in the Cascade Volcanic Area of northern Oregon, this peak rises to 11,249 feet and is home to numerous small glaciers. Even though the last eruption was in 1866, this 500,000-year-old volcano is considered potentially active (July 2009).

MOUNT HOOD, Mount Hood Wilderness, Mount Hood National Forest, Hood River County, Oregon, (May 1995).

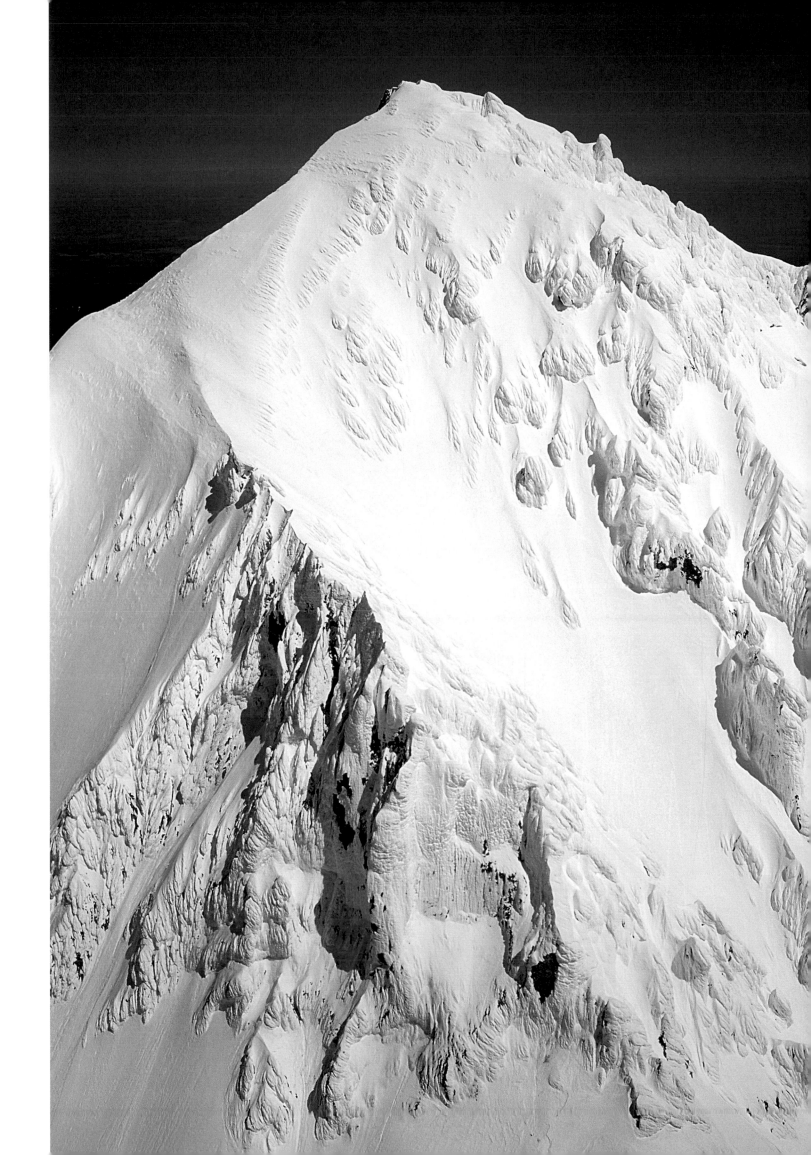

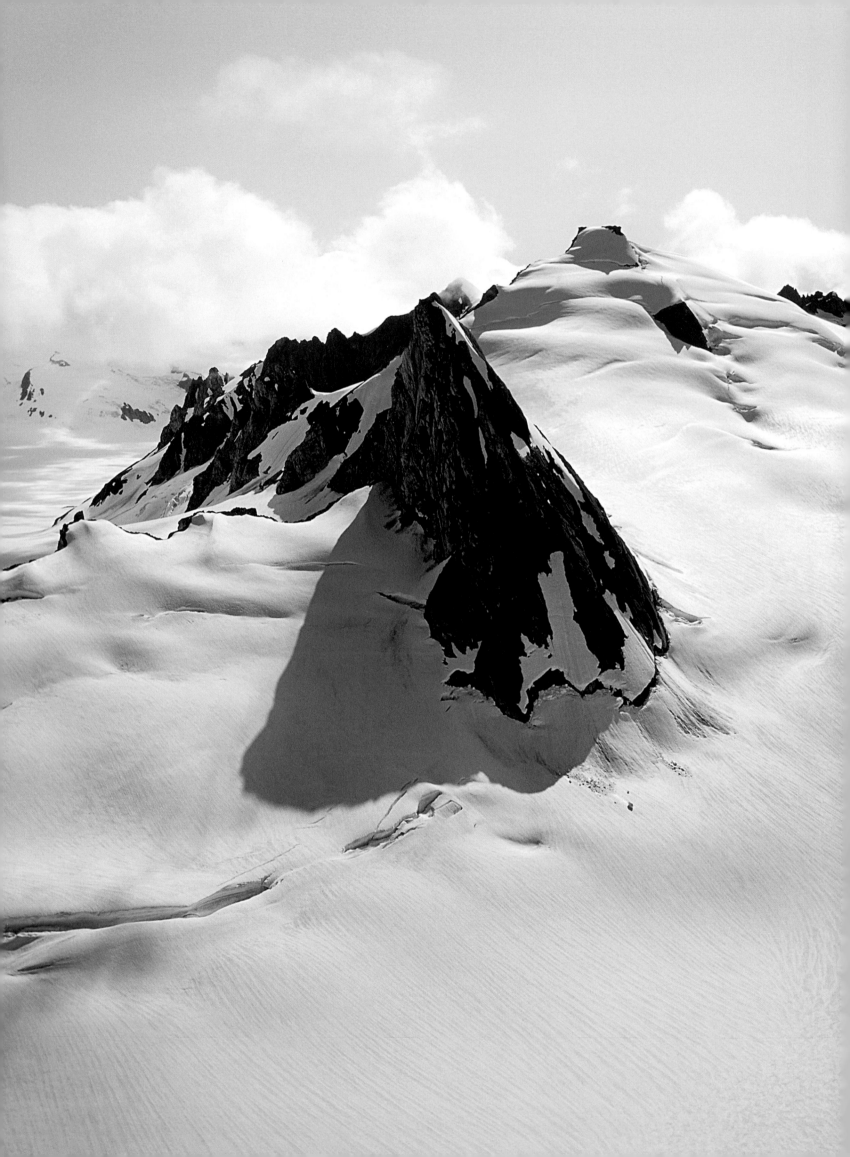

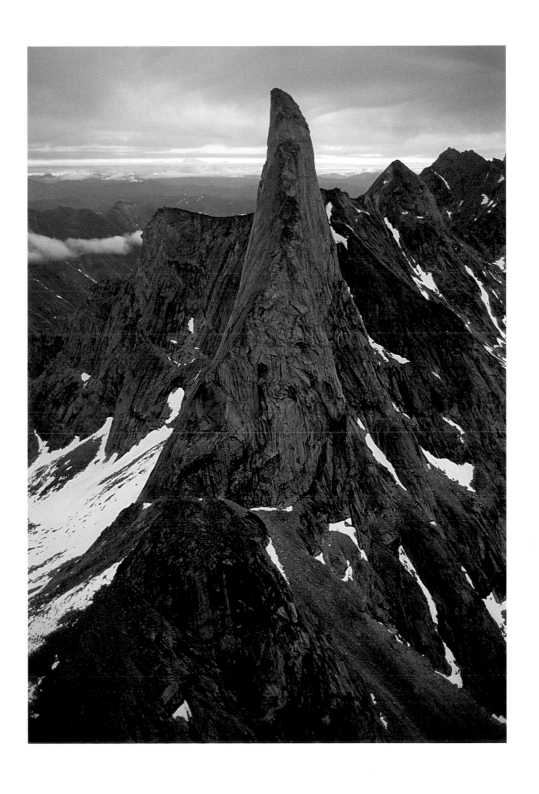

CHILKAT RANGE, southwest of Haines, Alaska (July 1992).

ARRIGETCH PEAKS, SHOT TOWER, Gates of the Arctic National Wildlife Preserve and Wilderness, Alaska. Shot Tower is one of a number of sharp spires comprising the Arrigetch Peaks of the Endicott Mountains, Brooks Range. It is one of the world's more difficult climbs (July 1997).

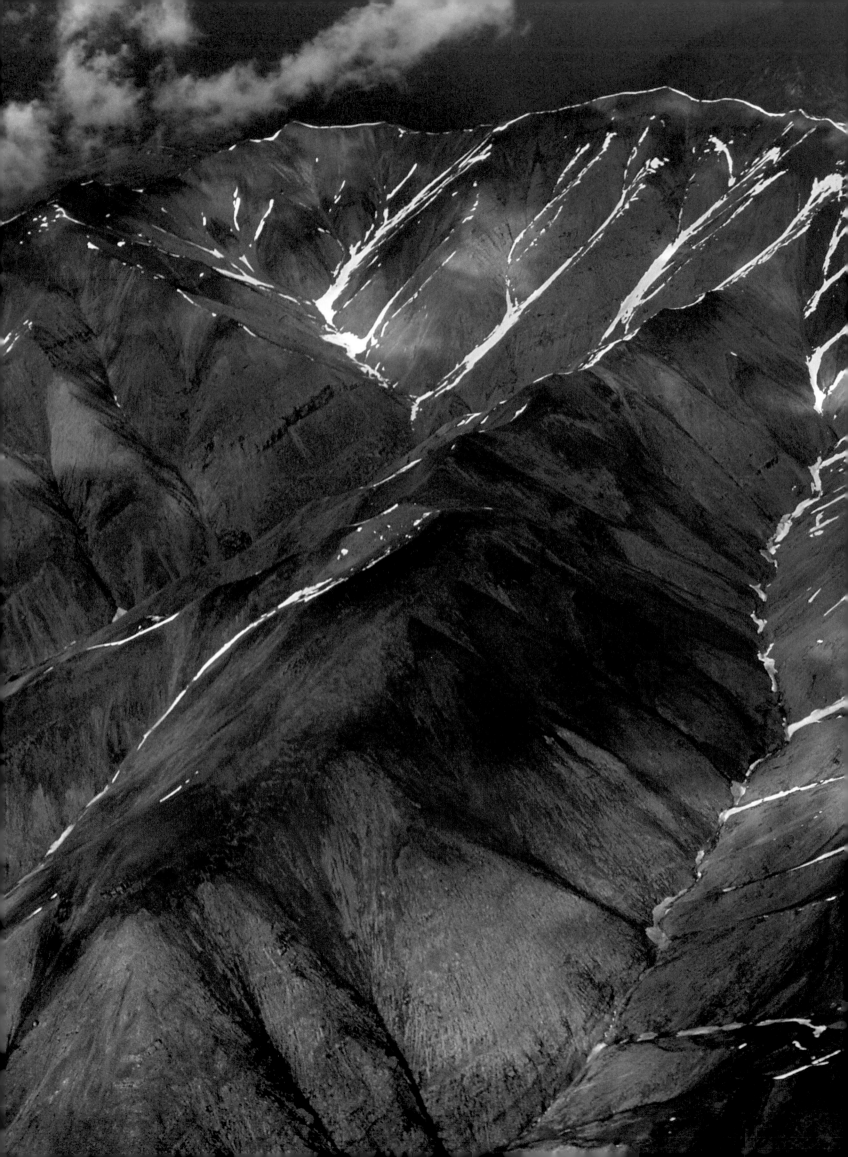

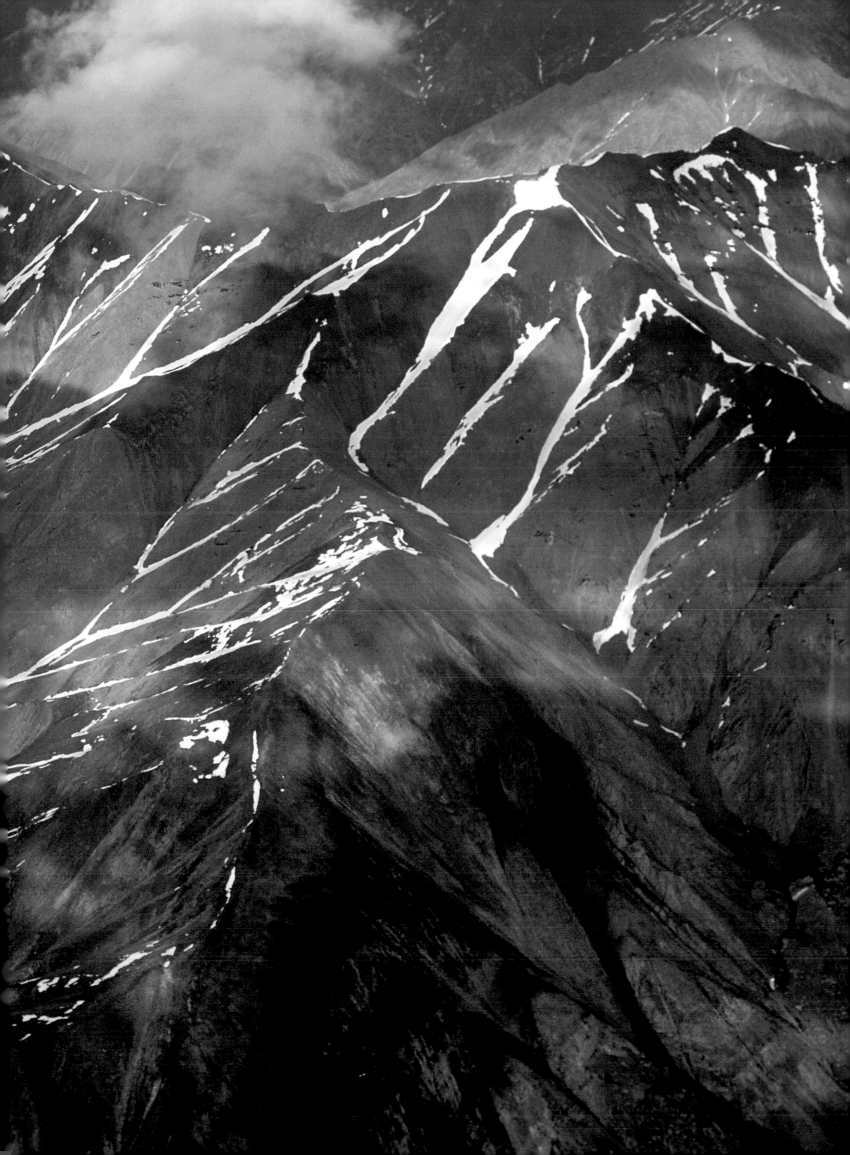

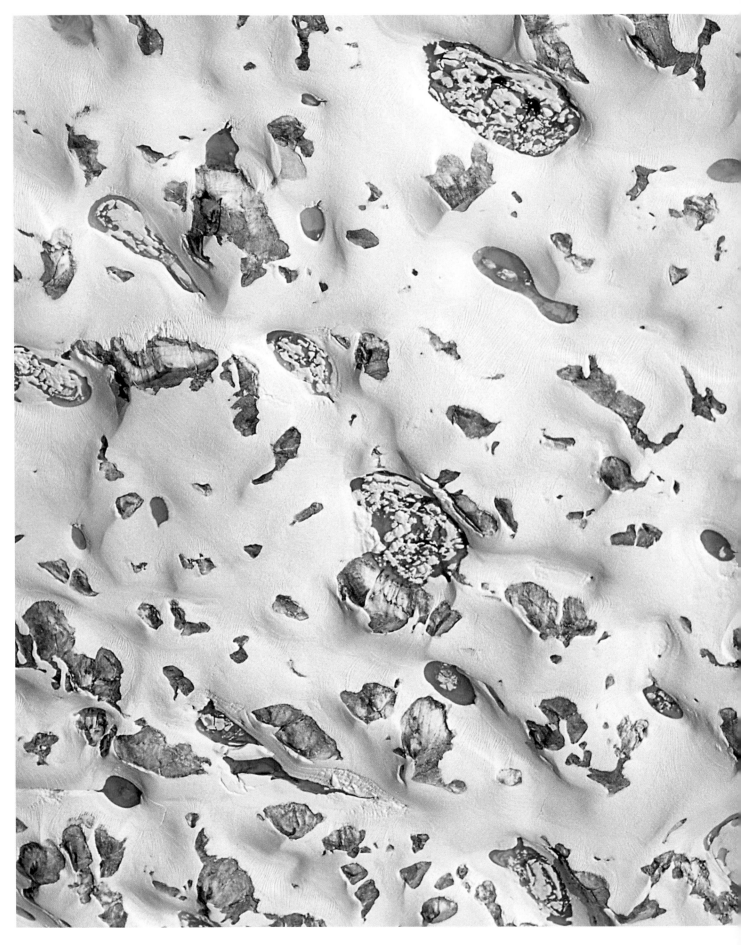

KAHILTNA GLACIER, Denali Wilderness, Alaska Range, Denali National Park, Alaska. This bombsight view from about 1,000 feet shows blue areas (pools of water), gray sections (ice), and white snow (July 1993).

(PRECEDING PAGES) GATES OF THE ARCTIC, North Slope, Alaska. The Philip Smith Mountains form most of the eastern part of the Brooks Range. This section is inside the Arctic National Wildlife Reserve. These mountains top out at only about 9,000 feet, but are starkly spectacular, with great topographic relief (June 2003).

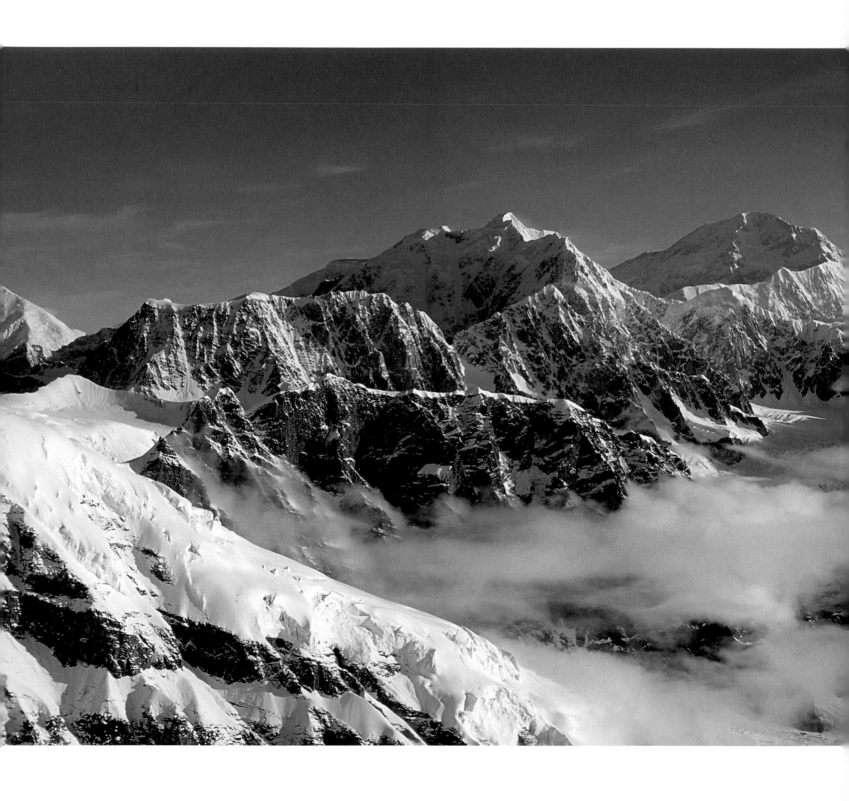

DENALI, Denali Wilderness, Alaska Range, Denali National Park, Alaska (July 1991). Seen here is Mount Hunter (13,965 feet) with Mount McKinley (20,320 feet) in the distance. McKinley is known as Denali Peak by Alaska's

Native Americans and is also called "The Great One." Denali, North America's highest peak, was first climbed in 1913; Hunter (a lower elevation, but more difficult) was first climbed in 1954.

RUTH GLACIER WALL, Denali Wilderness, Alaska Range, Denali National Park, Alaska. This photo zooms in on the north wall of the Great Gorge of the Ruth Glacier. The mile-wide gorge consists of 3,500 feet of glacier ice

topped by 4,500-foot-high granite walls. The deepest gorge in North America, this area was first explored in 1906 by Dr. Frederick Cook, who named the glacier after his daughter (July 1991).

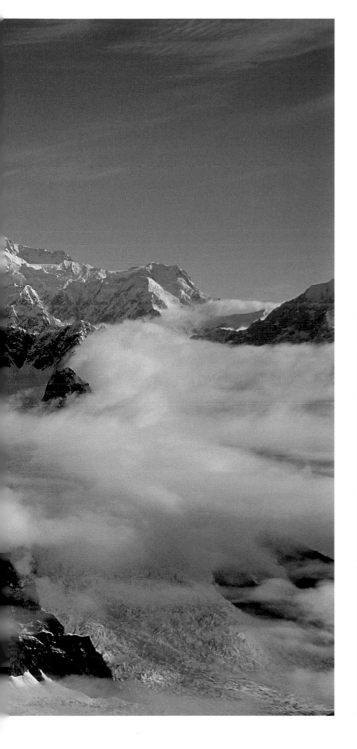

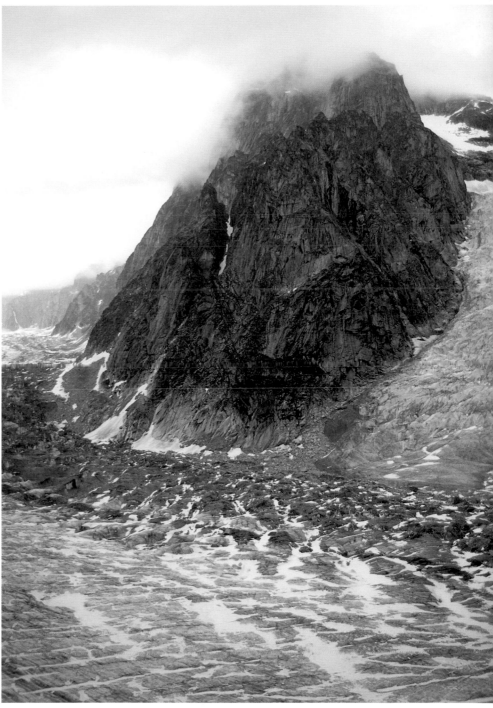

(FOLLOWING PAGES) WEST NUNATAK
GLACIER, Russell Fjord Wilderness,
Tongass National Forest, Alaska. This
near bombsight view from 5,000 feet
above is in southern Alaska, close to
the US–Canada border (June 2003).

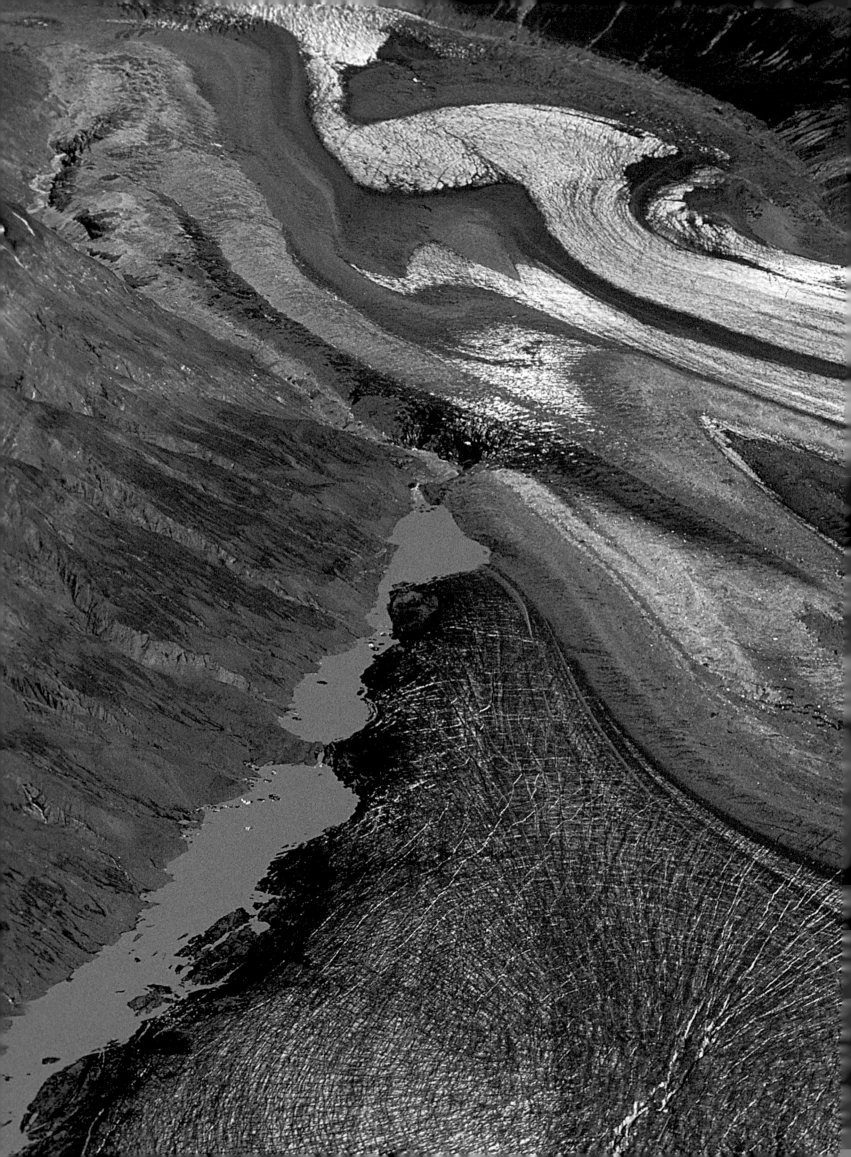

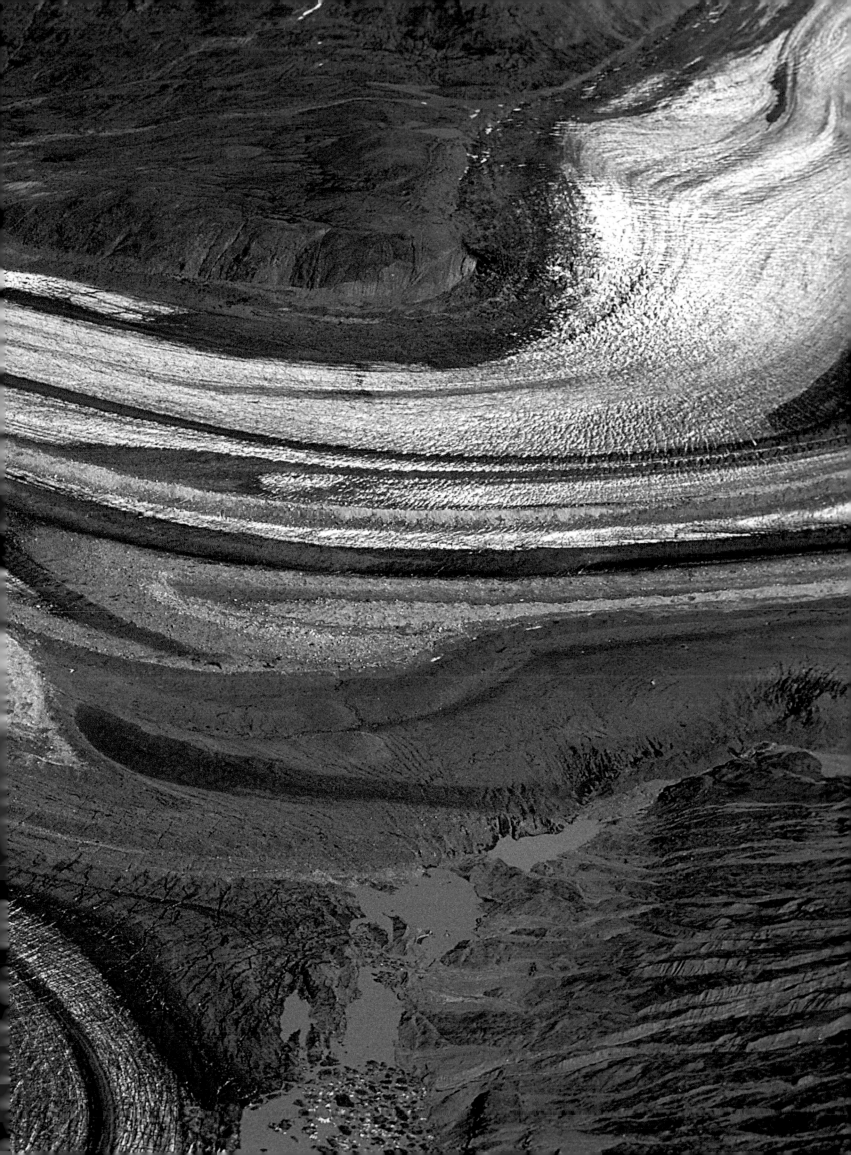

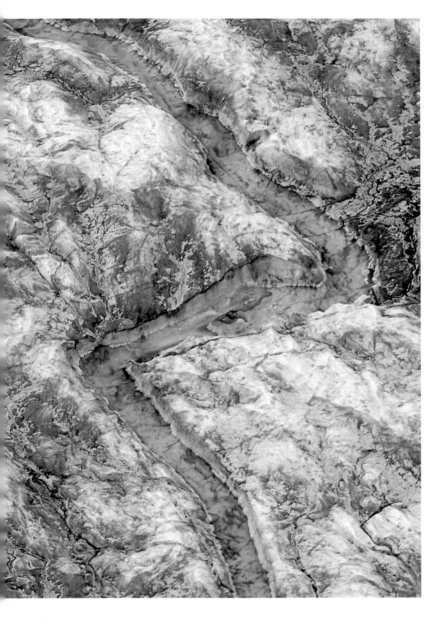

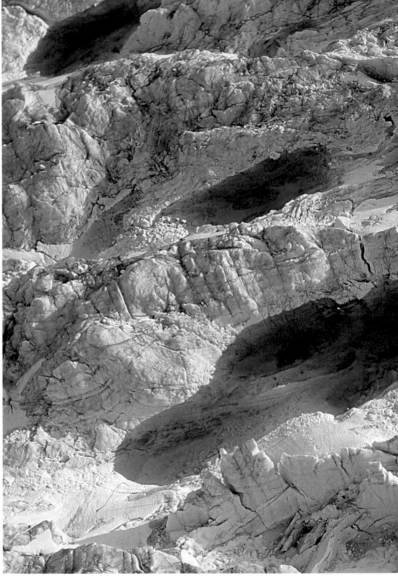

CHISANA GLACIER, Wrangell-Saint Elias Wilderness, Wrangell-Saint Elias National Park, Alaska. This pale China blue color is usually only seen in glacial waters (July 1991).

CHISANA GLACIER, Wrangell-Saint Elias Wilderness, Wrangell-Saint Elias National Park, Alaska. No place to land an airplane (July 1992).

MALASPINA GLACIER, Tongass National Forest, Wrangell-Saint Elias National Park, Alaska. This is a tiny section of a 1,500-square-mile piedmont glacier.

Each strand or stripe represents an individual contribution of ice or rubble to the flow (July 1997).

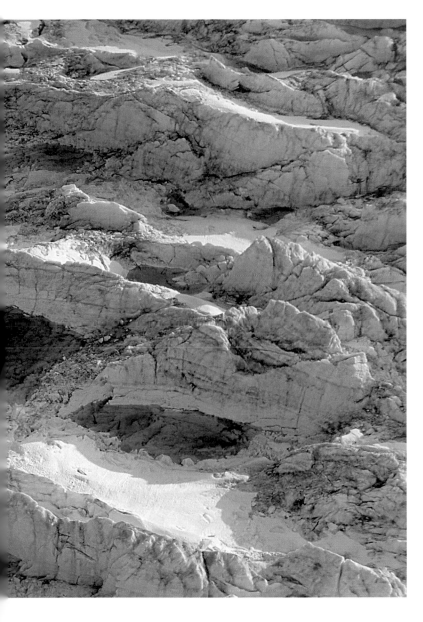

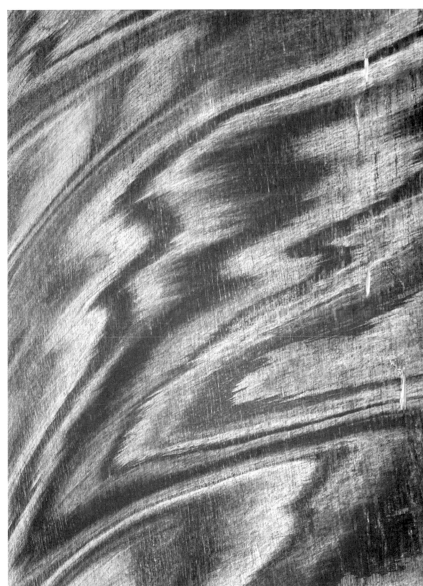

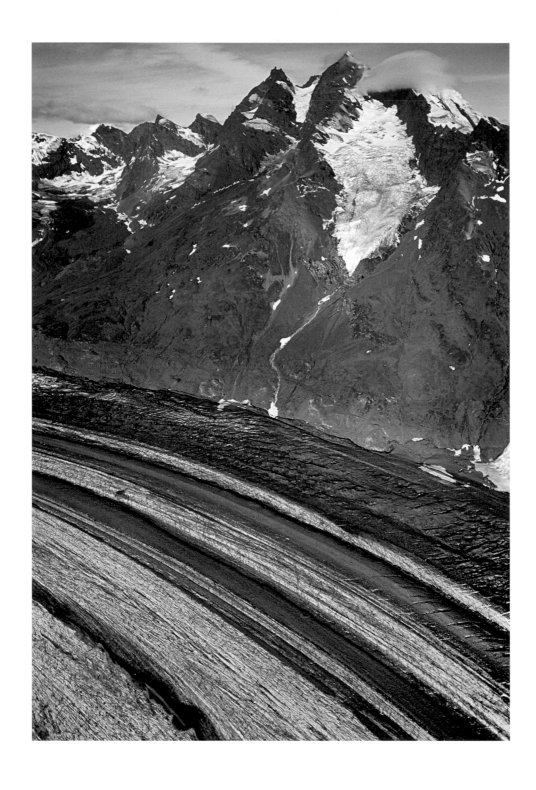

SCHWAN GLACIER, Chugach Mountains,
Chugach National Forest, Alaska
(July 1997).

EDGE OF MALASPINA GLACIER,
Wrangell-Saint Elias National Park,
Alaska. Here, the muddy glacier edge
meets Caetani River (July 1997).

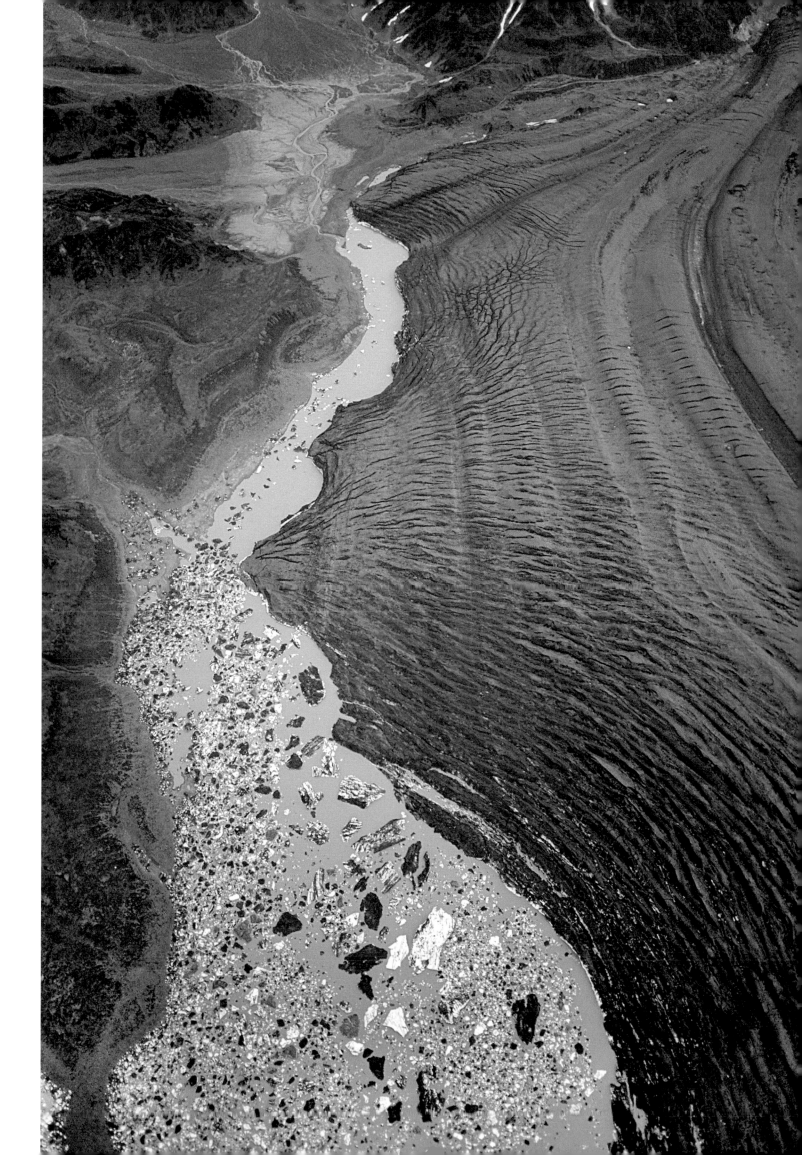

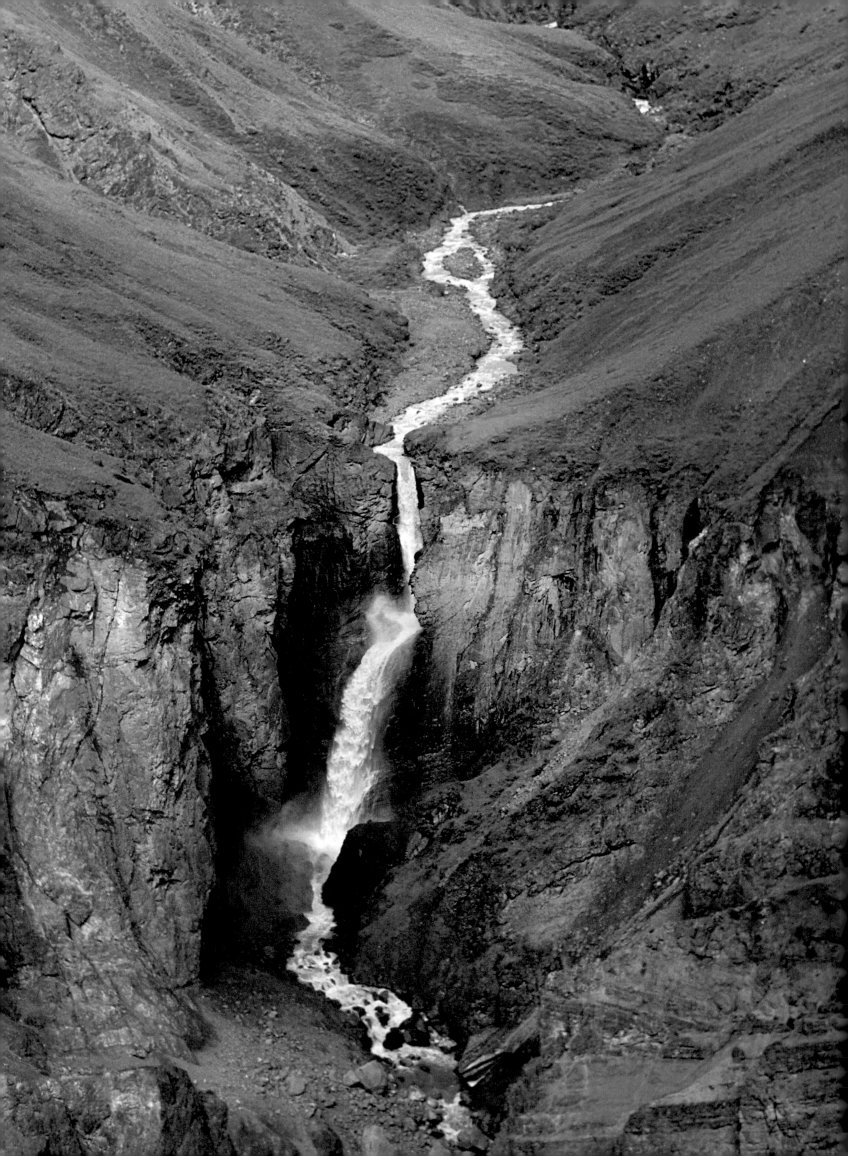

GLACIER CREEK, ALASKA (JUNE 1993). It's my third night in camp and at about midnight a black bear begins circling the tent. In two earlier Alaska trips locals had warned me that it was foolish to be camping in the bush without a gun for bear defense. So this time I was armed with a twelve-gauge pump-action shotgun. I had also taken the advice of an old-time bush pilot whose bear trick was to save his urine each day, mix it with a good dash of household ammonia, and sprinkle a wide ring around the tent each night. Most bears, he said, would respect this territory. True enough, the bear was showing respect, but both the fabric-covered airplane and my provisions were fair game.

I could see the bear in the dim midnight northern twilight. He would circle and sit, circle and sit. Banging on pans and shouting "I know you're out there, Bear, beat it" had no effect. He paid no attention, so it was time to get dressed, get the gun, step outside, and fire a shot over his head. But my gun jammed and wouldn't chamber a shell. After convincing myself this was not just a bad dream, I spent about twenty minutes holding a small flashlight in my teeth working on the gun when for no apparent reason it suddenly works. By this time the bear was into the provisions and was sitting down eating a can of Pringles. I approached to about fifty feet and fired well over his head. The blast reverberated and echoed off the canyon walls. The bear did not so much as look up.

Thinking this is one fearless bear and not wanting to become the main course, I kept closing with the intention of shooting to kill if he charged. At about fifty feet, he looked up, dropped the food (now a loaf of Wonder Bread), and bolted for the bush. I laid awake the rest of the night and departed at dawn. Two weeks later, recounting the incident, I realized I had not chambered a second round.

CHITISTONE FALLS, Wrangell-Saint Elias Wilderness, Wrangell Mountains, Wrangell-Saint Elias National Park, Alaska. A 300-foot-high falls on the Chitistone River (July 1992).

(INSET) GLACIER CREEK CAMP, (June 1993).

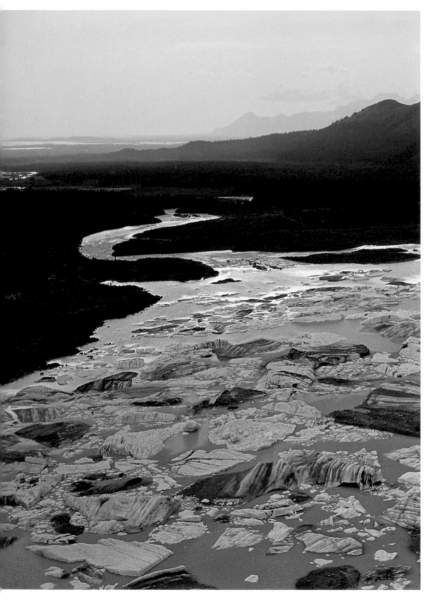

JOHNSON GLACIER POOL, Chugach Mountains, Alaska (July 1991).

BLUE ICEBERG, Chugach Mountains, Alaska. Among hundreds of small bergs in the Bering Glacier Pool, this was the only blue one. One year later it was smaller and smoother, but still unique (July 1991).

BERING GLACIER, Chugach Mountains, Alaska (June 2003).

(FOLLOWING PAGES) MOUNT MCKINLEY, Denali National Park, Alaska. North America's highest peak, 20,320 feet (June 1993).

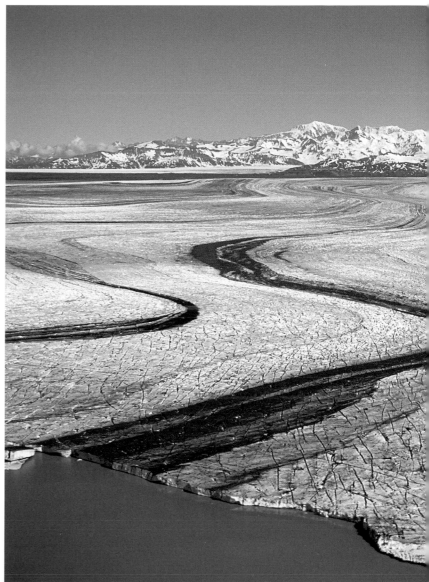

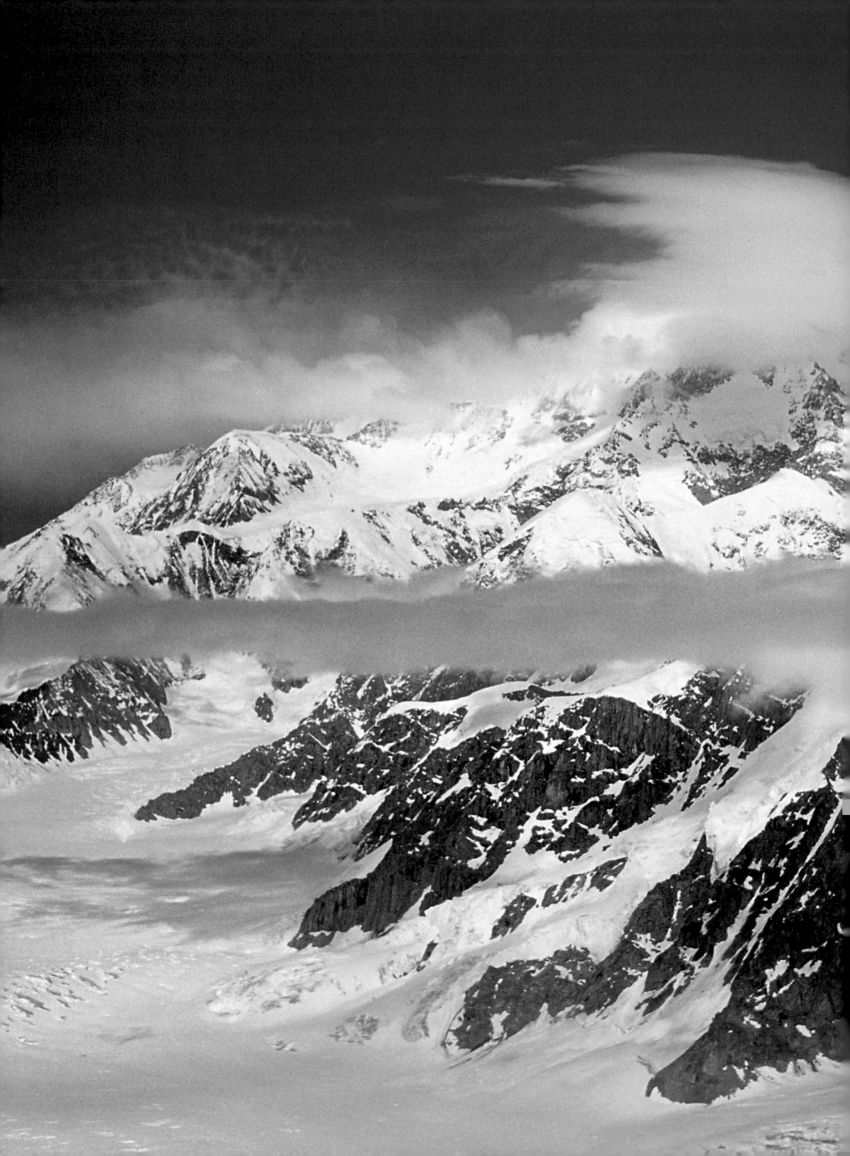

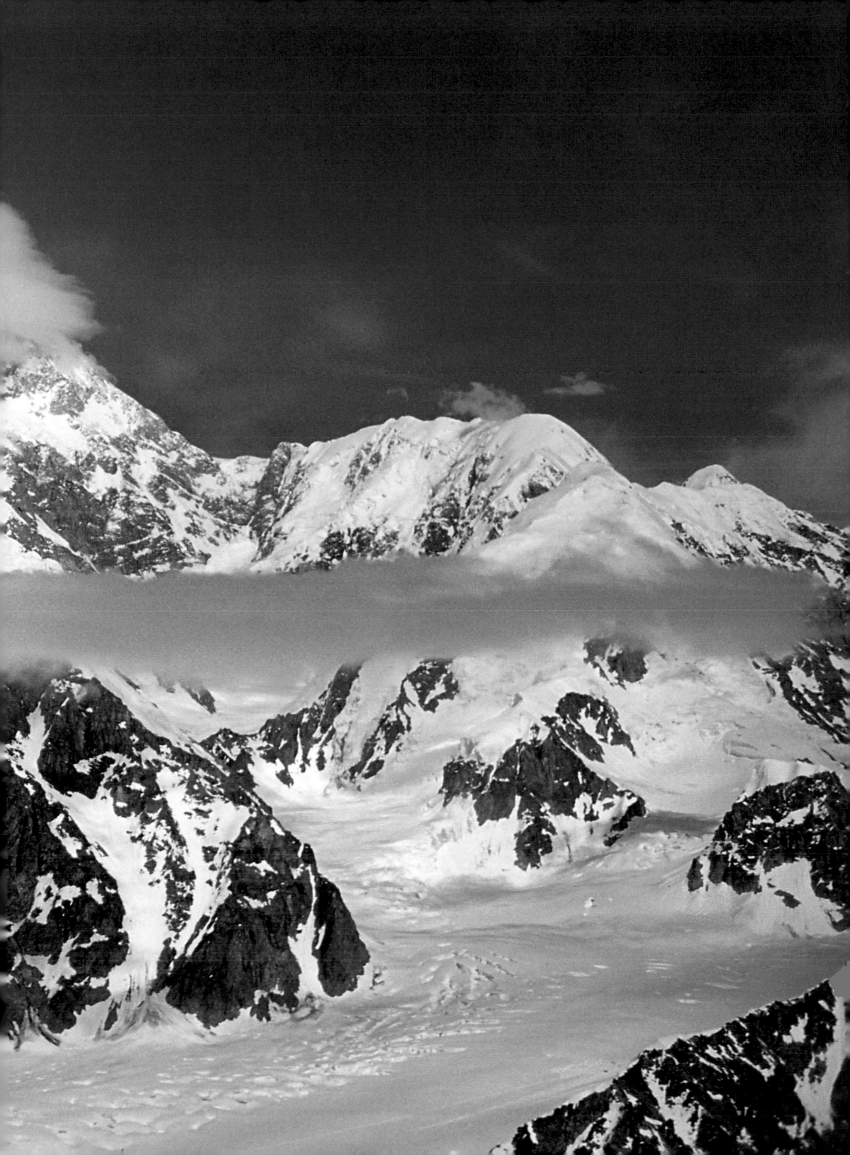

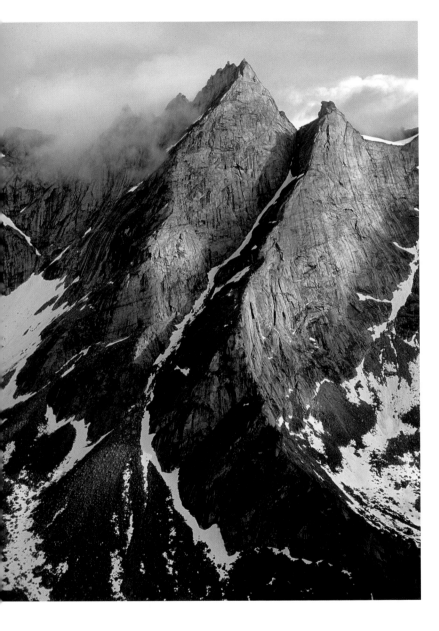

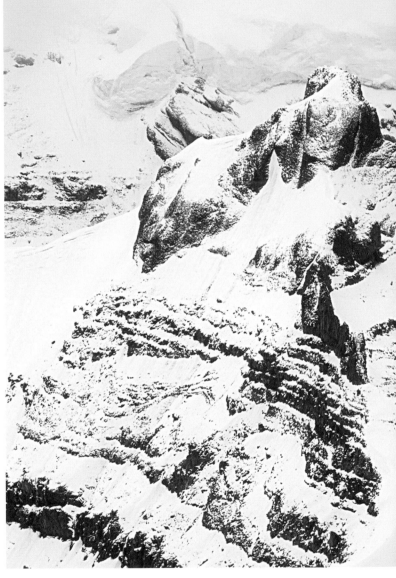

ARRIGETCH PEAKS, Endicott Mountains, Brooks Range, Alaska. Gates of the Arctic National Park and Preserve (June 1993).

ATNA PEAKS AT HEAD OF NABESNA GLACIER, Wrangell-Saint Elias Wilderness, Wrangell Mountains, Wrangell-Saint Elias National Park, Alaska (July 1991).

LOGAN GLACIER, Wrangell-Saint Elias Wilderness, Wrangell-Saint Elias National Park. An example of a superglacial moraine (June 1993).

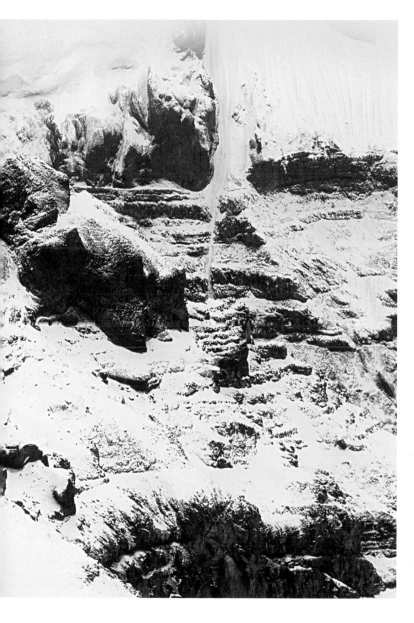
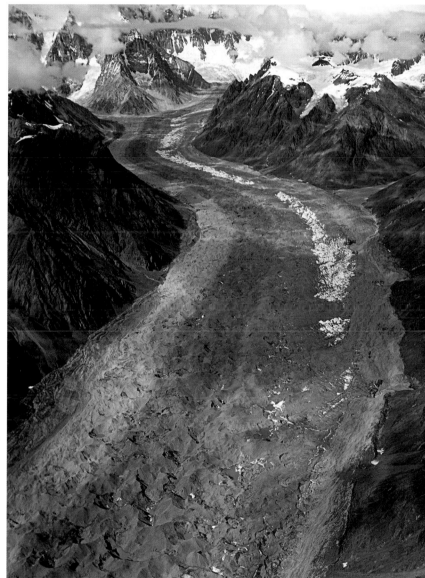

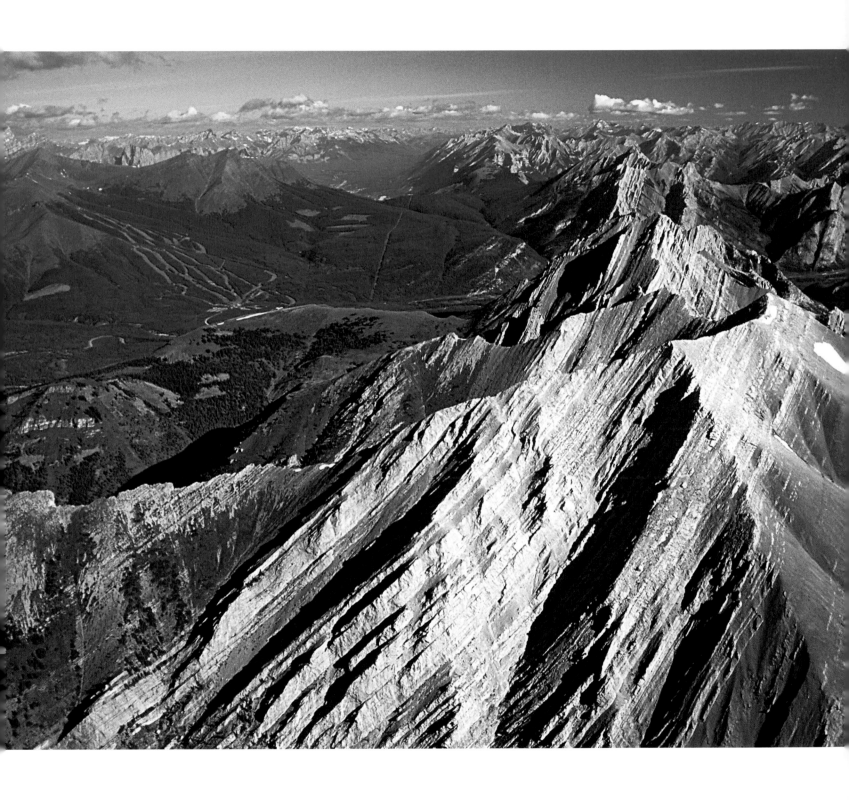

BARE RANGE, Banff National Park, Alberta. This low mountain range is named for its barren slopes (July 1997).

CIRQUE OF THE UNCLIMBABLES, Mackenzie Range, Northwest Territory. This view shows Mount Sir James MacBrien, 9,052 feet (July 1997).

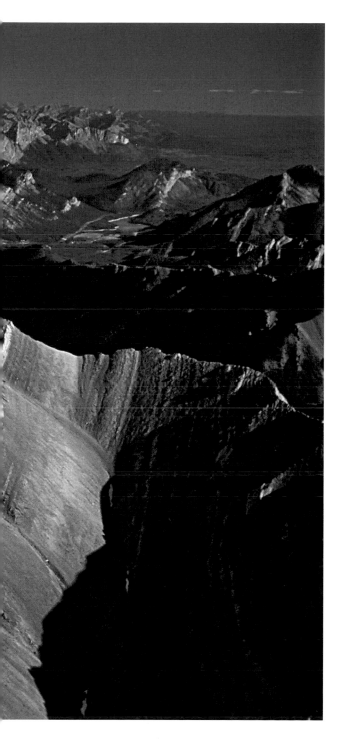

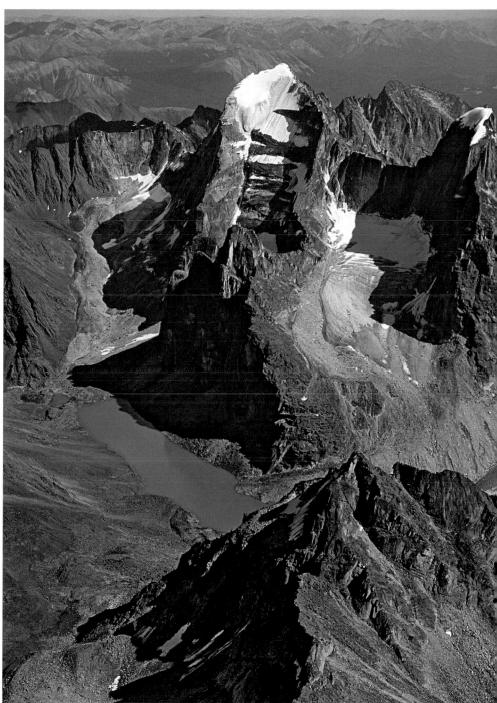

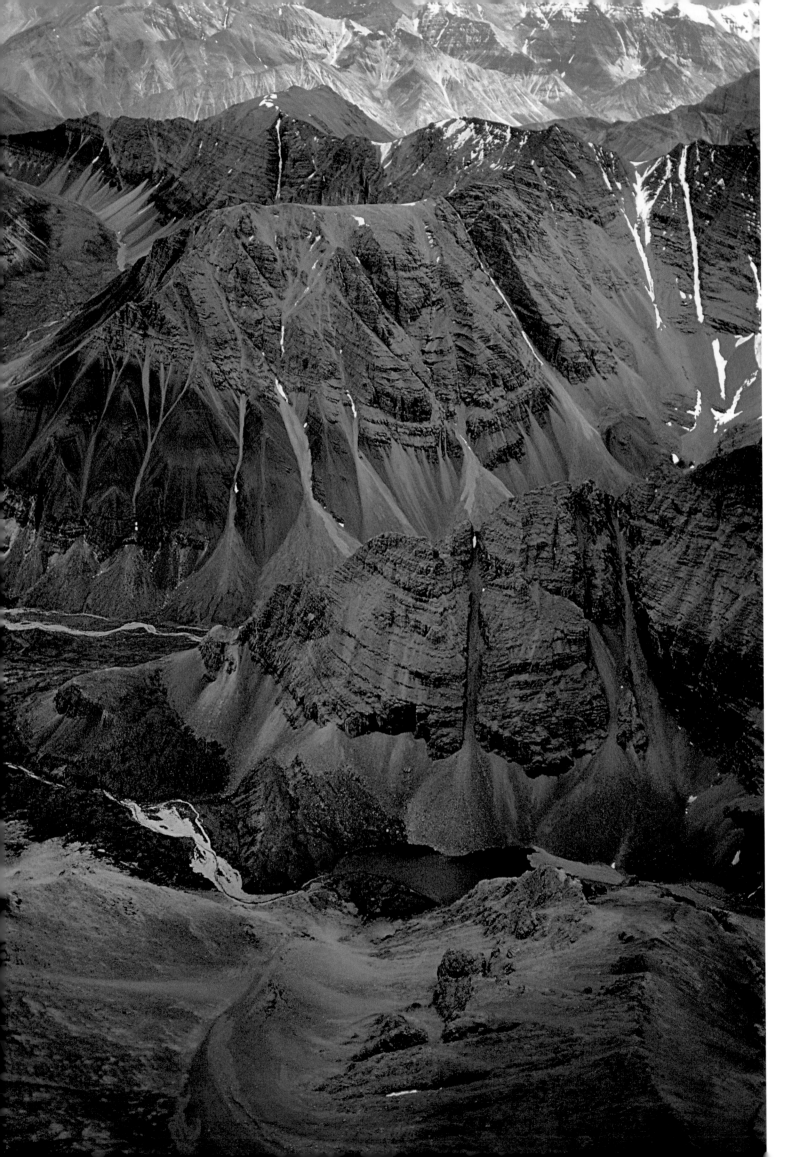

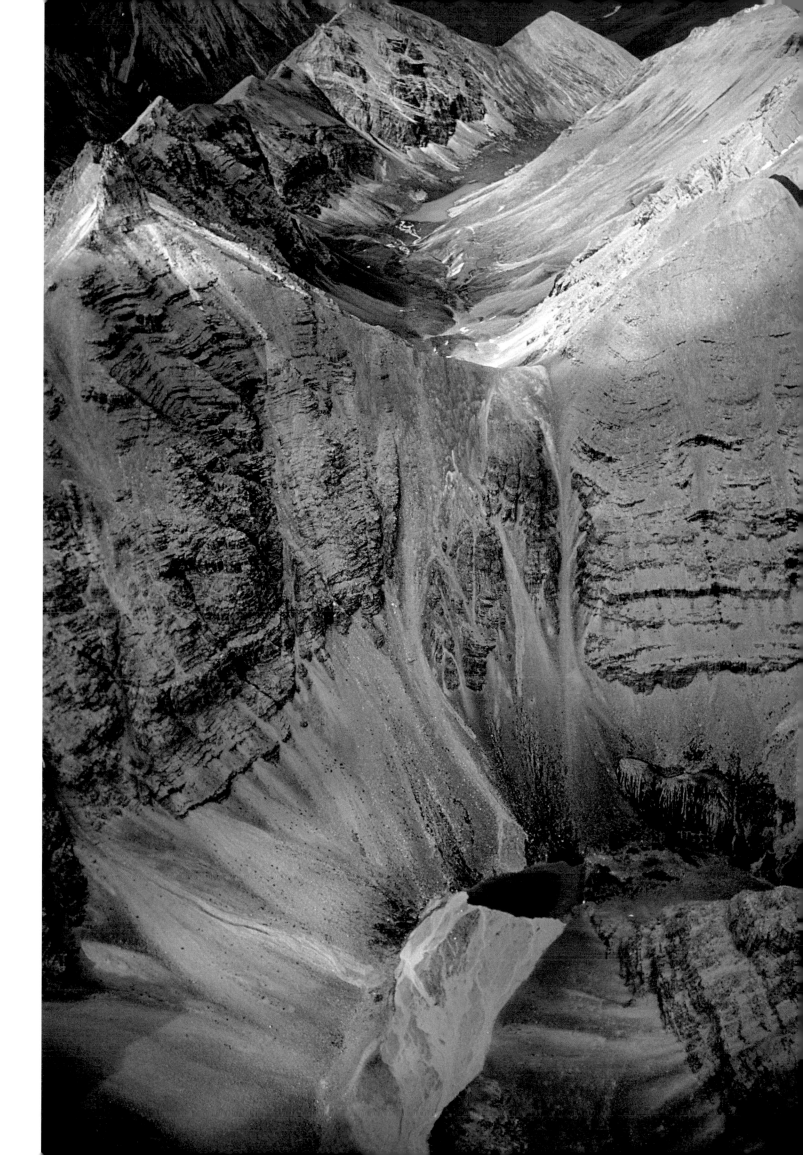

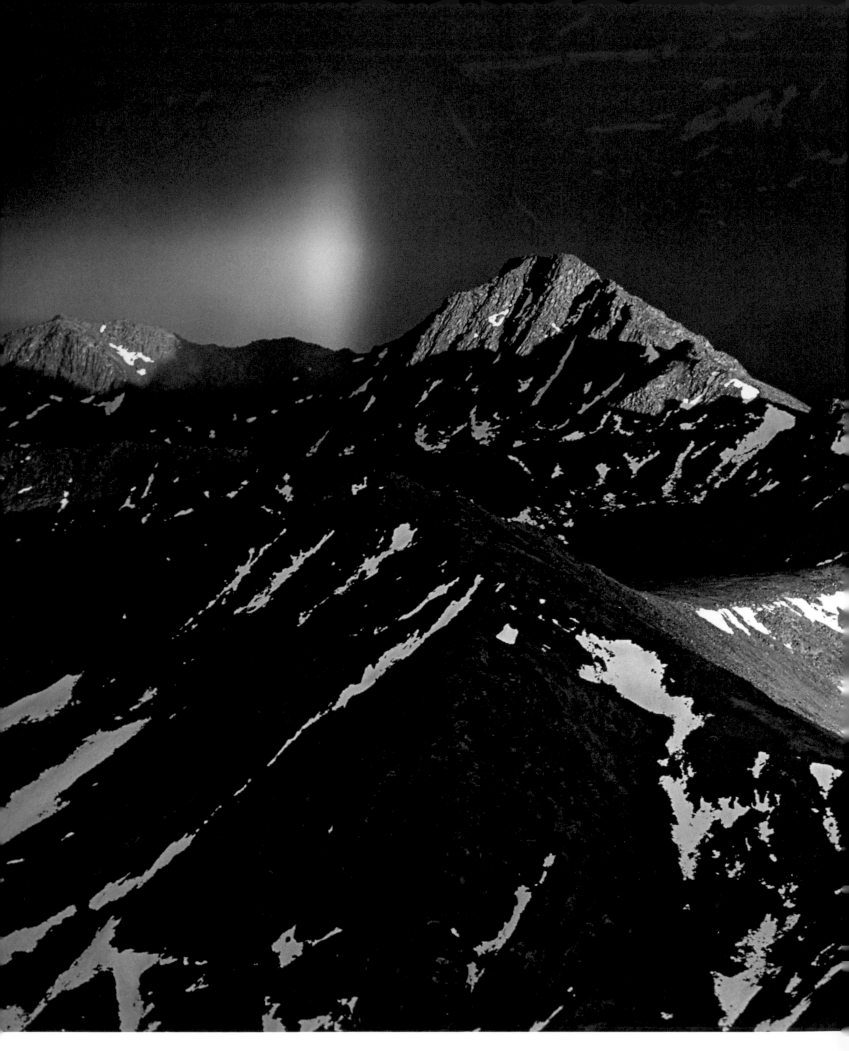

MIDNIGHT RAINBOW, Cassiar
Mountains, southern Yukon Territory.
Normally, I do not fly over mountains
at night, but after three weeks in
Alaska and having a bear visit the
night before at Glacier Creek, I was
on the move. This serendipitous
encounter came at about 11:30 p.m.,
midway between Whitehorse and
Watson Lake (June 1993).

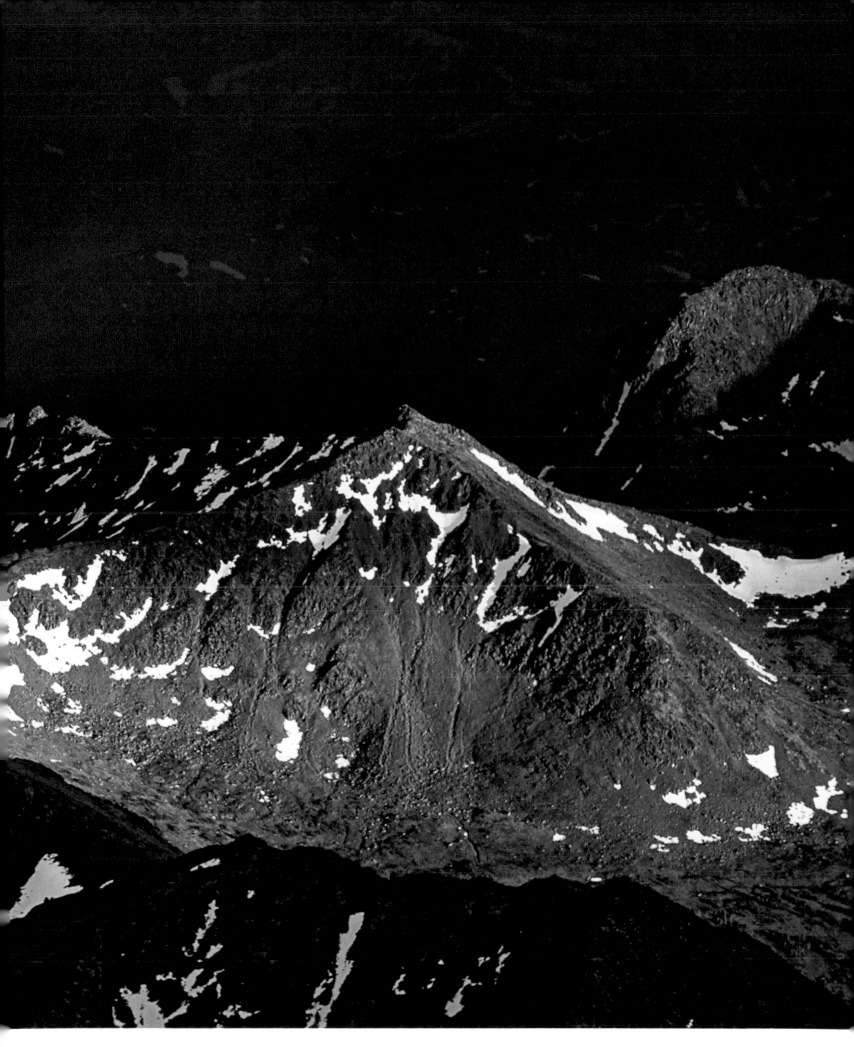

(PRECEDING PAGES) SENTINEL RANGE, near Kwadacha Wilderness Park, northern British Columbia. Left: Cirques and hanging lakes abound in the spectacular barren landscape of this small bunch of mountains, fifty miles southeast of Muncho Lake, BC. Right: These mountains top out at only 9,000 feet, but are some of the most spectacular alpine vistas in North America. The location is between Stone Mountain Park and Kwadacha Wilderness (both July 1997).

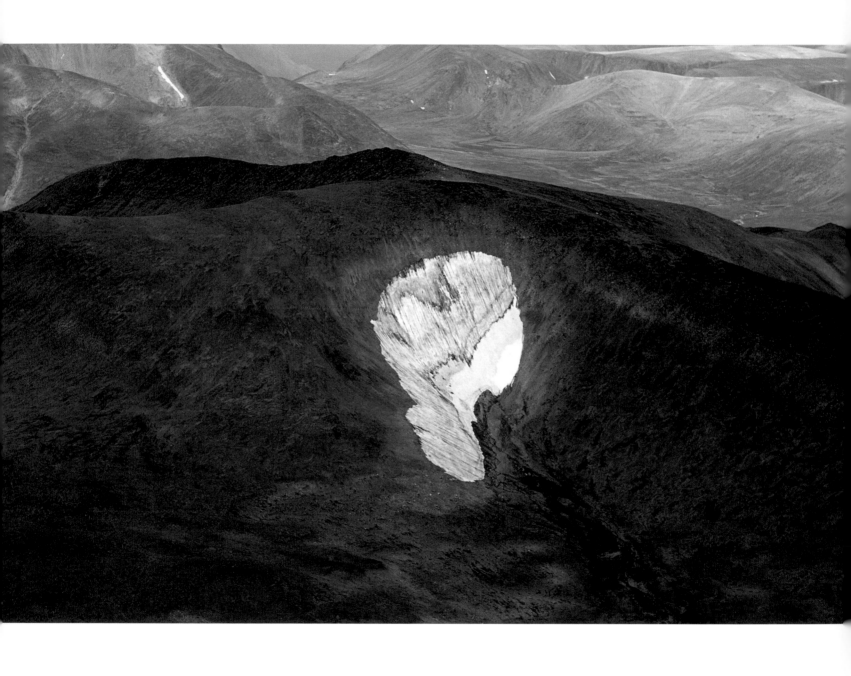

"INDIAN HEAD GLACIER," Torngat Mountains, Labrador Region, Newfoundland. My wife Judy only travels with me when I'm going to someplace exotic—like a fishing camp in Labrador's Ungava Peninsula. She insisted I take this photo of what she called "Indian Head Glacier." We were low on fuel and behind schedule, so I was hesitant to backtrack, but then a shaft of sunlight came through the high overcast and illuminated this wonderful scene (August 1998).

SAGLEK FJORD, Ungava Peninsula, Labrador Region, Newfoundland. A steep walled fjord exposes complex folding in the Torngat Mountains on the Atlantic coast (August 1998).

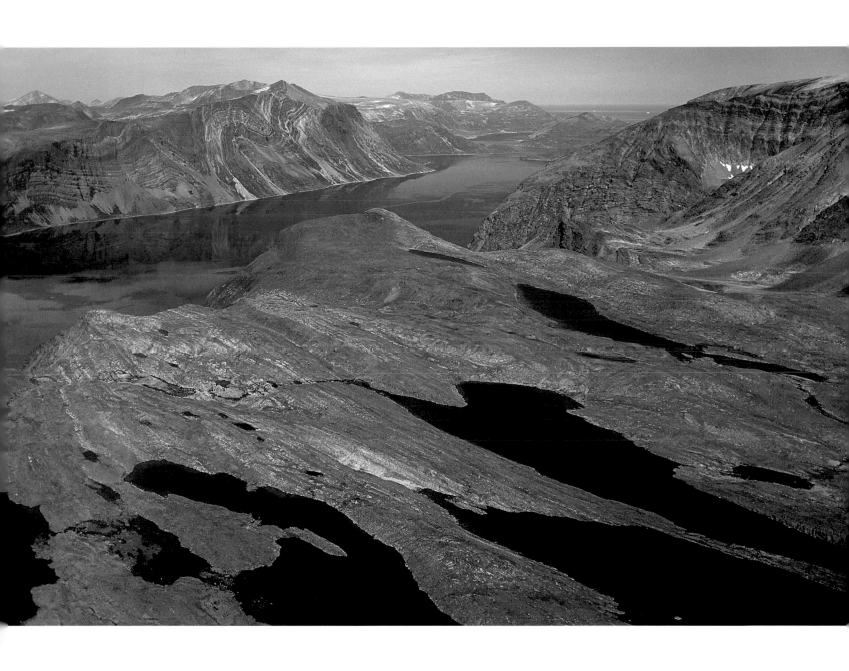

(FOLLOWING PAGES) MAUNA KEA, Hawaii February day. The lush green of the 121
Volcanoes National Park, Big Island, coastline is visible in the distance
Hawaii. More than a foot of new snow (February 2004).
blanketed the mountain on this late

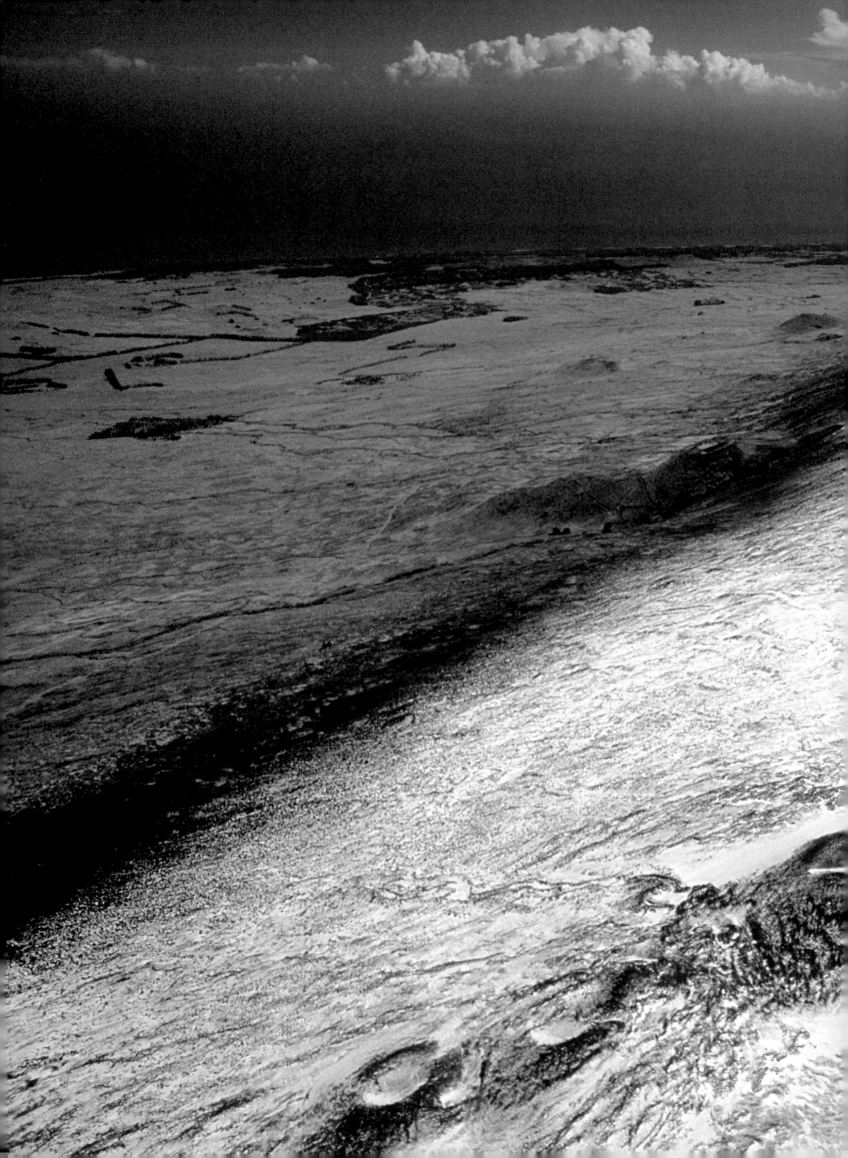

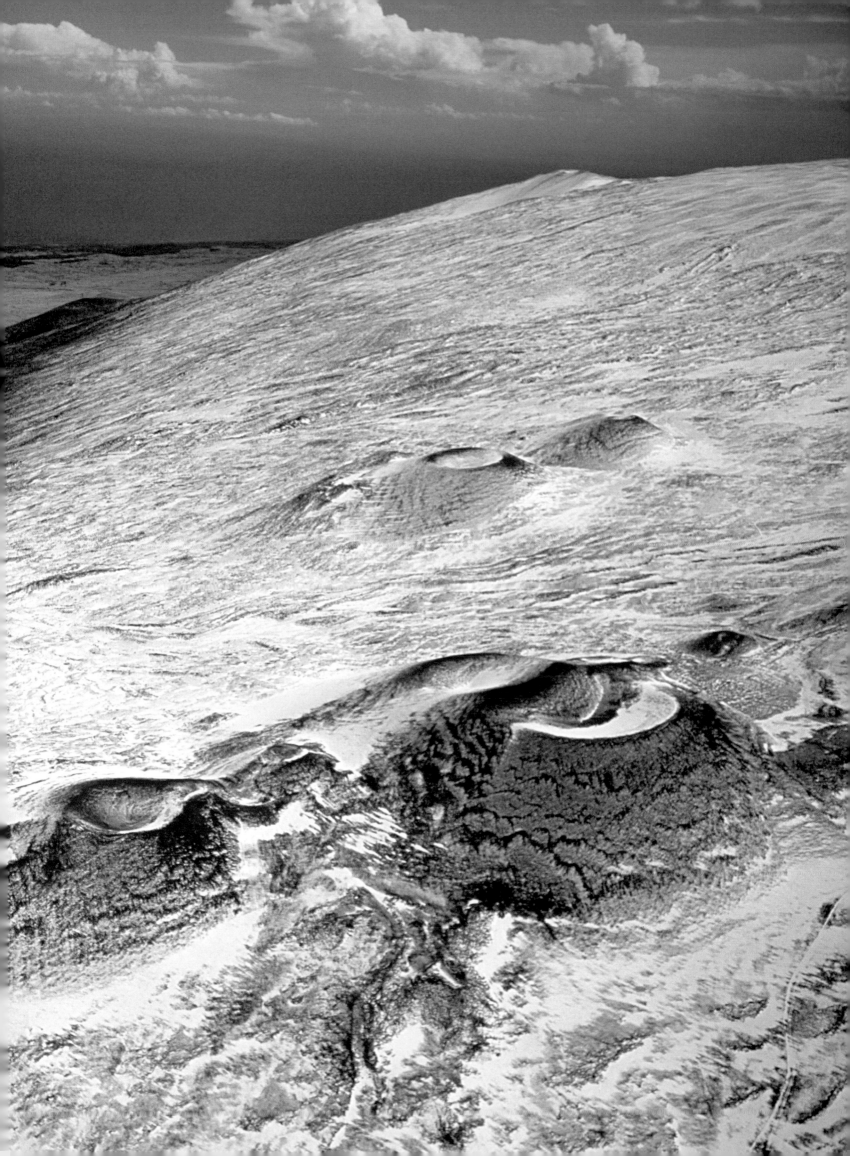

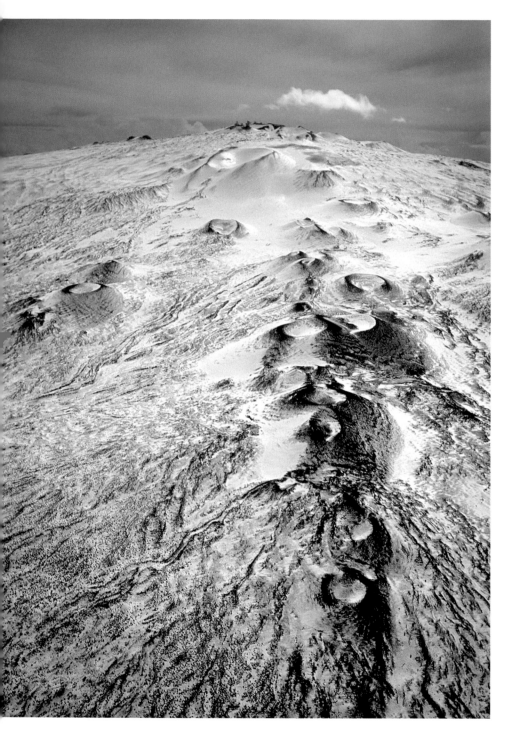
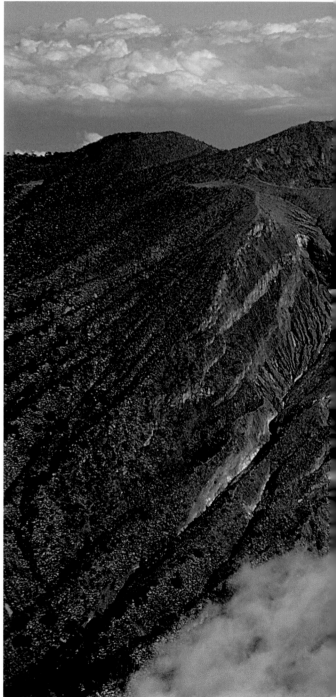

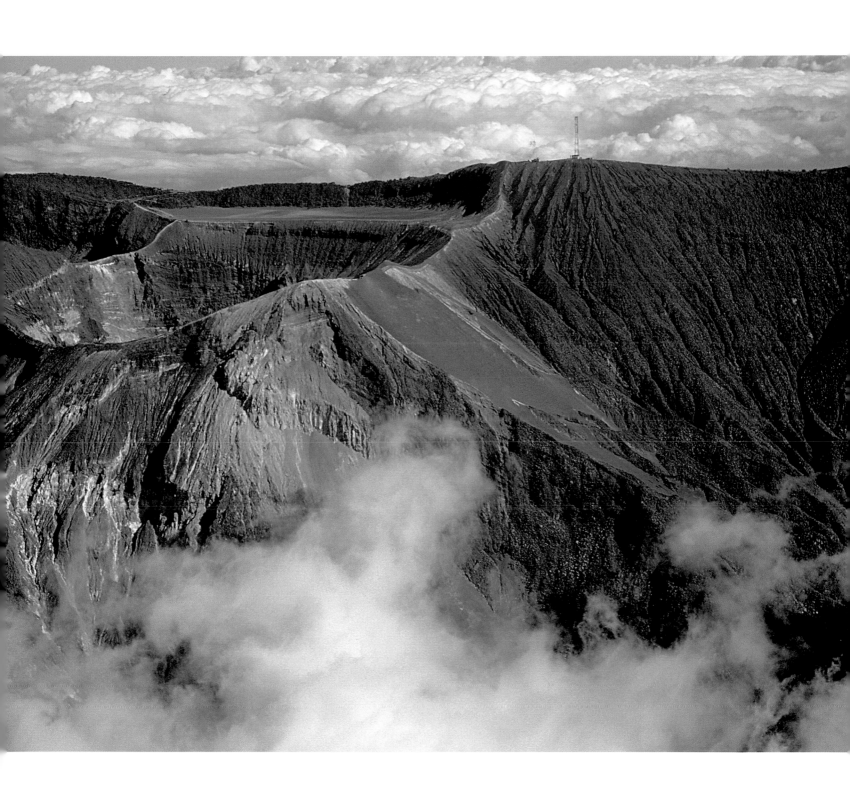

MAUNA KEA SUMMIT, Hawaii Volcanoes National Park, Big Island, Hawaii. A chain of small volcanic craters leads to the top of the 13,796-foot summit. Mauna Loa is dimly visible in the distance.

This is a shield volcano, estimated at about 400,000 years old. The last summit eruption is thought to have occurred about 2460 BC (February 2004).

IRAZÚ VOLCANO, Parque Nacional Volcán Irazú, Provence of Heredia, Cordillera Central, Costa Rica (April 1991). Irazú is the largest and most active volcano in Costa Rica.

At an elevation of 11,440 feet, its most recent major eruption was in 1961.

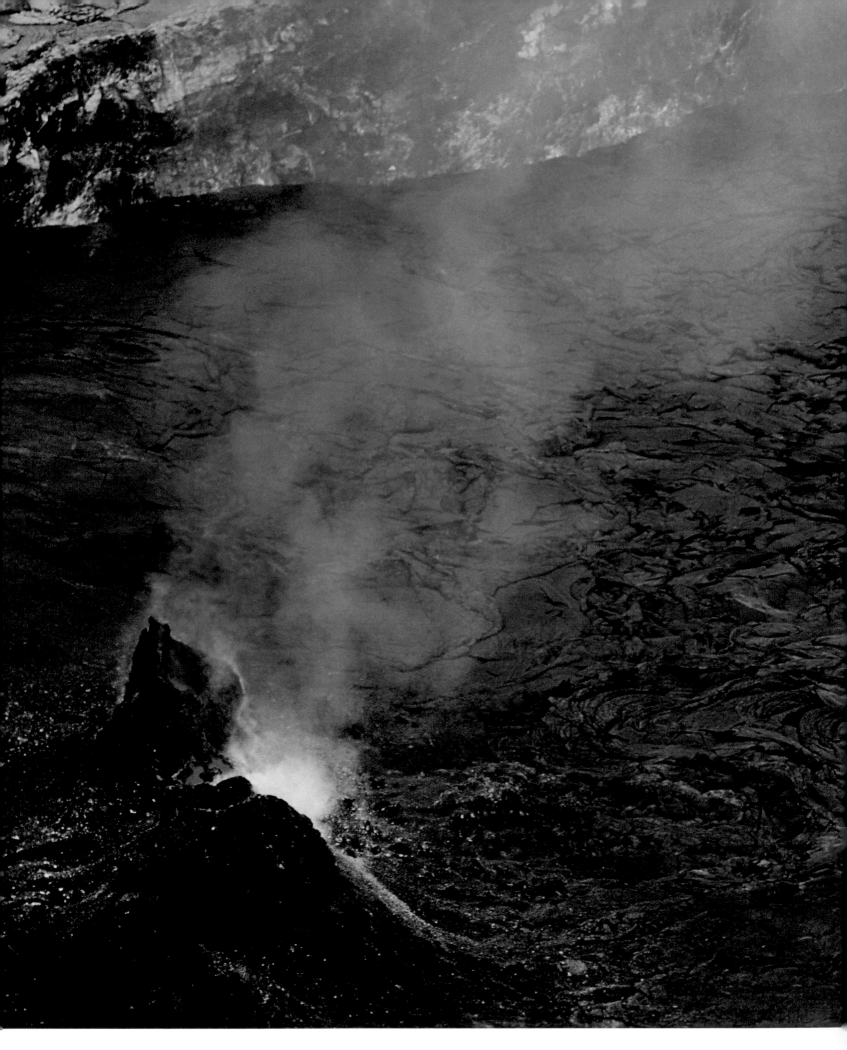

PU'U O'O CRATER, Big Island, Hawaii. These vents are part of the large Kilauea Crater system. Since the vents opened in a rainforest between 1983 and 2007, forty-five square miles of lava up to 115 feet thick have covered the slopes. Hundreds of homes have been lost and 544 acres have been added to the adjacent shoreline (February 2004).

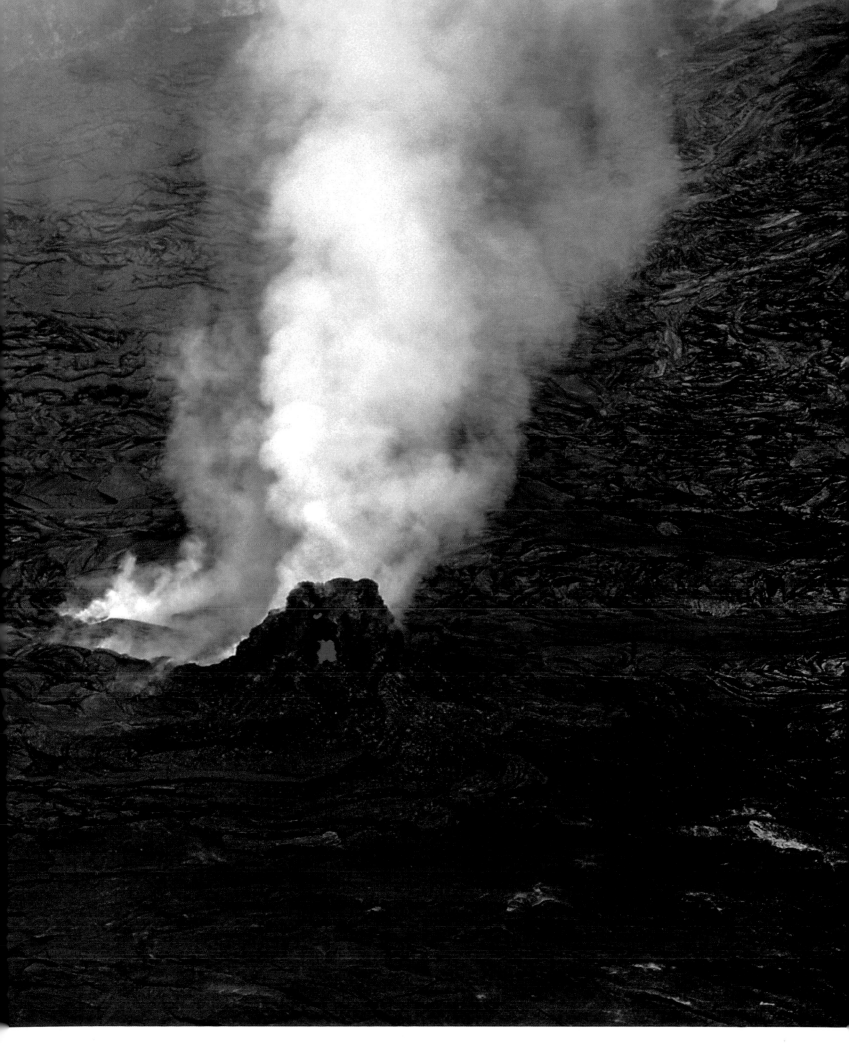

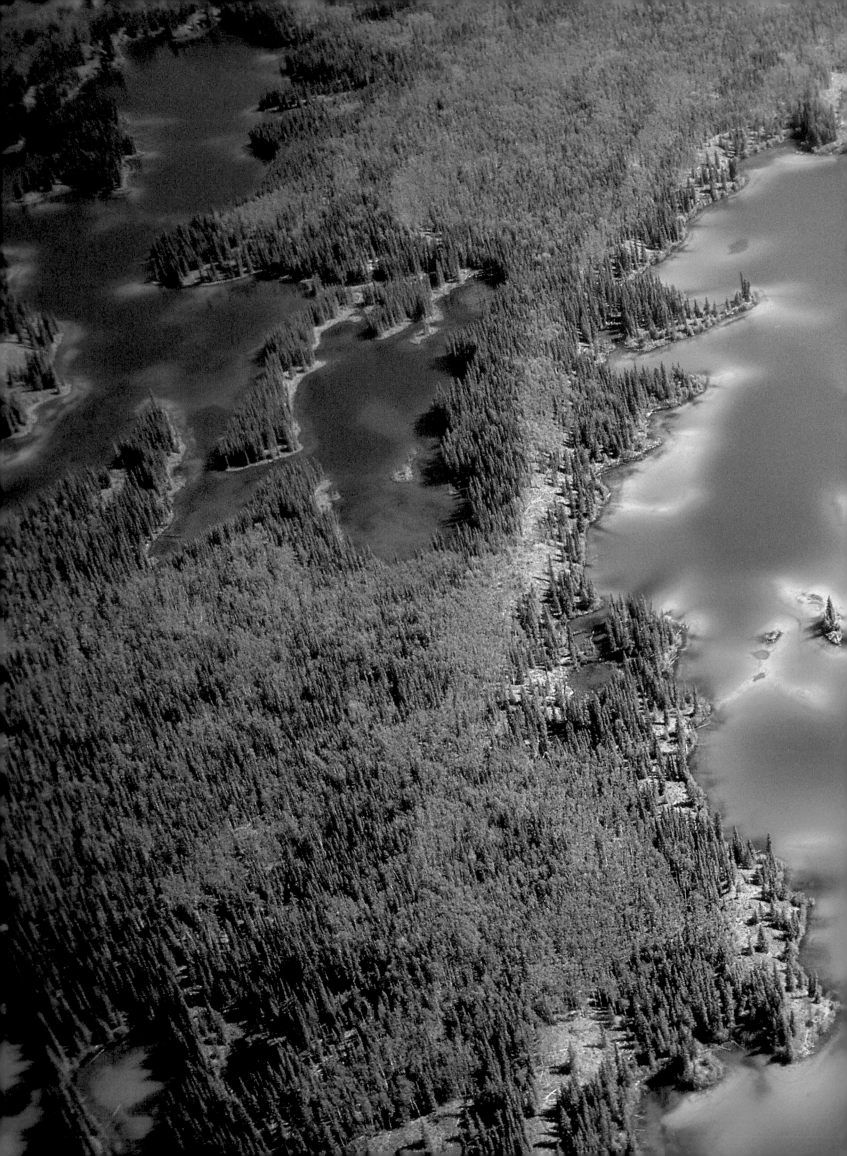

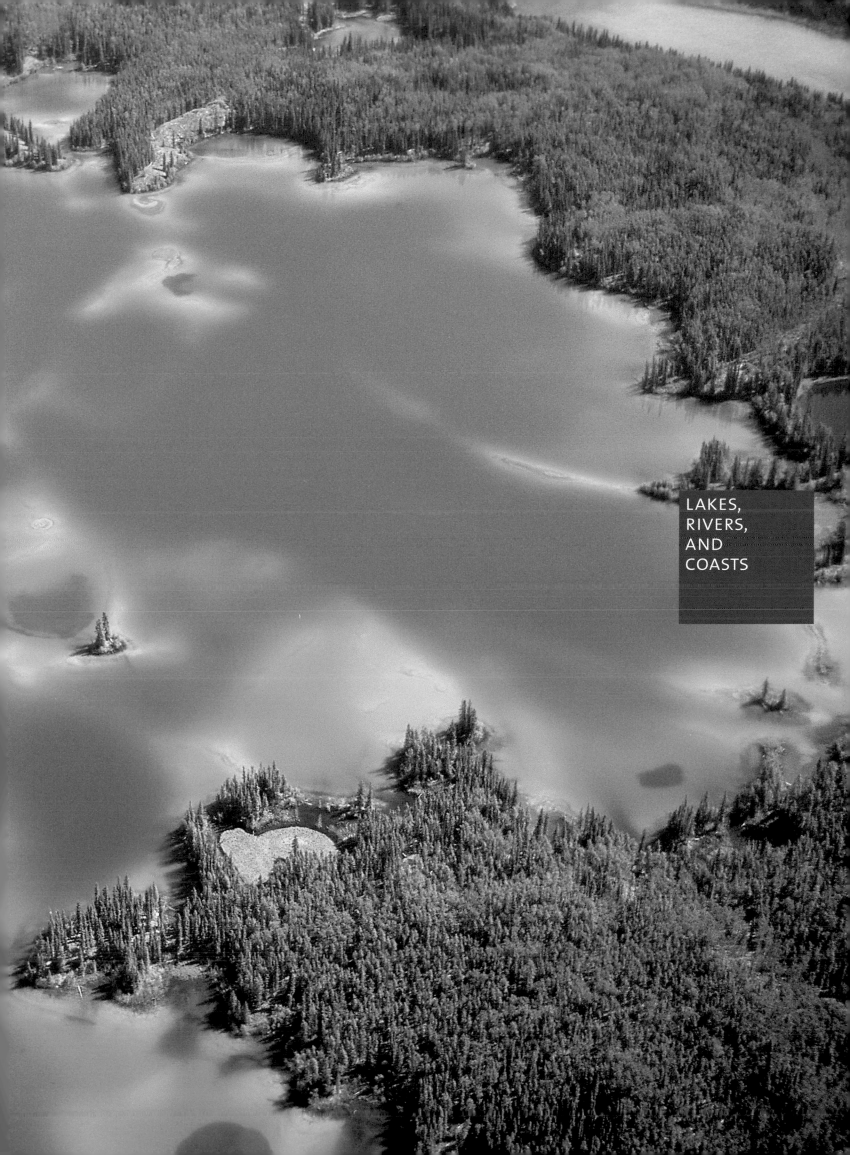

LAKES,
RIVERS,
AND
COASTS

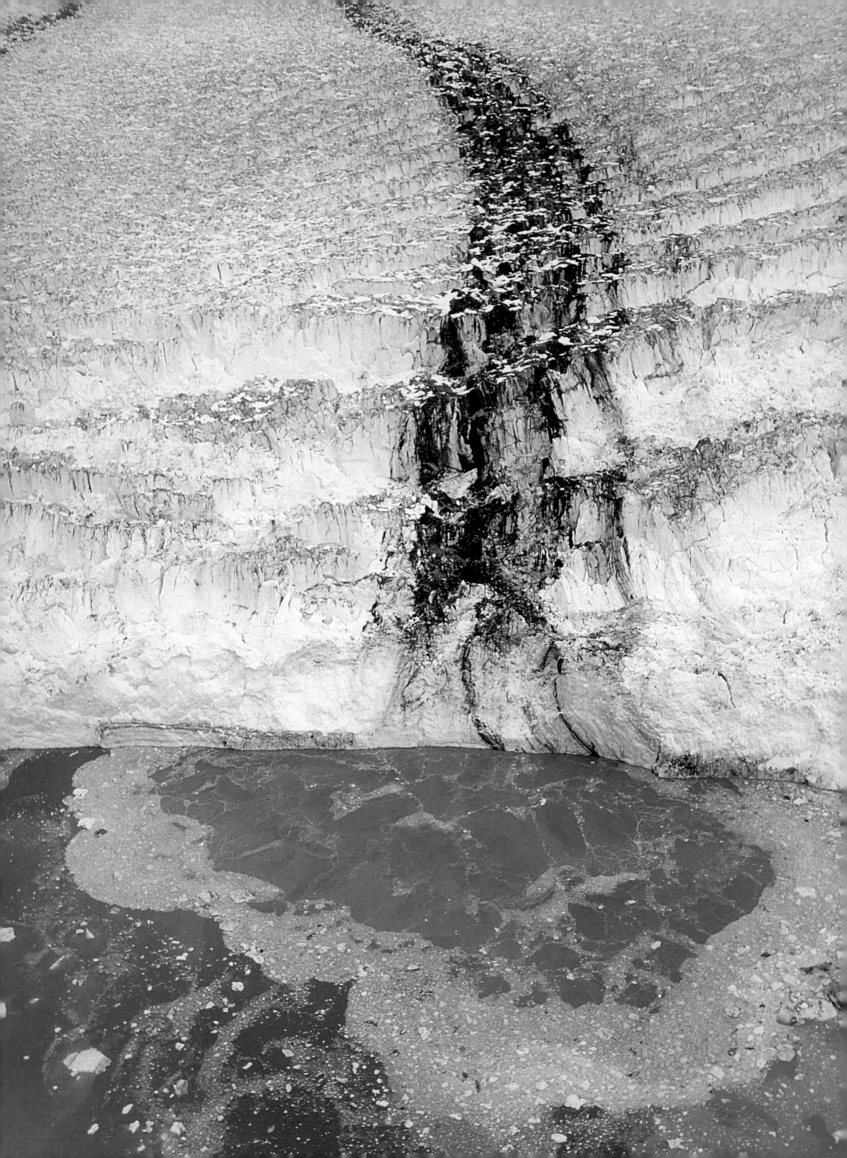

HOW WILL AMERICAN CIVILIZATION be remembered in history? No doubt we've done some regrettable things: slavery, for instance, and early Indian policy. On the other hand, we can take pride in policies like free public education and republican government. Americans can also take pride in the moon landing and in the invention of the airplane, baseball, and rock-and-roll music! To this list we should add laws creating national parks and, later, designated wilderness. These are contributions to civilization and, arguably, among the best ideas our country ever had.

The world's first national park was established in 1872 in northwestern Wyoming. Initially valued for geological science, Americans gradually came to understand Yellowstone's importance as wilderness and as a tourist destination. In 1885 New York State established a "forest preserve" in the Adirondack Mountains. The act stipulated the area was to remain "as wild forest lands," and seven years later the state expanded the reservation and renamed it Adirondack State Park.

The twentieth century saw great expansion of the national park system. The inclusion of wetlands (Everglades National Park, 1947) and deserts (Canyonlands National Park, 1964) marked a maturation of understanding about ecosystems and an extension of the definition of the aesthetics of nature. Robert Marshall, who grew up climbing the Adirondacks, took his passion for wild country into the American West and Alaska. His focus was the United States Forest Service, which had historically emphasized utilitarian values such as lumbering. Challenged in 1930 that he was proposing too many wilderness areas, Marshall asked in return, "How many Brahms symphonies do we need?"

In the middle of the century the rising tide of big-dam reclamation in the West almost derailed the national park and wilderness movements. One ominous precedent was the 1913 authorization of a dam in Yosemite National Park on the Tuolumne River in Hetch Hetchy Valley. A nationwide controversy and an aging John Muir's heroic efforts could not overcome the argument that San Francisco needed a supply of water in the aftermath of the devastating 1906 earthquake. But the loss in Yosemite proved to be a tipping point in favor of the park concept. The National Park Service was established in 1916 and park defenders vowed to never cave in to development again. A test case arose in the 1950s involving a dam proposed for Utah's Green River at Echo Park in Dinosaur National Monument. Its defeat in 1956 encouraged preservationists to press for a nationwide protection policy for wilderness. Eight years of effort led by Howard Zahniser of the Wilderness Society and David Brower of the Sierra Club led to passage in 1964 of the National Wilderness Preservation Act. It created an open-ended system of designated public land that would be kept "untrammeled" forever. A "trammel," Zahniser explained, was a hobble or halter to break the will of wild animals. He clearly knew his etymology!

Initially small, the wilderness system has expanded to include about 2 percent of the forty-eight states. The amount of protected land rose dramatically in 1980 when President Jimmy Carter signed the Alaska National Interest Lands Conservation Act, which added 27 million acres of designated wilderness lands. This protection of part of "the last frontier" will likely remain the greatest single act of wilderness preservation in world history and a lasting source of American pride.

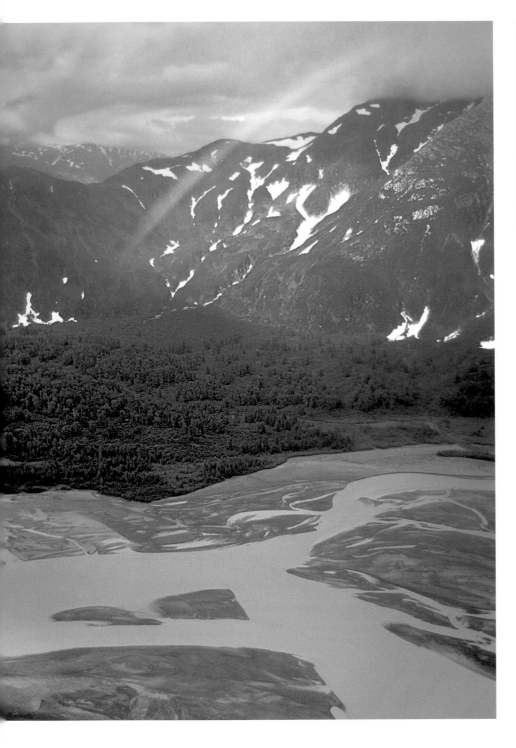
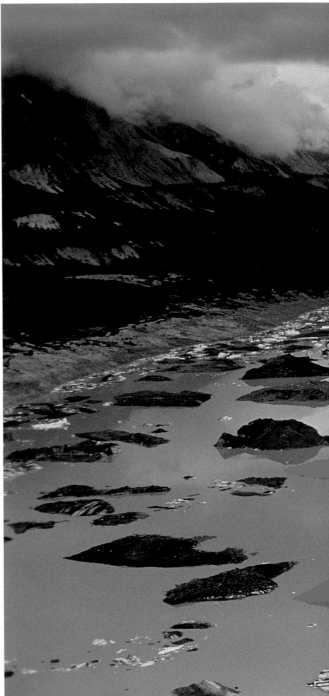

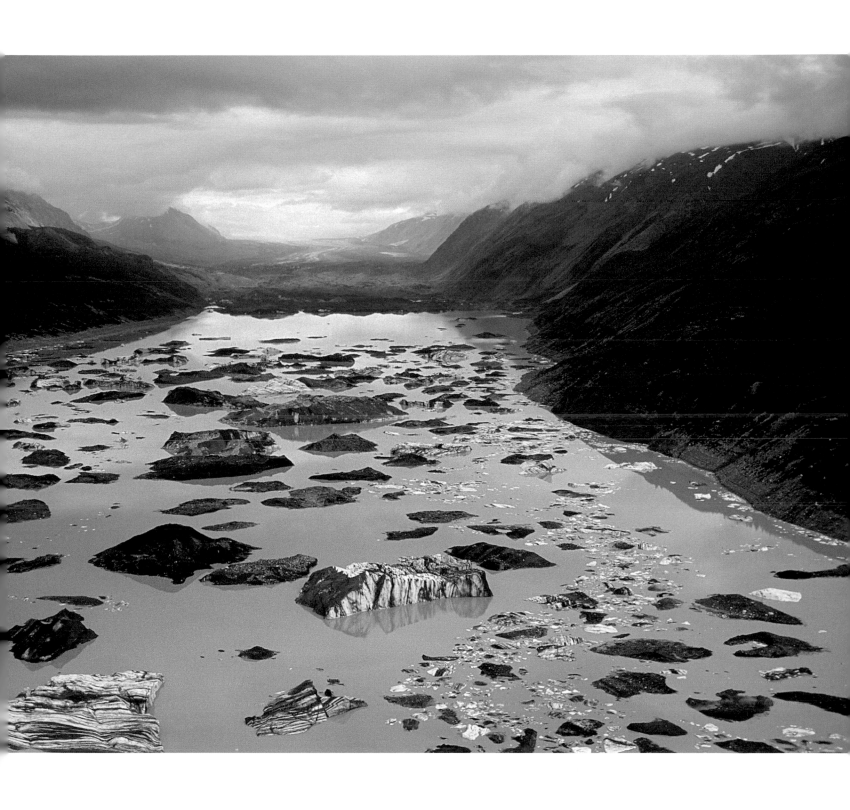

(OPPOSITE) ALSEK RIVER, Glacier Bay National Park and Wilderness, Alaska. The Alsek River flows out of the Alsek Mountains in British Columbia, then through the Saint Elias Mountains and into the Gulf of Alaska (July 1991).

(ABOVE) ALSEK RIVER, Glacier Bay National Park and Wilderness, Alaska (July 1991).

(PRECEDING PAGE) CALVING GLACIER, Hubbard Glacier into Disenchantment Bay, Wrangell-Saint Elias National Park, Alaska (June 1993).

(CHAPTER OPENER) UN-NAMED LAKE, fifteen miles south of Watson Lake, Yukon Territory (July 1991).

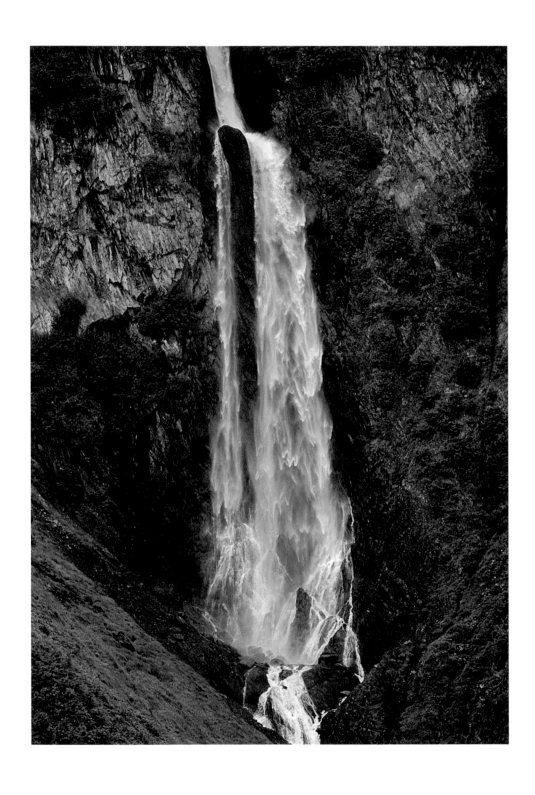

WATERFALL, Chugach National Forest,
Prince William Sound, Alaska (July 1991).

VIRGINIA FALLS ON THE NAHANNI RIVER,
Nahanni National Park Preserve,
Selwyn Range, Mackenzie Mountains,
Northwest Territory (July 1997).

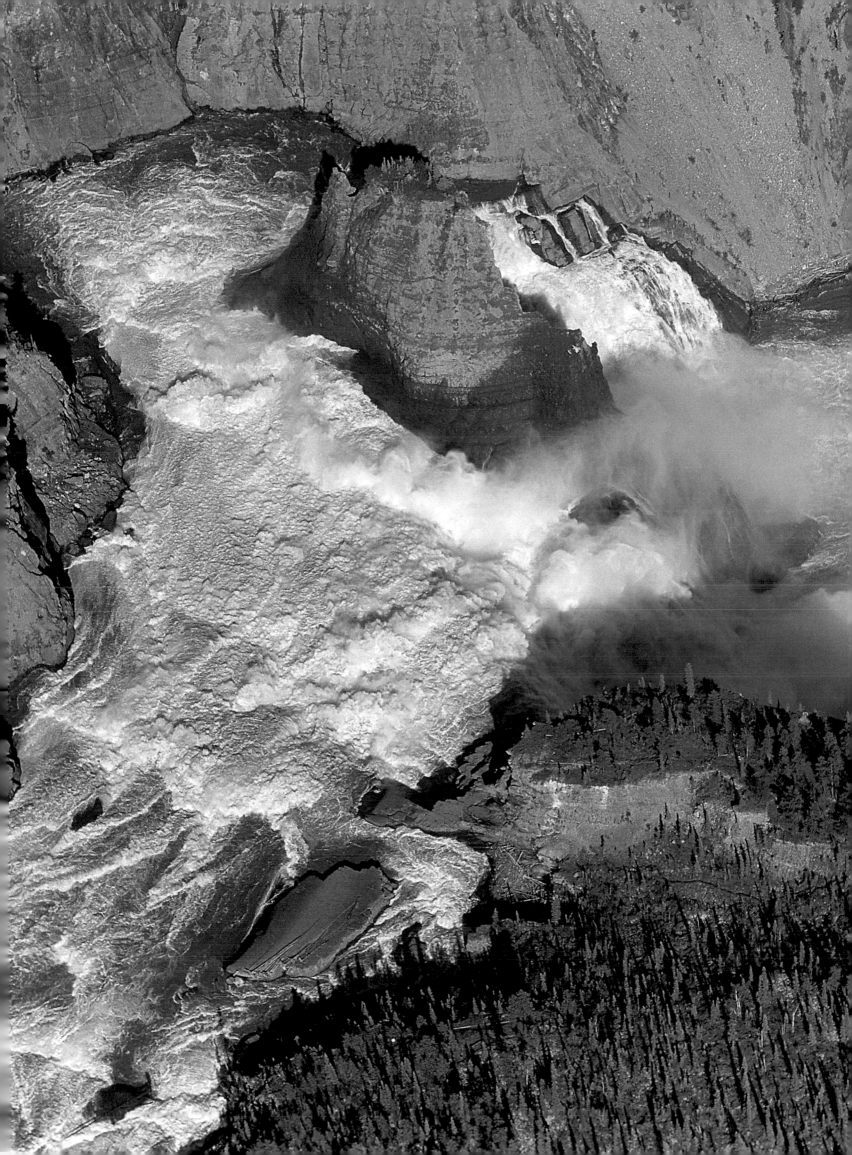

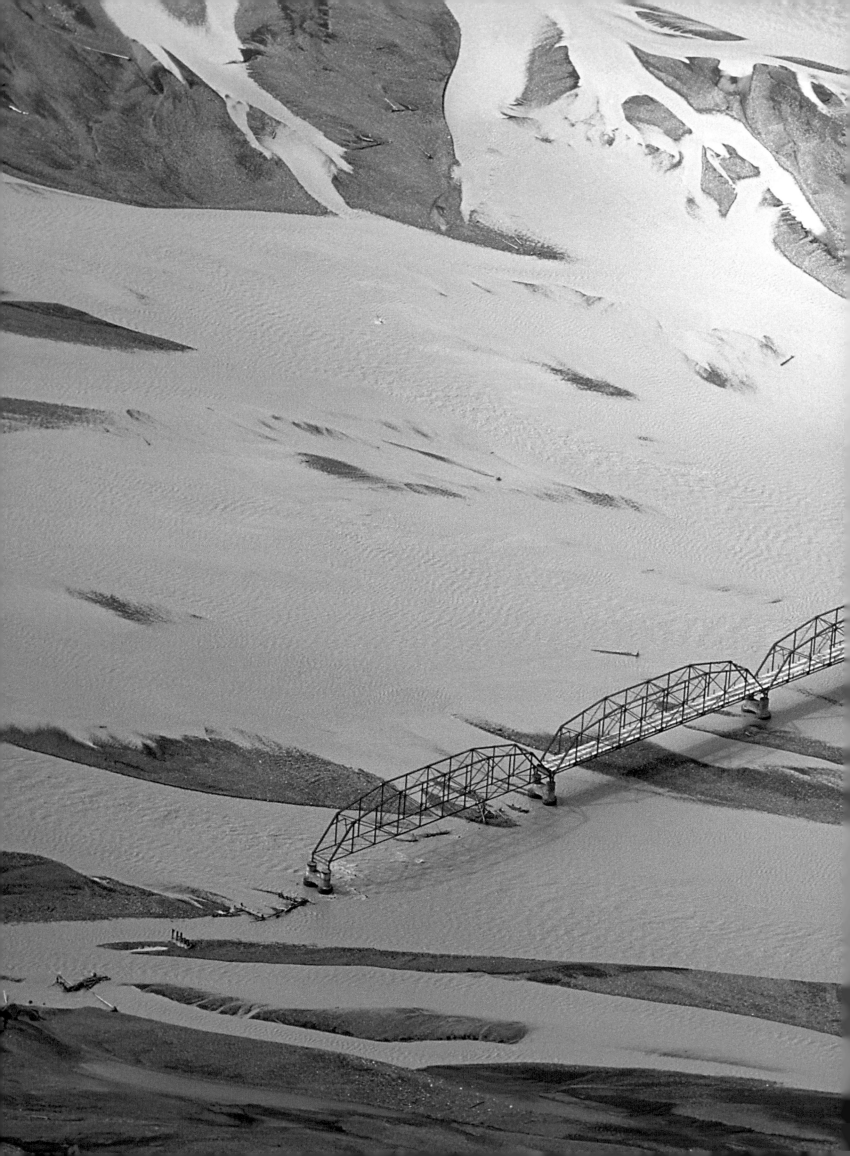

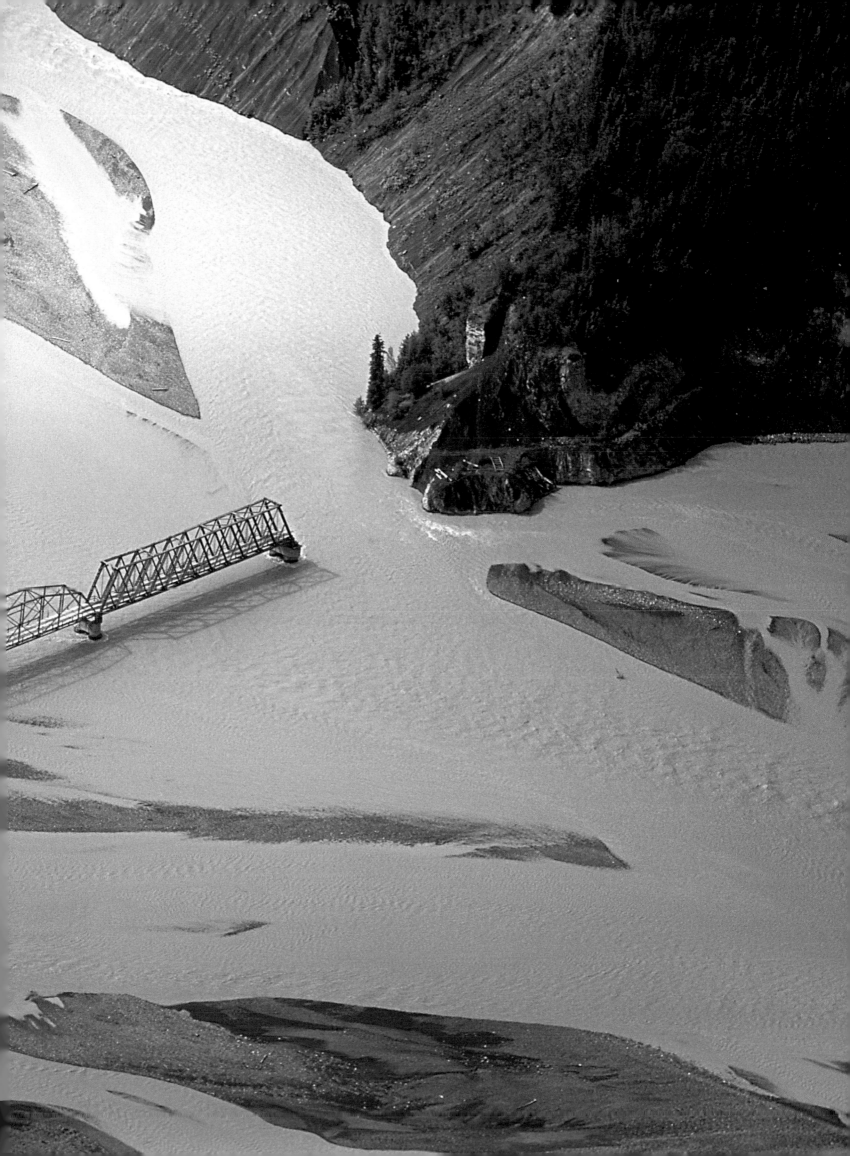

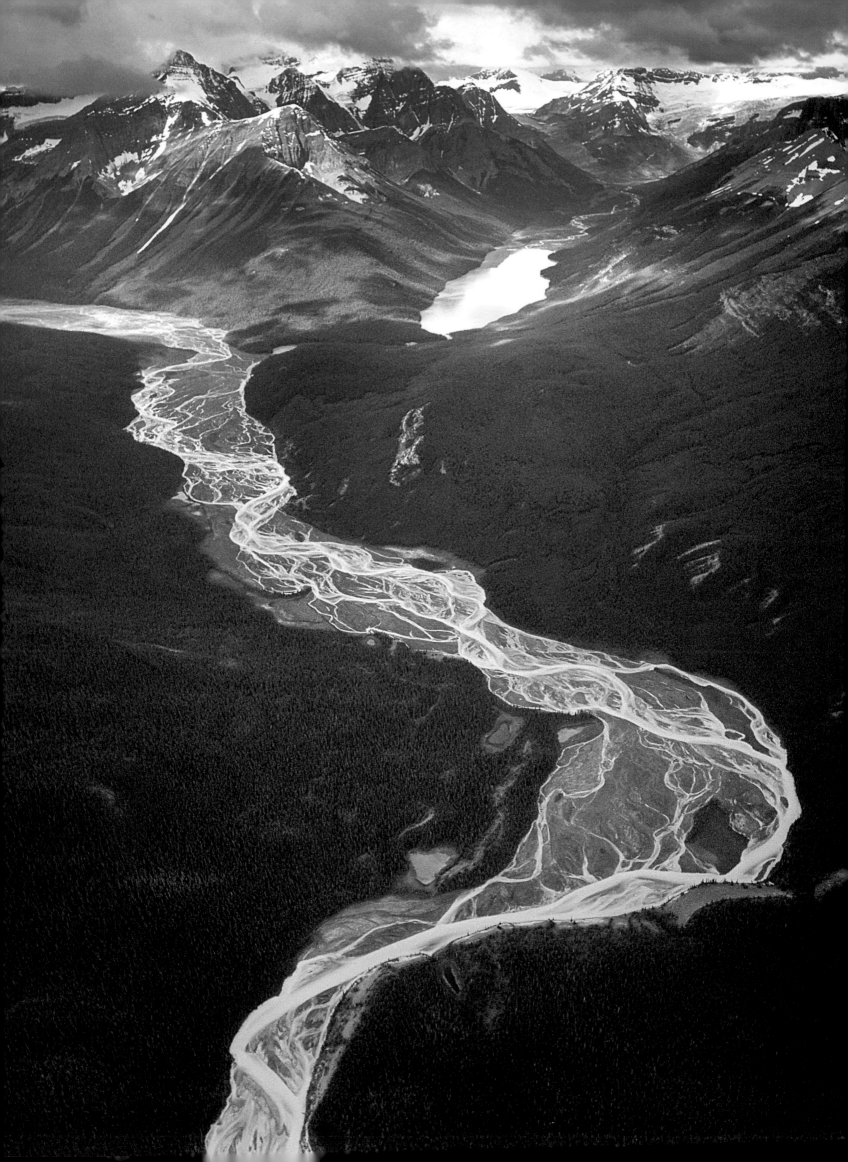

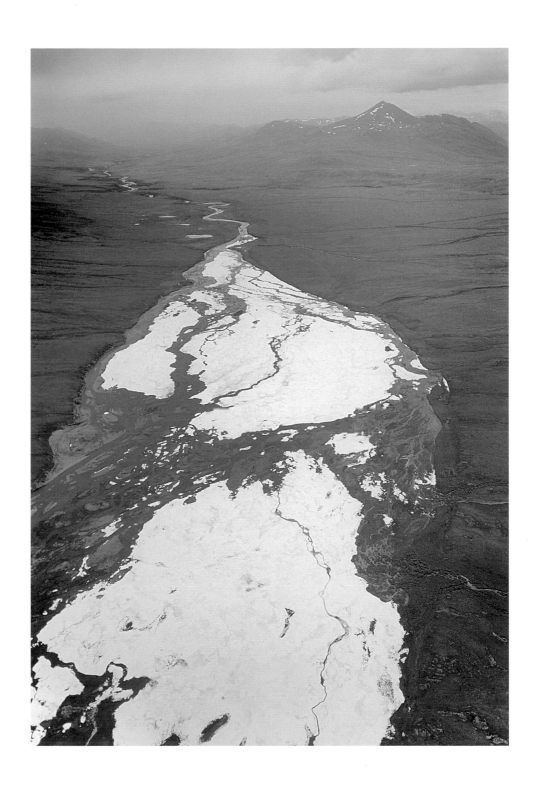

HOWSE RIVER, Banff National Park, Alberta. A short, intensely braided stream flowing into the Saskatchewan River (July 1997).

CANNING RIVER, North Slope, Alaska. This view looks toward the Philip Smith Mountains, Brooks Range. Artic National Wildlife Refuge is to the left (west) of the river (June 2003).

(PRECEDING PAGES) BRIDGE TO NOWHERE, Wrangell-Saint Elias National Park, Alaska. This abandoned railroad bridge on the Copper River near McCarthy once served the Kennicott copper mines, which closed in 1938 (June 1992).

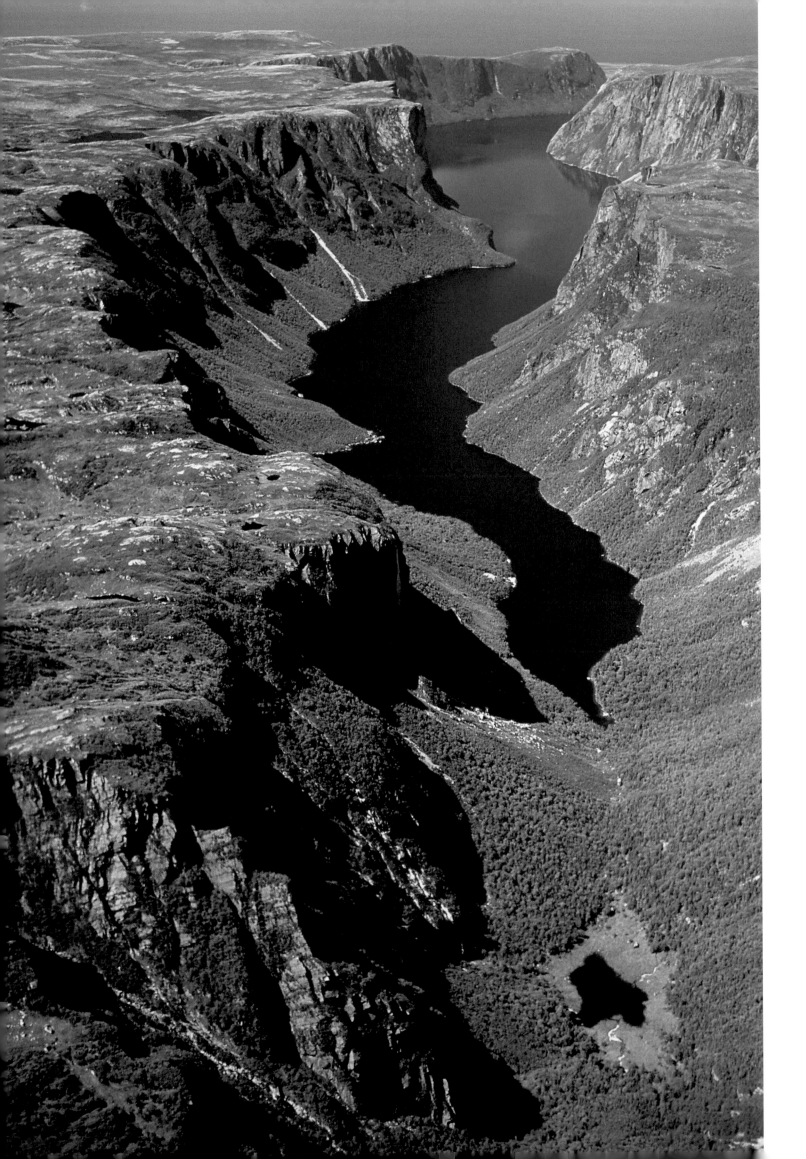

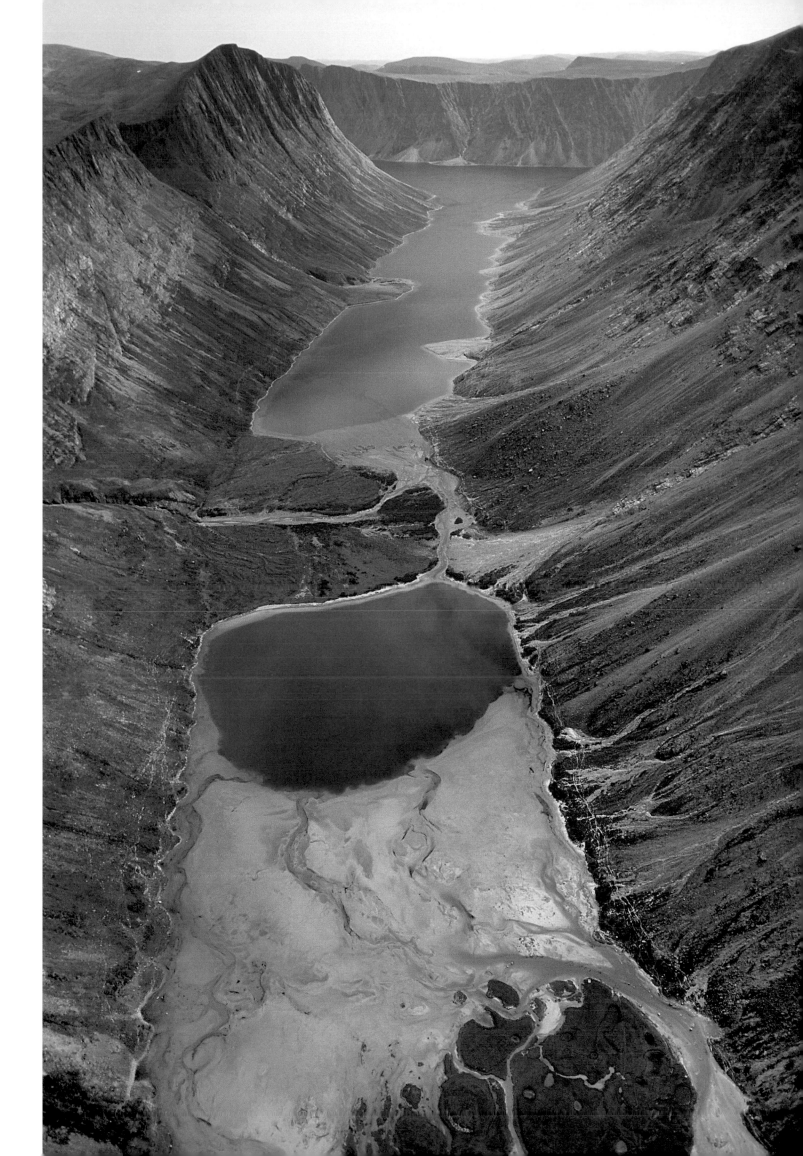

ICEBERG, Labrador Sea, Atlantic Ocean, east of Saglek Fjord, Labrador region, Newfoundland (August 1988).

CAPE COD SHOALS, Cape Cod National Seashore, Massachusetts. Bombsight view of airplane shadow and small craft (September 1994).

(PRECEDING PAGE, LEFT) GROS MORNE, Newfoundland Island, Newfoundland. A glacial fjord named Western Brook Pond, Gros Morne Provincial Park (August 1988).

(PRECEDING PAGE, RIGHT) GLACIAL VALLEY, Torngat Mountains, Labrador region, Newfoundland. A classic U-shaped glacial valley on the Ungava Peninsula (August 1998).

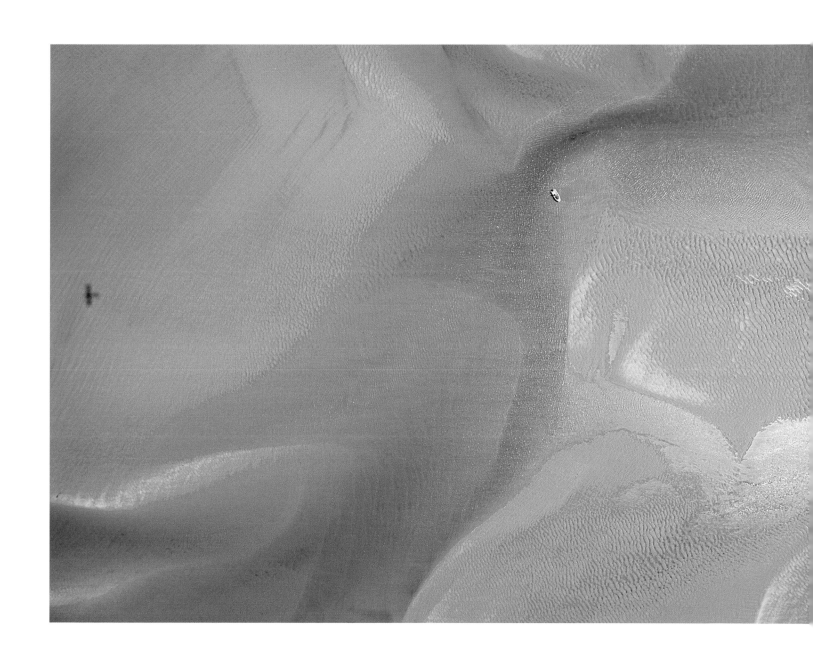

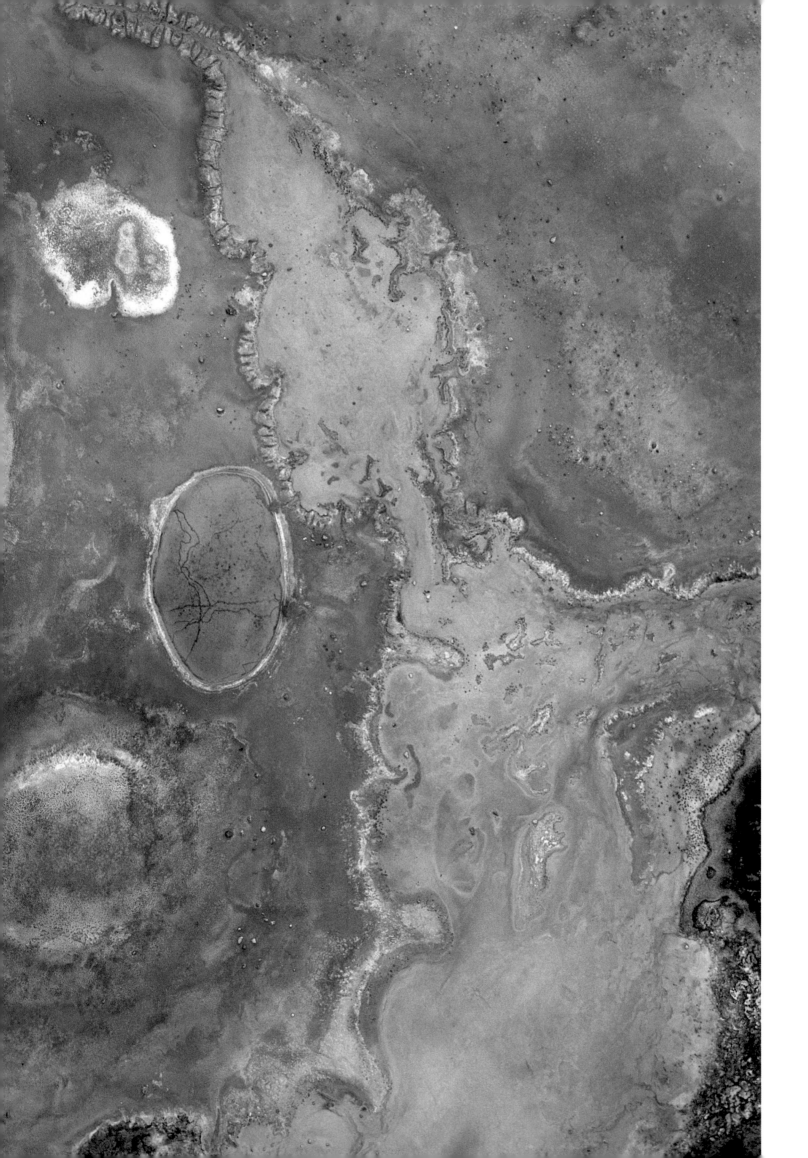

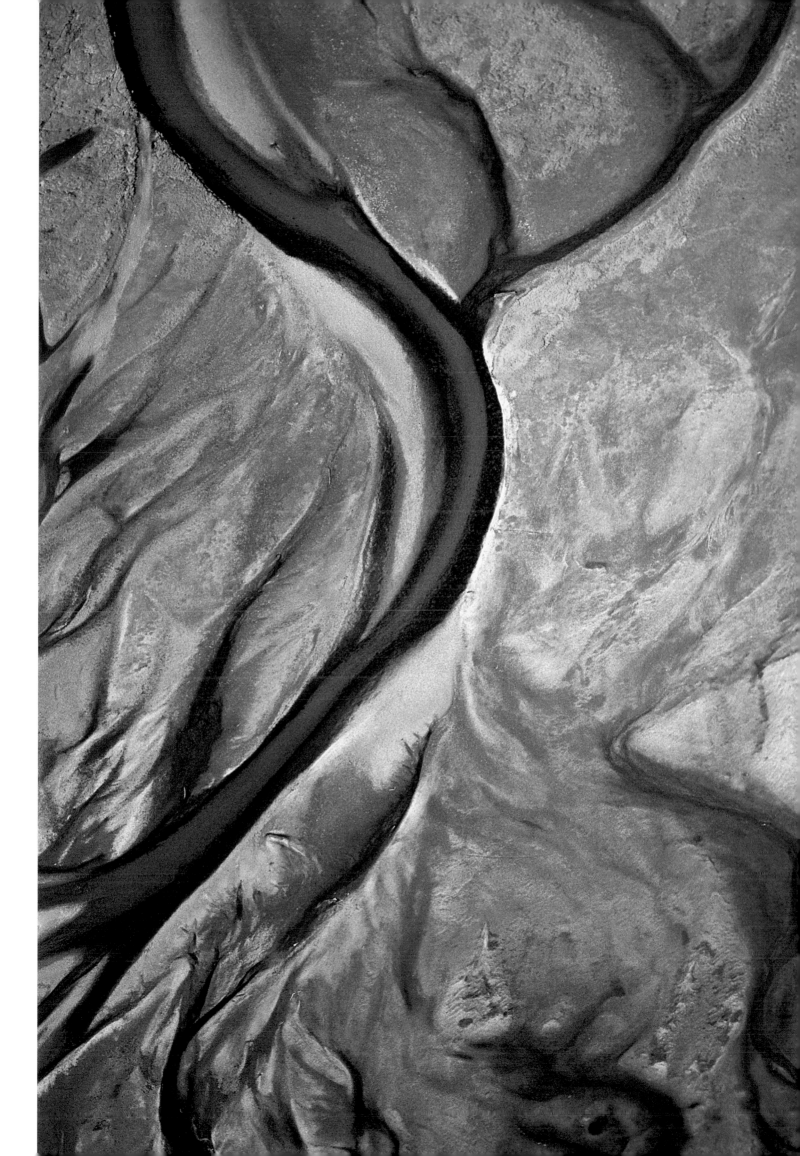

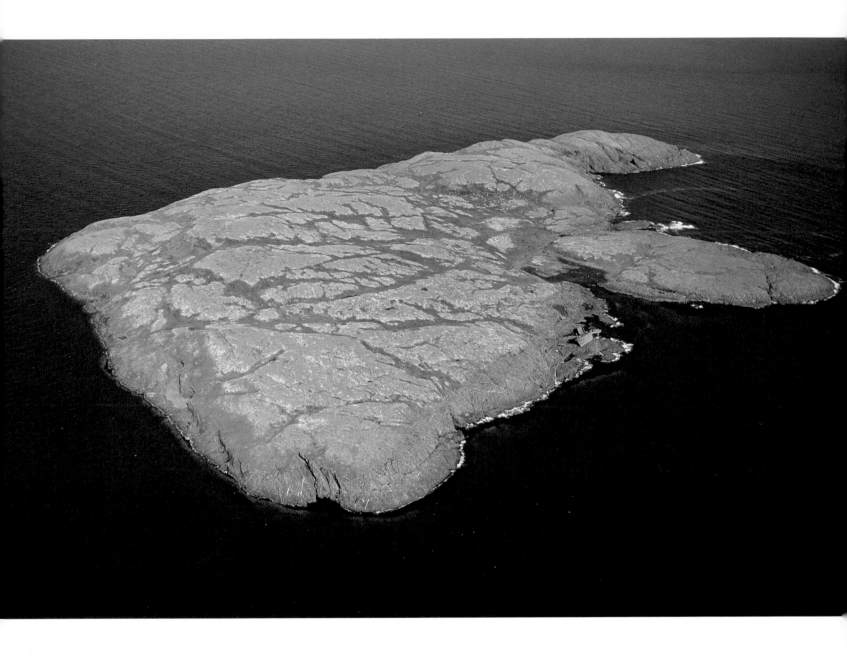

GREAT SACRED ISLAND, Gulf of St. Lawrence, Newfoundland. Shipwreck of British steamer *Langleecrag* from November 15, 1947, on Great Sacred Island off the northern tip of the island of Newfoundland. The rescue took four days and two seamen drowned (August 1998).

UNINHABITED ISLAND, Vinalhaven Civil Subdivision, Penobscot Bay, Maine. It seemed unusual that such a dense, healthy grove of trees could find root on this barren rock island (October 2000).

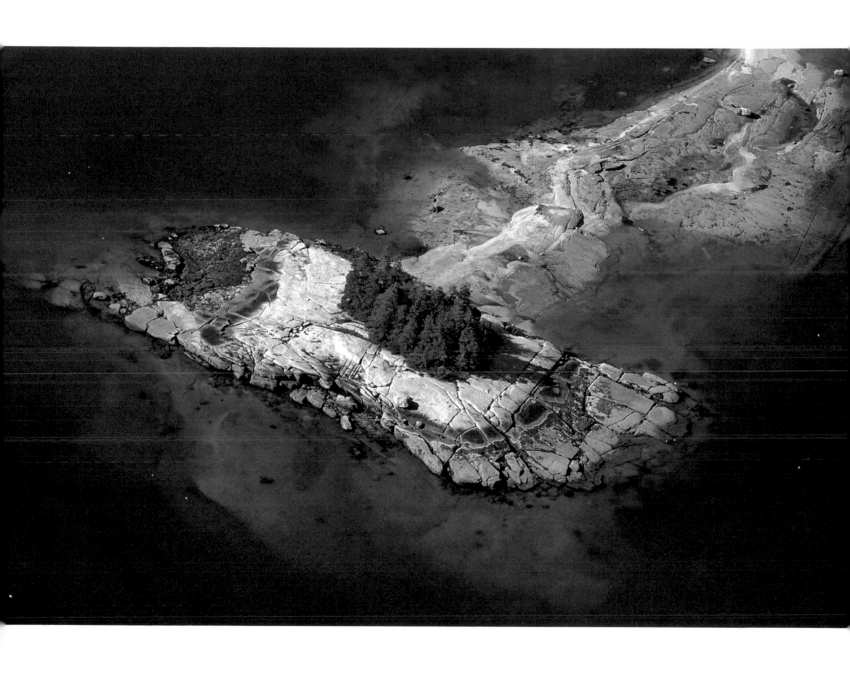

(PRECEDING PAGE, LEFT) SALT MARSH, Northern Alberta. Wood Buffalo National Park—Canada's largest national park—was created in 1922 to protect a large herd of Wood Bison.

It is also the only known nesting ground of the whooping crane (bombsight view) (June 2003).

(PRECEDING PAGE, RIGHT) TENNAKEE INLET DELTA, Chichagof Island, Alaska (bombsight view) (July 1992).

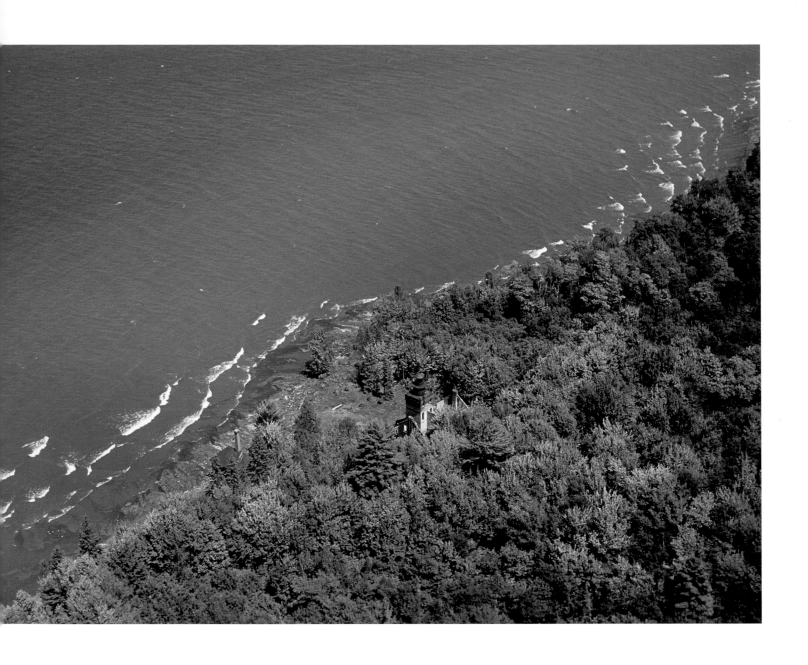

FOURTEEN MILE POINT LIGHTHOUSE, Lake Superior, Ontonagon County, Upper Peninsula, Michigan. A crumbling, but beautiful sentinel of the past. This location, north of Ontonogon, is now difficult to get to except by boat. Lit from 1894 to 1945, it is part of the Ontonagon State Forest, Ontonagon Indian Reservation (July 2007).

AU SABLE POINT, Pictured Rocks National Lakeshore, Lake Superior Shore, Alger County, Upper Peninsula, Michigan. This photo shows Twelve Mile Beach with Au Sable Point in the distance (June 1999).

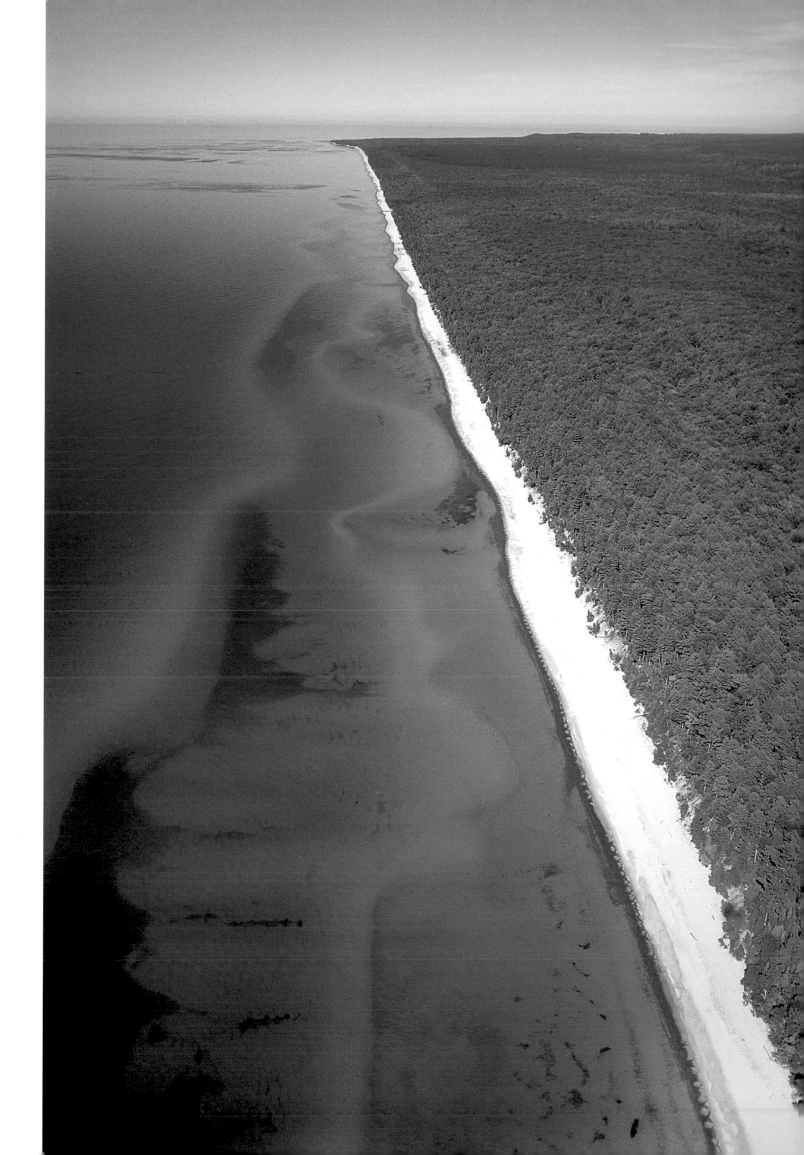

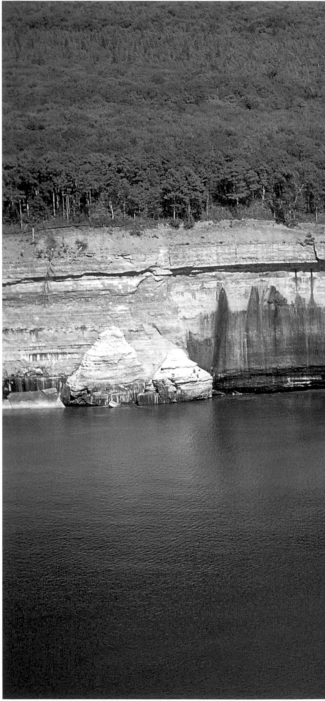

PICTURED ROCKS, Pictured Rocks National Lakeshore, Lake Superior Shore, Alger County, Upper Peninsula, Michigan. Above: Icicles cover the cliffs (March 2008).

Opposite: The national lakeshore extends for more than 40 miles (June 1999).

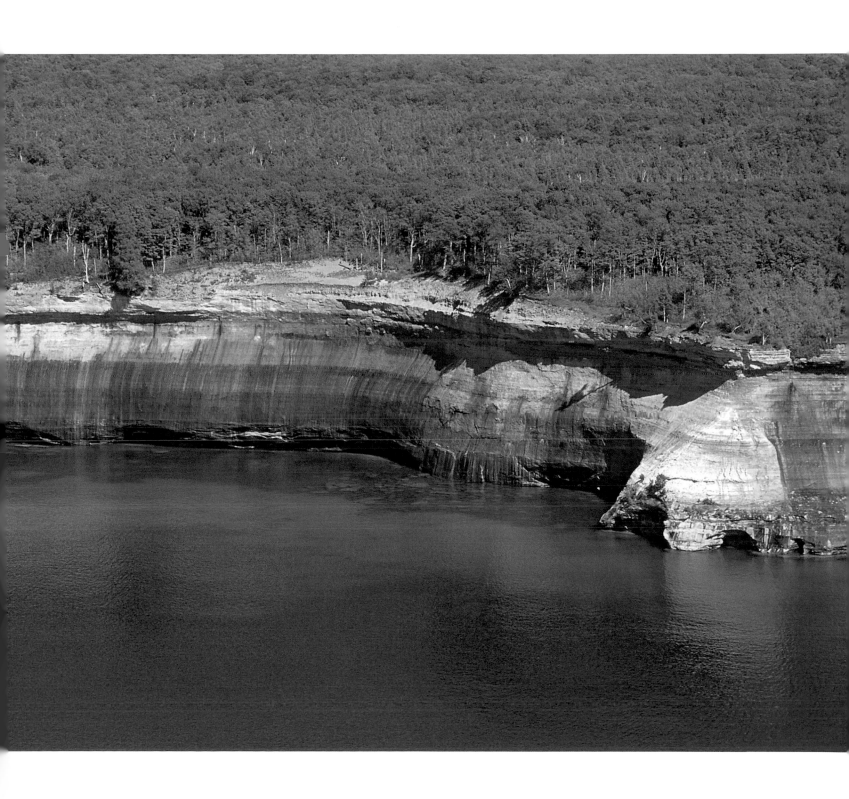

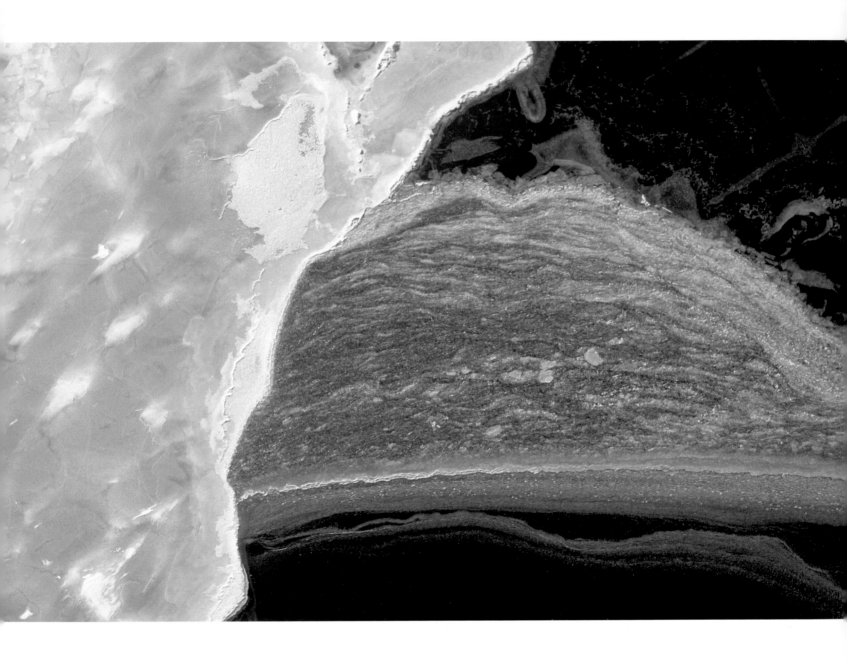

NEAR-SHORE ICE, Lake Michigan, Little Traverse Bay, Charleviox County, Michigan (bombsight view) (March 2008).

SHORE ICE, five miles north of Leelanau, Leelanau County, Lake Michigan, Michigan. Broken ice flow meets shoreline (bombsight view) (March 2008).

(FOLLOWING PAGES) GRAND SABLE DUNES AND BANKS, Pictured Rocks National Lakeshore, Lake Superior Shore, Alger County, Upper Peninsula, Michigan (March 2008).

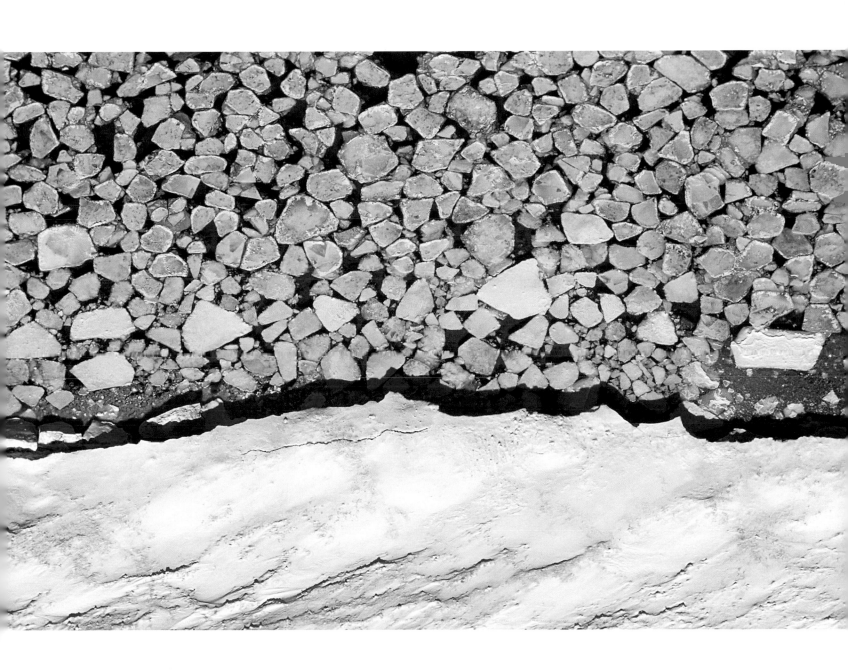

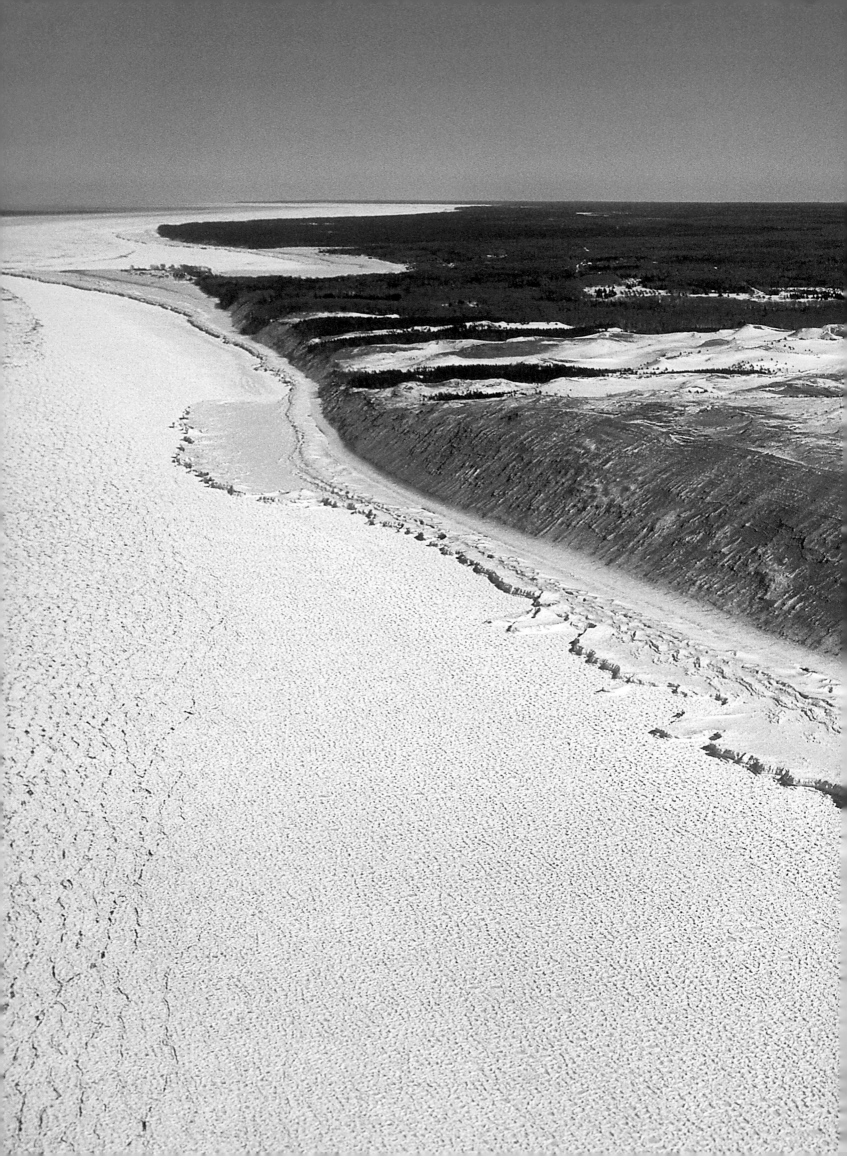

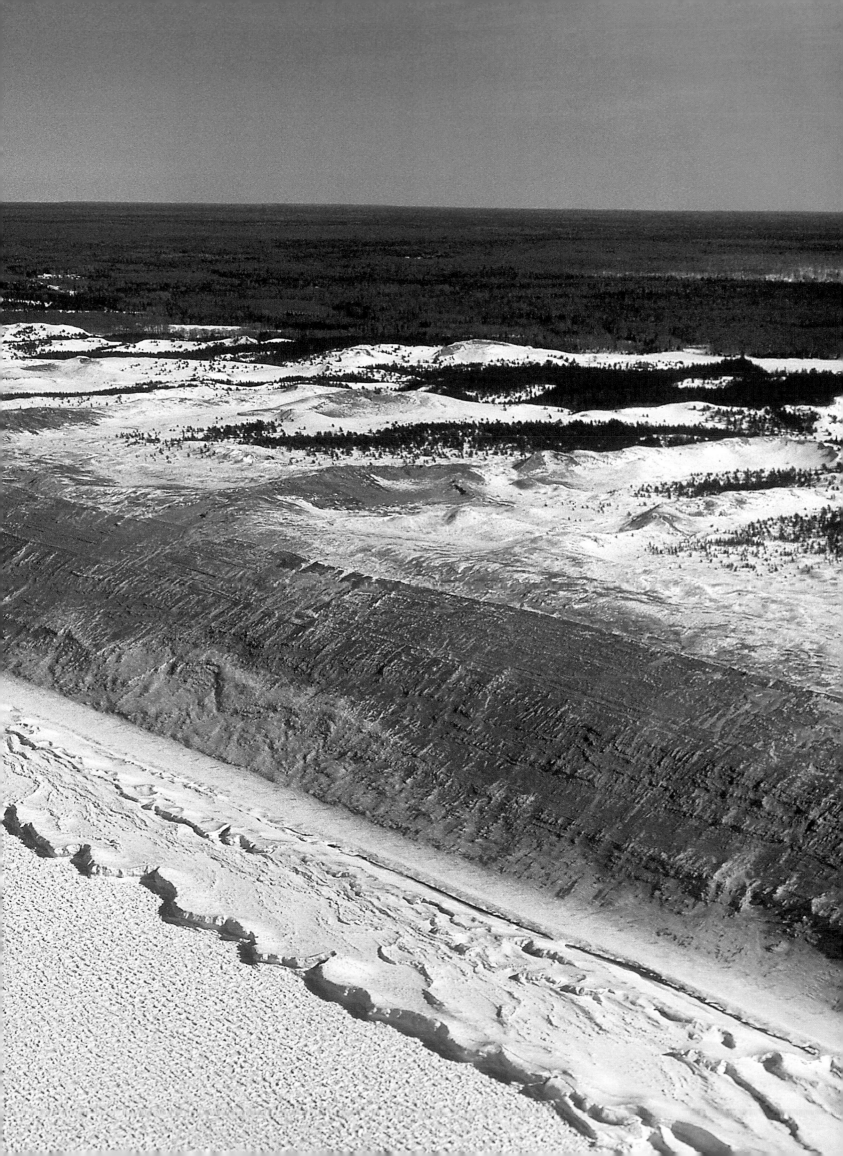

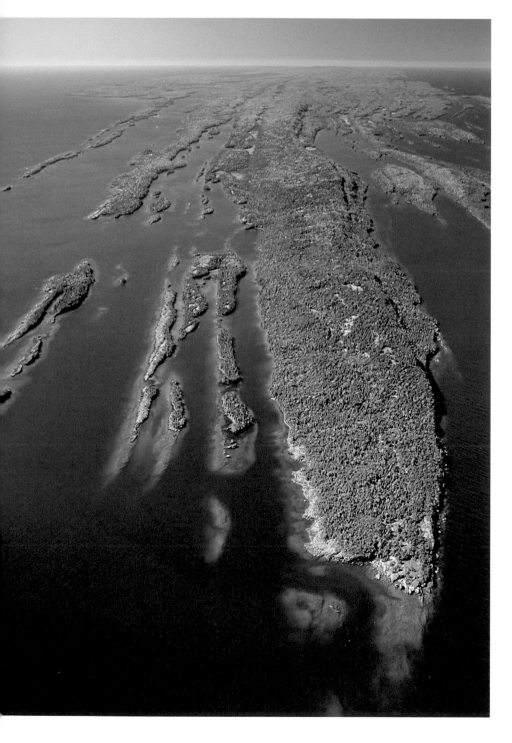
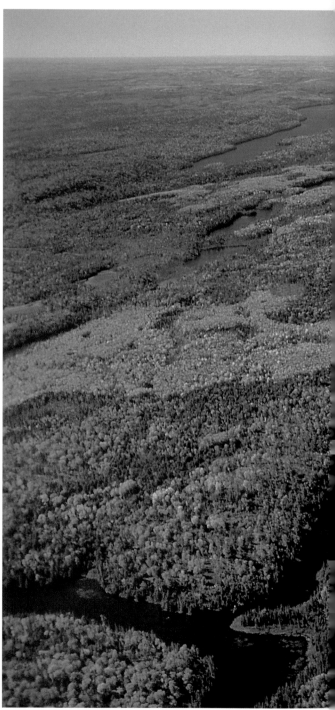

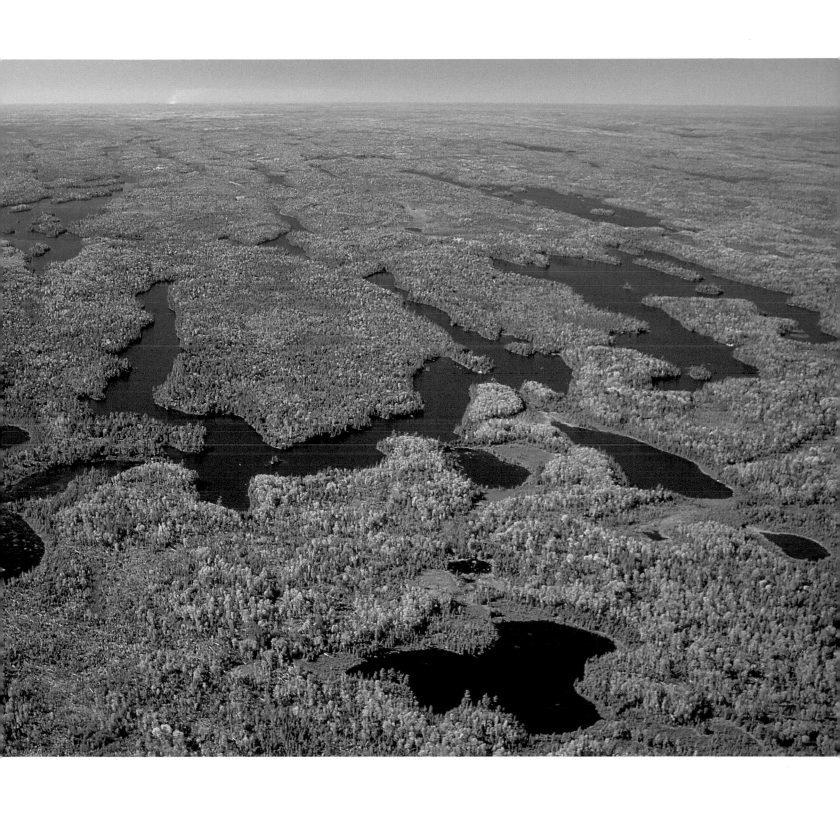

BLAKE POINT, Isle Royale National Park, Lake Superior, Keweenaw County, Upper Peninsula, Michigan. This is the northeast tip of the main island and looks in a southwest direction.

A geologic basin dips to the left and emerges fifty miles away as Michigan's Keeweenaw Peninsula (September 2004).

HORSESHOE LAKE, Boundary Waters Canoe Area Wilderness, Lake County, Minnesota. The autumn colors are just beginning to emerge (September 2004).

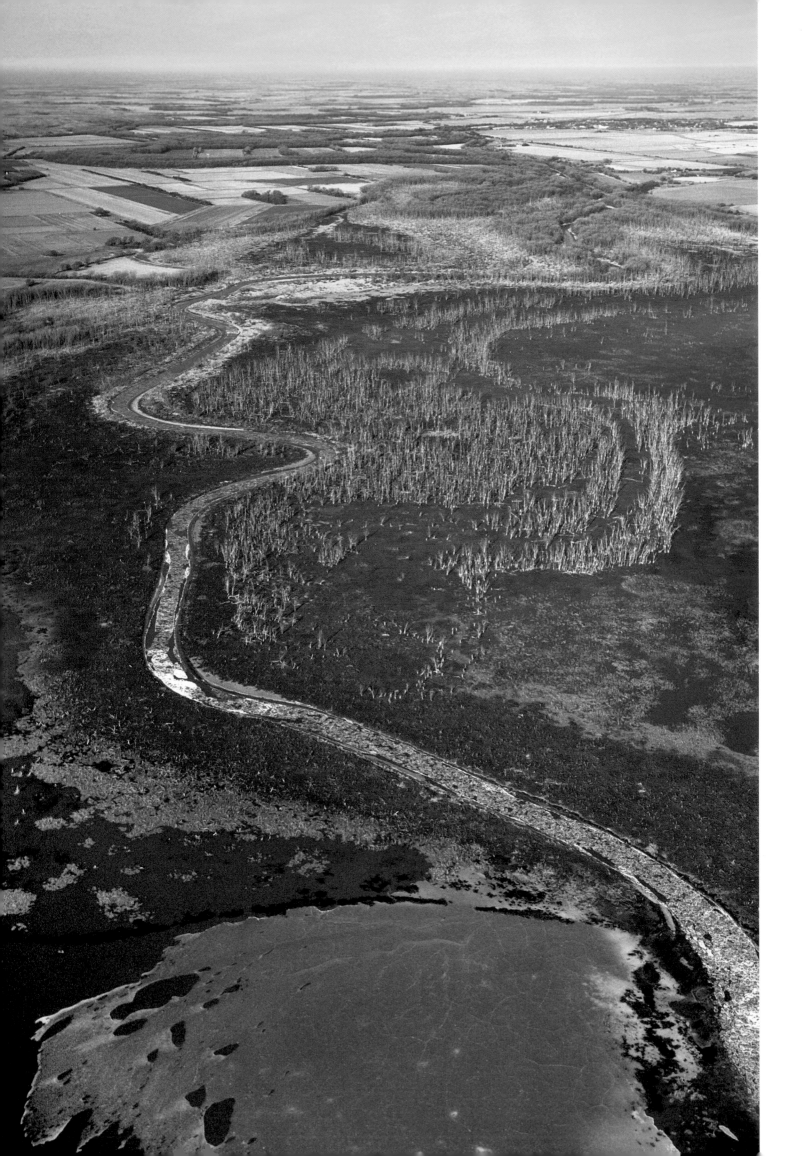

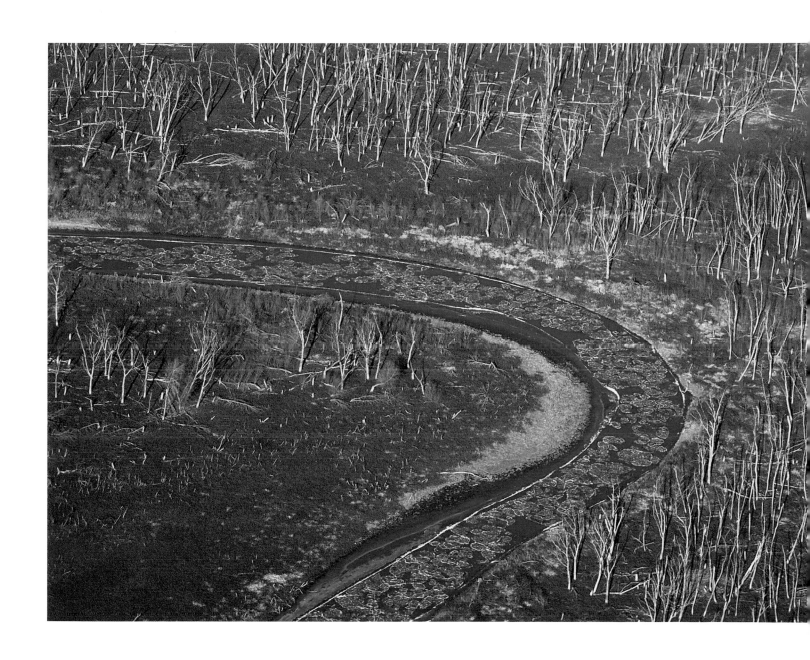

ICE-CHOKED RIVER, Republican River
near Alma, Harlan County, Nebraska
(January 2000).

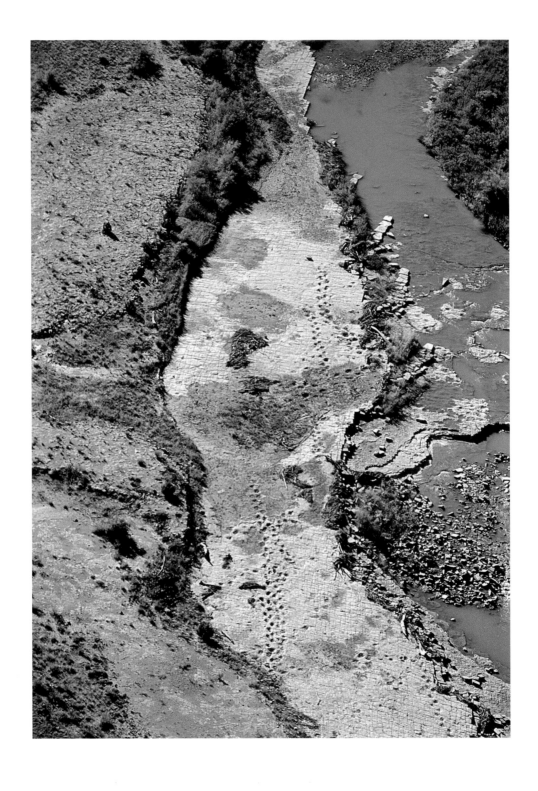

DINOSAUR TRACKS, Las Animas County, Colorado. These Brontosaurus and Allosarous tracks are said to be the world's finest fossil dinosaur tracks from the Jurassic period, about 150 million BC. The tracks are seen all over the bench to the left of the river. Located in Picketwire Canyon, Purgatory River, aka Pinon Canyon, Comanche National Grasslands (October 2003).

PELICAN RIVER INTO YELLOWSTONE LAKE, Yellowstone National Park, Teton County, Wyoming (June 2004).

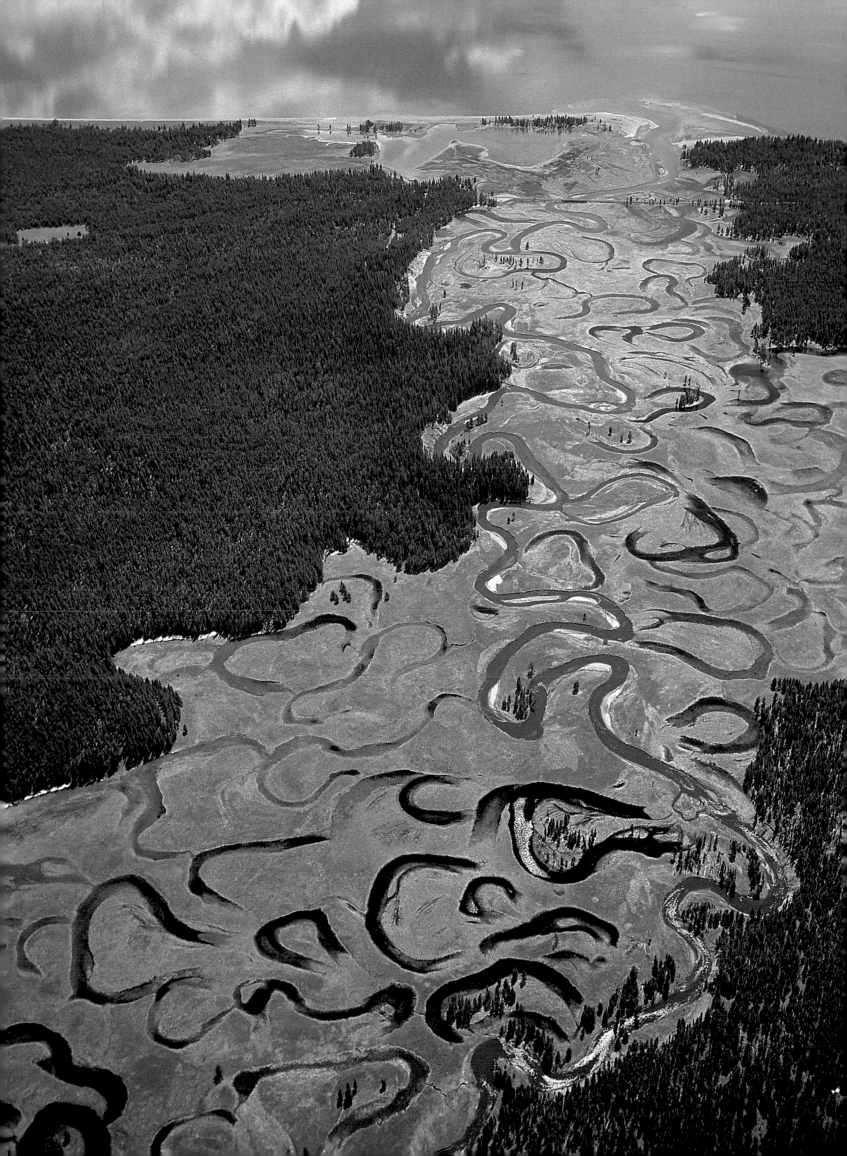

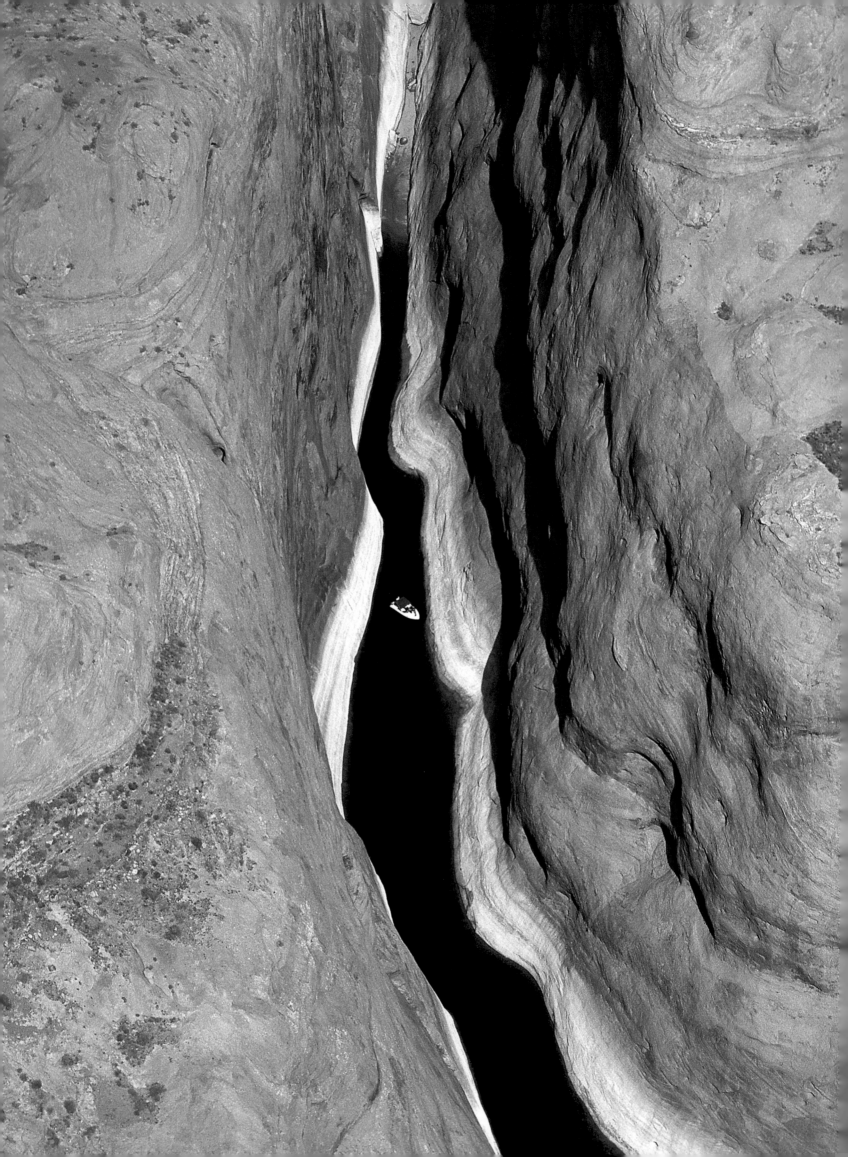

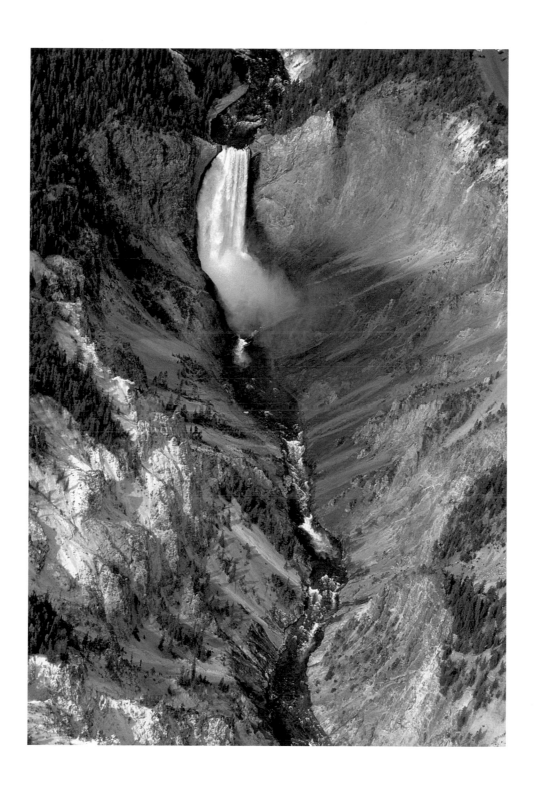

SLOT CANYON, Glen Canyon National Recreation Area, Lake Powell, Kane County, Utah. Lake Powell was formed by the damming of the Colorado River at Page, Arizona. The Glen Canyon Dam was completed in 1963 and flooded an area rivaling the Grand Canyon in both size and beauty. Fifty years after its inception, it remains an environmental controversy (August 2000).

YELLOWSTONE FALLS, Yellowstone River, Yellowstone National Park, Teton County, Wyoming (August 2002).

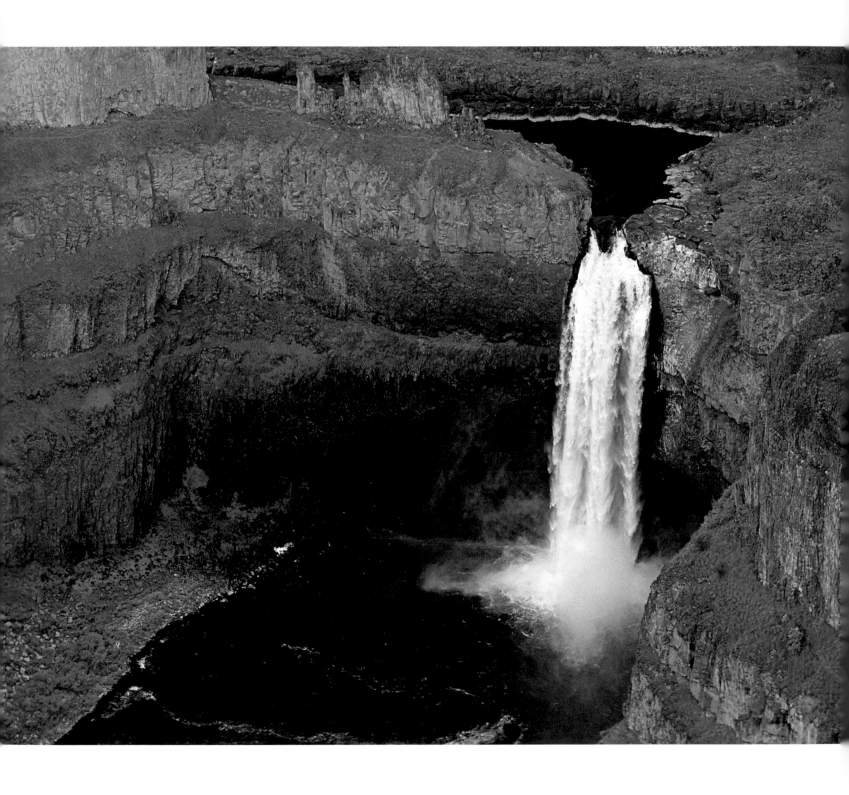

PALOUSE FALLS, Palouse River, Palouse Falls State Park, Whitman County, Washington. This is a 200-foot-high waterfall in a lava bed amphitheater (May 2007).

YOSEMITE FALLS, Yosemite Valley, Yosemite National Park, Mariposa County, California (April 1992).

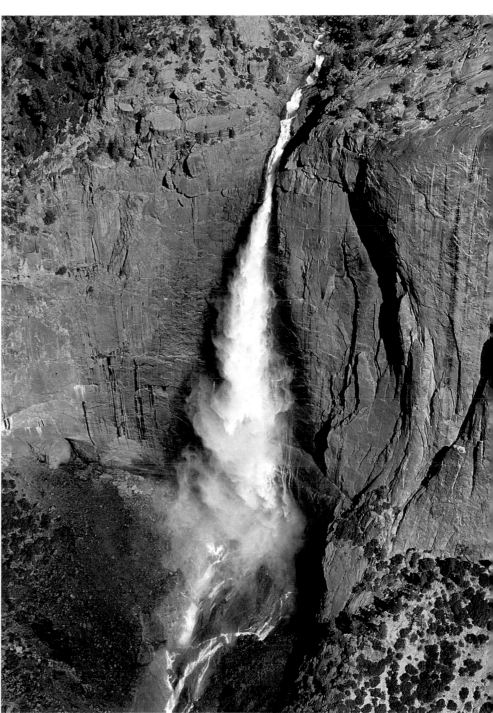

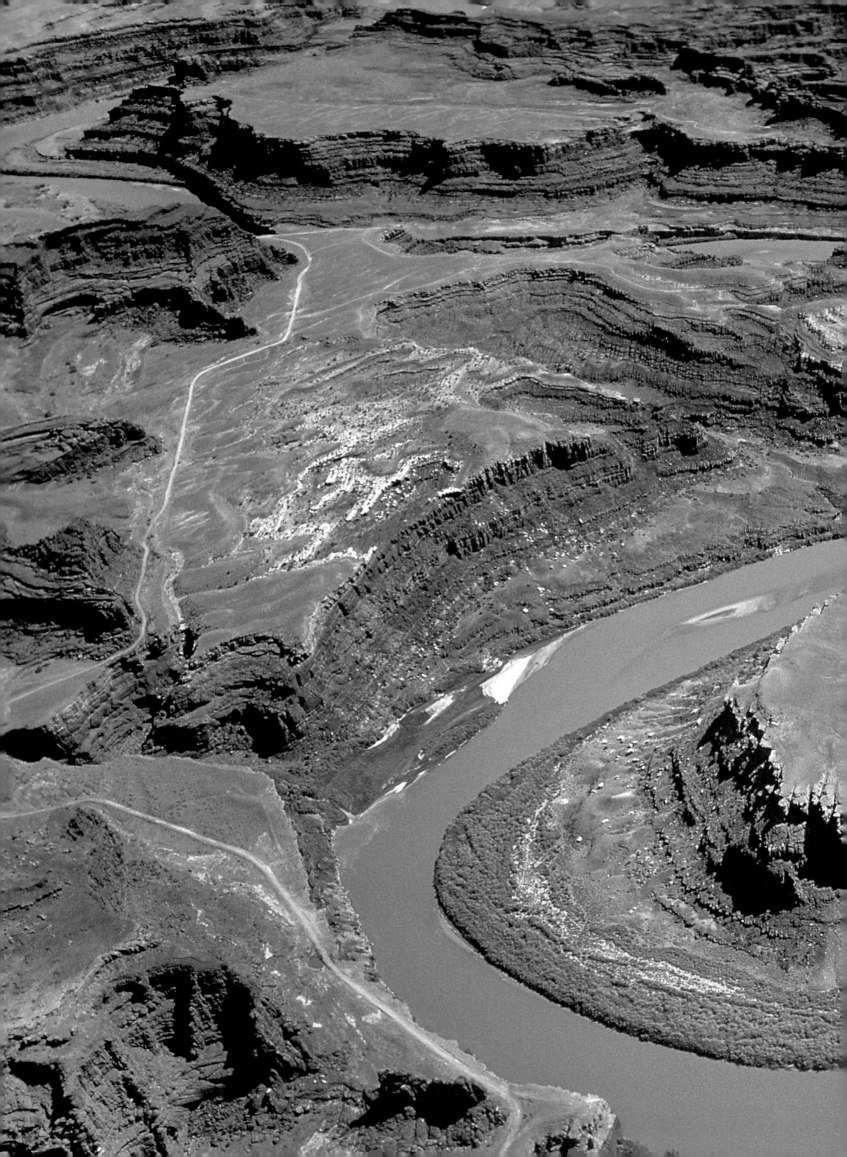

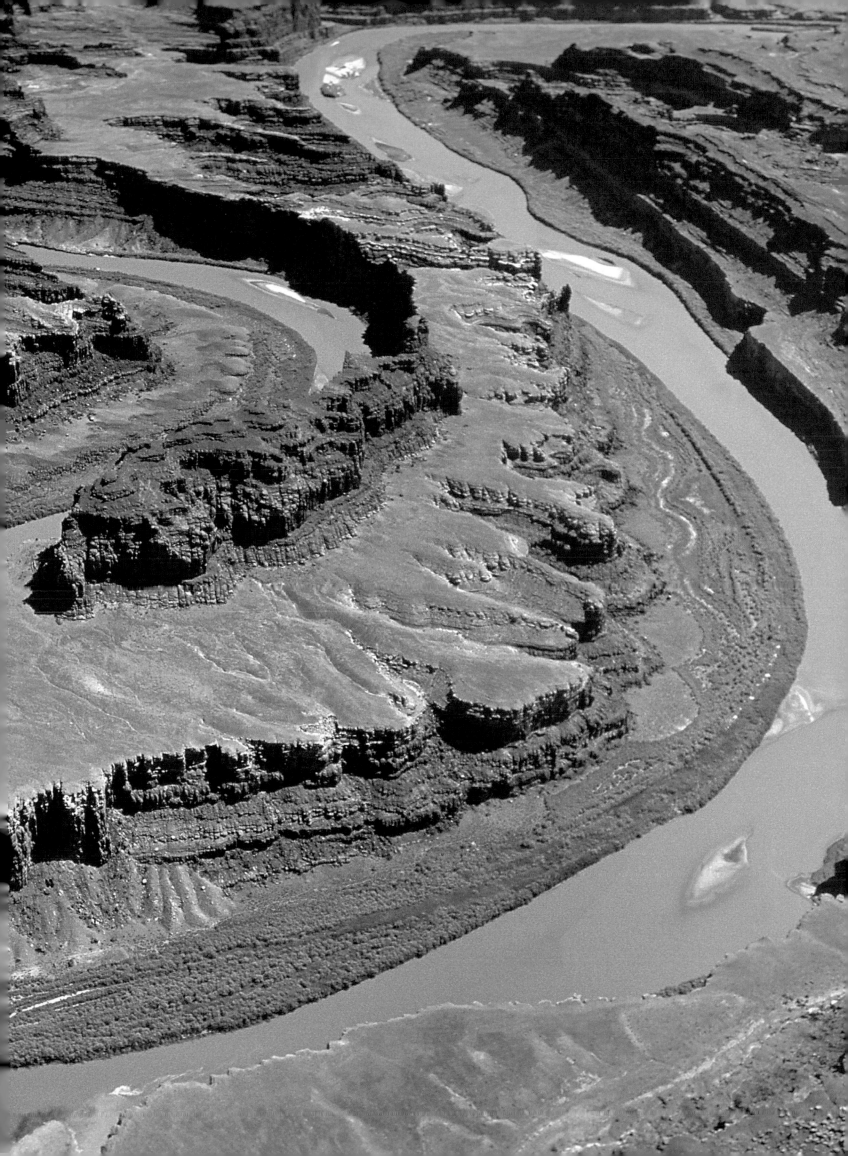

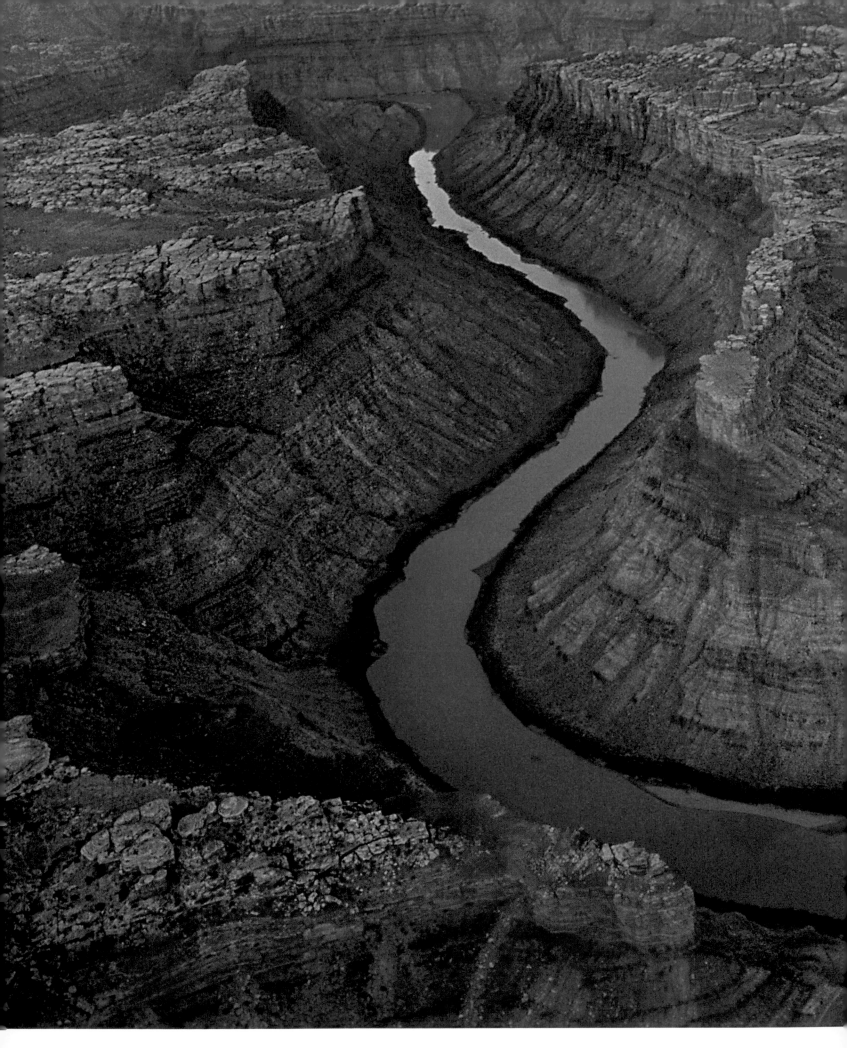

CONFLUENCE AT DAWN, Canyonlands National Park, San Juan County, Utah. After the Colorado and Green Rivers join, they form the Colorado River's Cataract Canyon (left side of photo) (September 2004).

(PRECEDING PAGES) THE GOOSENECK, Colorado River, Canyonlands National Park, San Juan County, Utah (September 2001).

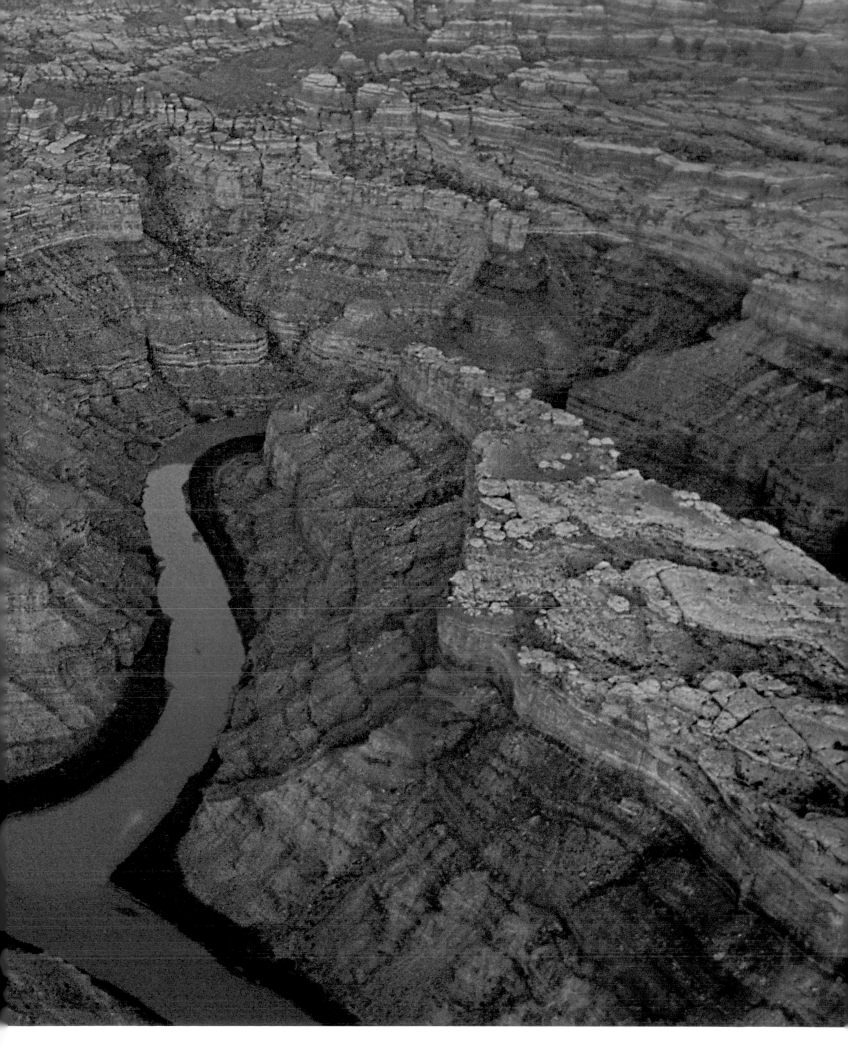

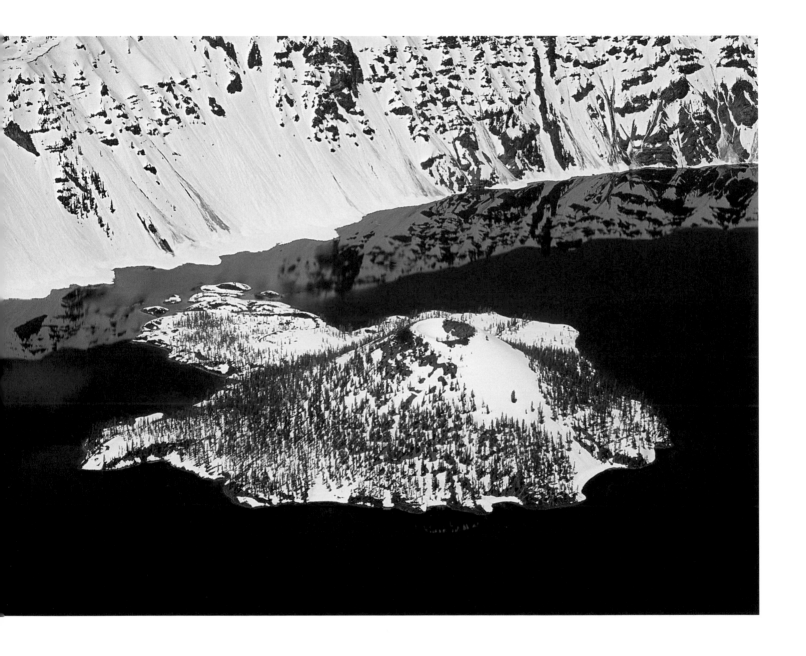

CRATER LAKE, Crater Lake National Park, Klamath County, Oregon. The photo shows Wizard Island, a small volcanic cone within the caldera of Crater Lake. Crater Lake was formed from the cataclysmic collapse of ancient Mount Mazama, about 7,700 years ago. It is the deepest lake in the United States at almost 2,000 feet and is 5.5 miles in diameter (May 1995).

MOLOKINI CRATER, Maui, Hawaiian Islands. This partially submerged cinder cone in the Alalakeiki Channel between Maui and Kahoolawe is a popular diving destination and a Hawaii state bird sanctuary (February 2004).

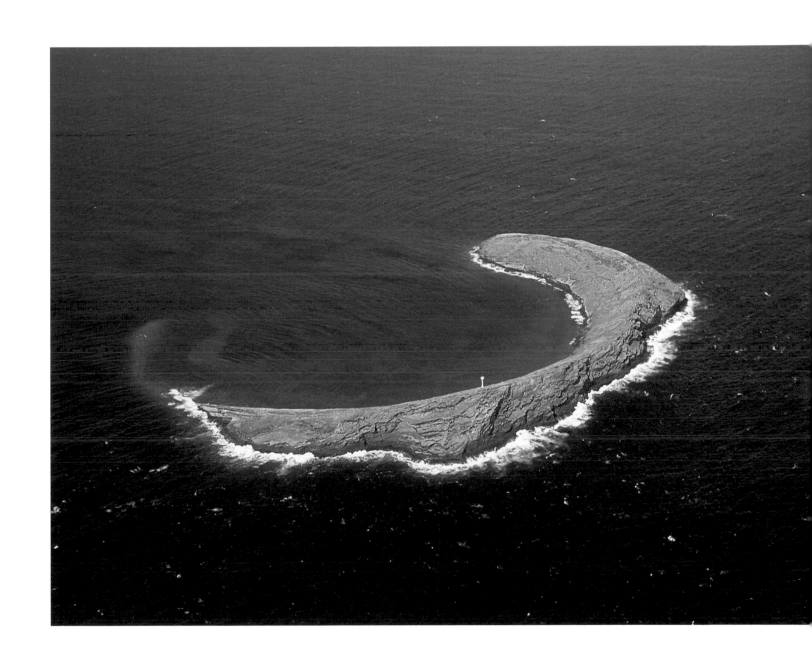

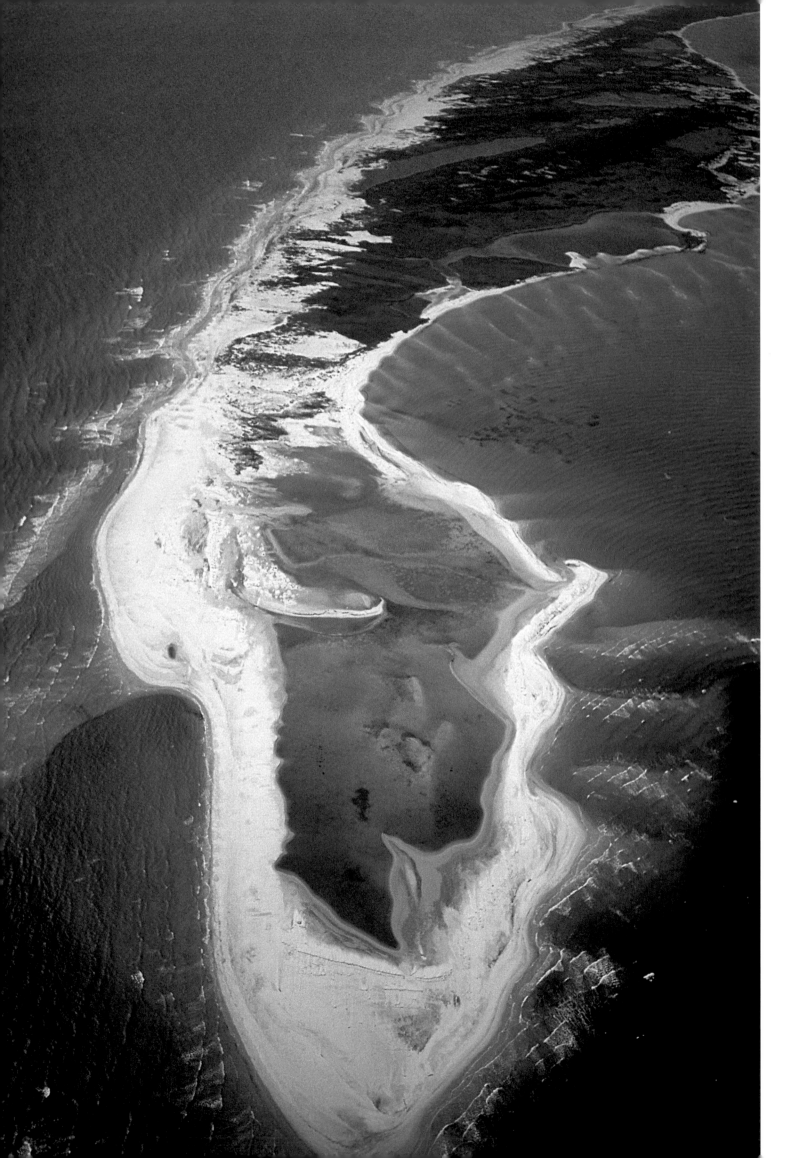

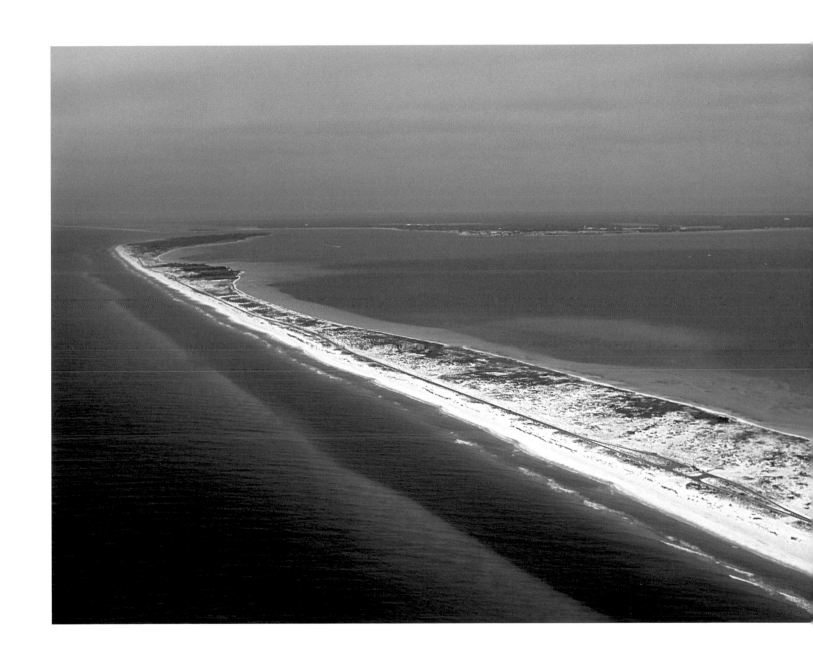

PETIT BOIS ISLAND, Gulf Islands National
Seashore, Jackson County, Gulf of Mexico,
Mississippi (February 2004).

SANTA ROSA ISLAND, Gulf Islands
National Seashore, Escambia County,
Gulf of Mexico, Florida (February 2004).

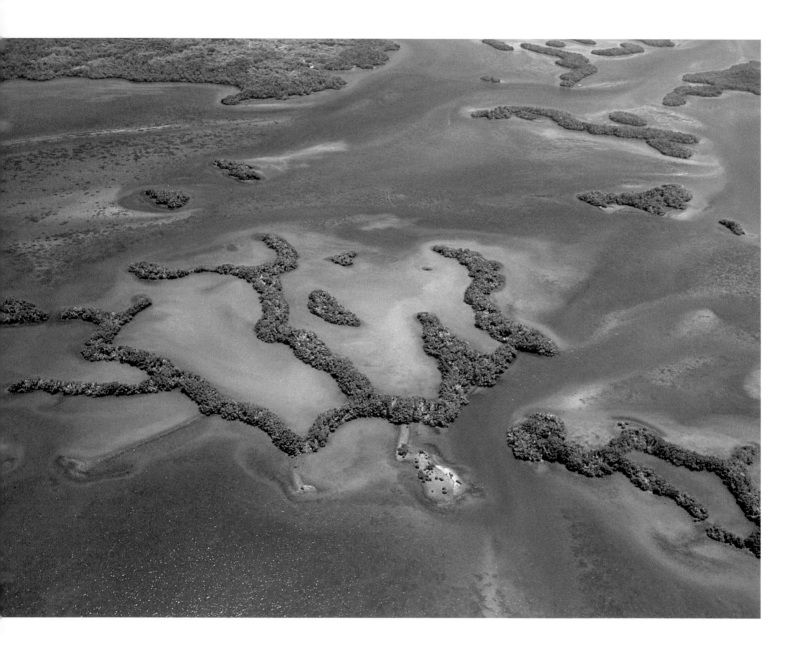

ESTRO BAY, Estro Bay Aquatic Preserve, Lee County, Gulf of Mexico, Florida (June 2006).

LAND'S END, Plaquemines Parish, Delta-Breton National Wildlife Refuge, Mississippi River Delta, Gulf of Mexico, Louisiana (April 2004).

(FOLLOWING PAGES) COLORADO RIVER DELTA, Sonora, Mexico. This is where the Colorado River flows into the Sea of Cortez, otherwise known as the Gulf of California (January 1996).

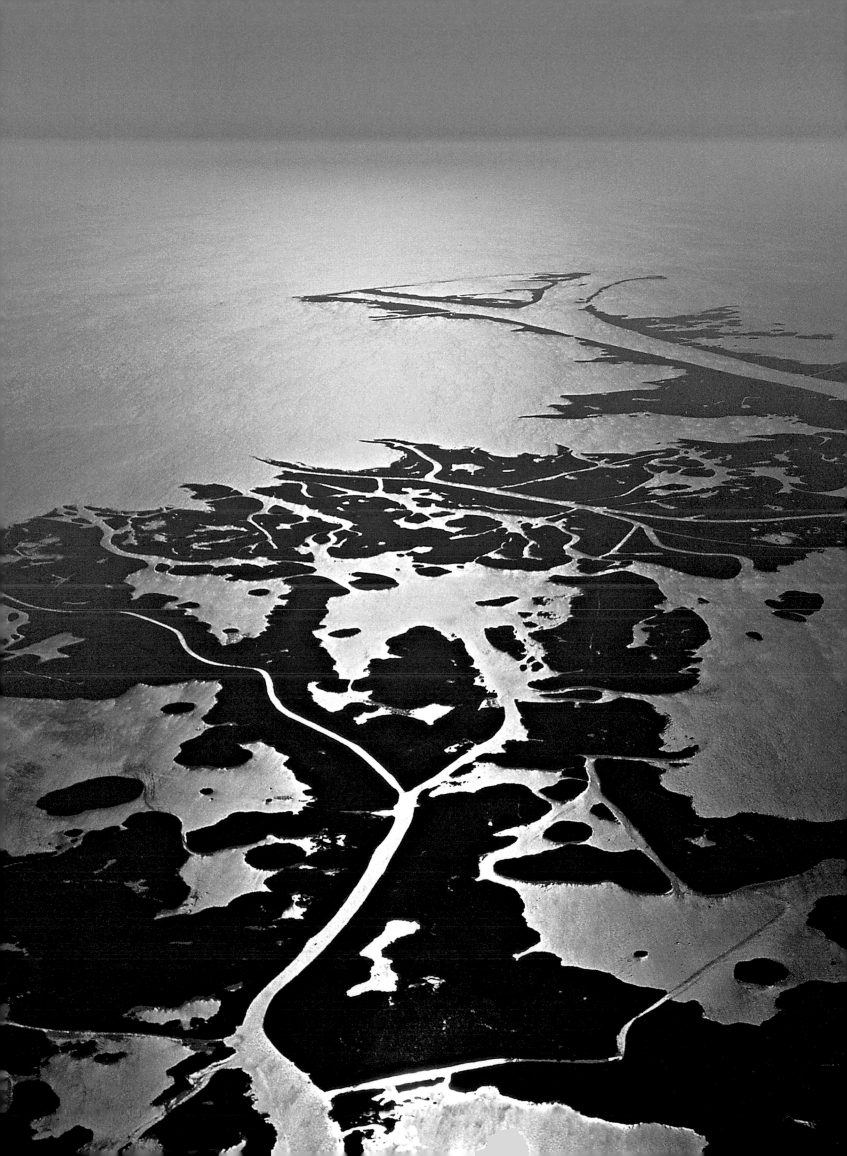

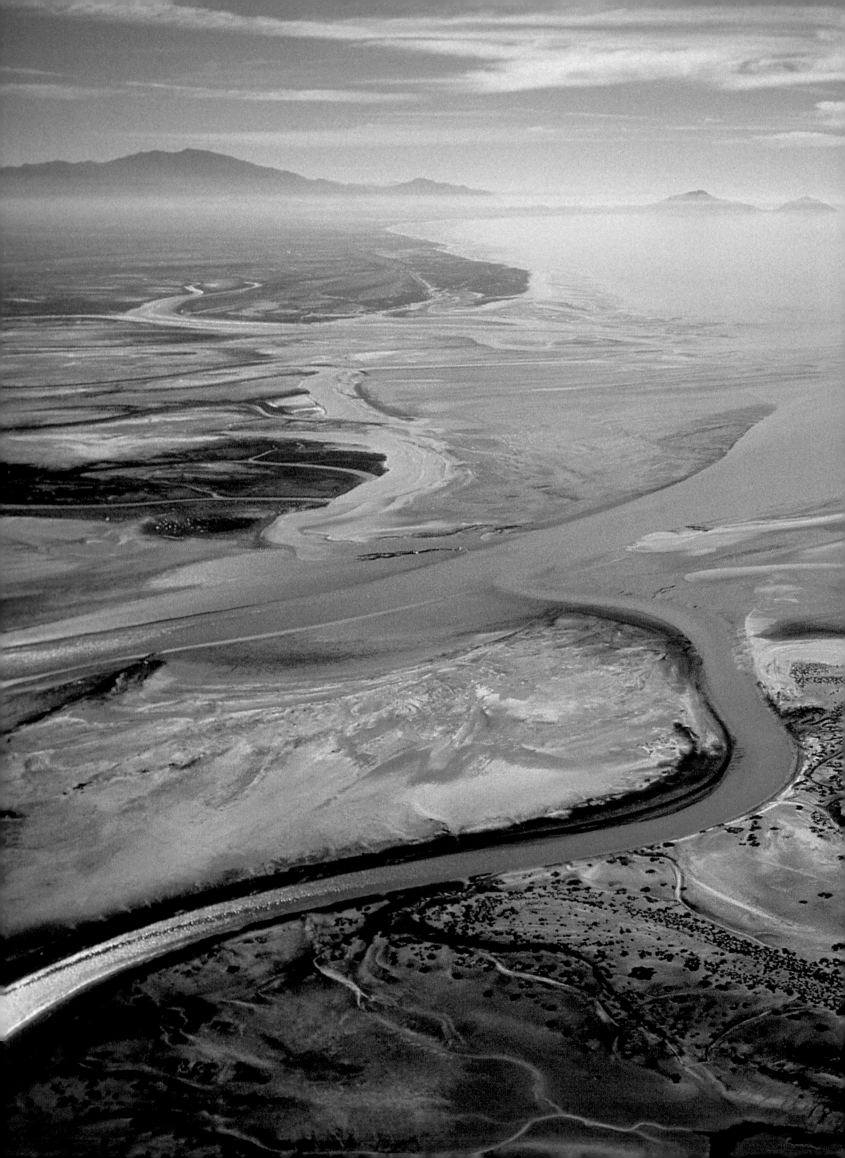

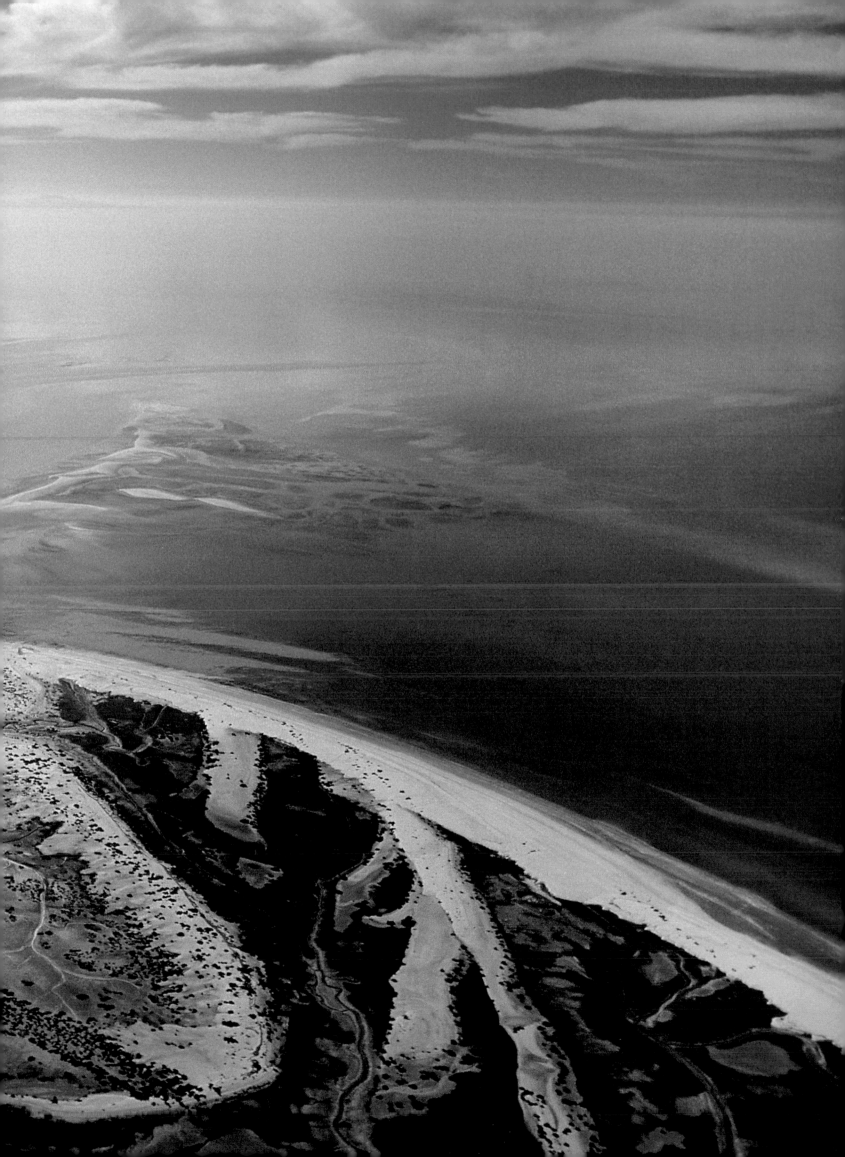

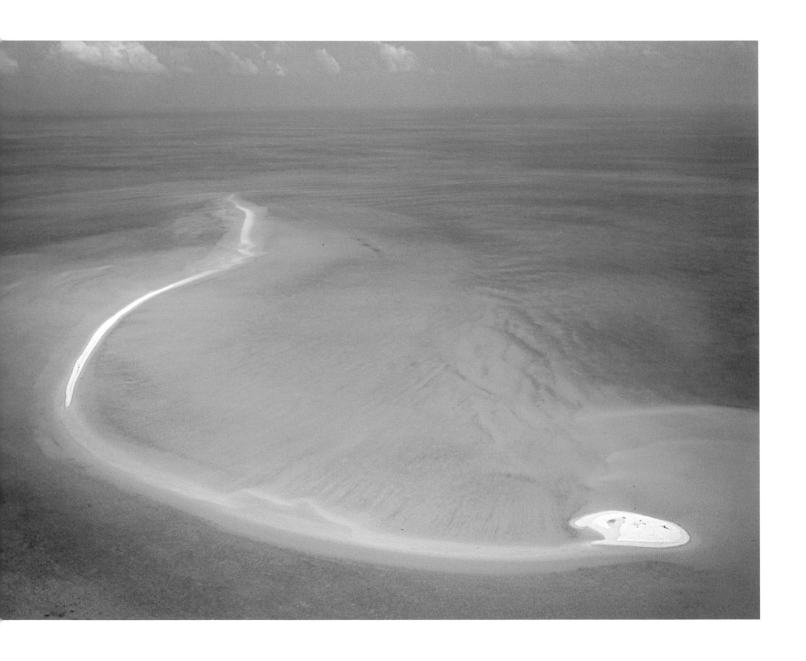

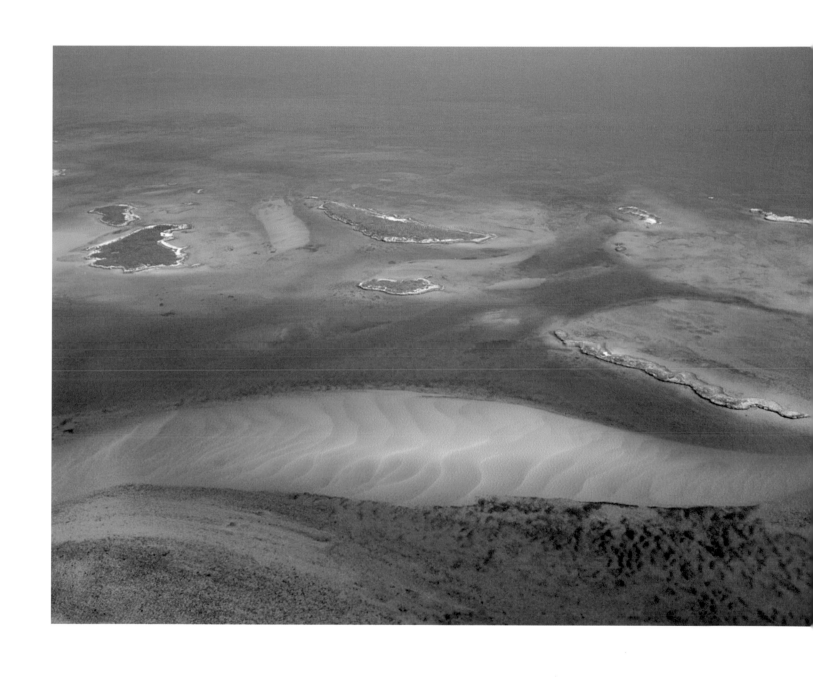

DESERT ISLAND, Great Bahamas Bank, Caribbean. Low tide forms a small sand island (March 1993).

EXUMA SHOALS, Bahamas (March 1993).

JUNGLE BEACH, near Tortuguero,
Provence of Limon, Caribbean coast,
Costa Rica (March 1991).

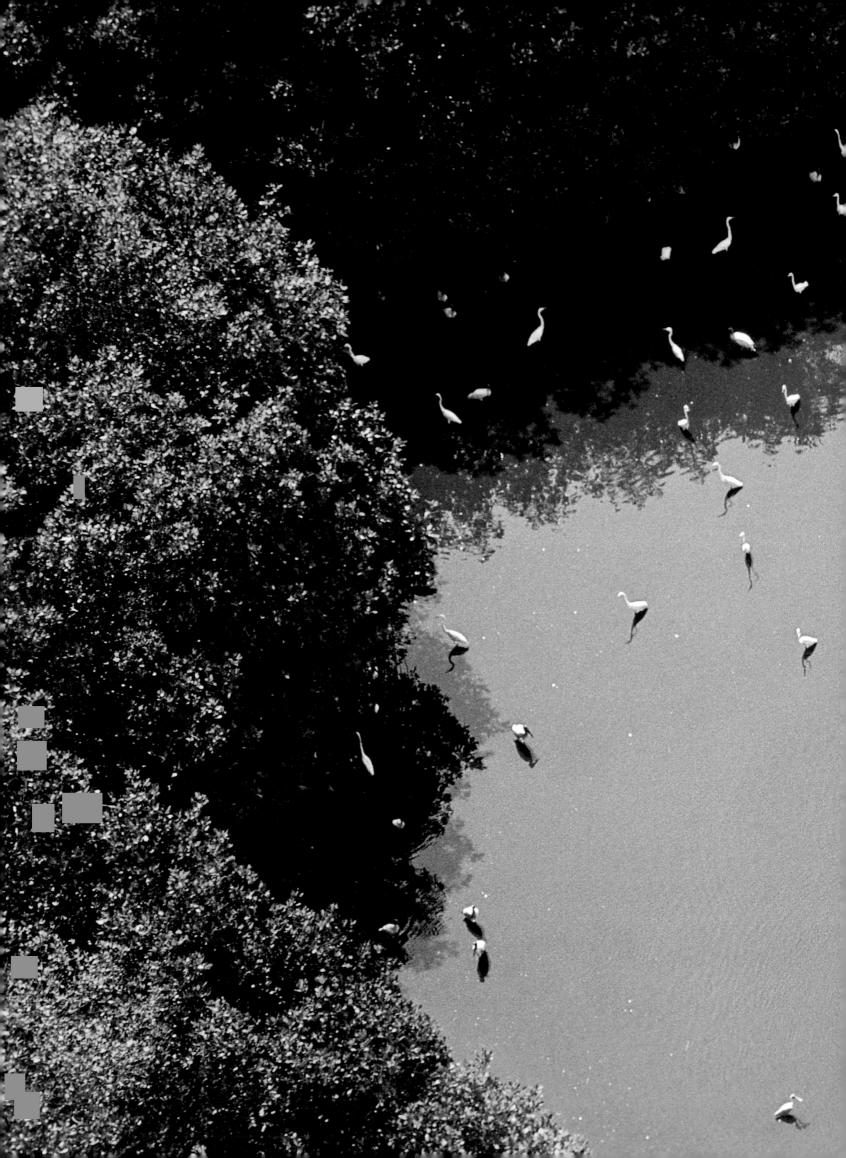

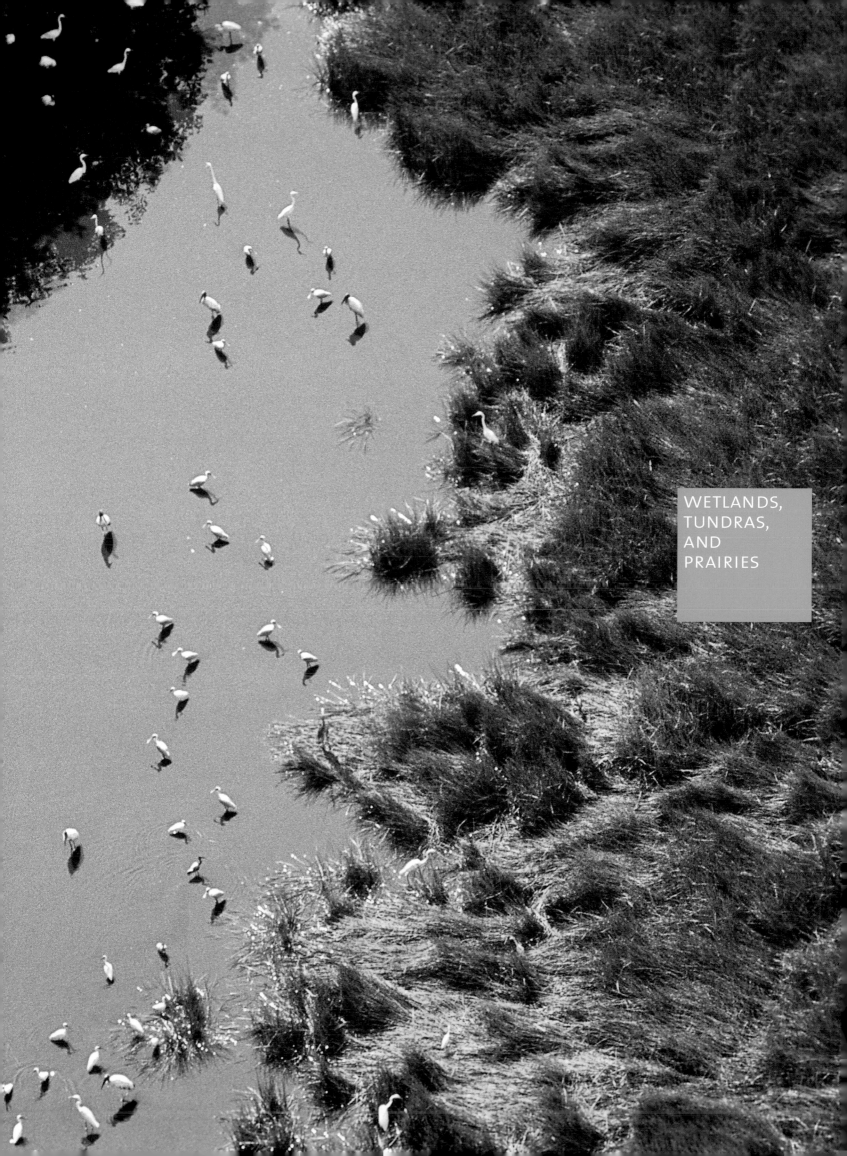

WETLANDS,
TUNDRAS,
AND
PRAIRIES

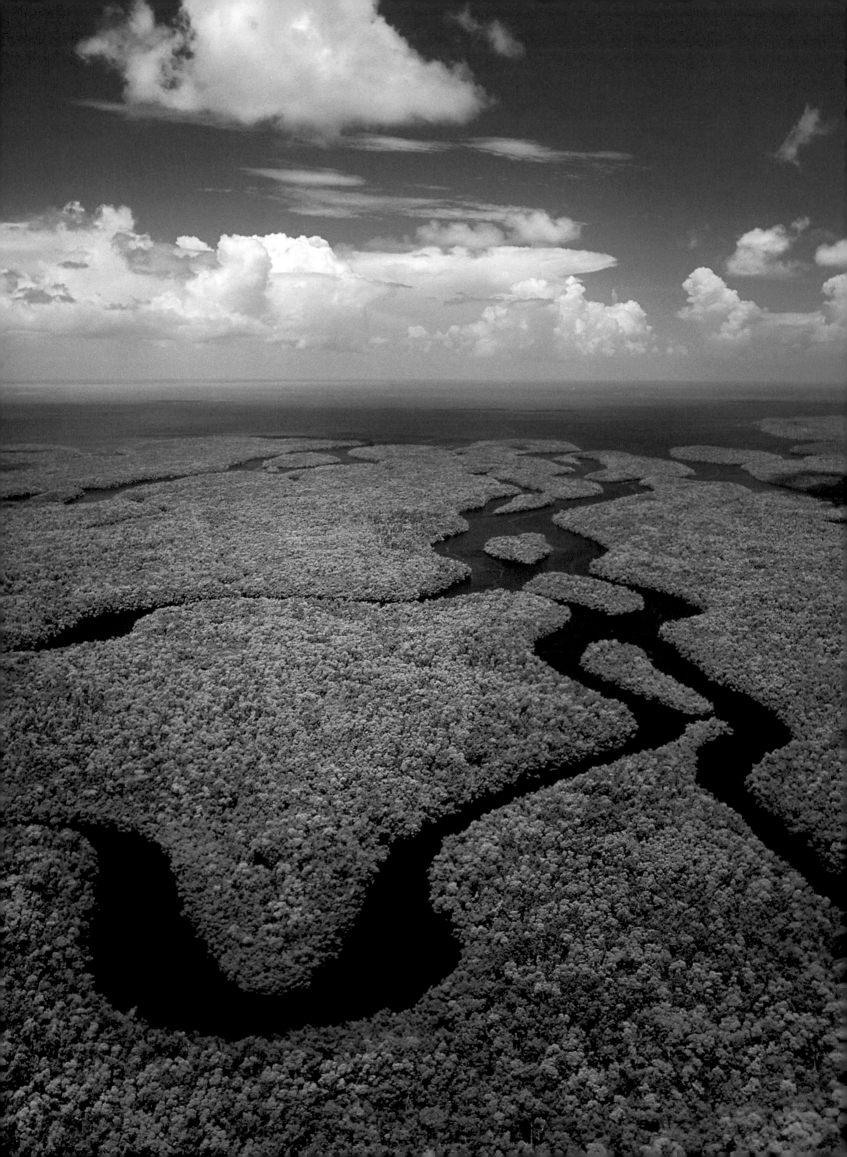

THE GREEK WORD "OIKOS," meaning house, is the root of both "economics" and "ecology," but a better translation would be household. Economics concerns how it manages time, labor, and material resources. "Ecology," which came into use among biologists in the 1890s, focuses on how the household functions as an interdependent community. Theologists had long understood the unity of the natural world to be a consequence of creation by a deity: ecology added science to the discussion. Using concepts like webs, chains, and balances, the ecological perspective made it possible to think about the "unspoiled" or "pristine" qualities of wilderness in a new way.

Aldo Leopold not only pioneered in ecological science, but the way he lived his life illustrates the changes this new awareness could bring in attitude toward wilderness. Born in 1887, the young Leopold was firmly rooted in the utilitarian valuation of nature. In 1909 he graduated from Yale's School of Forestry, which championed sustainable timber harvests. This was the cornerstone of an idea that Theodore Roosevelt, and his chief forester Gifford Pinchot, dubbed "conservation." Wilderness had no place at that table. The recently created "national forests" were considered timber reserves. It was all about the fulfillment of human needs and the extension of national prosperity. There were "good" animals—cattle and "game" such as deer—and the "bad" ones—like wolves and mountain lions—which ate them. As a junior member of the United States Forest Service, Leopold joined in a crusade-like campaign to exterminate the problematic predators.

As he matured and learned more about ecology, however, Leopold had second thoughts. In the 1920s he began to argue for the protection of wilderness qualities—primarily roadlessness—on public lands for recreational purposes. He also bought into the Frederick Jackson Turner idea that without wilderness Americans would have difficulty understanding their history and preserving the uniqueness of their culture and institutions. Success came with the first Forest Service inventories of roadless areas and, in 1924, the approval (as policy, but not yet as law) of one part of the Gila National Forest in New Mexico. A decade later, as Leopold shifted to the faculty of the University of Wisconsin, he realized that wild environments were also important to science as "a base-datum of normality, a picture of how healthy land maintains itself as an organism." Realizing that much of his country had been ecologically disrupted, with species lost and natural processes altered, Leopold declared that wilderness revealed "what the land was, what it is, and what it ought to be." Evolution operated in such places without human interference, providing "standards against which to measure the effects of violence." Recreation, Leopold concluded, was not the only or even the principle utility of wilderness. Wild places were valuable, in other words, even if they were never even visited.

Leopold used terms like "land organism" and "thinking like a mountain" when he explained these ideas to students. The first law of successful tinkering, he proposed, was to save all the parts. Wilderness provided the means: it was a kind of Noah's ark. And there was a second law: save the instructions. These were written in the physical and biological processes operating in unmodified environments. The showpiece of Leopold's case was the importance of predators, like wolves, to control deer and elk populations. The old good/bad animal distinction that guided him as a young man now seemed ecologically unsupportable.

Aldo Leopold died in 1948, a year before his masterwork *A Sand County Almanac* was published. The book had little impact in materialistic, postwar America, but time was on his side. Canadian conservationist Farley Mowat picked up the defense of the archtype wild animal in *Never Cry Wolf* (1963). Rachel Carson's writings about the sea and her seminal study of the disrupting effects of insecticides entitled *Silent Spring* (1962) made "ecology" a household word. Leopold's book finally became a best-seller in the 1960s. By this time many Americans were prepared to accept that wilderness was an anchor to windward in the seas of increasingly frightening ecological change.

WETLANDS, TUNDRAS, AND PRAIRIES

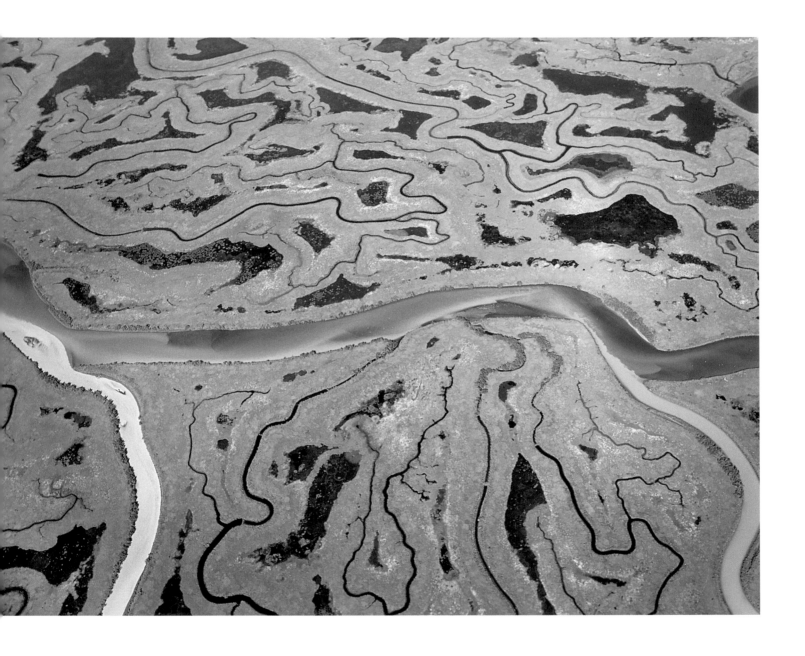

COPPER RIVER DELTA WETLAND, Copper River Delta State Critical Habitat Area, Gulf of Alaska, Alaska (bombsight view) (June 2003).

TIDAL MARSHLAND, Copper River Delta State Critical Habitat Area, Gulf of Alaska, Alaska. The Copper River Delta is a huge colorful area of mudflats, tidal marshland, tundra islands, small lakes, and braided streams framed in

a backdrop of mountains, glaciers, and open waters (June 2003).

(PRECEDING PAGE) THE EVERGLADES, Everglades National Park, Monroe County, Florida (July 1996).

(CHAPTER OPENER) JABARU STORKS AND EGRETS, Parque Nacional Palo Verde, Guanacaste Provence, Costa Rica (March 1991).

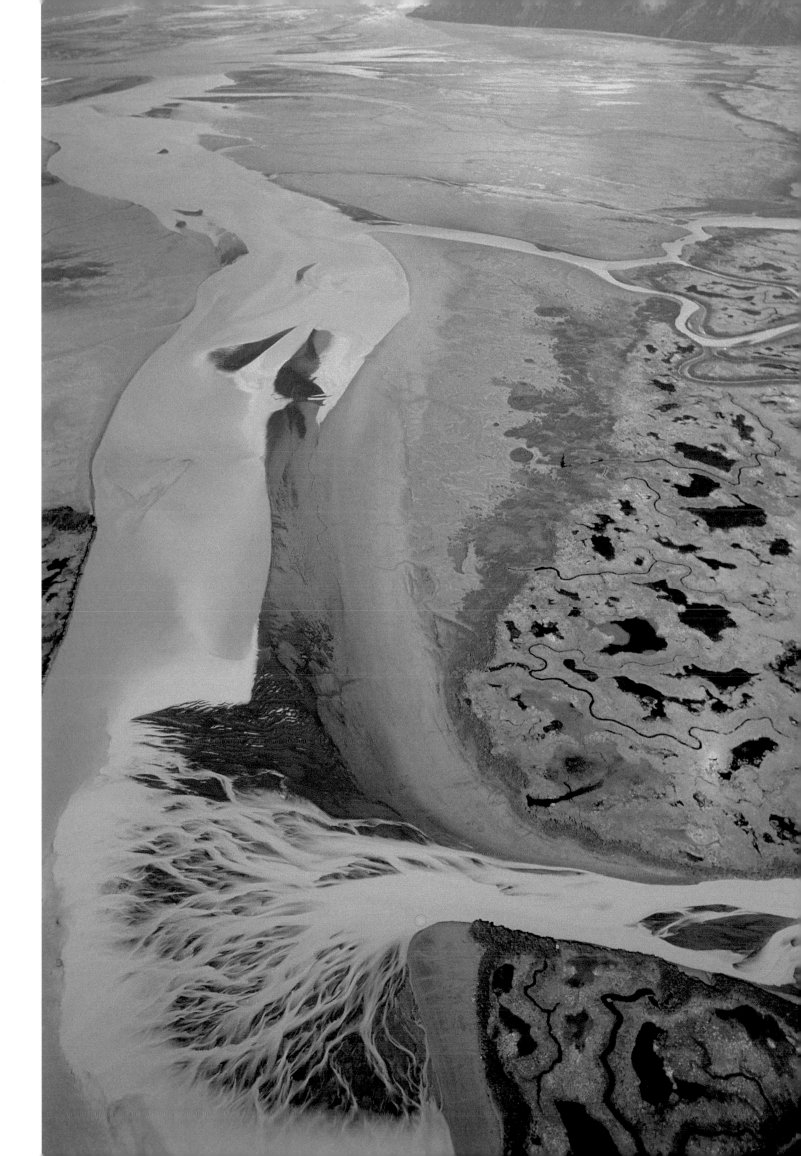

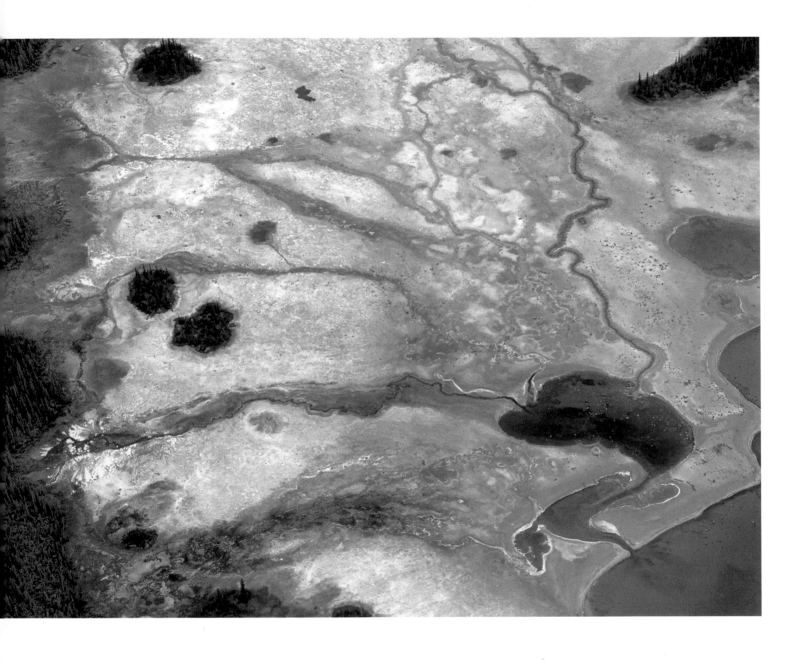

SALT MARSH, Wood Buffalo National Park, Northern Alberta. These salt marshes are created by numerous salt or mineral springs in the marshes. The colors are created from various forms of algae (June 2003).

MUSKEG, Wood Buffalo National Park, Northern Alberta. Muskeg is an Arctic term for bogland. The vegetative areas are often thin and underlain by water, which makes for treacherous footing and dangerous travel for man and animals (bombsight view) (June 2003).

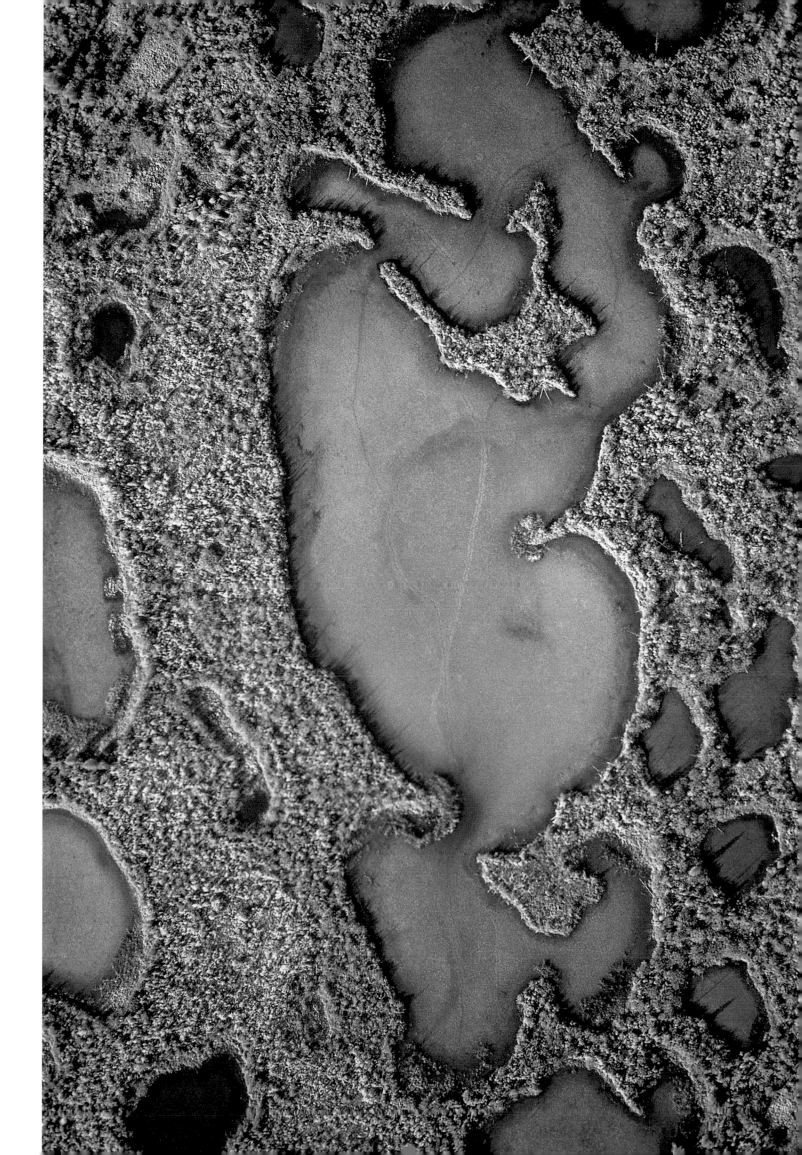

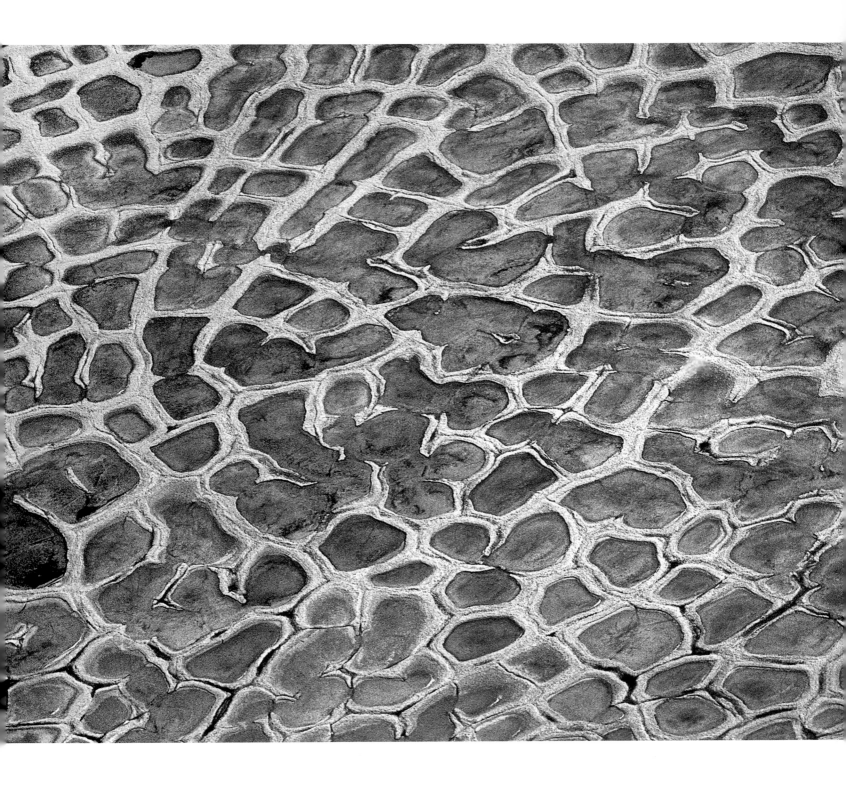

TUNDRA POLYGONS, National Petroleum Reserve, North Slope, Alaska. These polygons are formed by repeated freezing and thawing of the upper layer of the arctic permafrost (June 1993).

NORTH SLOPE OIL FACILITY, Prudhoe Bay, National Petroleum Reserve, North Slope, Alaska. This bombsight view shows the maze of structures and pipelines that transect an area of large tundra polygons (June 2003).

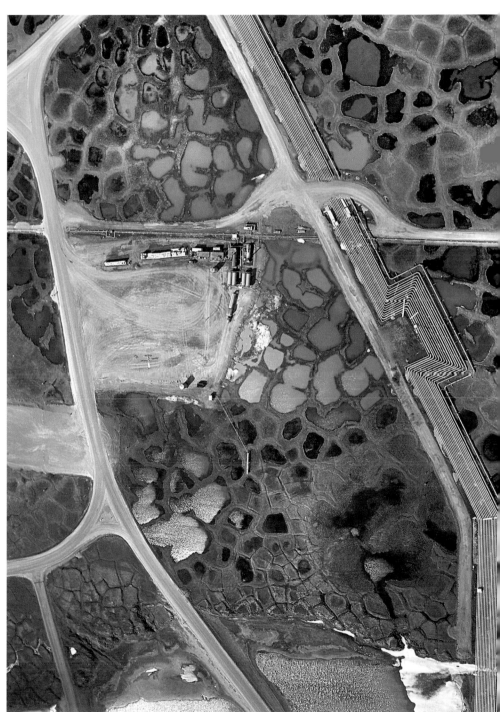

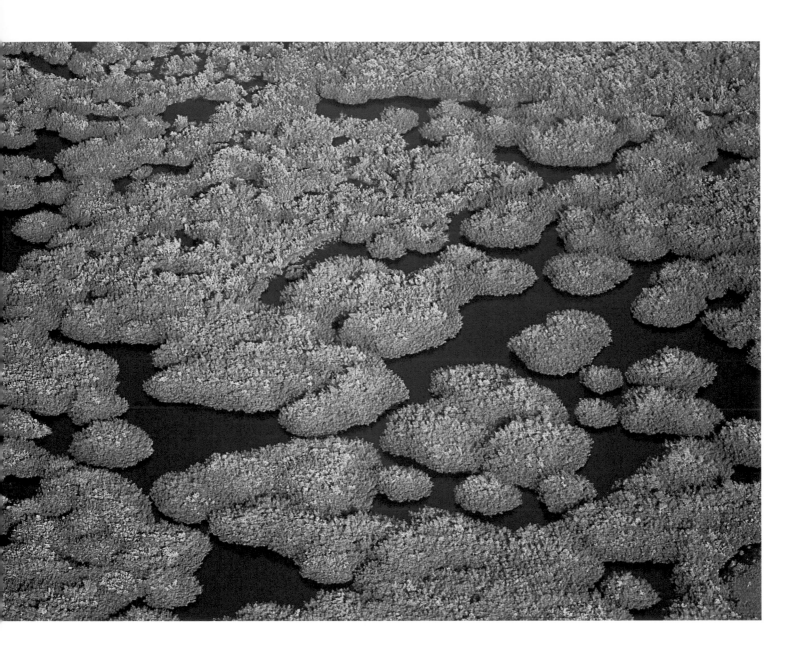

EVERGLADES HUMMOCKS, left and
LAKE INGRAHAM, right, Cape Sable,
Everglades National Park, Monroe
County, Florida (December 2004
and February 2006).

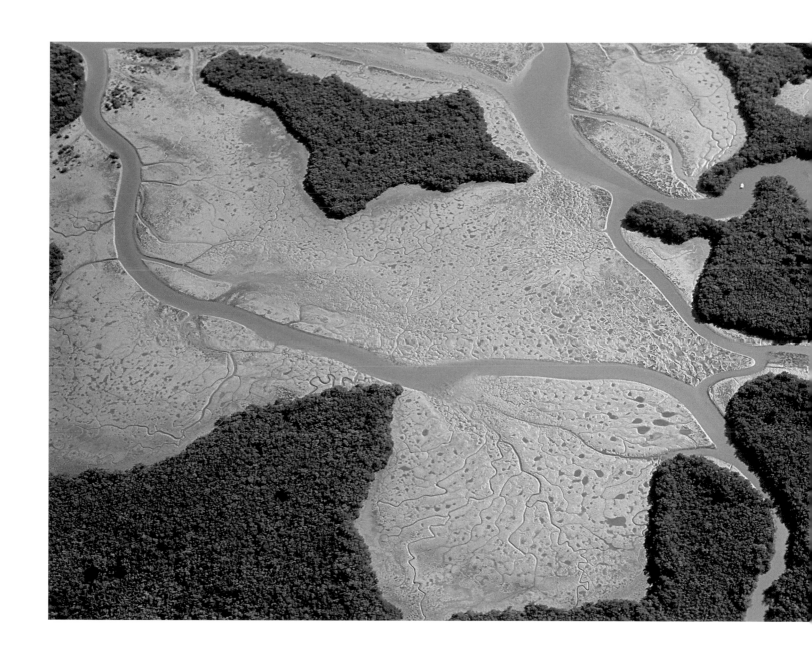

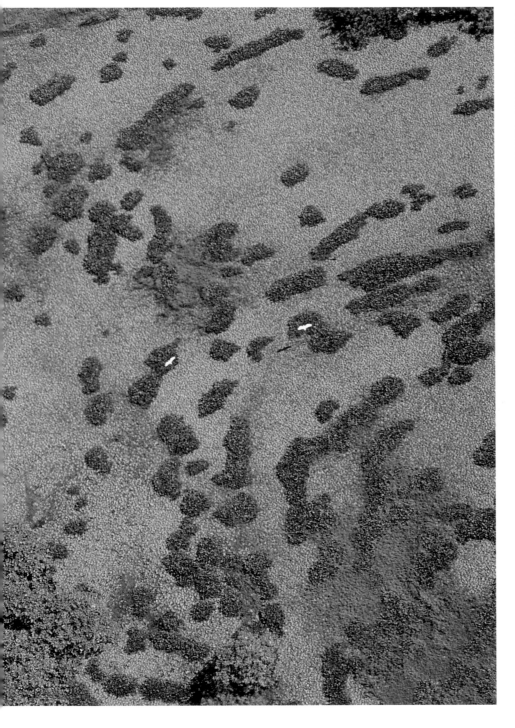

JABARU STORKS OVER SWAMP, Parque
Nacional Palo Verde, Guanacaste
Provence, Costa Rica (March 1991).

SWAMP WATERWAY, Okefenokee
National Wildlife Refuge, Charlton
County, Georgia. A small boat navigates
a swamp canal (July 1996).

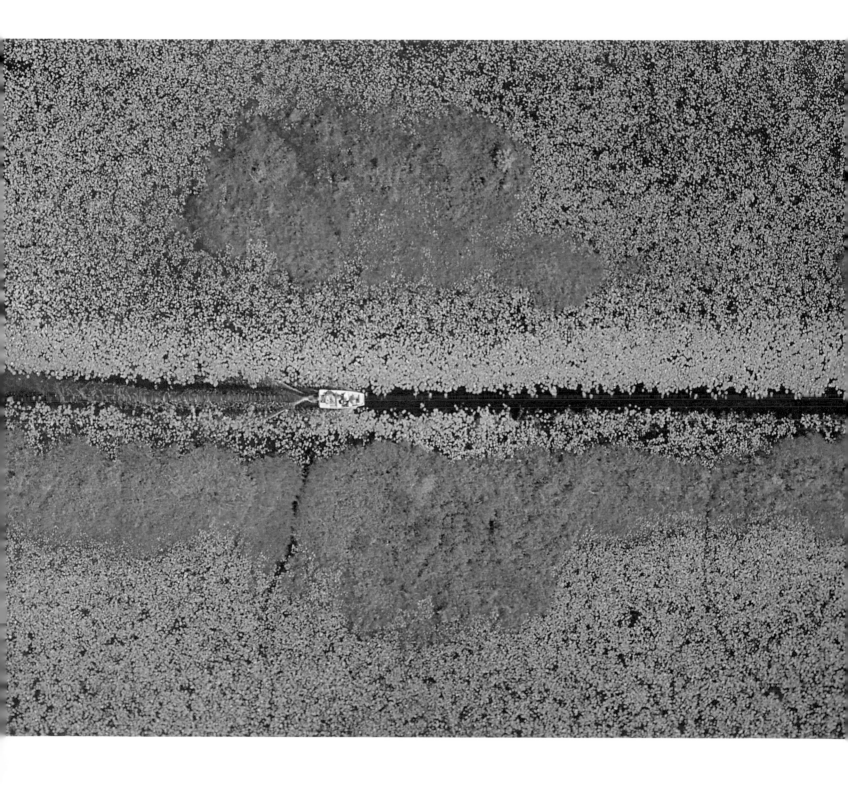

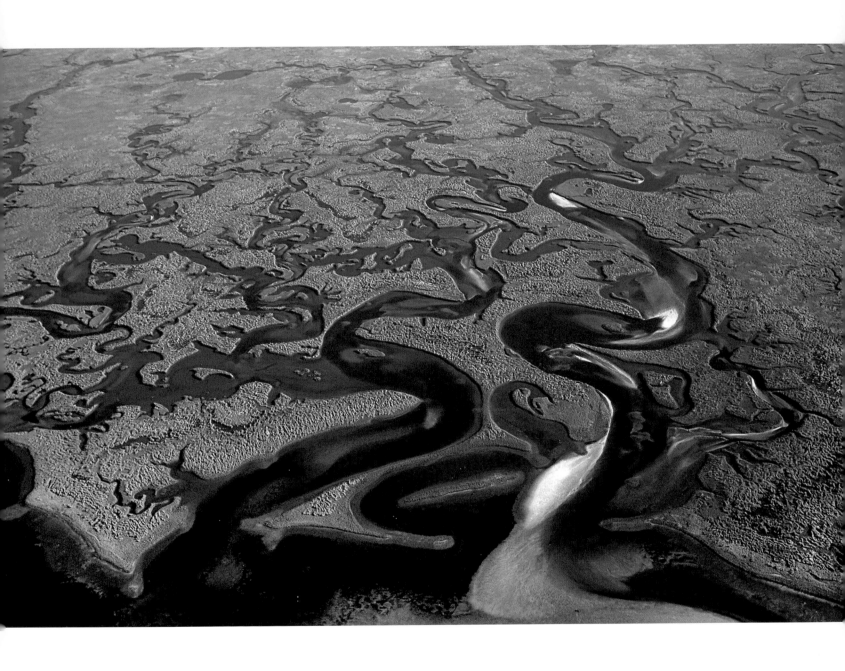

196 APALACHEE BAY WETLANDS, Franklin County, Gulf of Mexico Coast, Florida (February 2006).

BIRD FORMATION, Levy County, Florida. Flight of birds over Lower Suwannee National Wildlife Reserve (February 2006).

(FOLLOWING PAGES) SODA LAKE, PAISLEY, San Luis Obispo County, California. I know of no place on earth that can show as many faces as the Carrizo Plain. Each time it was visited, a different landscape was experienced (April 2005).

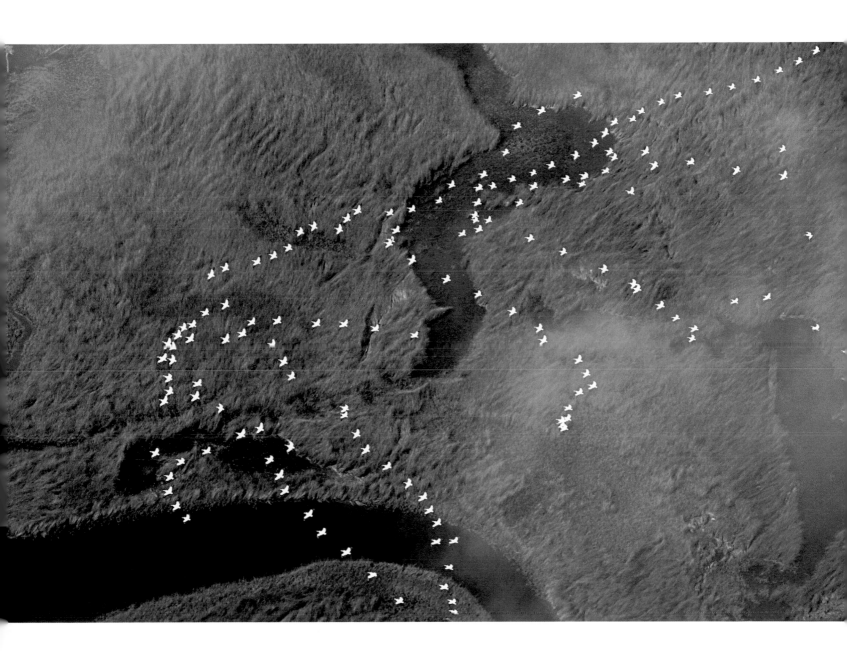

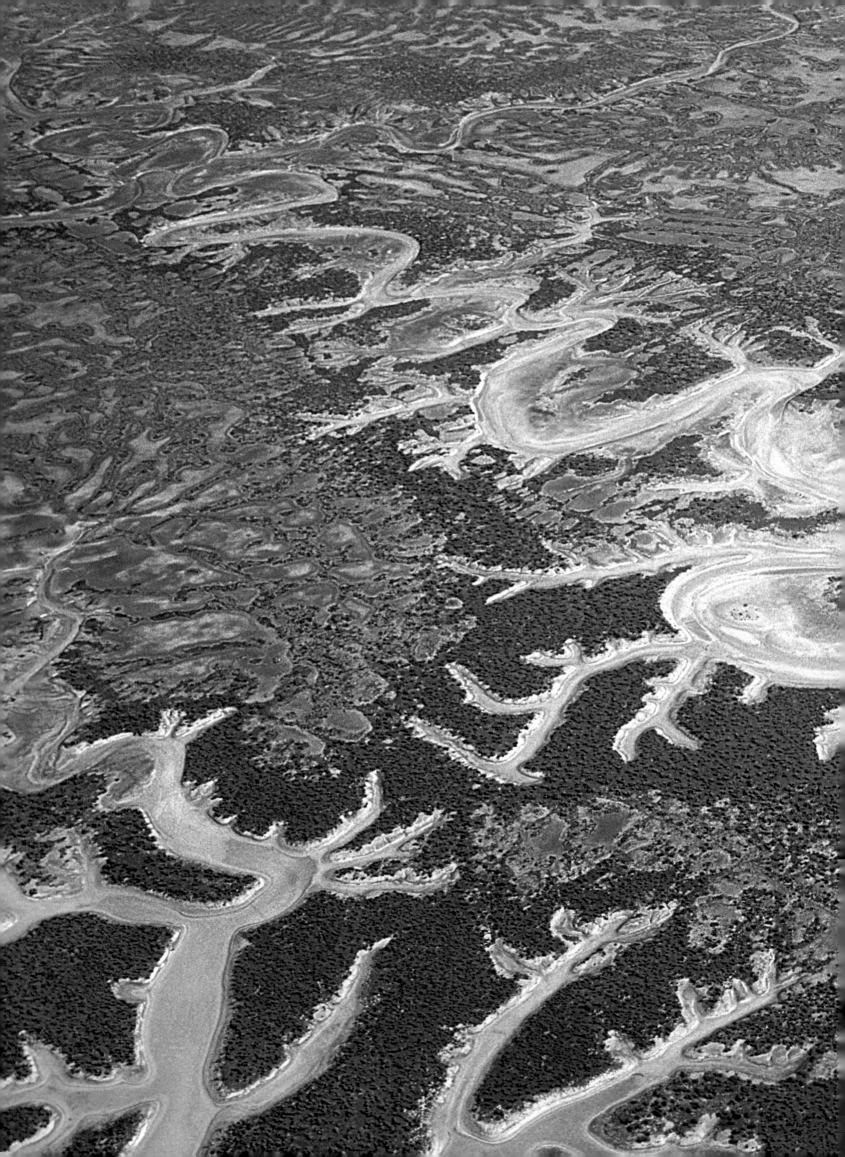

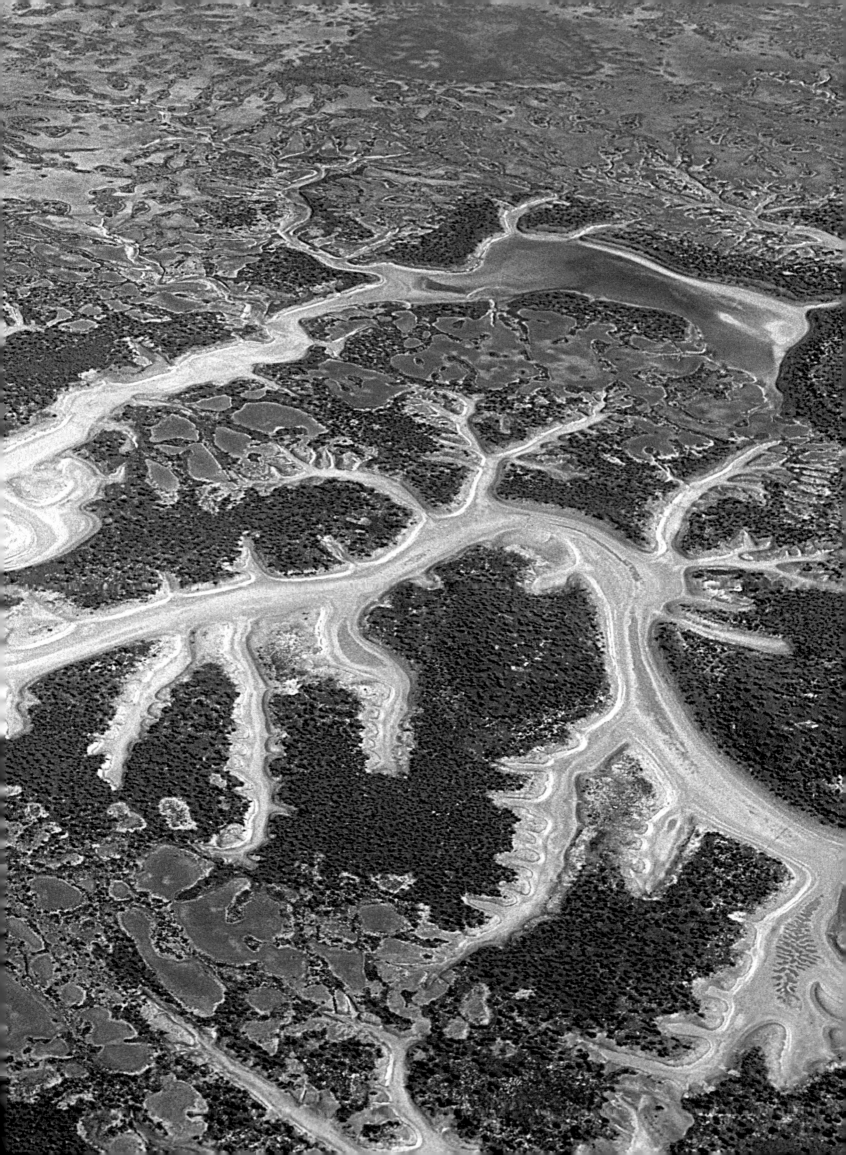

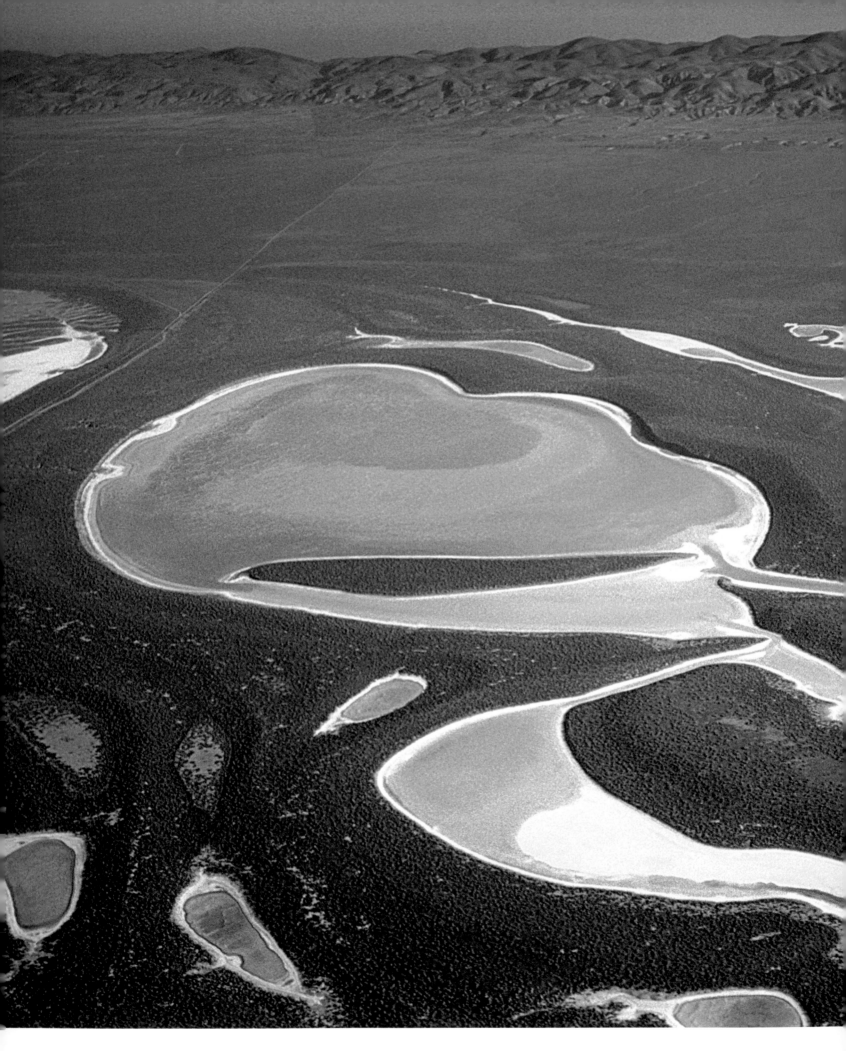

SODA LAKE CAST OF CHARACTERS,
San Luis Obispo County, California.
Froggie and Seahorse, Carrizo Plain
National Monument and Natural Area.
View looks east to the Temblor Range
in the distance (February 2002).

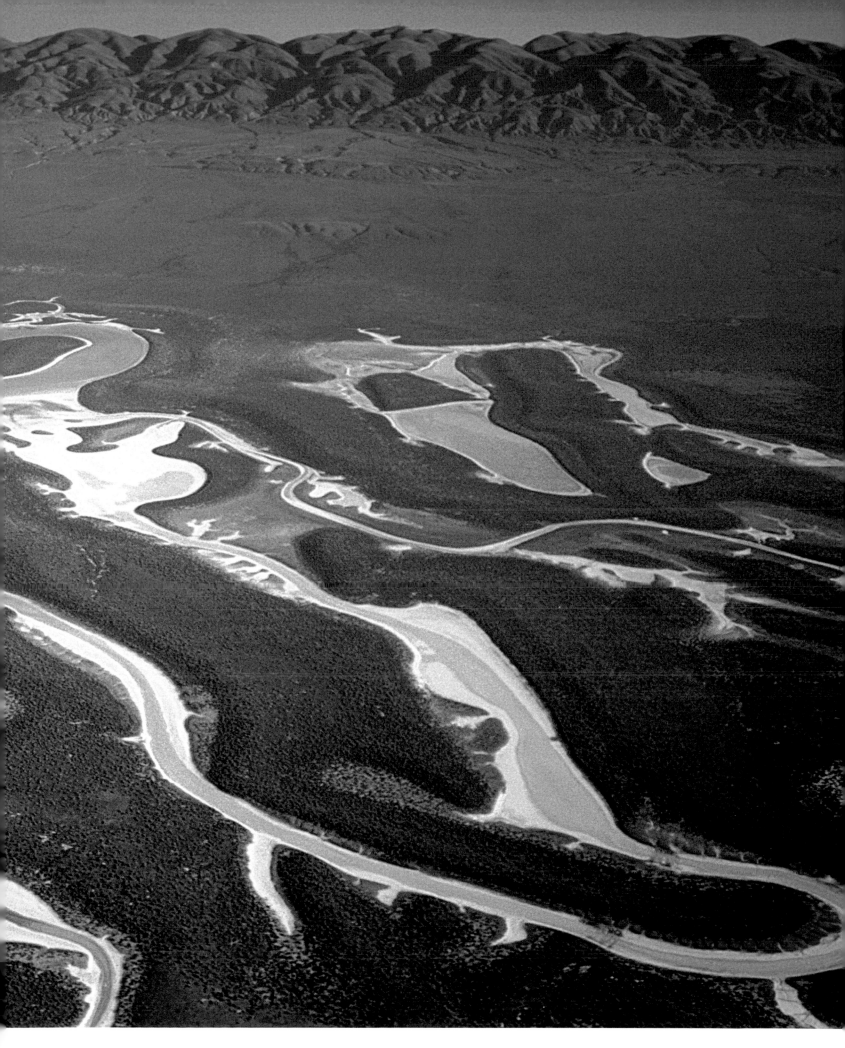

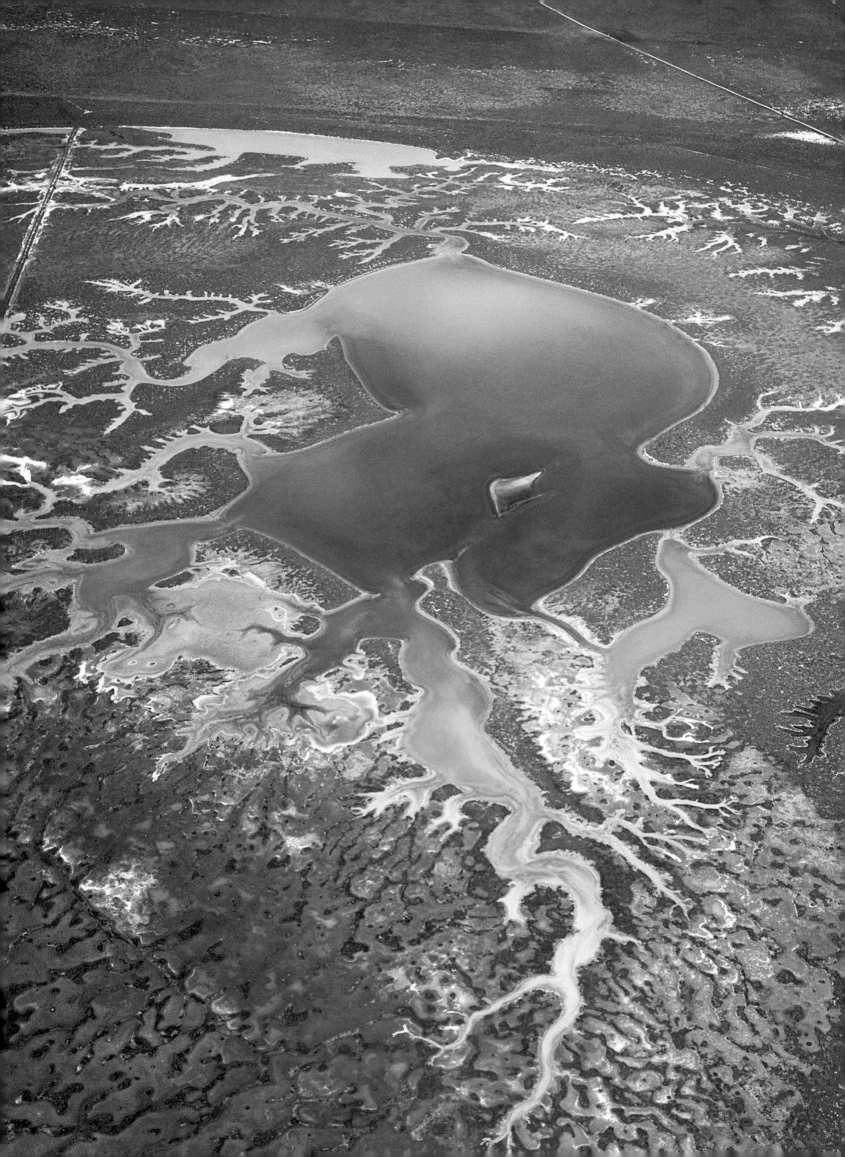

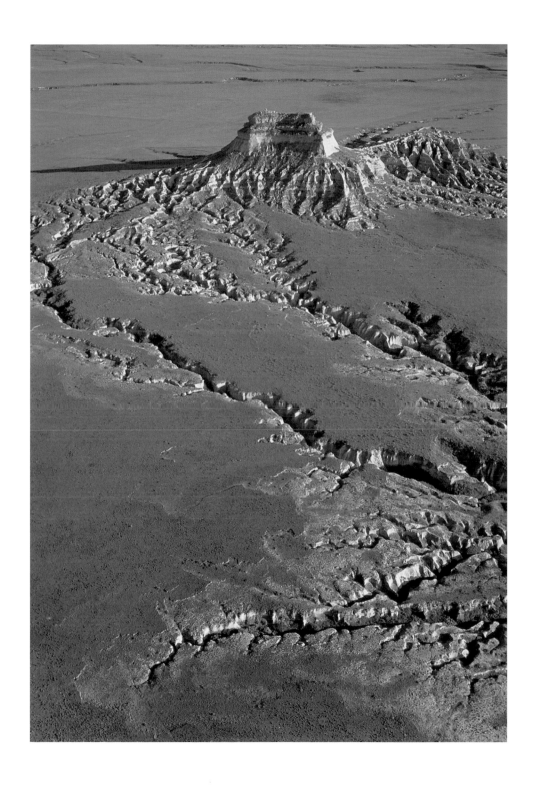

SODA LAKE, San Luis Obispo County,
California. The Carrizo Plain National
Monument is located about 150
miles northwest of Los Angeles.

The stunning magnificence of the area
is best revealed from the aerial view
(April 1998).

GRASSLAND EROSION, Pawnee Buttes
National Grasslands, Weld County,
Colorado (May 1999).

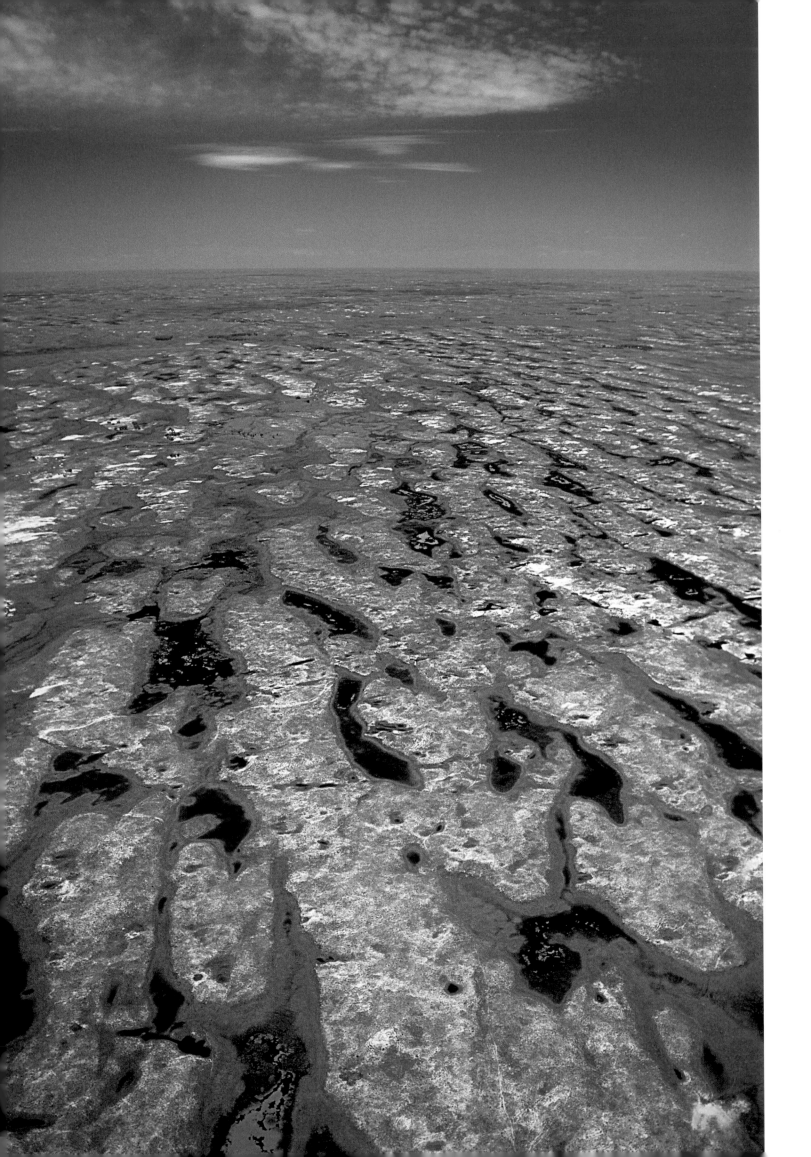

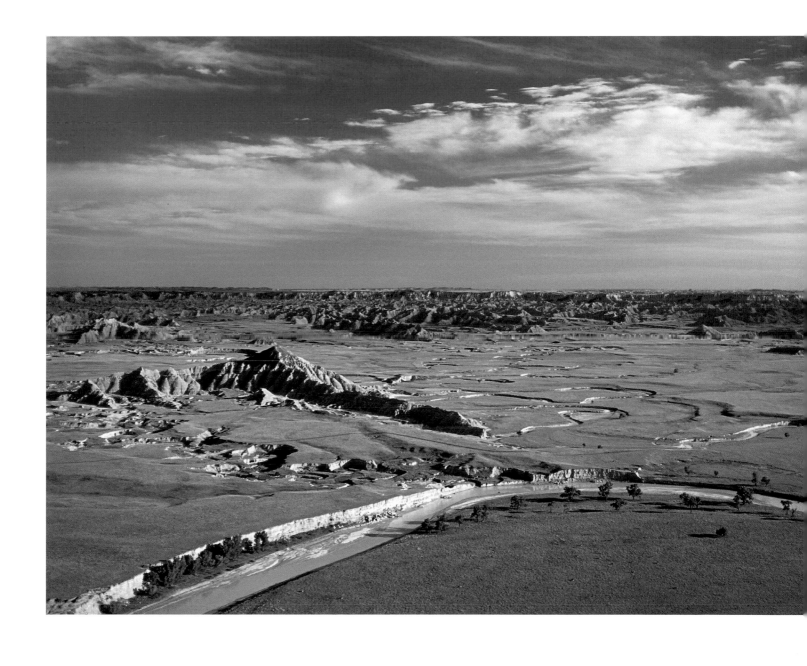

SAND HILLS, Loup County, Nebraska. The Sand Hills of Nebraska cover 24,000 square miles, more than one-fourth of the state. Most of it is barren and unsuitable for cultivation, but it does support some cattle ranching.

The area is underlain by the huge Ogallala Aquifer. Despite its unique geography and rich biodiversity, only a few thousand acres are protected (June 2001).

BADLANDS NATIONAL PARK, Shannon County, South Dakota. Designated as a national monument in 1929, it was re-designated as a national park in 1978. One hundred square miles of the

park's total 380 square miles is a designated wilderness area and is home to the country's single most endangered species—the black-footed ferret (June 1994).

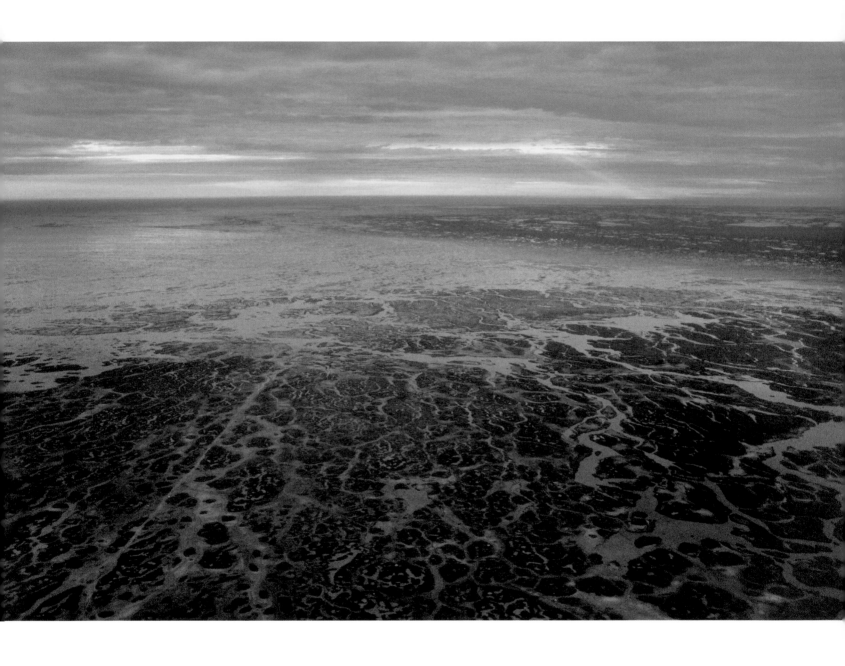

COASTAL WETLAND, Button Bay, north of Churchill, Hudson Bay, Manitoba. This area abounds with polar bears and beluga whales (August 1995).

TUNDRA, National Petroleum Reserve, North Slope, Alaska. What you don't see here in this colorful, idyllic tundra scene are the bugs. It is estimated that 10 percent of the Earth's land area can be classified as tundra (June 1993).

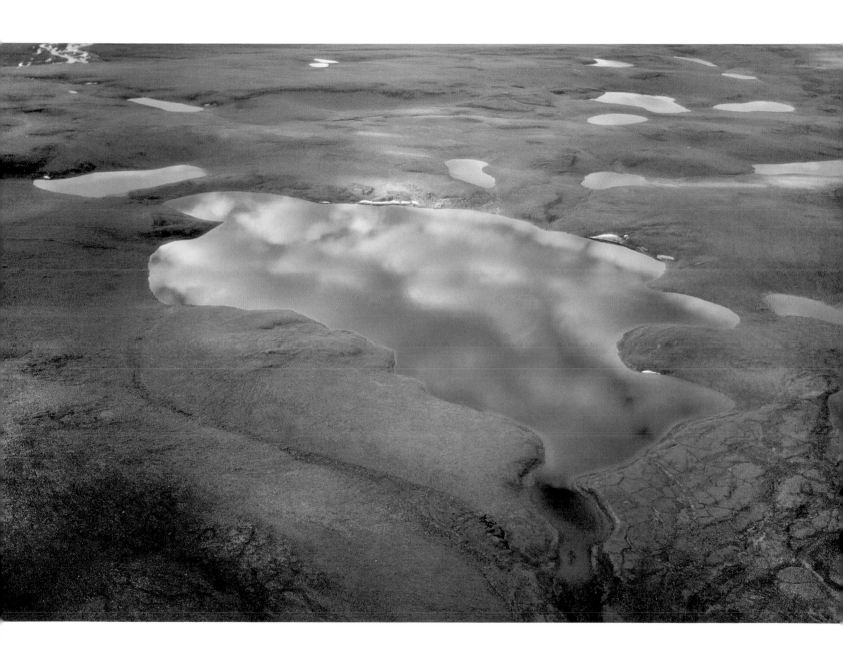

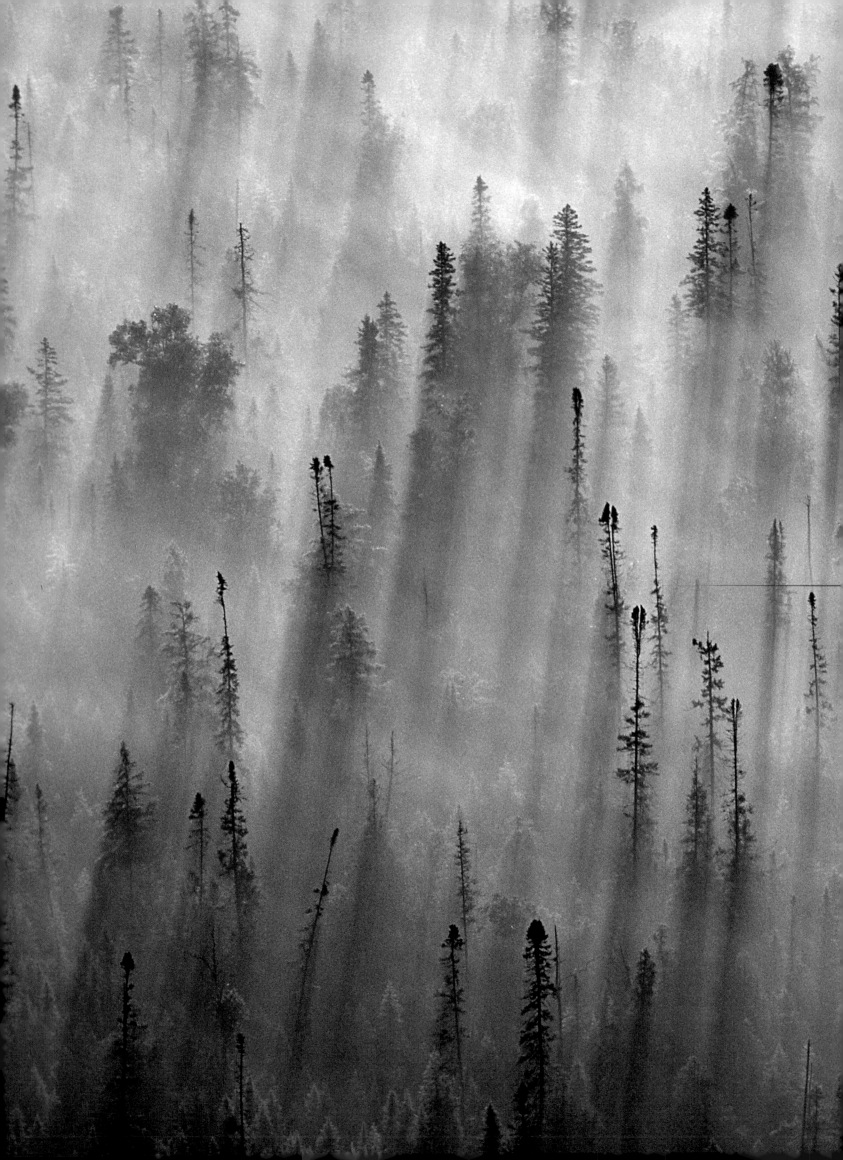

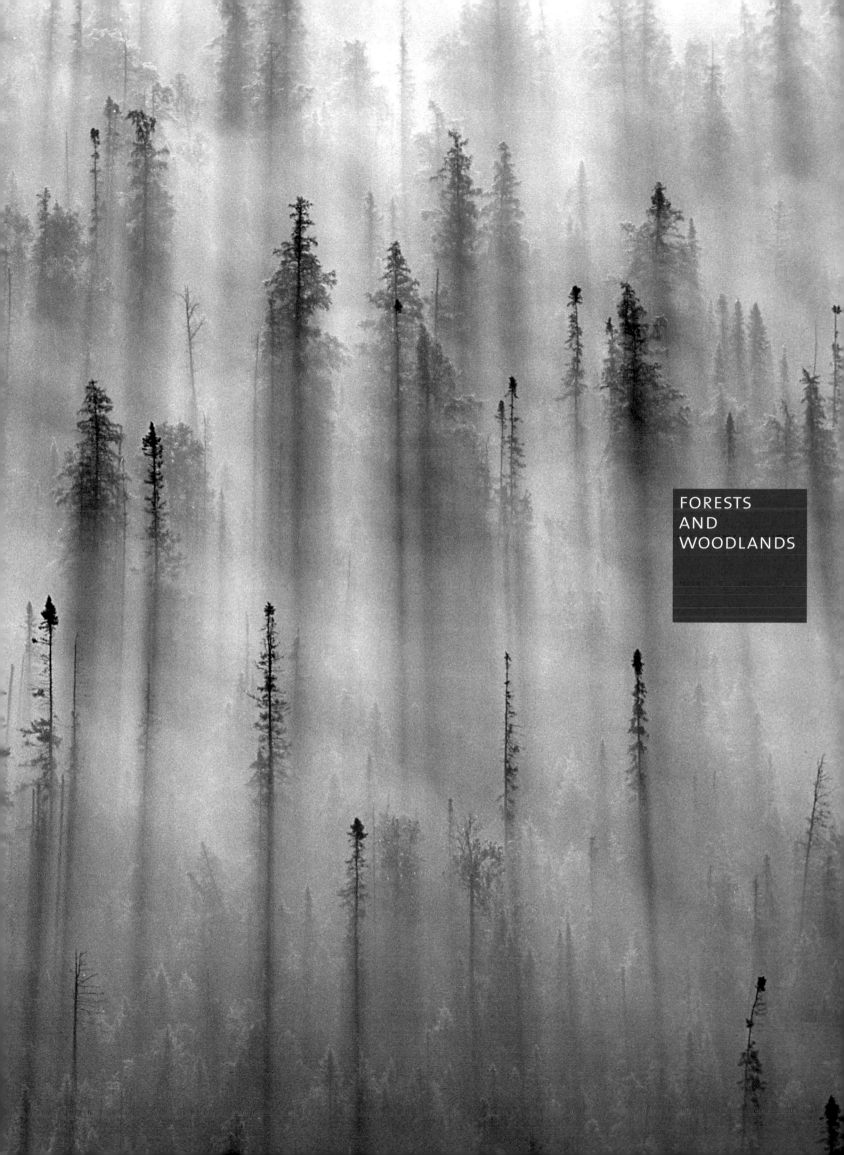

FORESTS
AND
WOODLANDS

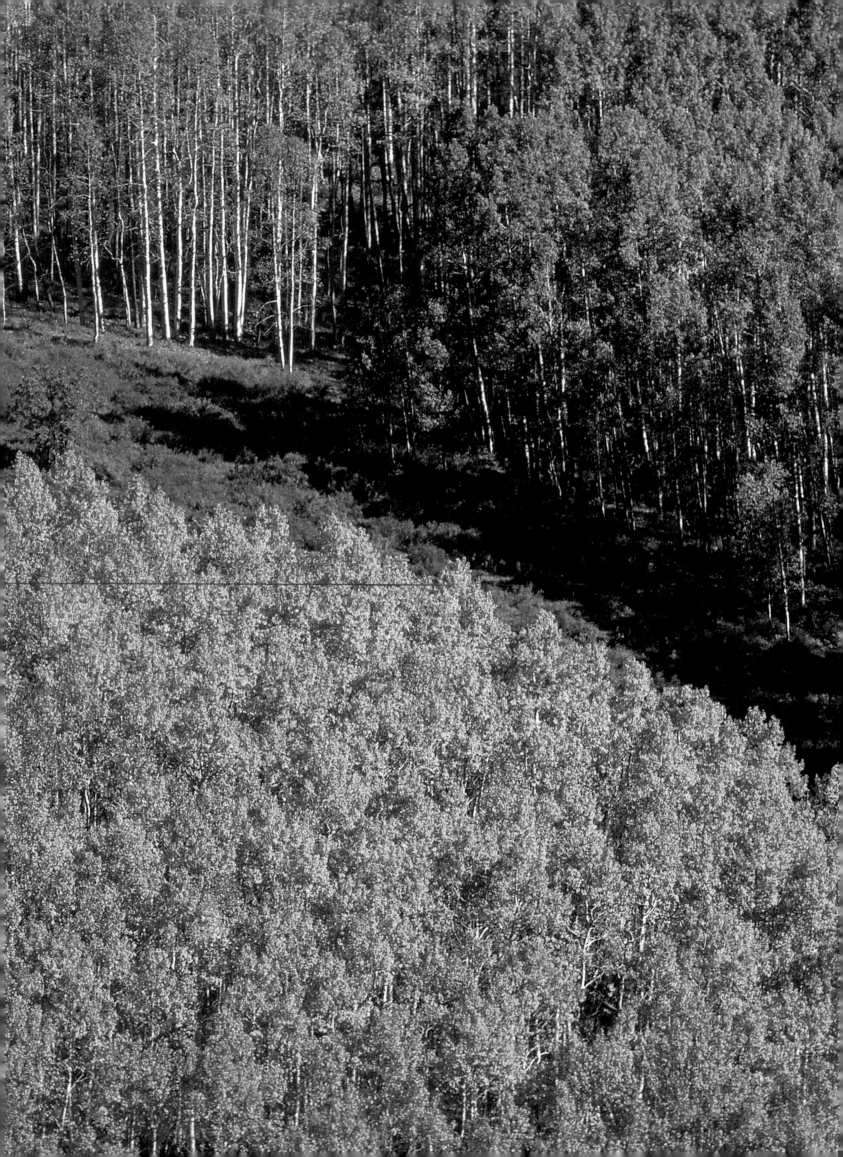

THE RATIONALE WITH WHICH APPRECIATION of wilderness began, and which has sustained most preservation achievements to date, was almost entirely anthropocentric. Scenery, recreation, and the economics of a new nature-based tourism fueled the call of the wild. Sportsmen, like Theodore Roosevelt, respected wild animals but mostly when they were in their rifle sights. More sophisticated, but no less utilitarian, were ideas of wilderness as a church, a source of national pride, a stimulant to art and literature, and a psychological aid. Even the ecological angle, which understood wilderness as a kind of biological safe deposit box, was initially very instrumental. The cure for human cancer, for instance, might come from the chemistry of an organism that only lives in unknown, undisturbed environments. But there were higher, less utilitarian horizons in the valuation of wild land waiting in the wings of American thought.

The ecocentric defense of wilderness derives from the relatively recent idea that non-human life and wild environments have intrinsic value and the right to exist regardless of their importance to human beings. Wilderness preservation from this perspective is a gesture of planetary modesty on the part of a species notorious for its selfishness. It's a manifestation of much-needed capacity for restraint, a way to share the spaceship on which all life travels together. And there is no doubt about the fact that we have been a bad neighbor to most of the millions of other species that are trying to share this planet. What our species needs is a planetary time-out; a lesson in how to share. Bottom line: we don't act like members of an ecological community or, if we are a part, it is a toxic one, endangering the larger whole.

FORESTS AND WOODLANDS

The roots of the ecocentric valuation run back to Henry David Thoreau's 1859 belief that "wildness is a civilization other than our own." John Muir wrote about "the rights of all the rest of Creation" that our species consistently ignored since the beginnings of herding and agriculture. In the last few decades environmental ethics and deep ecology have called attention to the possibility that rights and ethical obligations do not end with human-to-human relationships but rather extend to the farthest limits of nature. Americans, especially, should not find the concept strange because our nation began on a philosophical platform of natural rights that has expanded impressively since 1776. The abolition of slavery and women's liberation are two of the best-known milestones. Legislation, like the Endangered Species Act (1973), suggests that natural rights can extend to the rights of nature.

Protecting wilderness is an expression of the idea that nature is a community to which we belong, not a commodity we possess. To keep land wild is to restrain our technological power to conquer and have dominion. Think about self-willed land: we didn't make it, we don't "own" it, in fact, it's not about us at all! In the words of the 1964 Wilderness Act, we go to designated wilderness as "visitors." Many now understand this to mean that we are entering someone else's home. Consequently, there are house rules to be followed. The first one is not to trash our host's residence! Of course this kind of limitation entails a compromise of our freedom. It's a familiar concept—the price we have long paid for membership in human society. John Locke called it the "social contract." Maybe it's time to define a broader "ecological contract" and an enlargement of the concept of community. Maybe respect for wilderness could be the cutting edge of an expanded, environmental ethic and the key to a kinder, gentler, and more sustainable relationship with Earth and all its inhabitants.

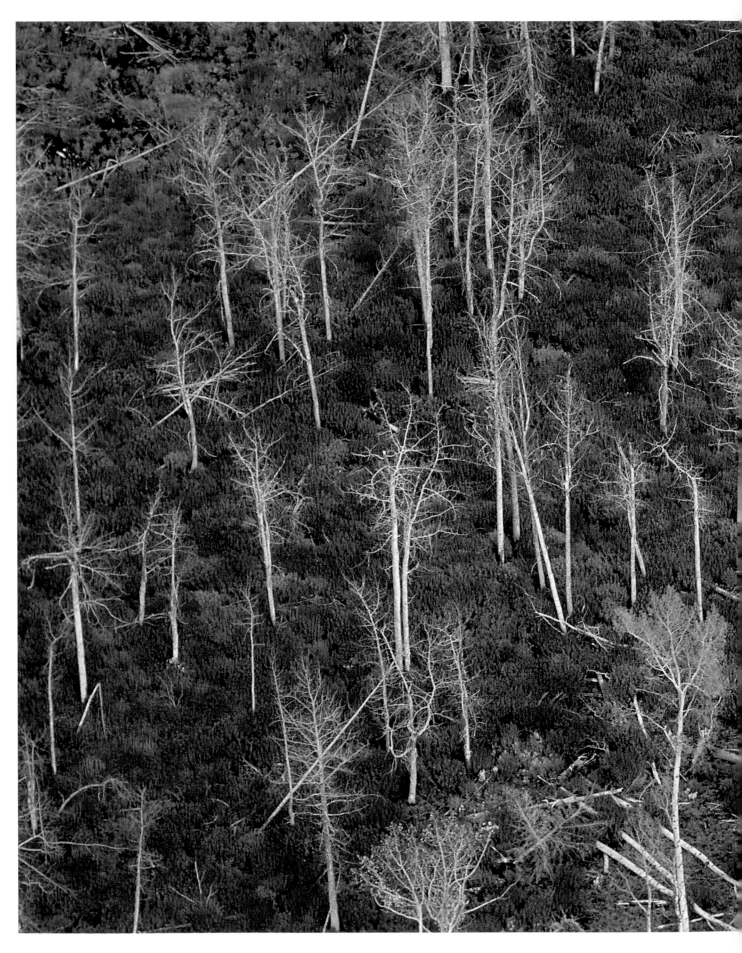

FIREWEED, Tanana Valley State Forest, Alaska. Fireweed is a pioneer species herb that thrives in open spaces, such as recently burned forest areas. When new growth shades it out, the seeds lie dormant until the next fire. Two years after being burned, this forest near Tok is making rapid recovery (July 1992).

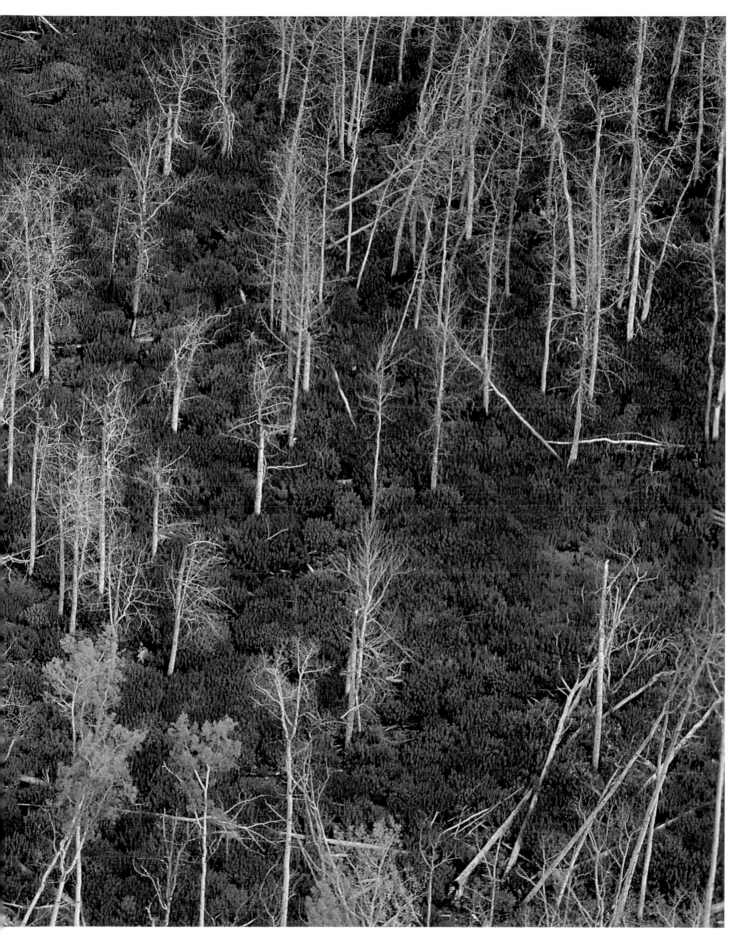

(PRECEDING PAGE) ASPEN COMMUNITIES, Uncompahgre Plateau, Uncompahgre National Forest, Montrose County, Colorado. In this photo three distinct biological units are evident by the different stages of autumn leaves (September 1999).

(CHAPTER OPENER) FOREST IN FOG, Goulias Point, Ontario. On Lake Superior's north shore, twenty-five miles north of Sault Ste. Marie (June 1996).

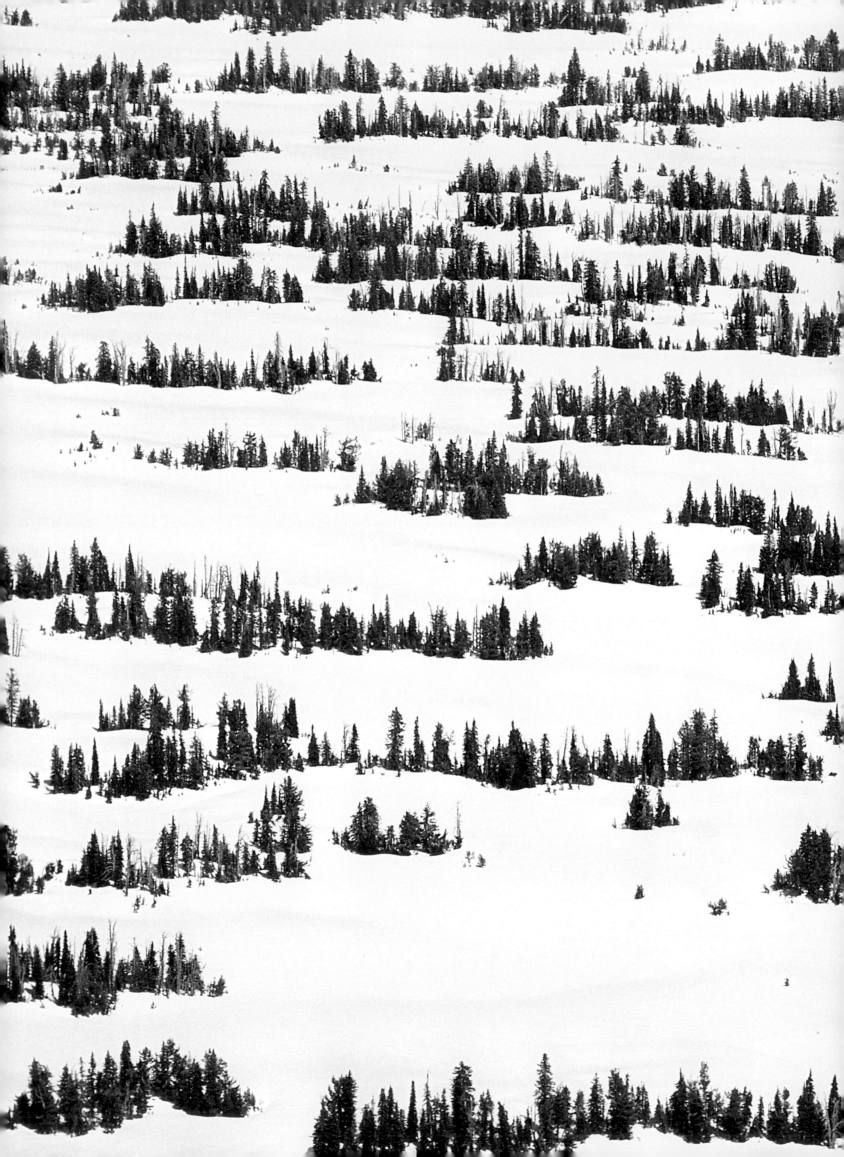

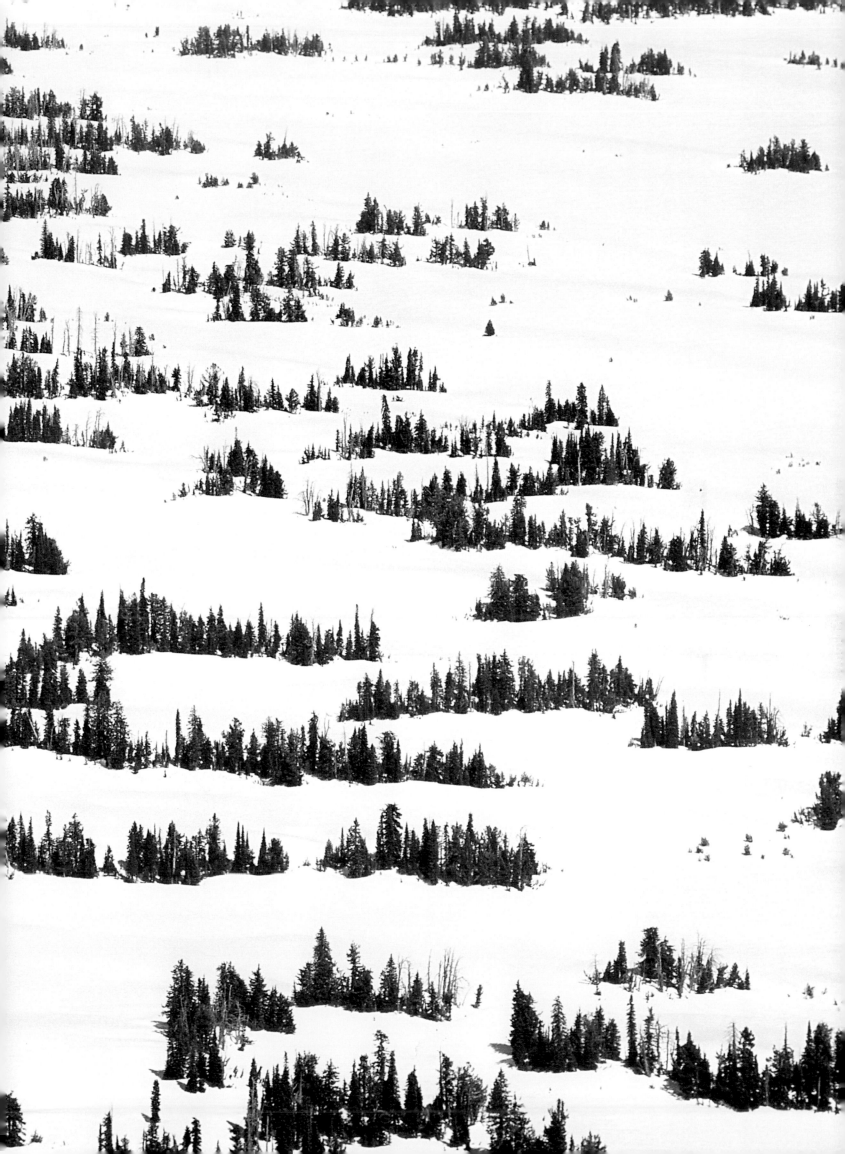

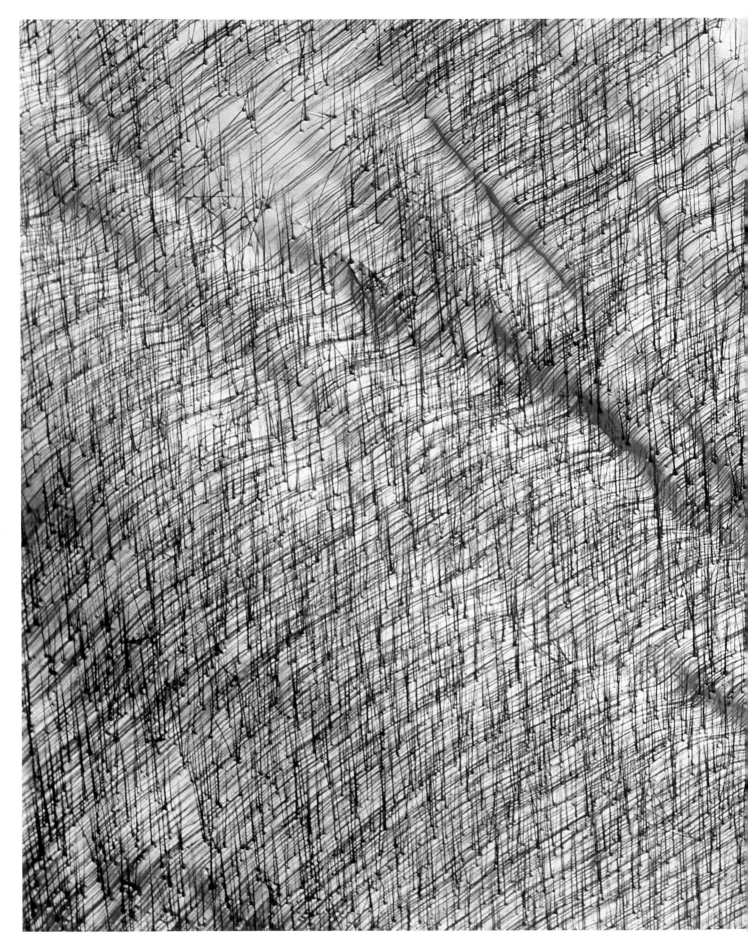

AFTERMATH, Yellowstone National Park, Teton County, Wyoming (May 1999). Ten years after the great park wildfires of 1989.

(PRECEDING PAGES) KRUMHOLTZ VEGETATION, Yellowstone National Park, Teton County, Wyoming. Krumholtz topography such as this is found on windblown arctic or alpine terrain.

The vegetation is fragile with shallow roots (April 2001).

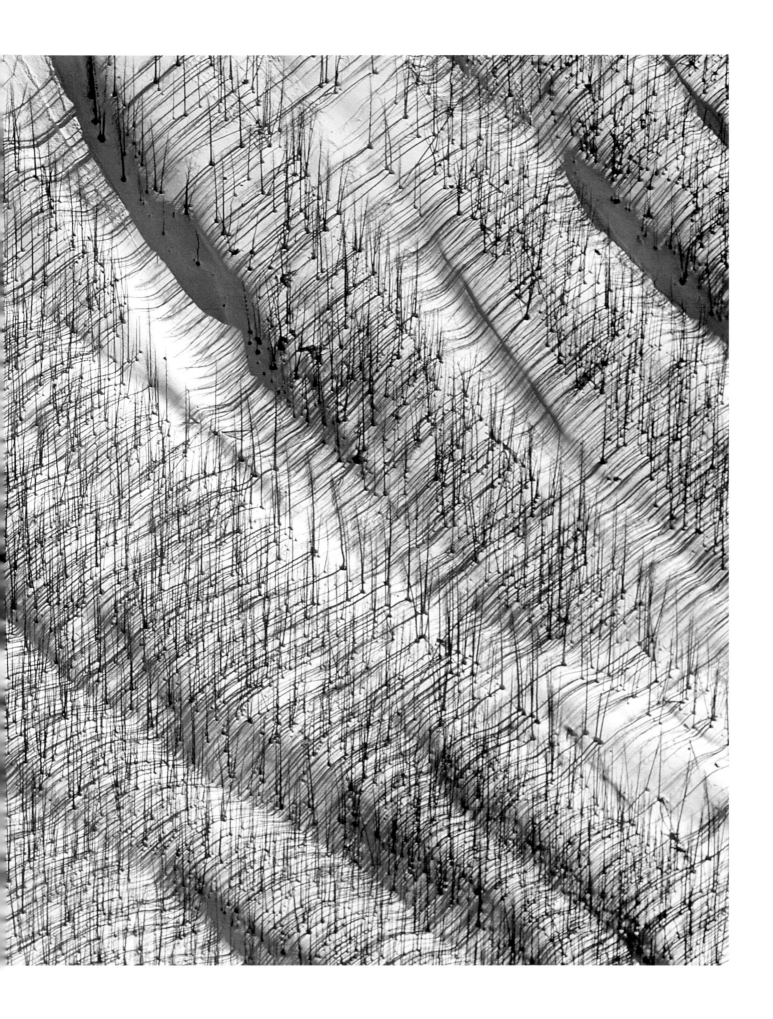

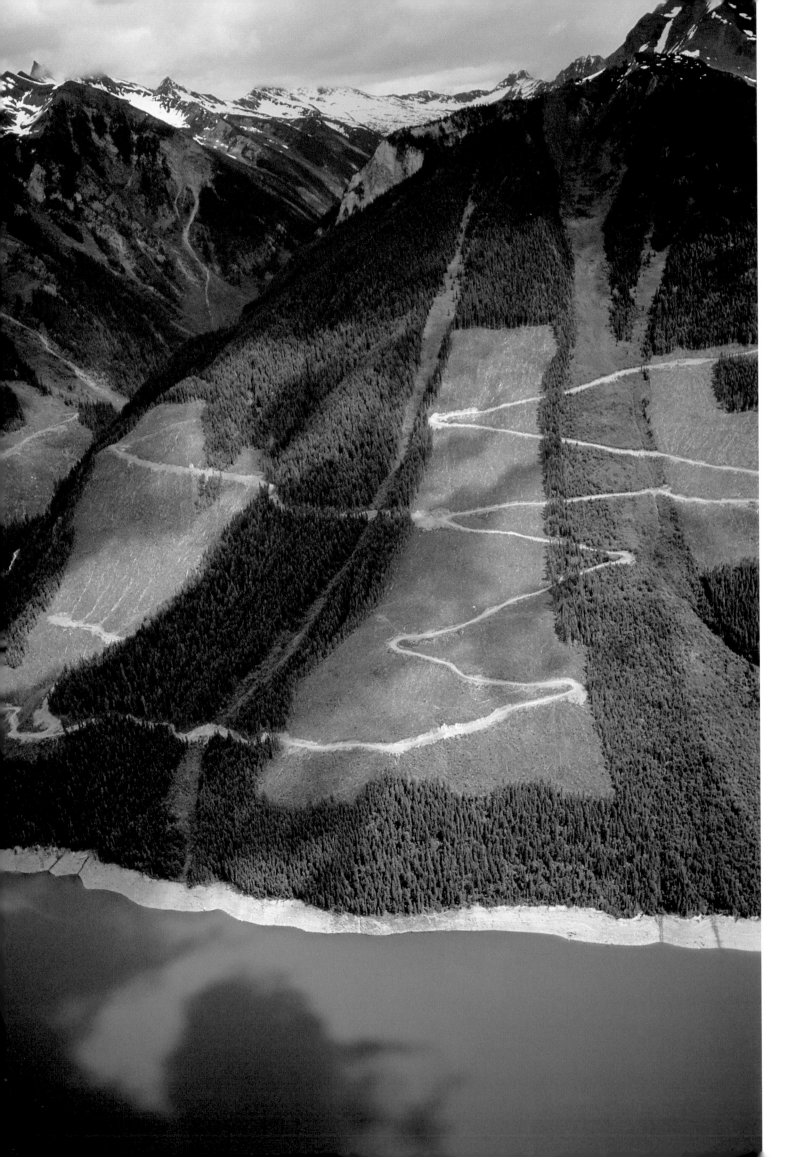

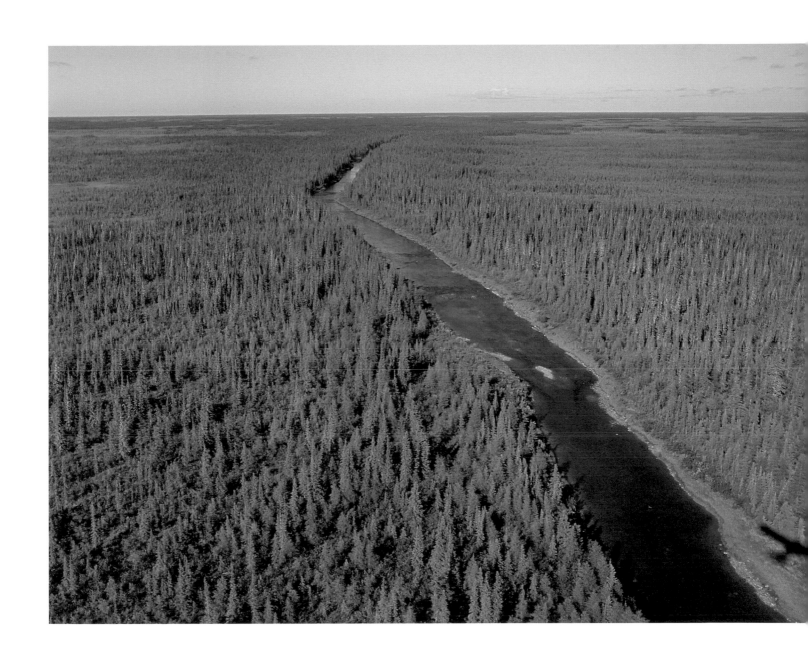

CLEAR CUTS, Columbia Reach, British Columbia. On the Columbia River, Selkirk Mountains, near Glacier National Park (July 2003).

SNOW FOREST, Churchill River, Manitoba. I define it as silence. In W. Koppen's climatic classification, a "snow forest" is defined by a coldest-month mean temperature of less than 26.6 degrees Fahrenheit and a warmest-month mean temperature of greater than 50 degrees Fahrenheit. This location is between Gillam and Churchill, northeast Manitoba (August 1998).

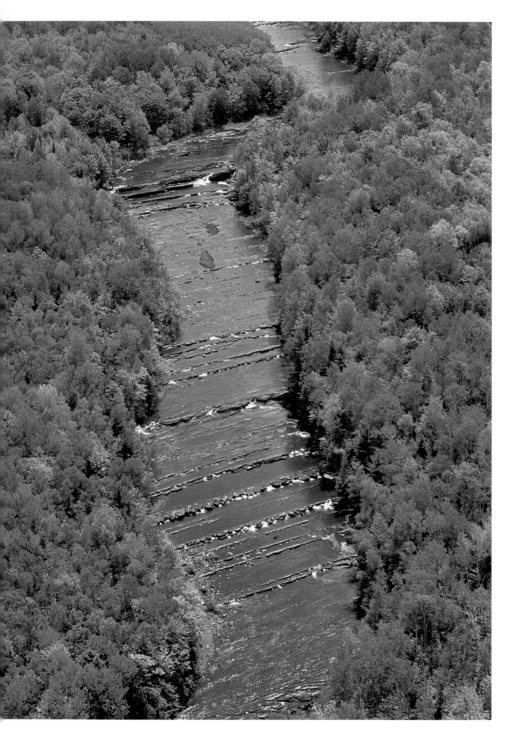

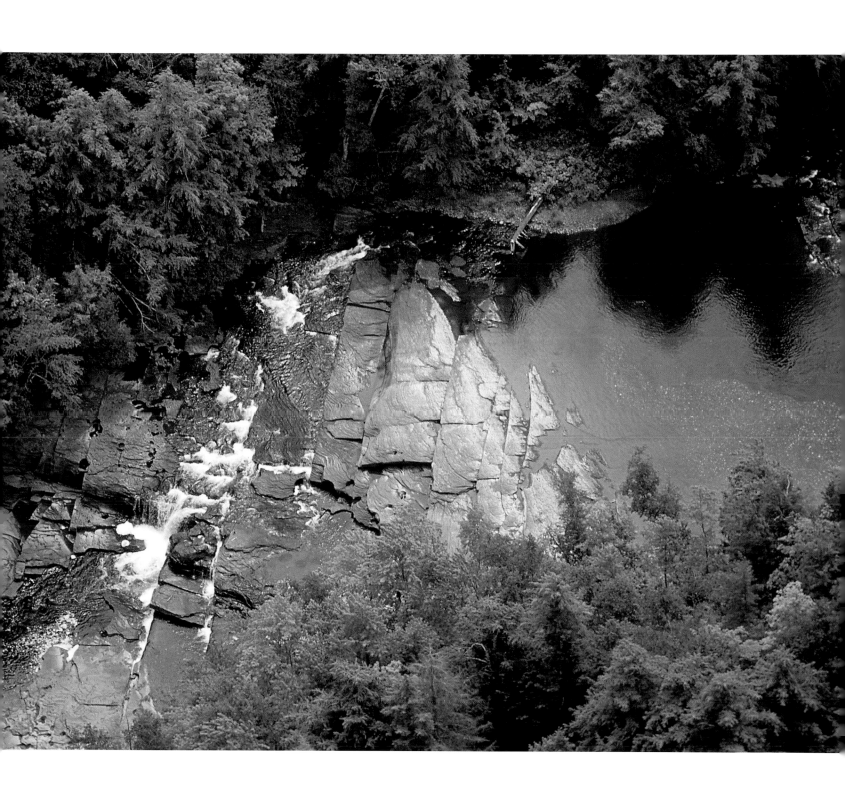

IRON RIVER, Lake Superior Shore,
Ontonagon County, Upper Peninsula,
Michigan. Adjacent (on the east) to
Porcupine Mountains Wilderness State
Park. This river flows into Lake Superior
near Silver City, MI (June 2005).

PRESQUE ISLE RIVER, Porcupine
Mountains Wilderness State Park,
Gogebic County, Upper Peninsula,
Michigan. Typical north-woods
vegetation near Lake Superior shore
(July 2007).

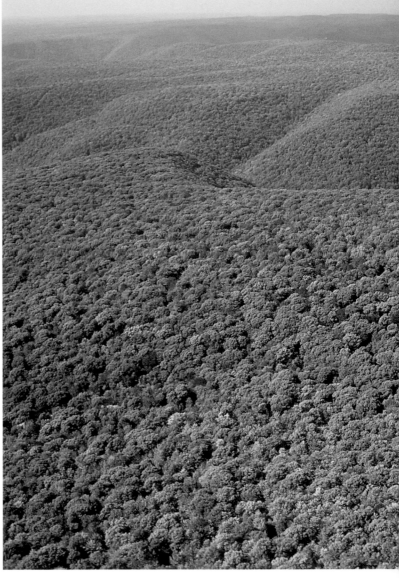

AUTUMN PANORAMA, Otter Creek Wilderness, Monongahela National Forest, Tucker and Randolph Counties, West Virginia. This hardwood forest was almost completely logged at the turn of the twentieth century, but by 1975 it had recovered enough to be designated a wilderness area (October 2000).

FOREST EXPANSE, Susquehannock State Forest, near Emporium, Potter County, Pennsylvania. Nowhere in North America do I know of such vast areas of unbroken woodlands as exist on the Allegheny Plateau of central Pennsylvania (September 2007).

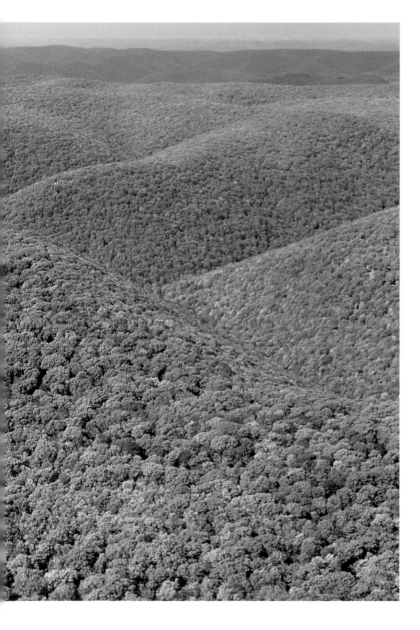
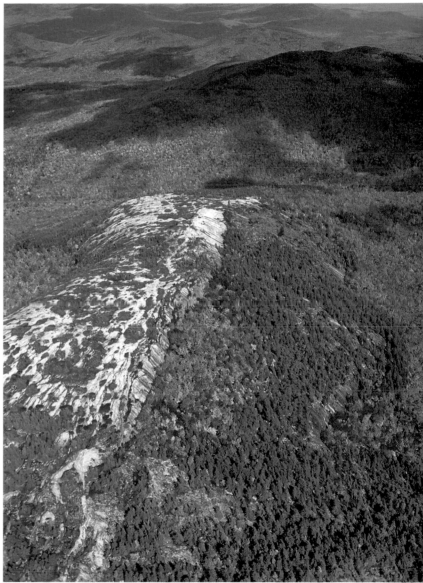

WHITECAP MOUNTAIN, Appalachian
Trail, 100 Mile Wilderness, Piscataquis
County, Maine. Autumn color surrounds
the granite pegmatite cap of Whitecap
Mountain (October 2000).

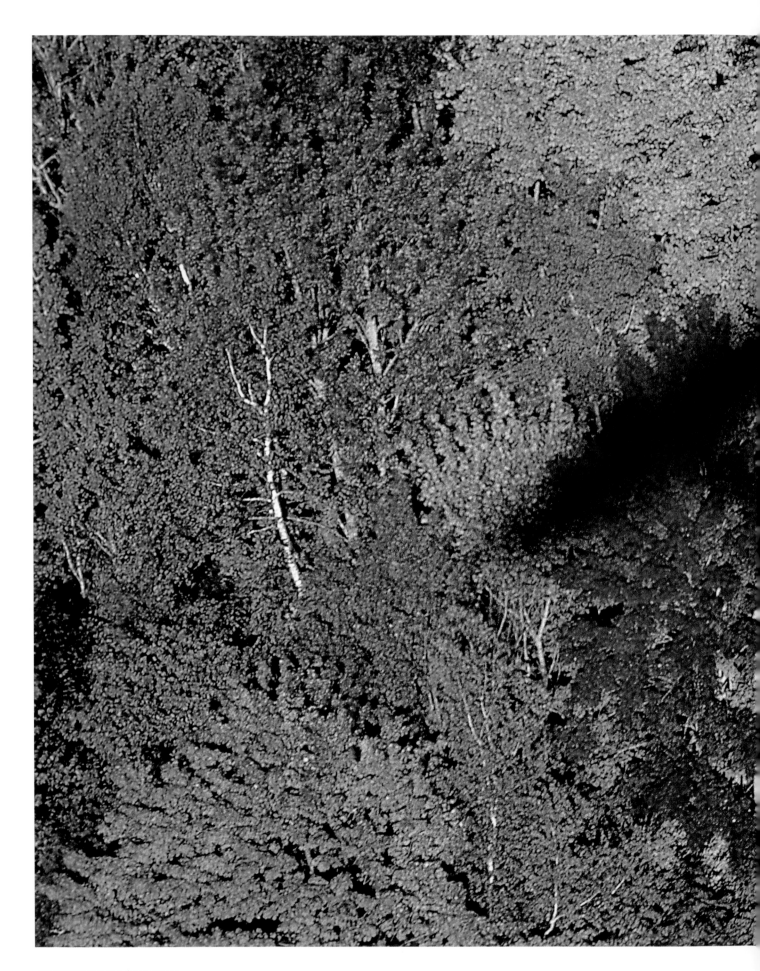

AIRPLANE SHADOW, Penobscot County,
Maine (September 1994).

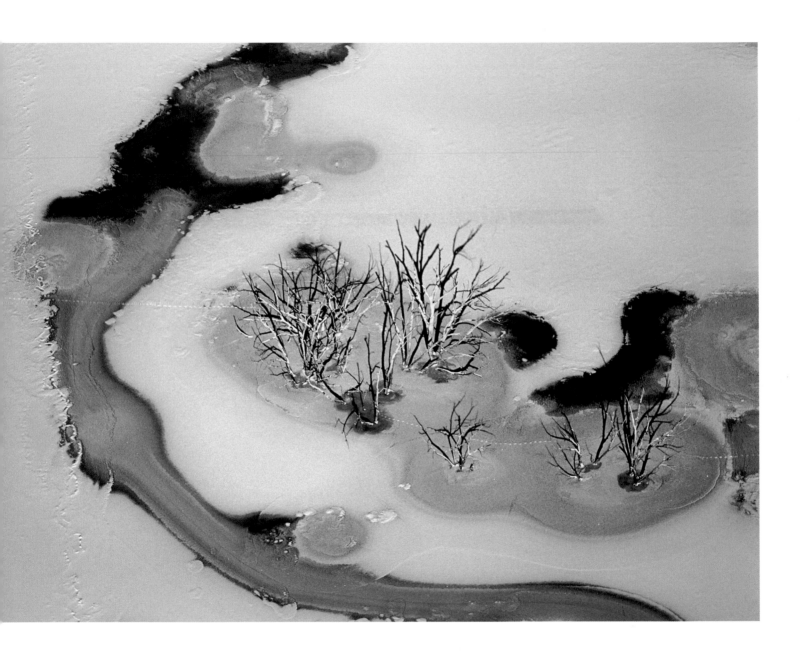

TREES IN ICE, Lake Pueblo State Park, Arkansas River, Pueblo County, Colorado (December 1998). This small grove of trees is a remnant of a woodland submerged by the creation of the Pueblo Reservoir in 1975.

WINTER ASPEN, Cedar Mountain, Ashdown Gorge Wilderness, Dixie National Forest, fifteen miles southeast of Cedar City, Iron County, Utah (January 1995).

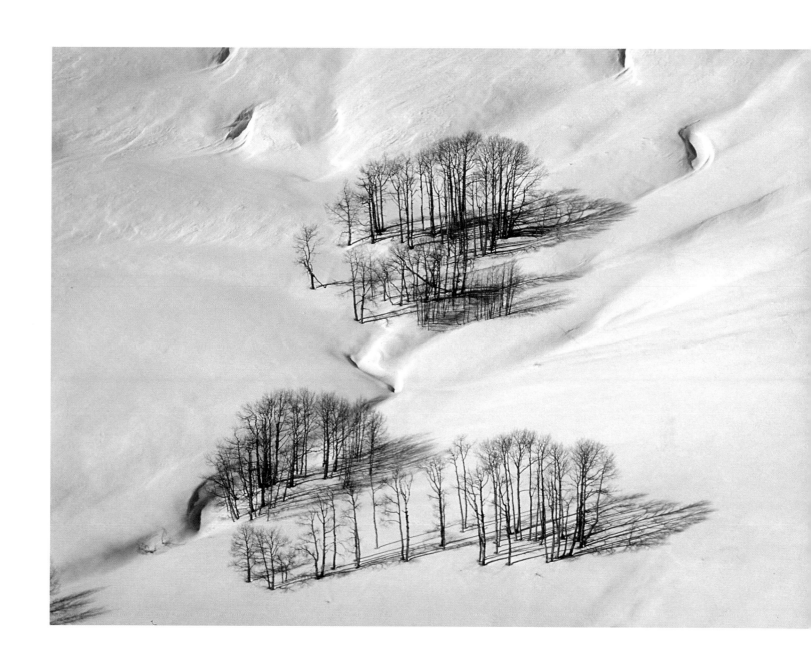

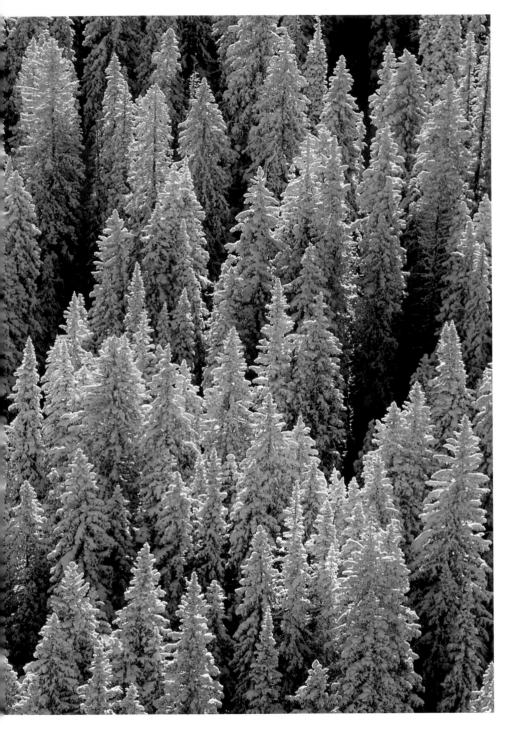

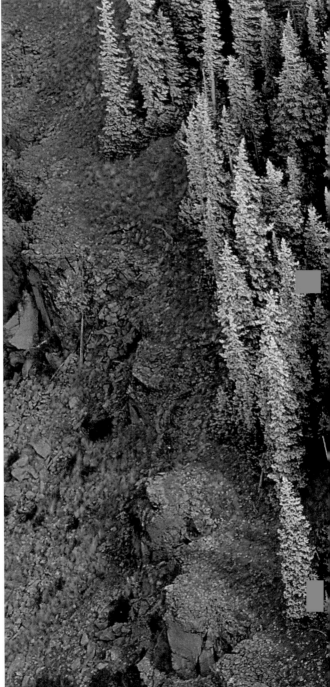

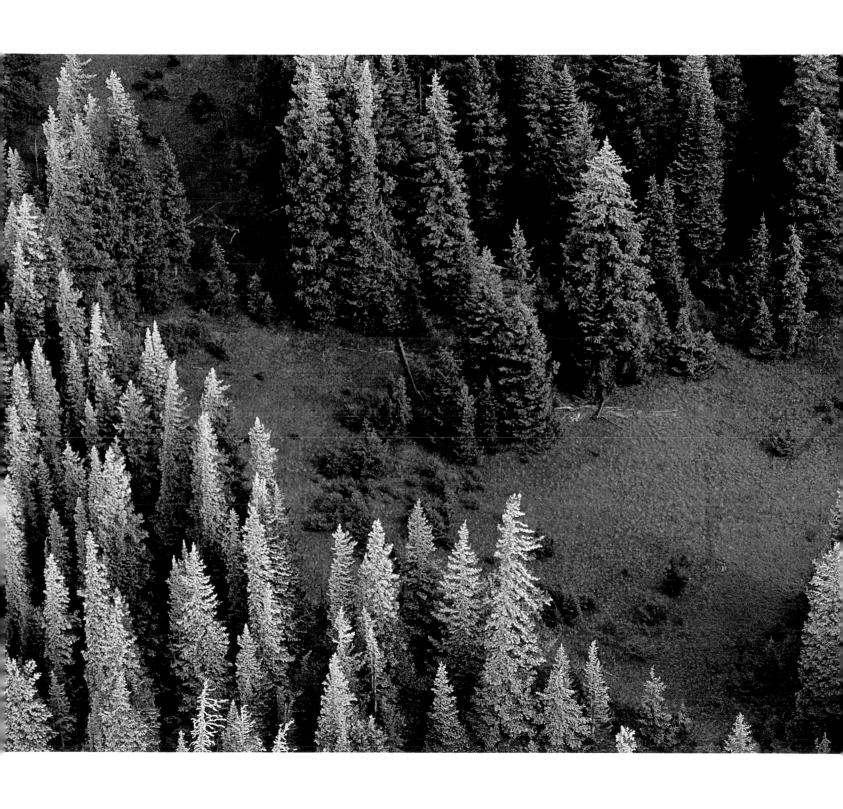

SNOW LADEN FOREST, Chalk Mountains, San Juan National Forest, Archuleta County, Colorado (January 2001).

BANDED PEAK, South San Juan Wilderness, Rio Grande National Forest, San Juan Mountains, Archuleta County, Colorado. Mountain-top fir trees get their first taste of the coming winter. Elevation here is about 10,000 feet (October 1991).

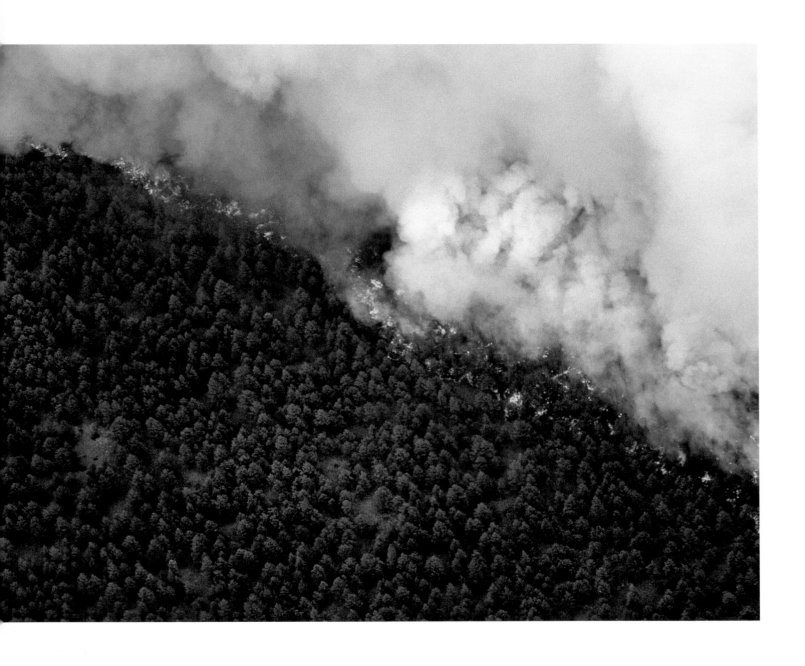

WILDFIRE LINE, Colfax County, New Mexico (June 2002).

MAIO-VEGA WILDFIRE, La Veta Pass, Sangre de Cristo Mountains, Costilla County, Colorado. Such fires are surrounded by no-fly zones to provide protected airspace for fire-fighting aircraft. This photo was taken from 14,000 feet (June 2006).

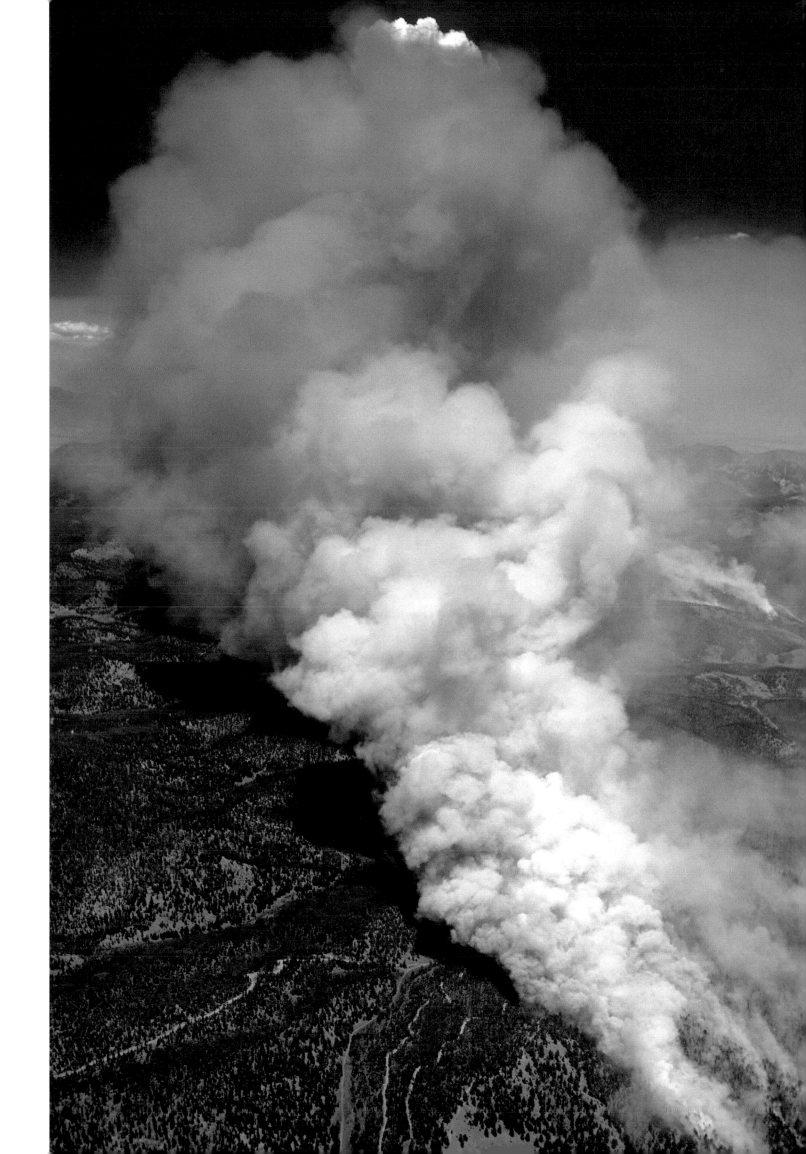

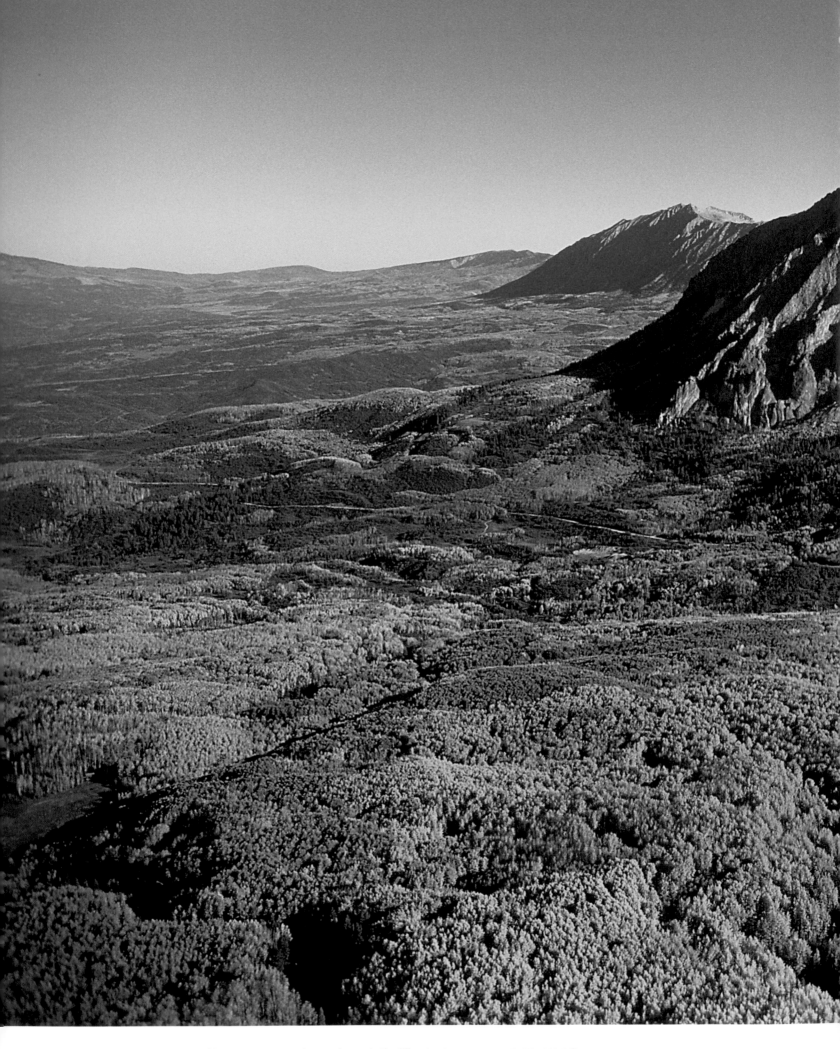

ASPEN COMMUNITIES, Kebler Pass, Gunnison County, Colorado. Aspen groves form a single organism through their root system. The individual organisms can be seen by the different colors of the turning leaves. Marcellina Mountain is seen in the distance (September 1992). (FOLLOWING PAGES) ASPEN GROVE, Taos County, New Mexico (October 1993).

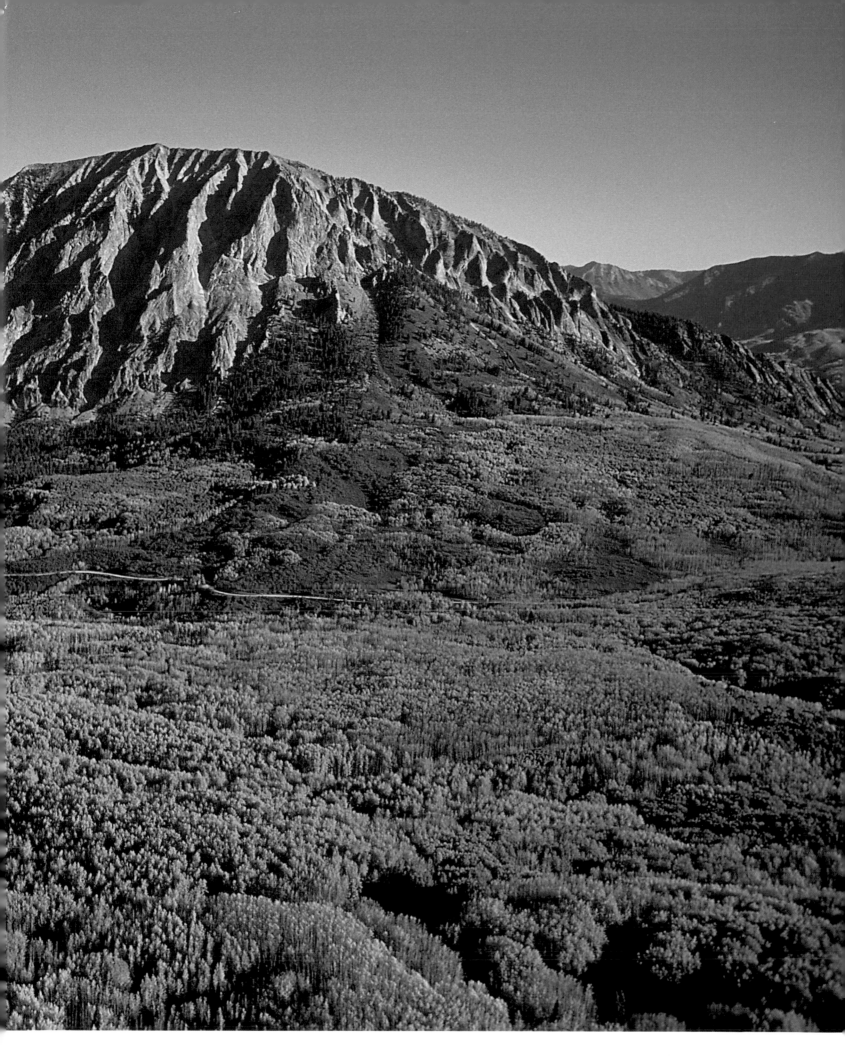

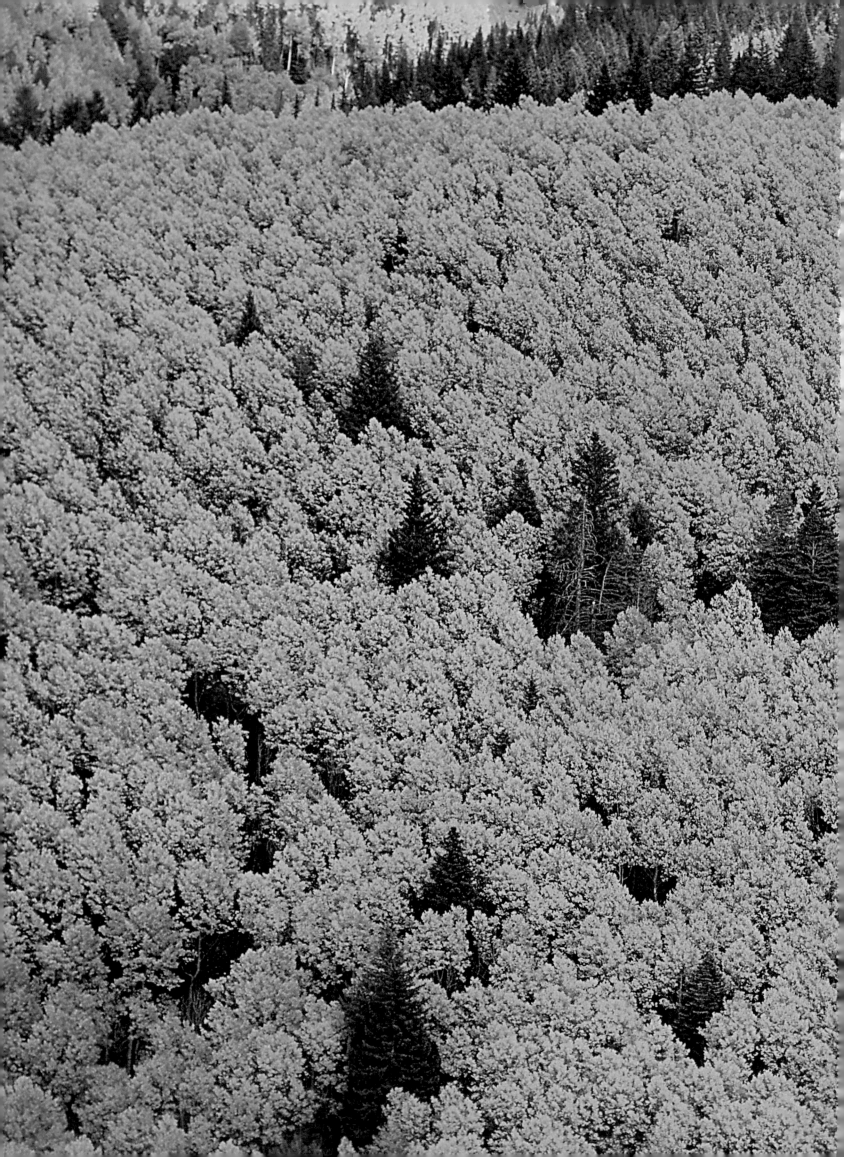

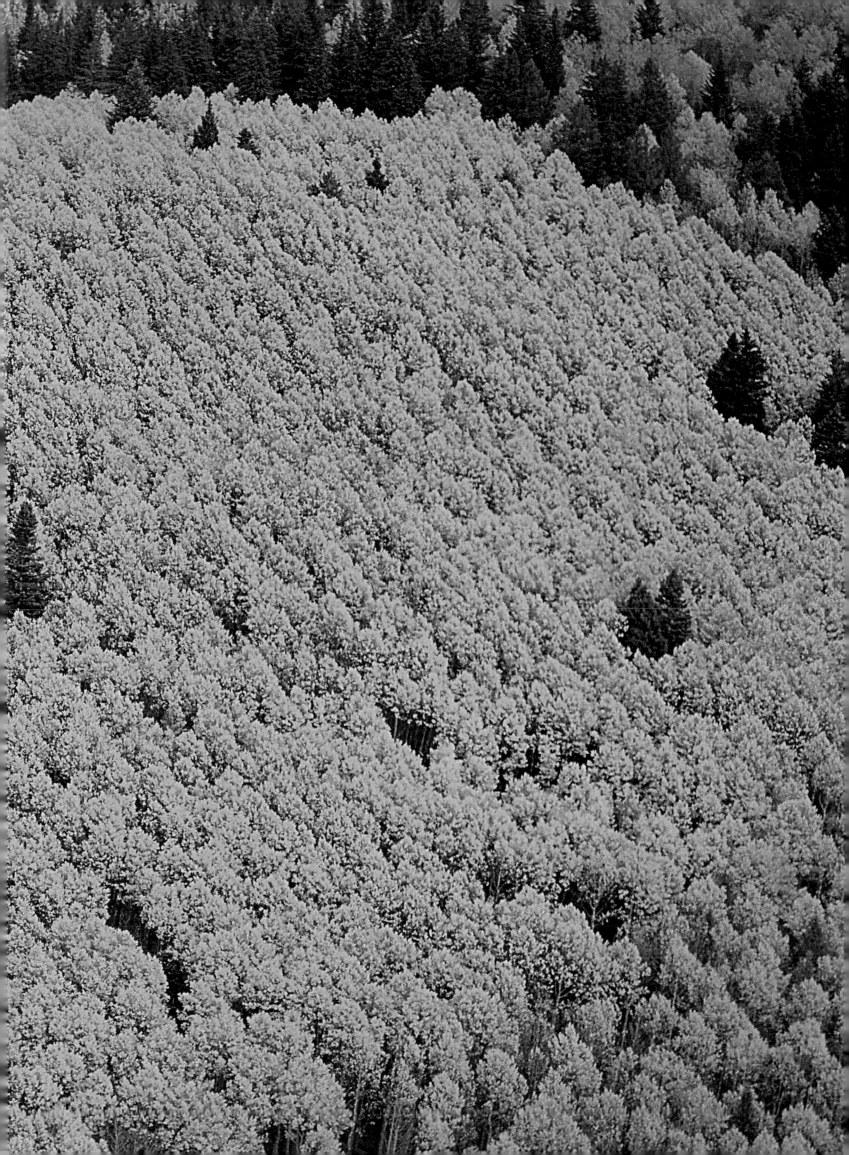

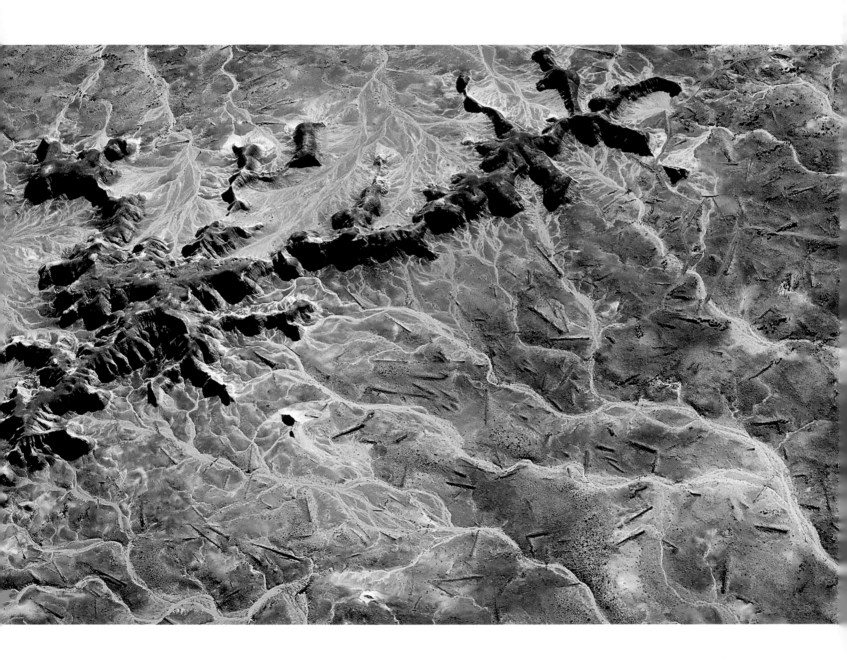

PETRIFIED FOREST, Petrified Forest
National Park, Apache County, Arizona
One can only fantasize as to what a
forest wilderness experience would be
like in the late Triassic Period

(225 million years ago). These trees
were buried in sediment and volcanic
ash and preserved in what is now
known as the Chinle Formation
(January 1999).

BLOWDOWN, Mount Zirkel Wilderness,
Routt National Forest, Routt County,
Colorado. The devastation from the
100-mph storm of October 1997 is seen
here. It will take centuries for this forest
to fully recover (September 1999).

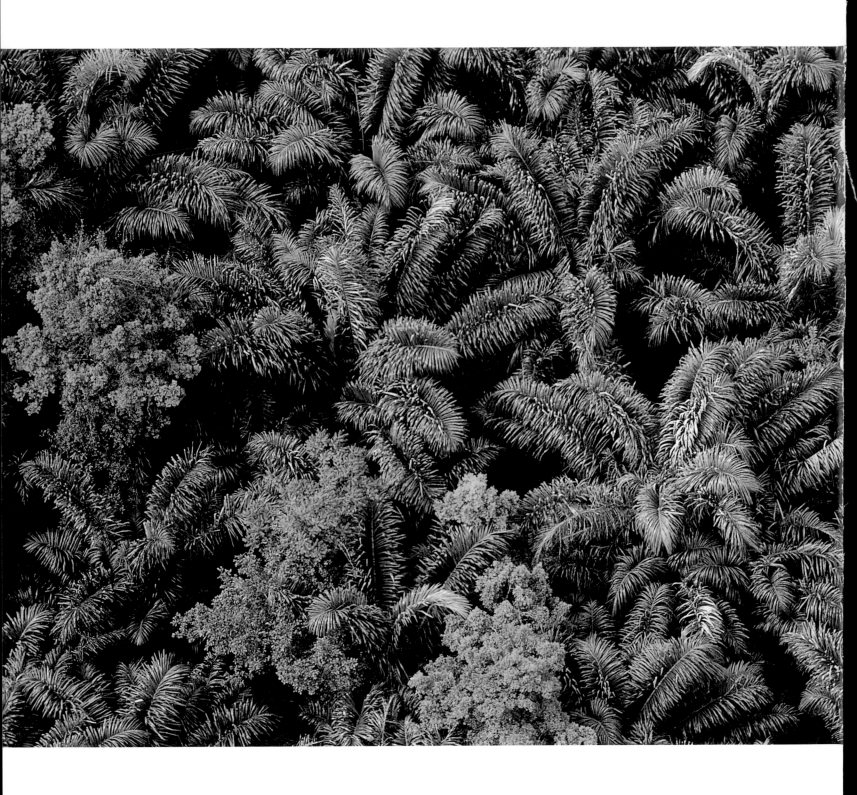

JUNGLE CANOPY, Corcovado National
Park, Costa Rica. Opposite: Scarlet
macaws (March 1991).

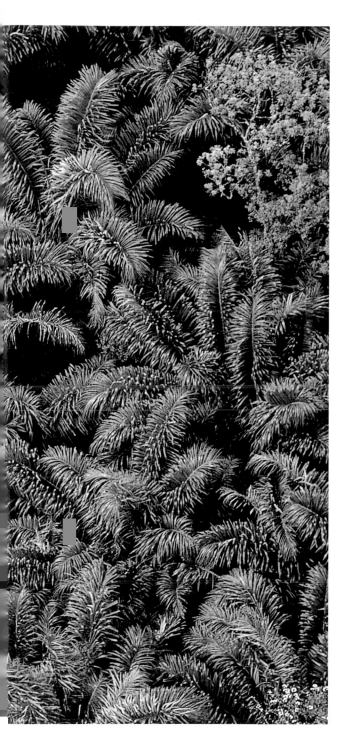